Gun-Dagmar Helke & Hela Schandelmaier

Höfische Begleiter

Möpse und andere Hunde
in Porzellan und Fayence

EINE SÜDDEUTSCHE PRIVATSAMMLUNG

Courtly Companions

Pugs and Other Dogs
in Porcelain and Faience

A PRIVATE COLLECTION
FROM SOUTHERN GERMANY

arnoldsche Art Publishers

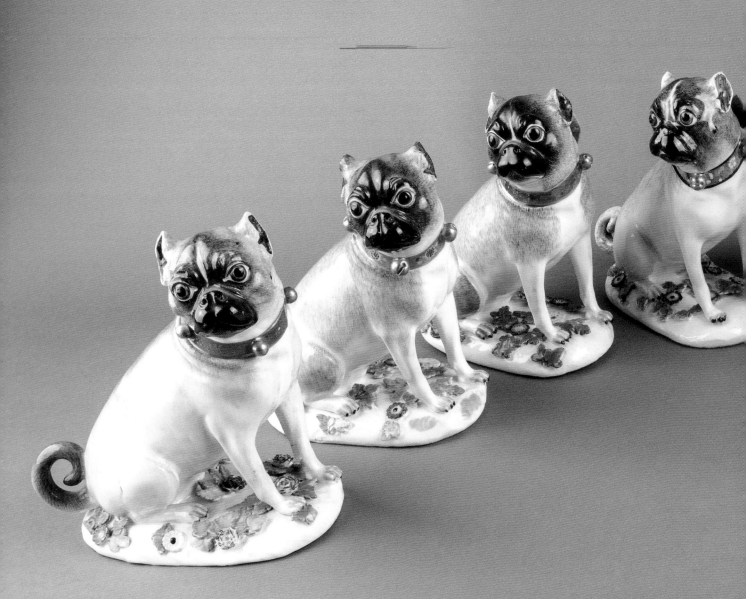

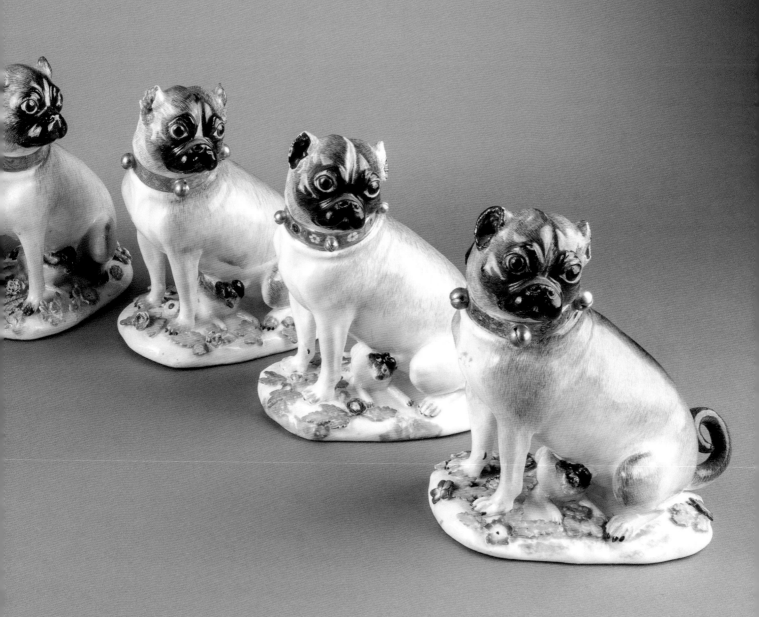

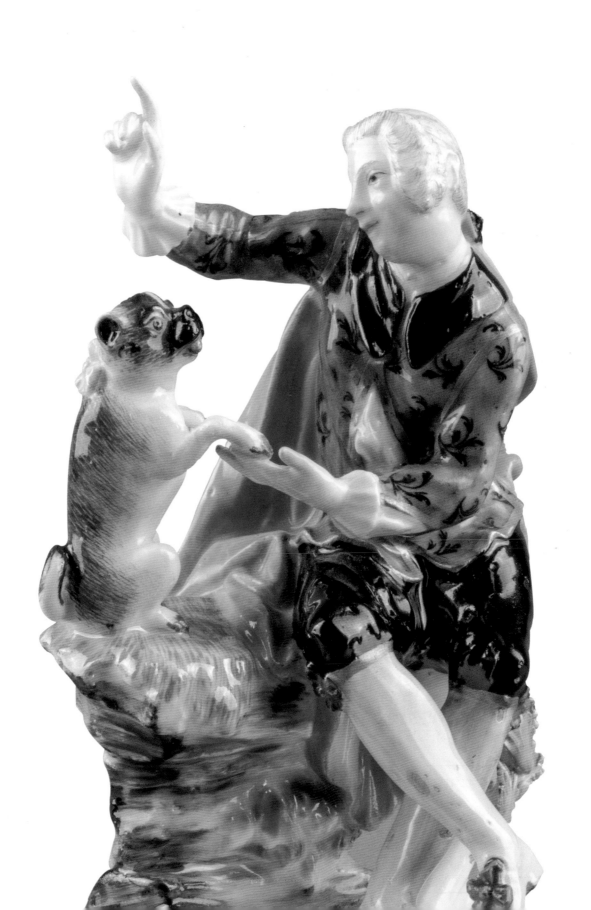

Inhaltsverzeichnis Contents

Vorwort

Alles begann an meinem 40. Geburtstag. Meine Schwägerin schenkte mir, wohl wissend um meine große Tierliebe, drei kleine Porzellanhunde, darunter einen braunen Porzellanmops aus der Manufaktur Potschappel bei Dresden. Ehrenhalber soll dieser hier als eines der ersten Keramiktierchen abgebildet werden. Ich ahnte nicht, was sich daraus entwickeln sollte. Zu jedem Geburtstag und auch zu anderen Anlässen gesellten sich zu diesem ersten Mops nach und nach weitere Porzellantiere, darunter viele Möpse und auch andere Hunderassen, größere und kleinere, aus verschiedenen Manufakturen und Materialien. Die meisten waren jedoch aus Porzellan. Meine Familie und Freunde hatten etwas gefunden, was mir zunehmend Freude bereitete.

Hin und wieder entdeckte auch ich einige Stücke, sei es auf Auktionen oder in Antiquitätengeschäften. Ich hätte mich jedoch nie als Sammlerin bezeichnet. Echte Sammler kannte ich nur aus der Literatur, wie den „Cousin Pons" (1847) von Honoré de Balzac, der ärmlich gekleidet zusammen mit seinem Gegenspieler Elias Magus seiner Leidenschaft frönt. Oder zuletzt „Utz" von Bruce Chatwin (1988), dem zwar durch den Prager Frühling alle Reichtümer seiner Vorfahren abhandengekommen waren, der aber seine kostbare Sammlung Meissner Porzellans in eine kleine Zweizimmerwohnung in Prag retten konnte.

Mit der Zeit lernte ich auch andere Sammler kennen, manche, die sehr speziell sammeln, andere, die ganze Konvolute kaufen in der Überzeugung, es wird schon etwas Gutes dabei sein.

Mir liefen meine Hunde im Grunde zu. Ich kaufte eine erste Vitrine, der weitere folgen sollten. Mit der Zeit und immerwährender Betrachtung lernte ich Unterschiede zu erkennen und Gruppen zu bilden, und ich begann, gezielt nach weiteren Gefährten Ausschau zu halten.

Und dann kam der Tag, an dem selbst ich einsehen musste, ja, ich bin eine Sammlerin und ich habe eine Sammlung. Man sagt, einen Sammler zeichnet Glück, Leidenschaft und Verantwortung aus. Glück hatte ich von Anfang an, Leidenschaft habe ich mit der Zeit entwickelt, nun fehlte nur noch die Verantwortung. Darum habe ich mich entschlossen, meine Sammlung professionell fotografieren und bearbeiten zu lassen. Zum einen, um den wunderbaren Stücken gerecht zu werden, aber auch anderen mit dieser Publikation eine Freude zu bereiten.

Preface

It all began on my fortieth birthday. My sister-in-law, knowing what an animal lover I am, gave me three little porcelain dogs, including a brown porcelain pug made by the Potschappel Manufactory near Dresden. It has the honour of being the first china animal to be pictured in the book. I myself had no inkling of where all this would go. On all birthdays and other important occasions more porcelain animal figurines gradually joined that first pug, among them many pugs as well as dogs of other breeds, large and small, made by a wide range of factories in a variety of materials. Most of them, however, were made of porcelain. My family and friends had discovered something that would bring ever more joy to me.

Now and then I would come across pieces myself, either at auctions or in antique shops. But I had never styled myself as a collector. The only genuine collectors I knew were in novels, such as the main character in *Le Cousin Pons* (1847) by Honoré de Balzac, who, shabbily dressed, indulges a passion for collection in the face of competition from the collector Élie Magus. Or most recently, Bruce Chatwin's *Utz* (1988), who lost all his treasured ancestral possessions in the Prague Spring but was able to hang on to his precious collection of Meissen porcelain in a cramped two-room Prague flat.

With time I came to know other collectors, some of them highly specialised while others, convinced a mixed lot is a lucky dip, snap up entire batches of objects.

Basically, my dogs have adopted me. To house them, I bought my first display case, which would be followed by others. With time and constant observation, I learnt how to draw distinctions and group

Ich danke allen, die zum Gelingen beigetragen haben, besonders den drei Akteuren Gun-Dagmar Helke und Hela Schandelmaier, die ich schon lange aus der Gesellschaft der Keramikfreunde kenne und die die Sammlung sortierten und wissenschaftlich bearbeiteten, sowie Bernd Bauer, der alle Objekte wunderbar fotografierte. Außerdem danke ich Dirk Allgaier und seinem Team. Er nahm sich der Veröffentlichung so professionell an und integrierte sie in das Programm von arnoldsche Art Publishers aus Stuttgart.

Die Sammlerin

my pieces, and I began a targeted search for more companions for them.

And then the day came when I had to concede that I, too, am a collector and have a collection. Collectors are said to be distinguished by good luck, passion and a sense of responsibility. I was lucky from the outset, and my passion for collecting has grown over time. All that was missing was the responsibility. That is why I decided to have my collection professionally photographed and adapted for publication. On the one hand, to do justice to these wonderful pieces, but also to give joy to others with this book. I thank all those who have contributed to its success, particularly the three who have been actively involved in the project: Gun-Dagmar Helke and Hela Schandelmaier, whom I have known for a long time from the German Society of Friends of Ceramics, for sorting the collection and subjecting it to scholarly study, and Bernd Bauer for superbly photographing all the objects. My thanks also to Dirk Allgaier and his team. He has lavished all his professional aplomb on this publication and integrated it into the arnoldsche Art Publishers Stuttgart programme.

The collector

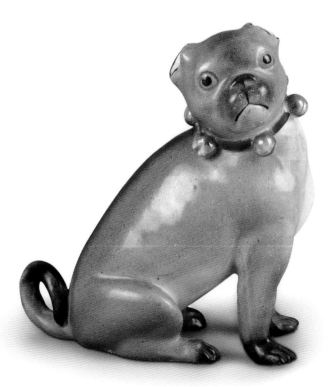

Der Mops –
eine Jahrtausende alte Rasse

The Pug –
a Breed Thousands of Years Old

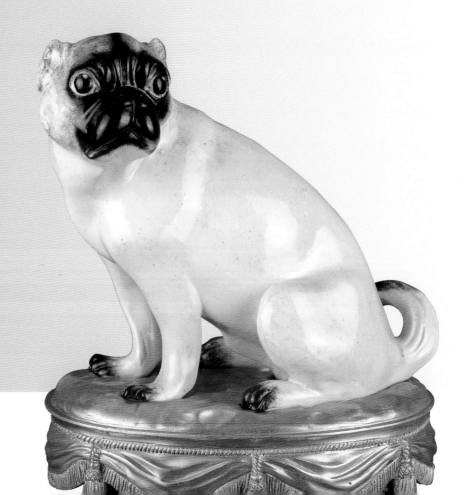

Der Mops blickt auf eine erstaunlich lange und bewegte Geschichte zurück.[1] Bereits vor etwa 2.400 Jahren ist die Existenz seiner Vorfahren in China belegt.[2] Damals waren Möpse noch große, kräftige Molossen-Doggen, die als Hirten- und Wachhunde vom Menschen gehalten wurden.

Im Kaiserreich China widmete man sich der systematischen Zucht, bei der die Größe von Generation zu Generation schrittweise abnahm. Chinesische Chroniken aus der Zeit des Konfuzius (1700 v. Chr.) erwähnen bereits kleine, kurzschnauzige Hunde.[3] Der so entwickelte Mops galt im Reich der Mitte als Kaiserhund. In der Zeit der Han Dynastie (206 v. – 220 n. Chr.) stand nur dem mächtigen, gottgleichen Herrscher das Privileg zu, Möpse besitzen und anfassen zu dürfen. Entsprechend durften sie ausschließlich an kaiserlichen Höfen gehalten werden. In den Stirnfalten des Hundes erkannten die Gelehrten das Schriftzeichen für „Prinz", weshalb der Mops zum Glückssymbol avancierte. Der in den Jahren 168 bis 189 amtierende Kaiser Ling Di erhob seine Möpse in den gleichen Stand wie seine Gemahlinnen, gleich wie Menschen wurden sie von Soldaten bewacht und ihr Diebstahl wurde mit der Todesstrafe geahndet.

Während der Song Dynastie (960–1279) wurde Kaiser Taizong (regierte 976–997) ein Hund mit der Bezeichnung „Lo-Chiang-sze" überreicht. Der Name „Lo Chiang" soll auf einen Ort in China verweisen. Die schriftliche Überlieferung erwähnt explizit das kurzhaarige Fell und den zusammengedrängten Fang, was darauf hindeutet, dass es sich um einen Mops gehandelt hat.[4]

Seit dieser Zeit hatten Möpse den Status eines hochgeachteten Geschenkes und verbreiteten sich in kaiserlichen Residenzen, wurden dort verehrt und gezüchtet. Nur in seltenen Fällen wurden der Ehre „unwürdige" und nicht zur Zucht geeignete Möpse an wohlhabende Bürger teuer verkauft. So fanden sie als repräsentativer Luxusartikel der gehobenen Gesellschaftsschicht nach und nach ihren Weg in Haushalte höfischer Beamter.

Im Dienste der Diplomatie – der Mops als Staatsgeschenk

Über die Rolle als kaiserliche Gesellschaftshunde hinaus erlangten Möpse eine weitreichende politische Bedeutung. Als diplomatische Geschenke wurden sie rund um den Erdball verschickt. Wollte sich der chinesische

The pug looks back on an astonishingly long and turbulent history.[1] Its ancestors are recorded in China 2,400 years ago.[2] At that time pugs were still large, powerful animals like Molossian hounds, which were domesticated as herding and watchdogs.

In imperial China empire, breeders dedicated themselves systematically to reducing the size of these dogs, which gradually became more diminutive from generation to generation. By the Confucian era (1700 BC), Chinese chronicles mention small dogs with short muzzles.[3] The dog developed in this way was regarded in the Middle Kingdom as an imperial dog. In the Han Dynasty (206 BC–AD 220), only the omnipotent ruler, who was viewed as divine, possessed the privilege of touching and owning pugs. Unsurprisingly, they were kept exclusively at imperial courts. Scholars read the character for 'prince' in the wrinkles on the pug's forehead, which explains why the pug advanced to the status of good luck symbol. The Eastern Han emperor Lingdi, who ruled from AD 168 to 189, elevated his pugs to the same rank as his concubines. Like human beings, they were guarded by soldiers, and the theft of a pug carried the death penalty.

During the Song Dynasty (AD 960–1279), a dog called a Lo-Chiang-Sze was given to Emperor Taizong (reign AD 976–997). The name Lo Chiang is believed to refer to a Chinese place name. Written records

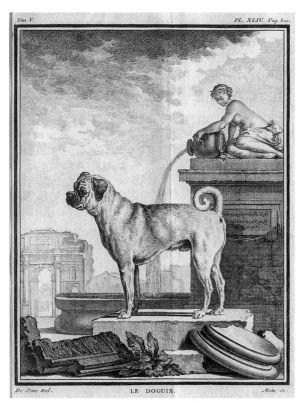

1 Jacques de Sève, Le Doquin, aus: Histoire Naturelle, Tom V., Pl. XLIV, Grafik 1755 Jacques de Sève, *Le Doguin*, from *Histoire Naturelle*, Vol. V, pl. XLIV, 1755, print

Kaiser die Gunst anderer Würdenträger sichern, verschenkte er als Zeichen der Wertschätzung Möpse aus seiner Zucht.

Mit Schiffen der Ostindienkompanie fanden Möpse in der Mitte des 16. Jahrhunderts ihren Weg nach Europa. Sie waren exotische Gastgeschenke für das holländische Königshaus, in einer Zeit, in der alle Waren, die aus Ostasien in den Häfen der Niederlande ankamen, mit besonderem Interesse erwartet wurden. Fremde Stoffe und Porzellane, Gewürze und Tee avancierten zu bewunderten und teuer gehandelten Luxuswaren. Im letzten Drittel des 17. bis weit ins 18. Jahrhundert hinein schätzte man die ostasiatischen Produkte so sehr, dass die europäischen Kaiser, Könige und Fürsten zu begeisterten Käufern wurden. Gleichzeitig versuchten sie, ähnliche, aber preiswertere Nachahmungen in eigenen Manufakturen herzustellen, wofür die Geschichte der europäischen Fayence- und Porzellanherstellung ein beeindruckendes Beispiel ist.

Die Liebe zum Mops als Standeszeichen exotischer Herkunft verbreitete sich vom Königreich der Niederlande in der Regierungszeit Williams III. (1650–1702) nach England.

explicitly mention a short-haired coat and compressed muzzle, which suggests that the dog must have been a pug.[4]

From that time on, pugs enjoyed the status of being highly prized presents and became widespread at imperial palaces, where they were venerated and bred. Only in rare cases were pugs that were 'unworthy' of such honour and unsuitable for breeding sold to rich patricians. Thus they gradually found their way into the households of court officials as ostentatious luxury articles signifying high social status.

On his majesty's service – the pug as a diplomatic gift

Above and beyond the role they played as imperial society dogs, pugs attained far-ranging political significance. As diplomatic gifts they were sent around the world. When the Chinese emperor wanted to ensure the favour of other dignitaries, he sent pugs from his kennels as a sign of esteem.

In the mid-sixteenth century, pugs found their way to Europe on Dutch East India Company vessels. They were exotic presents for the Dutch royal family at a time when all goods that arrived in Dutch ports from East Asia were awaited with avid interest. Foreign materials and porcelain, spices and tea climbed to luxury-goods status, and their market value soared accordingly. In the last third of the seventeenth century until well into the eighteenth, East Asian products were so highly appreciated that European emperors, kings and princes became enthusiastic purchasers of them. At the same time, they attempted to support the manufacture of simple but less expensive imitations in

In der ersten Hälfte des 18. Jahrhunderts hielten Möpse als Begleit-, Gesellschafts- und Schoßhunde in ganz Europa Einzug in die Salons adliger Damen.[5] In der Juliausgabe des *Journal des Luxus und der Moden* von 1789 ist der „Mode der Schossthiere" sogar ein eigenes Kapitel gewidmet, in dem vorrangig Hunde, aber auch Katzen, Affen, Vögel, Schlange, Eidechsen und Zikaden in dieser Funktion beschrieben werden. Zu den Hunden heißt es dort:

„Welche Race von Hunden zuerst den Anfang dieser Mode gemacht habe, davon schweigen die Geschichtsschreiber. Unter die ältesten Schooshunde gehören aber ohnstreitig die Mopse. Auf den Galerien des herzoglichen Residenzschlosses zu Gotha, befindet sich eine Folge von Gemälden in Lebensgröße von allen Sächsischen Fürsten und Fürstinnen, wo fast jeder Fürst seinen treuen, großen Bullenbeißer zu seinen Füssen, und jede Prinzessin ein kleines Schooshündchen neben sich hat; die letzten sind entweder Möpse, oder kleine dänische Hunde... Der Mops ist ein Blendling [Mischling] von dem englischen Bullenbeißer und dem kleinen dänischen Hunde. Von ihm und der Vermischung mit anderen Hundearten stammen noch drey Schoosgattungen ab, der Roquet, das Alicantische und das Artisische oder Kysseler Hündchen."[6]

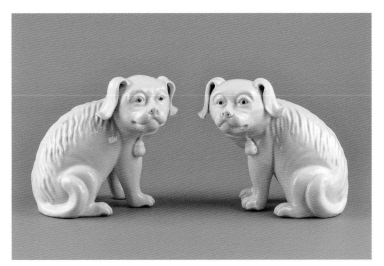

2 Zwei Porzellanhunde, China, Qing-Dynastie, Jiaqing-Periode (1760–1820)
Two porcelain dogs, China, Qing dynasty, Jiaqing reign period (1796–1820)

their own factories. The history of European faience and porcelain-making compellingly exemplifies this trend.

The fondness for pugs as status symbols of exotic origin spread from the United Provinces of the Netherlands to England during the reign of William III (1650–1702).

During the first half of the eighteenth century, pugs found their way into the salons of noble ladies throughout Europe as companion animals, statement pets and cuddly lapdogs.[5] The July 1789 issue of *Journal des Luxus und der Moden* devotes a chapter – 'Mode der Schossthiere' – to the fashion in small pets, in which dogs as well as cats, monkeys, birds, serpents, lizards and cicadas are described in this function. On dogs it says,

'Historians are silent on which breed of dog first ushered in this fashion. However, pugs are uncontestedly among the earliest lapdogs. In the galleries of the ducal palace in Gotha, there is a series of paintings of all Saxon princes and princesses in life-size, where almost every prince has his faithful, big German bulldog to heel, and every princess has a little lapdog next to her; the latter are either pugs or small Danish dogs. [...] The pug is a mongrel, a cross between the English bulldog and the small Danish dogs. From the pug and crossbreeding with other breeds of dogs, three more types of lapdog descend: the roquet, the Alicantian and the Normand Artesian Basset, or Kyssel dog.'[6]

Even though an article was devoted to court hunting and companion dogs in this very widely read journal, the popularity of the pug had peaked by the 1780s. As early as 1781, Johann Georg Friedrich Franz noted

Auch wenn den höfischen Jagd- und Gesellschaftshunden in dieser sehr populären Zeitschrift ein Betrag gewidmet wurde, war die Hochzeit in den 1780er-Jahren bereits vorüber. Schon 1781 hatte dies Johann Georg Friedrich Franz in seinem Hundeführer angemerkt[7]. Im Journal von 1789 heißt es:

> „Auch die Mode der Mopse ist bey uns vorüber und ihre Stelle haben Boloneser- oder Maltheser- und das Löwenhündchen, das kleine englische Windspiel, und der kleine Spitz ec. eingenommen."[8]

Möpse waren in der Zeit zwischen 1745 bis 1765 bei den Damen höheren Standes jedoch nicht nur als Modeaccessoire en vogue, sondern sym-

this fact in his dog book.[7] This conclusion is confirmed in the 1789 *Journal des Luxus und der Moden:*

> 'The pug is also out of fashion here, and its place has been taken by the Bolognese or Maltese and the löwchen, the small English whippet and the miniature spitz, etc.'[8]

Pugs were, however, en vogue among ladies of the upper classes between 1745 and 1765, and not just as fashion accessories; they also symbolised membership of a particular social group as well as the virtues of faithfulness, patriotism and constancy.[9] For this reason noble ladies often sat for their portraits with their beloved pugs. One of them was Henriette Marie von Brandenburg-Schwedt (1702–1782), heiress to the throne of Württemberg, who in 1745 was immortalised by Georg Lisiewski (1674–1751) in Berlin in a portrait lavishly furnished with staffage including the sitter's pet.

Quite apart from the virtuous symbolism, the pug in portraits alludes to the para-Masonic Order of the Pug, founded *c.*1740, to which women were also admitted if they were Catholic (Fig. 3).[10]

3 Georg Lisiewski, Henriette Marie von Brandenburg-Schwedt, Öl auf Leinwand, 1745
Georg Lisiewski, Henriette Marie von Brandenburg-Schwedt, oil painting, 1745.

The 'Mopperer' conquers Europe – where it got its name and what his salient characteristics are

Mops, the German term for the squat little dogs with distinctive facial markings, can be traced back to Dutch pug owners. They noticed that the animals uttered grumbling sounds, succinctly described as snorting and grunting. The Dutch verb *mopperer* describes this sort of acoustic behaviour, giving some indication as to how the present-day *Mops* – the term

bolisierten eine bestimmte gesellschaftliche Zugehörigkeit sowie die Tugenden Treue, Patriotismus und Standhaftigkeit.[9] Aus diesem Grund ließen sich adlige Damen oft mit ihrem geliebten Mops porträtieren, so beispielsweise Henriette Marie von Brandenburg-Schwedt, Erbprinzessin von Württemberg (1702–1782), die von Georg Lisiewski (1674–1751) 1745 in Berlin auf einem reich ausstaffierten Bildnis verewigt wurde (Abb. 3).

Über die tugendhafte Symbolik hinaus verweist der Mops in Porträts auf die Zugehörigkeit zum 1740 gegründeten freimaurerischen Mopsorden, zu dem auch katholische Frauen zugelassen wurden.[10]

Der „Mopperer" erobert Europa – warum er so heißt und was ihn auszeichnet

Die Bezeichnung für die kleinen, gedrungenen Hunde mit der markanten Gesichtszeichnung geht auf holländische Mopshalter zurück. Ihnen fiel auf, dass die Tiere brummende Laute von sich geben, schnarchen und grunzen. Das holländische Verb „mopperer" beschreibt ein derartiges Verhalten, wodurch die heutige Bezeichnung „Mops" entstand, die sich in den Niederlanden, Deutschland und Belgien durchsetzte.

In seiner Ausführlichen Geschichte der Hunde ordnete Johann Georg Friedrich Franz schon 1781 Möpse der Abstammung nach den kräftigen Jagdhunden zu und beschrieb sie so:

„Mops, Steindogge macht linkerhand eine Seitenlinie von dem Bullenbeißer aus. Er ist im Kleinen dasjenige, was der Bullenbeißer im Großen ist. Sein Kopf ist platt und rund, die Schnauze kurz, zwischen den Augen eingedrückt und schwarz, die Nase aufgeworfen und breit, die Lippen kurz, der Leib dick und kurz, die Schnauze aufwärts zusammengerollt, die Ohren hängen herunter, ob sie ihm auf widernatürliche Art abgeschnitten werden. Das Haar ist kurz gelblich, mehrentheils erbsfarben, schwarz insonderheit an der Schnauze. Von dem Bullenbeißer unterscheidet er sich dadurch, daß er eine mindere Größe, einen schwächeren Kopf, dünnere und kürzere Lefzen, und eine schmälere und nicht so stumpfe Schnauze hat. Er gleicht ihm aber an Gestalt des Leibes,

which has remained in use for the pug in the Netherlands, Germany and Belgium – got its name.

In his extensive history of dogs, Johann Georg Friedrich Franz assigned pugs by descent to the dog breed group of powerful hunting dogs back in 1781 and described them as follows:

'Mops, Steindogge [stone Great Dane], on the left is a collateral line descending from the bulldog. It is a miniature of the bulldog, which in turn is an enlarged pug. Its head is flattened and round, its muzzle short, depressed between the eyes and black, its nose flaring and broad, its lips short, its body plump and short, its muzzle wrinkled in folds towards the tip, its ears hanging down as if they had been cropped in an unnatural way. The coat is short-haired and yellowish, usually fawn-coloured, black, especially around the muzzle. It differs from the bulldog in that it is smaller, has a less massive head, thinner and shorter lips, and a narrower and not so blunt muzzle. It does, however match it in the shape of its body, the length and colour of its coat, yet its descent from bulldogs is not at all discernible; only through crossbreeding with other dogs have they become rather degenerate. Where character is concerned, this breed of dog is one of the gentlest. Once they were very commonplace yet have now gone quite out of fashion.'[11]

The term *Steindogge* was standard German usage alongside *Mops* for a long time and alluded to the purported relationship of pugs to Great Danes. An entry on pugs in the 1839 *Oeconomisch-technologischen Enzyklopädie* [Economic-Technological Encyclopaedia] runs: 'Steindocke, Steindogge, a type of small

an der Länge und Farbe der Haare, und man kann darinn ihre Abstammung von ihnen gar nicht erkennen, nur durch die Vermischung mit anderen Hunden sind sie ein wenig ausgeartet. In Ansehung des Charakters ist diese Hundeart eine der Sanftmüthigsten. Sonst waren sie sehr gewöhnlich, sie sind aber itzt ziemlich aus der Mode gekommen."[11]

Die Bezeichnung Steindogge war lange Zeit parallel üblich und verwies auf die Verwandtschaft zur Dogge. 1839 ist in der *Oeconomisch-technologischen Enzyklopädie* zu lesen: „Steindocke, Steindogge, eine Art kleiner Hunde, Mops genannt."[12] Die dort zu findende Beschreibung und Charakterisierung der Möpse wurde nach fast 60 Jahren wörtlich aus dem Hunderassenführer von 1781 übernommen.

Bis 1877 waren in Europa nur Möpse in hellfalbfarbigem Fell mit dunklen Akzenten bekannt. Nachdem ein schwarzes Hundepaar vom Orient eingeführt wurde, begann die Nachzucht dieser Farbvariante, die sich dann ebenfalls rasch an den europäischen Höfen verbreitete.

Möpse gelten als ausgeglichene, fröhliche und lebhafte Gesellschafts- und Begleithunde. Sie werden 12 bis 15 Jahre alt. Mit einer Schulterhöhe von 25 bis 30 Zentimetern und einem Gewicht von sechs bis acht Kilogramm wirken die Tiere recht gedrungen und kompakt.

dog, known as a Mops.'[12] The physical description and characterisation of pugs in that work was taken over verbatim from the 1781 guide to dog breeds after a lapse of nearly sixty years.

Until 1877 only pugs with light fawn-coloured or tawny coats with dark markings were known in Europe. After a pair of black pugs was imported from the Near East, breeding began for this colour variant, which also rapidly spread at European courts.

Pugs are regarded as even-tempered, cheerful and lively statement pets and companion dogs. Their lifespan ranges from twelve to fifteen years. Standing 25 to 30 centimetres at the withers and weighing from six to eight kilograms, they are quite squat and compact in appearance.

Nowadays pugs are somewhat more short-legged than they were in the eighteenth century. A characteristic feature is still the black markings of the 'mask', the black line running down the spine from occiput to tail (in German called *Aalstrich*, 'eel line') the dark markings on jowls and brow, the ears, the tip of the tail and the toes, which are known as 'badges' in German. 'Cropped' ears that are small and folded with the front edge touching the side of the head are called 'rose' ears while larger pug ears are known as 'button' ears: both ear styles are a persistent physical feature (Fig. 4).

The salient physical characteristic, however, is the lack of a protruding snout, which means the muzzle and nose are very flat, making the head look round.

Pugs are highly adaptable to their surroundings, low-maintenance and happy to be with both people and other animals, characteristics that go quite a way to explaining why their popularity is again increasing.[13]

4 Möpse nach heutigen Rassestandarts Pugs by today's breeding standards

Heute sind Möpse etwas kurzbeiniger als im 18. Jahrhundert. Charakteristisch sind nach wie vor die schwarze Zeichnung der Maske, die als „Aalstrich" bezeichnete Rückenlinie, die Wangen- und Stirnflecken, Ohren, die doppelt geringelte Posthornrute und Zehen, die „Abzeichen" genannt werden. Typisch sind weiterhin die kleinen, nach vorn fallenden, kupierten Ohren, auch Knopf- oder Rosenohr genannt (Abb. 4).

Das wesentlichste Merkmal ist jedoch das Fehlen eines Fangs, das heißt: Maul und Nase sind sehr flach und lassen den Kopf rund wirken.

Möpse passen sich ihrer Umgebung gut an, sind pflegeleicht und fühlen sich in Gesellschaft von Mensch und Tier wohl, weshalb sie sich heute wieder zunehmender Beliebtheit erfreuen.[13]

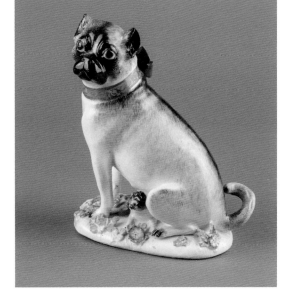

5 Sitzender Mops, Meissen, um 1745 → Kat.-Nr. 39 Sitting pug, Meissen, *c.*1745 → Cat. No. 39

1 Wegmann/Schmitz 2016, S. 54; Räber 1993, S. 634.
2 Fédération Cynologique Internationale (AISBL), FCI-Standard Nr. 253 vom 13.07.2011.
3 http://www.pug.eu/gallery-of-pug-history/geschichte-des-mops-herkunft/
4 ebd.
5 Noeske 2001, S. 11–13.
6 Bertuch/Kraus 1789, S. 281–282.
7 Franz 1781.
8 Bertuch/Kraus 1789, S. 282.
9 Illgen 1973. Kat. S. III.
10 Siehe Kapitel 3.
11 Franz 1781, S. 89–90. Zum Bullenbeißer siehe auch Kapitel 7.
12 Krünitz 1839, 172. Theil, S. 291.
13 Auch die Ernährung ist unkompliziert. Allerdings neigen Möpse aufgrund ihres kompakten Körperbaus zu Übergewicht und sind in den heißen Sommermonaten gefährdet, rasch einen Hitzeschlag zu erleiden. Außerdem sollte der Kontakt mit Kaffee- und Kakaobohnen unbedingt vermieden werden, da diese ein sofortiges, starkes Würgen hervorrufen.

1 Wegmann/Schmitz 2016, p. 54; Räber 1993, p. 634.
2 Fédération Cynologique Internationale (AISBL), FCI - Standard No. 253 from 13 July 2011.
3 http://www.pug.eu/gallery-of-pug-history/geschichte-des-mops-der-mops-herkunft/
4 Ibid.
5 Felicitas Noeske, *Das Mopsbuch*, Frankfurt a.M./Leipzig 2001, pp. 11–13.
6 Bertuch/Kraus 1789, pp. 281–282.
7 Franz 1781.
8 Bertuch/Kraus 1789, p. 282.
9 Illgen 1973. Kat. p. III.
10 See chapter 3.
11 Franz 1781, pp. 89–90. Bullbaiter, see chapter 7.
12 Krünitz 1839, 172. Theil, p. 291.
13 They are also easy to feed. However, due to their compact build, pugs tend to become overweight and during the hot summer months are in danger of soon suffering heat stroke. In addition, contact with coffee and cocoa beans must be avoided at all costs because they immediately induce violent retching.

Berühmte Möpse und ihre Besitzer

—·—·—·—·—

Famous Pugs and Their Owners

—·—·—·—·—

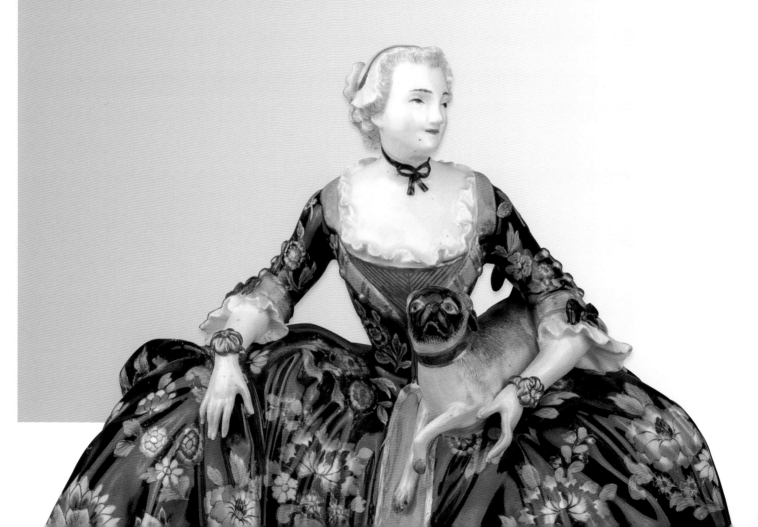

Im Laufe der Jahrhunderte begegnen uns Möpse immer wieder als Begleiter historischer Persönlichkeiten. So fanden sie Eingang in die politische und kulturhistorische Überlieferung.

Ein berühmtes Beispiel ist die Belagerung der Stadt Bretten im Jahre 1504 durch Ulrich von Württemberg (1487–1550), die der Sage nach nur durch einen Mops, das *Brettener Hundle*, beendet werden konnte.[1] Die Stadt, so wird berichtet, sei vom Feind umzingelt gewesen und sollte ausgehungert werden. Kurz bevor die letzten Nahrungsmittelreserven aufgebraucht waren, hätten die Bewohner eine List ersonnen und ließen einen wohlgenährten Mops durch das Stadttor entkommen. Als die Belagerer den dicken Hund erblickten, glaubten sie, dass eine Stadt, die ihre Hunde noch so gut ernähren könne, über genügend Vorräte verfügte und gaben die Blockade auf. Noch heute erinnert der *Hundles-Brunnen* (Abb. 6) und ein Fresko in der evangelischen Stiftskirche von Bretten an den stadtbekannten Mops.

Eine andere Geschichte soll sich 1570 im Heerlager zu Hermigny zugetragen haben.[2] Prinz Wilhelm I. von Nassau-Dillenburg und Fürst von Oranien (1533–1584), der eine bedeutende Rolle im niederländischen Unabhängigkeitskrieg gegen Spanien (1568–1648) spielte, besaß einen Mops namens „Pompey", der ihn immer begleitete. Es war der erste Hund seiner Art, dessen Name überliefert ist. Als spanische Schergen eines nachts die Ermordung des Prinzen planten, soll Pompey seinen Herrn, den Statthalter der Niederlande, durch lautes Bellen geweckt haben. Ohne die rettende Tat des Hundes wäre die Geschichte Europas zweifellos anders verlaufen.

Das Prinzenpaar Wilhelm III. (1650–1702) und Maria II. (1662–1694) von Oranien, spätere Könige von England, Schottland und Irland, brachten mit ihrer Übersiedelung von den Niederlanden nach England im Jahr 1689 auch ihre geliebten Möpse mit. Schnell entwickelte sich daraufhin die Mopsbegeisterung auch auf der britischen Insel, und die dortige Aristokratie geriet in kürzester Zeit in den Bann dieser eigentümlichen Hunderasse.

Ein anderes Mal soll der Sage nach ein Vertreter des so harmlos wirkenden Gesellschaftshundes ein enormes Maß an Ausdauer und Orientierungsvermögen bewiesen haben. Herzog Karl Alexander von Württemberg (1684–1737) zog nicht ohne seinen Mops in die Schlacht um Belgrad. Im Kampfgetümmel gegen die osmanischen Truppen im Jahr 1717 wurden Herr und Hund getrennt. Alles Suchen half nichts und

Over the course of centuries, we constantly encounter pugs as the companions of famous people. Thus they became part of political and cultural history.

One famous example is the siege laid to the city of Bretten in 1504 by Ulrich of Württemberg (1487–1550). According to legend, the siege could only be ended by a pug, the *Brettener Hundle*.[1] The city, as the story goes, was surrounded by the enemy and set to be starved to death. Just as the last food reserves were about to run out, the residents of Bretton thought up a trick and opened the city gates a crack to allow a well-fed pug to squeeze its way out. The sight of the portly pet convinced the besieging forces that a city that could feed even its dogs so well would have sufficient stocks of food to withstand a long siege, and they withdrew. The *Hundlesbrunnen* (Fig. 6), a fountain with a statue of a pug atop a tall column, and a fresco in the Bretten Lutheran Collegiate Church commemorate the city's famous pug.

Another pug story is said to chronicle events that took place in the army encampment at Hermigny in 1570.[2] William I of Nassau-Dillenburg, Prince of Orange (1533–1584), who played such a significant role in the Dutch War of Independence from Spain (1568–1648), owned a pug named Pompey, who always accompanied him. This is the first dog of its breed to have bequeathed its name to posterity. When Spanish assassins plotted to kill the prince, the stadtholder of the Netherlands,

6 Hundlesbrunnen in Bretten The *Hundlesbrunnen* in Bretten, memorial of the famous Bretten dog

man glaubte den Mops verloren. Dieser nahm jedoch sein Schicksal selbst in die Hand und folgte seinem Instinkt zurück ins heimatliche Winnenden. Nach einer Strecke von über 1000 Kilometern soll er schließlich heil im Schloss Winnental angekommen sein.[3] Über diese Leistung waren nicht nur der Herzog, sondern auch die Winnender Bürger erstaunt. Als Erinnerung an diese Begebenheit wurde dem treuen Mops im Ortszentrum ein Denkmal gesetzt (Abb. 7).

In das italienische Volkstheater, der Commedia dell'arte, hielten Möpse allerdings aus ganz pragmatischen Gründen Einzug. Ursprünglich trat an der Seite des Harlekins ein Affe auf. Da diese exotischen Tiere jedoch schwer zu beschaffen und aufwändig zu halten waren, ersann der italienische Schauspieler Carlo Antonio Bertinazzi, genannt Carlin (1710–1783, Abb. 8) eine Alternative.[4] Er ersetzte das flinke Klettertier durch den schlauen Mops, der ebenso gerne kleine Kunststückchen vorführte und durch seinen Ringelschwanz und die flache Schnauze lustig wirkte. Dieser Eindruck wurde dadurch verstärkt, dass er sich mit Zweispitz, plissiertem Kragen und Glöckchen um den Hals auf seinen Hinterbeinen tänzelnd über die Bühne bewegte.[5] So erlangte der Mops

one night, Pompey is said to have awakened his owner by barking loudly. Without the dog's life-saving intervention, European history would undoubtedly have taken a different course.

William, Prince of Orange (1650–1702), and his wife, Mary Stuart (1662–1694), became joint sovereigns of England, Scotland (as William III and II and Mary II, queen regnant of England) and Ireland. When they moved to England from the Netherlands, in 1689, they brought their precious pugs with them. A pug craze then swept the British Isles, and the aristocracy lost no time in succumbing to the charm of this oddly appealing breed of dog.

On yet another occasion, a representative of the breed is said to have shown astonishing stamina and long-distance homing instinct for such a harmless-looking status pet. Karl Alexander, Duke of Württemberg (1684–1737), refused to leave Fortunatis, his pug, behind at the Siege of Belgrade in 1717. In the thick of battle against Ottoman forces, the dog was separated from its master. The pug was sought high and low and believed to have been lost. The plucky dog, however, took its fate into its own paws and followed its homing instinct unerringly all the way back to Winnenden. After covering a stretch of over 1,000 kilometres, Fortunatis arrived safe and sound at Castle Winnental.[3] The duke and the townspeople of Winnenden were stunned at this feat of canine endurance. To commemorate the legendary event, a monument was raised to the faithful pug in the town centre (Fig. 7).

On the other hand, pugs became involved with the Italian popular touring comedy theatre, the Commedia dell'arte, for entirely pragmatic reasons. Originally it was a monkey that performed with Harlequin; however, since those exotic creatures were difficult to procure and high-maintenance once sourced, the Italian actor Carlo Antonio Bertinazzi, known as Carlin

in der Commedia dell´arte neue Berühmtheit und kam auf den Bühnen des Barock in Mode. Die französische Bezeichnung *Carlin* für Mops geht auf den italienischen Komödianten zurück und erinnert bis heute an dessen Verbundenheit zu diesen Hunden.

Zur Blütezeit der Commedia dell´arte waren Möpse in ganz Europa die beliebtesten Gesellschaftshunde. Sie tummelten sich in Schlössern und Adelssitzen, auf den Armen der Damen und fungierten als Begleiter müßig-gehender adeliger Herren. Niemanden schien es zu stören, dass der beste Freund dieser höfischen Gesellschaft grunzte, haarte, schnarchte und in der Regel den besten Platz für sich beanspruchte. Einen Nutzen hatte er nicht, da er sich weder zur Jagd noch als Wachhund eignete. Der Mops diente allerdings umso besser dazu, den Menschen zu erfreuen, als Ge-fährte, manchmal als wärmendes Haustier in den kalten und zugigen Räumen der damaligen Zeit. Sein drolliges Aussehen spielte sicher eine

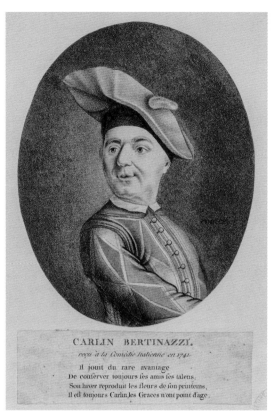

8 J. Coutellier, Carlo Antonio Bertinazzi, Farbradierung, 1742
J. Coutellier, Carlo Antonio Bertinazzi, colour etching, 1742

7 Winnender Hund The pug memorial in Winnenden

(1710–1783, Fig. 8), came up with a viable alterna-tive.[4] He replaced the nimble simian with the cobby but clever pug, which was just as happy to perform little tricks and looked comical with its curled tail and crumpled velvet muzzle. The comedic impres-sion was heightened by having a pug, dressed up in a bicorne hat, crisply pleated collar and bells round its neck, caper about the stage on its hind legs.[5] Thus the pug consolidated its fan base with Commedia dell'arte appearances to become a hit on the Baroque stage. The French term for pug, *carlin*, derives from the Italian player's name and is a lasting reminder of his links with these dogs.

In the heyday of the Commedia dell'arte, pugs were the most popular statement pets in Europe. They disported themselves in castles and manor houses, in the arms of ladies and as leisure companions to aristo-crats and gentlemen. No one seemed to mind that court

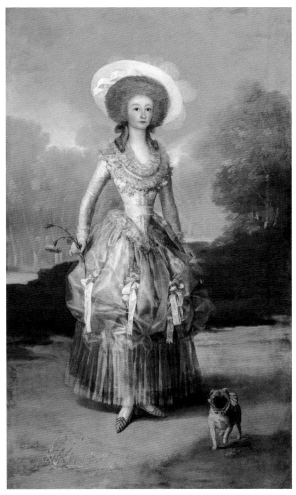

9 Francisco José de Goya, Doña María Ana de Pontejos y Sandoval,
Öl auf Leinwand, um 1786 *Francisco José de Goya, Doña María Ana de
Pontejos y Sandoval, oil painting, c.1786*

society's best friend grunted, shed hair, snorted and snored, and tended to bag the best seats for itself. The pug was not useful since it was unsuitable as a hunting dog or guard dog. Still its apparent uselessness made pugs all the better suited to delight their owners, as companions, sometimes even as hand warmers and hot water bottles in the cold, draughty rooms of the time. The pug's comical appearance is bound to have played an important role, but it also has a reputation for being intelligent, courageous and teachable. The enthusiasm for these dogs resulted in pugs as staffage in paintings and representations of the dogs in a wide variety of materials.

Many reigning princesses sat for their portraits with their favourite pets. One of the most distinguished of these was painted *c.*1786 by Francisco José de Goya (1746–1828). Doña María Ana de Pontejos y Sandoval, known as the Marquesa de Pontejos (1762–1834), was the keen patroness of the painter and commissioned this portrait from him shortly before her marriage to the Spanish ambassador to Portugal. Goya has captured her in a landscaped park. She is wearing an elaborately designed dress, her hair in an ornate coiffure beneath a broad-rimmed sun hat (Figs. 9, 10). The pink carnation in her hand symbolises love and betrothal, and the colour reappears in the pug's collar. Her immovable pose and the pug's lively gait are wonderfully complementary.

The same dramaturgical tension between contemplative calm and spontaneous movement informs a 1769 portrait of Anna Amalia, Duchess of Saxony-Weimar and Eisenach (1739–1807, Fig. 11). Anna Amalia, née Princess of Brunswick-Wolfenbüttel, was at the centre of court life in Weimar and her summer residence in Tiefurt as a reigning princess, patron of the arts, art lover and composer. Johann Ernst Heinsius (1731–1794), painter to the Weimar court, portrayed her in settings befitting her status as the wife of Ernest Augustus II

wichtige Rolle, ihm wird aber auch Intelligenz, Mut und Gelehrigkeit nachgesagt. Die Begeisterung für diese Hunde mündete in der Abbildung auf Gemälden und der Darstellung in unterschiedlichsten Materialien.

Zahlreiche Regentinnen ließen sich mit ihrem Lieblingstier porträtieren. Eines der prominentesten Bildnisse fertigte Francisco José de Goya (1746–1828) um 1786. Doña María Ana de Pontejos y Sandoval, genannt Marquesa de Pontejos (1762–1834) war die begeisterte Mäzenin dieses Malers und gab das Porträt kurz vor ihrer Heirat mit dem spanischen Botschafter in Portugal in Auftrag. Goya stellt sie in aufwändig gearbeitetem Kleid, mit kunstvoller Frisur und ausladendem Sonnenhut in einer Parklandschaft dar (Abb. 9, 10). Die rosa Nelke in ihrer Hand symbolisiert die Liebe und den Brautstand und setzt sich farblich im Halsband des Mopses fort. Ihr Posieren und seine Beweglichkeit ergänzen sich wunderbar.

Diese dramaturgische Spannung zwischen besonnener Ruhe und spontaner Bewegung kann man auch im 1769 entstandenen Porträt der Herzogin Anna Amalia von Sachsen-Weimar und Eisenach (1739–1807) beobachten (Abb. 11). Die als Prinzessin von Braunschweig-Wolfenbüttel geborene Regentin, Mäzenin, Kunstliebhaberin und Komponistin stand im Mittelpunkt des gesellschaftlichen Lebens am Weimarer Hofe und in ihrem Sommerdomizil in Tiefurt. Als Frau von Ernst August II. Konstantin, Herzog von Sachsen-Weimar und Sachsen-Eisenach (1737–1758), stellte sie der Weimarer Hofmaler Johann Ernst Heinsius (1731–1794) in standesgemäßem Ambiente dar. Literatur und Musik sind durch die Accessoires symbolisiert. Die Aufmerksamkeit zieht jedoch der links unten dargestellte Mops auf sich, der ungestüm an der Herzogin emporspringt.

Ganz zufrieden und die Ruhe genießend liegt dagegen der Mops auf dem Schoß der noch kindlichen Élisabeth Philippine Marie Hélène de Bourbon, genannt Madame Élisabeth von Frankreich (1764–1794) (Abb. 12). Das Mädchen sitzt mit durchgedrücktem Rücken Modell. Beide schauen dem Betrachter direkt in die Augen und vermitteln so eine eindrückliche Nähe und Präsenz. Die Schwester Ludwigs XVI., die mit nur 30 Jahren kurz nach ihm durch das Revolutionstribunal verurteilt wurde und ihrem Bruder in den Tod folgen musste, ist hier als Sechsjährige von Joseph Ducreux (1735–1802) festgehalten worden. Der Maler betont die sensible Vertrautheit von Kind und Mops.

Auch der englische, sozialkritische Maler und Grafiker William Hogarth (1697–1764) hatte ein inniges Verhältnis zu seinem Mops *Pugg*, dem später ein zweiter namens *Trump* folgte. Letzterer hat an verschiedenen Stellen Eingang in die Arbeiten des Künstlers gefunden. Am bekanntesten ist sicher sein Selbstbildnis von 1745, das sich mit radierten Varianten von 1749 in der Tate Gallery London befindet (Abb. 13). In anderen Bildern vertritt Trump seinen Herren und fungiert praktisch als Signatur, Stellvertreter oder Alter Ego. Beide besaßen eigensinnige und streitlustige Charaktere, die sich offenbar wunderbar ergänzten.

Außerdem stand Trump 1730 dem Mopswelpen Pate, der im Porträt der Familie Fountaine zu sehen ist.[6] Die berühmteste Darstellung ist jedoch in der auflagenstarken Serie *A Rake's Progress* („Lebenslauf eines Wüstlings") zu finden, die ursprünglich acht Gemälde umfasste, die zwischen 1730 und 1735 entstanden, und in der druckgrafischen Umsetzung zu einem Verkaufsschlager avancierte. Thema ist der Abstieg

Constantine, Duke of Saxony-Weimar and Saxony-Eisenach (1737–1794). Literature and music are symbolised in the painting by accessories. What catches the eye here, though, is the pug pawing the Duchess's skirt, bottom left, as boisterous staffage.

By contrast, the pug portrayed with Élisabeth Philippine Marie Hélène de Bourbon, later known as Madame Élisabeth of France (1764–1794, Fig. 12), is contentedly resting on the girl's lap while she sits bolt upright. Both the pug and its mistress look the viewer directly in the eye, thus conveying a vivid immediacy and presence. The sister of Louis XVI, who at only thirty years of age was condemned by the Revolutionary tribunal shortly after her brother and had to die as he did, has here been captured as a six-year-old by Joseph Ducreux (1735–1802). The painter has sensitively interpreted the affectionate relationship between the child and her pug.

The English social critic, painter and graphic artist William Hogarth (1697–1764) also bonded closely

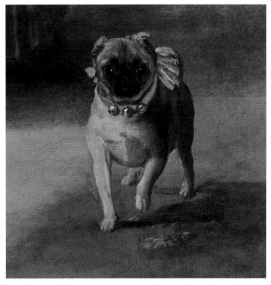

10 Ausschnitt aus Abb. 9 Detail from Fig. 9

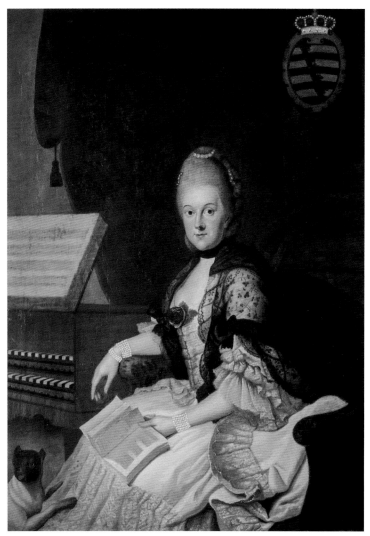

11 Johann Ernst Heinsius, Anna Amalia von Sachsen-Weimar und Eisenach, Öl auf Leinwand, 1769 Johann Ernst Heinsius, *Anna Amalia of Saxony-Weimar*, oil painting, 1769

with his pug, called Pugg, who was succeeded by a second pug, named Trump. The latter made various appearances in the artist's work. The best known portrayal is surely the artist's 1745 self-portrait, which along with a 1749 engraved version is in the Tate Gallery, London (Fig. 13). In other pictures, Trump represents his master, functioning practically as his signature, surrogate or alter ego. Both the pug and its owner were known for their obstinate and confrontational dispositions so they were evidently a perfect match.

In 1730 Trump also stood in for the pug puppy that is depicted in the Fountaine family portrait.[6] Trump's most celebrated portrait is, however, in *A Rake's Progress*, which originally comprised eight paintings executed between 1730 and 1735 but became a bestseller running to numerous editions as a print series. The subject is the decline and fall of one Tom Rakewell, who, after inheriting his father's fortune, squandered it by leading a debauched life that led to debtor's prison and ultimately the madhouse. Hogarth based his moralising series, which at the time corresponded to what was still a new genre in art, on Tom's sad fate. In the fifth painting and print, *Married to an Old Maid*, the already ruined rake is shown marrying an old maid in a vain attempt to halt his inexorable decline (Fig. 14). The bride and groom are mirrored by two pugs. Hogarth's pug, Trump, is indicating an interest in a female pug that is perched elegantly on a stool. Thus the pug was assigned a socially critical role. Hogarth himself was caricatured as a pug by fellow artists, such as Paul Sandby (1730/311809).[7] Louis-François Roubiliac (1695–1762), a sculptor who was a friend of Hogarth's, modelled Trump in clay. In the latter half of the 1740s, variants of the sculpture were made in porcelain, definitively immortalising this particular pug.[8]

The decorative arts gave rise to the widest range of pug portrayals, specifically at the faience and later

von Tom Rakewell, der nach dem Tod seines Vaters dessen Vermögen durch einen ausschweifenden Lebensstil verprasste und schließlich im Schuldgefängnis und später im Irrenhaus endete. Dieses Schicksal nimmt Hogarth als Anlass für die moralisierende Serie, die dem damals noch neuen Genre der Kunst entspricht. Im fünften Blatt *Married To An Old Maid* („Verheiratet mit einer alten Jungfer") vermählte sich der schon ruinierte Protagonist mit einer alten Witwe, um dem weiteren Absturz zu entkommen (Abb. 14). Das Brautpaar wird durch zwei Möpse gespiegelt. Zu sehen ist Hogarths Mops Trump, der sich für eine ältere Mopsdame, die elegant auf einem Hocker Platz genommen hat, interessiert. Dadurch kam dem Tier die Rolle einer sozialkritischen Figur zu. Von anderen Künstlern wurde Hogarth selbst auch als Mops karikiert, so beispiels-

weise von Paul Sandby (1730/31–1809).[7] Der Bildhauer Louis-François Roubiliac (1695–1762), ein Freund Hogarths, fertigte eine Plastik Trumps in Ton, von der in der zweiten Hälfte der 1740er-Jahre Varianten aus Porzellan entstanden und diesem Mops endgültig ein Denkmal setzten.[8]

Die größte Vielfalt an Mopsdarstellungen entstand jedoch in der angewandten Kunst, besonders in den Fayence- und später Porzellan-manufakturen, von denen jeder Fürst, der etwas auf sich hielt, eine sein Eigen nannte. Eine eigene Manufaktur zu besitzen, Brennholz, Räume, Privilegien oder finanzielle Hilfen zum Aufbau eines Unternehmens zu gewähren, diente dazu, die Rohstoffe des eigenen Landes zu nutzen, den Wohlstand der Bevölkerung zu fördern, um in der Folge durch Steuern die Finanzkraft des Landesherrn zu mehren. Diese Förderungen hatten aber neben der Produktionssteigerung noch einen weiteren Vorteil. Produkte zur Repräsentation mussten nicht teuer im Ausland

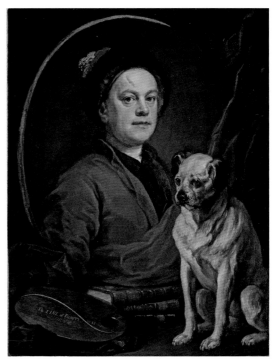

13 William Hogarth, Selbstbildnis mit Mops Pugg, Öl auf Leinwand, 1745 William Hogarth, self-portrait, *The Painter and his Pug*, oil painting, 1745

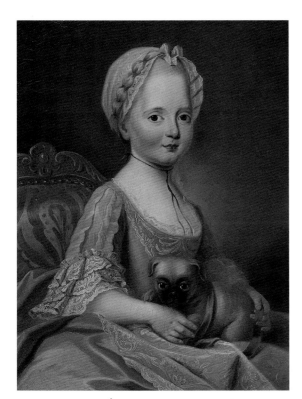

12 Joseph Ducreux, Élisabeth Philippine Marie Hélène de Bourbon, Öl auf Leinwand, 1768 Joseph Ducreux, *Élisabeth Philippine Marie Hélène de Bourbon as a Child*, oil painting, 1768

porcelain factories owned by every territorial prince worth his salt. Possessing a factory of his own, granting firewood, premises, patents or financial support to build up an enterprise enabled a prince to use raw materials from his own territorial state and promote the welfare of the populace, subsequently increasing the revenue coming into the state's coffers through higher tax yields. Promoting all the above domestic industries brought a further advantage, however. It made buying in expensive products from abroad for ostentatious promotion of the prince's personal and political authority and transporting them through numerous customs borders unnecessary since they could be delivered from his own 'fabriques'.

From the outset the pug figured particularly prominently in the tablescape of ceramic animal figurines. Far more was at stake here than naturalistically depicting a dog. The pug became a symbol, a bugbear, a clown and appeared in disguise, was dressed up, rendered in anthropomorphic terms and much more. The

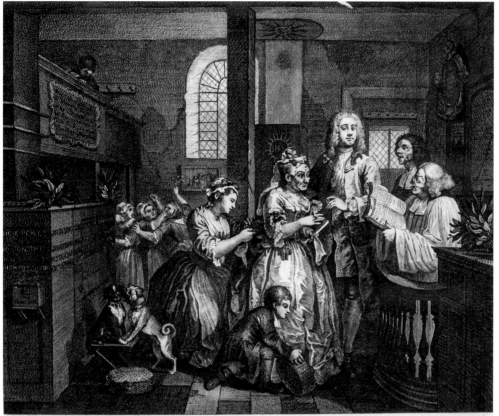

14 William Hogarth, A Rake's Progress, Plate 5 Married To An Old Maid, Radierung, nach 1735 William Hogarth,
A Rake's Progress, pl. 5 *Married to an Old Maid*, engraving after 1735

gekauft und durch zahlreiche Zollgrenzen transportiert werden, sondern wurden von den eigenen „Fabriquen" geliefert.

In der keramischen Tierplastik nimmt der Mops von Anfang an eine Sonderstellung ein. Es ging dabei um weit mehr als um die naturalistische Nachbildung eines Hundes. Er wurde zum Bedeutungsträger, zum Popanz, zum Clown, wurde verkleidet, angezogen, vermenschlicht und vieles mehr. Die damals beispielgebende Manufaktur war die Porzellanfabrique Friedrich Augusts I. von Sachsen, genannt August der Starke (1670–1733), in Meißen. Ihr wohl bedeutendster Modelleur Johann Joachim Kändler (1706–1775) versäumte nicht, sich des Themas anzunehmen.

Kändler modellierte über 60 Mopsvarianten, stehende, liegende, sich kratzende, Männchen machende, auf einem Polster oder Hocker sitzende und viele mehr. Am Anfang dieser Produktion ab 1738 stand der Mops der Gräfin Maria Anna Franziska Brühl (1717–1762). Auch ihr Mann Heinrich von Brühl (1700–1763), der einflussreiche sächsische Minister, ließ seinen

paramount factory at the time was the porcelain manufactory in Meissen owned by Frederick Augustus I of Saxony, known as Augustus the Strong (1670–1733). Johann Joachim Kändler (1706–1775), who was probably the best known modeller in its employ, had no qualms about taking on the motif and its implications.

Kändler modelled over sixty pug variants: standing on their hind legs, lying down, scratching, sitting up and begging for attention or titbits, lolling on cushions or perching on stools and the like. Kändler's production of pug figurines began in 1738 with a likeness of the pug owned by Maria Anna Franziska, Countess Brühl (1717–1762). Her husband, Heinrich von Brühl (1700–1763), the most influential Saxon minister of state, also had Kändler portray his

Mops von Kändler portraitieren (Abb. 15). Dafür musste dieser extra zum kurfürstlichen Schloss Hubertusburg reisen. Auf dem blauen Schellenhalsband steht das Monogramm HGVB (Heinrich Graf von Brühl).

Auffallend ist, dass Kändlers Möpse und die Gruppen zum Thema alle dicht um das Jahr 1740 entstanden sind. Neue Entwürfe nach 1760 kommen weder in Meissen noch in anderen Manufakturen vor.

Kändler schuf Möpse in allen Größen oder fügte sie seinen Gruppen hinzu, die bis heute die Sitten und Gebräuche des höfischen Lebens im 18. Jahrhundert spiegeln; zum Beispiel bei dem großen Thema Commedia del'arte, einem beliebten höfischen Spaß. Einer seiner Harlekine nutzt einen Mops als Drehleier. Dieser verkörpert den französischen Harlekin Carlin, was an der für ihn typischen Gestaltung der Kopfbedeckung deutlich wird (Abb. 8, 16).

Welch hohe Wertschätzung die kleinen Weggefährten darüber hinaus genossen, zeigt das „Hündlein der Königin Maria Josepha" (1699–1757), der Schwiegertochter Augusts des Starken. Das Mopsweibchen hockt auf einem sächsischen, reich verzierten Tabourette, einem kleinen Hocker, der aufwändig mit Gold verziert wurde. (Abb. 17, 18).

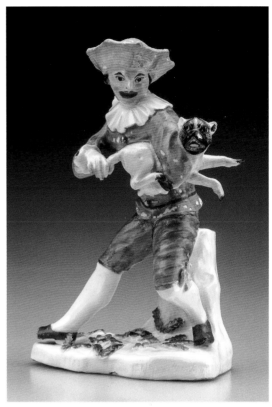

16 Harlekin mit Mops als Drehleier, Meissen, J. J. Kändler, 1740/41 *Harlequin with a Pug as his Hurdy-Gurdy*, Meissen, Johann Joachim Kändler, 1740/41

own pug (Fig. 15). To do so, the master modeller had to go to Hubertusburg Palace specially for sittings. The figurine's blue collar with bells on bears the monogram HGVB (Heinrich Graf von Brühl).

Remarkably, Kändler's pugs and pug-themed groups were all made in a cluster very shortly before and not long after 1740. No new designs appeared after 1760 in Meissen or at any other porcelain factories.

Kändler made pugs of all sizes or added them to his groups of figurines, which still reflect the customs and manners of eighteenth-century court life. Much was made, for instance, of the Commedia dell'arte theme, a popular source of merriment at court. One of Kändler's *Harlequins* is using a pug as a hurdy-gurdy; he embodies the French Harlequin Carlin, as is evident in the very similar design of the headgear (Figs. 8, 16).

The esteem in which these little companions were held is shown by the *Hündlein der Königin Maria Josepha*

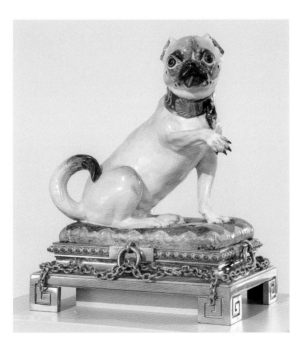

15 Mops des Grafen Heinrich von Brühl, Meissen, J. J. Kändler, 1743/44 Pug owned by Count Brühl, Meissen, J. J. Kändler, 1743/44

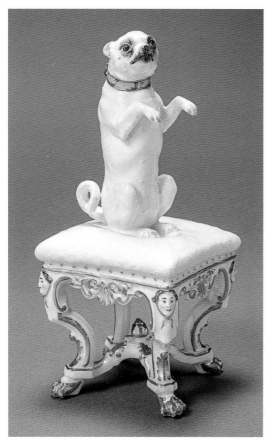

17 Unikate, Meissen, J. J. Kändler für die Königin von Polen und Kurfürstin von Sachsen Maria Josepha, Meissen, um 1739, Halsband mit den Initialen „M.J.R.P. 1739" (Maria Josepha Regina Poloniae) Johann Joachim Kändler, one-offs made for Maria Josepha, Queen of Poland and Electress of Saxony, Meissen, c.1739, collar with the inscription 'M.J.R.P. 1739' (Maria Josepha Regina Poloniae)

(1699–1757), the daughter-in-law of Augustus the Strong. 'Maria Josepha's little dog' is sitting up and begging on a richly ornate Saxon tabouret, a small stool, which was elaborately decorated with gold (Figs. 17, 18).

The only persons permitted to sit on that stool, which was placed near their highnesses, were those who equalled the queen in rank. Her lapdog was the loveable exception which shows its importance.

Very popular pug figurines, which were also the ones made most often, showcased the little animals on magnificent cushions or islets of flowers painted

Auf diesem Hocker, der in der Nähe der Hoheiten stand, durften nur Personen Platz nehmen, die der Königin im Rang ebenbürtig waren. Ihrem Hündchen war es gestattet, was seine Bedeutung zeigt.

Sehr beliebt und am häufigsten ausgeführt sind Möpse auf farbig staffierten Prunkkissen oder kleinen Blumeninseln. Sie sind immer als Pendant ausgeführt, etwa 15 cm hoch und in der Regel als Männchen und Weibchen erkennbar. Bei den Größeren, die etwa 20 cm hoch sind, tummeln sich manchmal Junge zu Füßen der Mutter.

In vielen europäischen Manufakturen entstanden Mopsfiguren und Gruppen. Sie schmückten Kaminsimse, Tische, Schlafräume, sie sitzen auf Kissen, sind mit Bronze montiert, dienten als Tabakdosen, Stockknäufe etc. In allen Lebenslagen tritt der Mops in Erscheinung: als Ballerina, gerne auch als Paar, à la Chinoise bis hin zu peinlichem Nippes.[9]

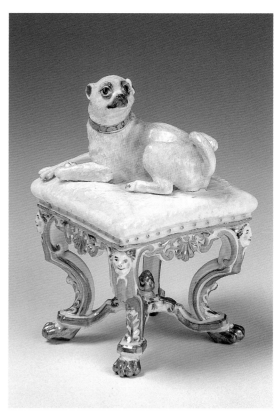

18 Der gleiche Tabouret mit liegendem Mops, Inschrift auf dem Halsband „R.P.M.J. 1739" (Regina Poloniae Maria Josepha).[10] The same stool with a pug reclining on it, here the inscription on the collar runs 'R.P.M.J. 1739' (Regina Poloniae Maria Josepha)[9]

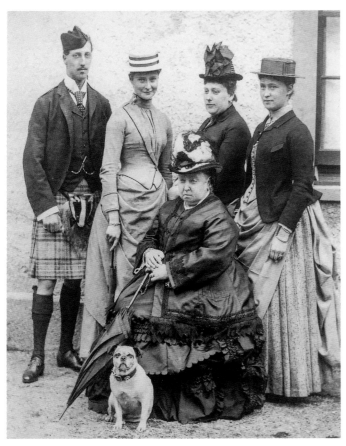

19 Queen Victoria mit ihrer Familie und Mops, 1887 Queen Victoria with four of her children and her pug, 1887

in bright colours. Such pieces were always made to be displayed in pairs and usually consisted recognisably of a male and a female pug. The larger figurine groups of this type, which are about 20 centimetres high, sometimes include puppies playing around the mother dog's feet.

Individual figures of pugs and groups of them were made at many European porcelain manufactories. They adorned chimney pieces, tables and bedchambers. They sit on cushions, are mounted in bronze and served as snuffboxes, walking-stick knobs and so forth. The pug appears in all sorts of situations, as a ballerina, often as a pair, as chinoiserie and sometimes simply as embarrassingly kitschy bric-a-brac.[10]

Pugs have remained in fashion, with some ups and downs, to the present day. The best known nineteenth-century pug owners were Napoleon Bonaparte (1769–1821) and Victoria, Queen of the United Kingdom of Great Britain and Ireland (1819–1901). As the royal patron of the RSPCA, the Royal Society for Prevention of Cruelty to Animals, Queen Victoria was also an enthusiastic pug breeder (Fig. 19). She gave thirty-eight pugs and other dogs a loving home.[11]

Die Mops-Mode hält sich mit einigen Auf- und Abwärtsbewegungen bis heute. So waren die bekanntesten Mopsbesitzer des 19. Jahrhunderts Napoleon Bonaparte (1769–1821) und die englische Queen Victoria (1819–1901). Letztere war Vorsitzende des nationalen Tierschutzvereins und begeisterte Mops-Züchterin (Abb. 19). Sie gab 38 Möpsen und anderen Hunden ein liebevolles zu Hause.[11]

1 Bahn 2011.
2 Lauer, Welt online vom 09.11.2014 (www.welt.de/print/wams/wissen/article134144844/AufdenMops-gekommen.html, letzter Zugriff: 24.3.2020); Leyen, Die ZEIT, Nr. 33/2002 vom 8.8.2002 (http://www.zeit.de/2002/33/Der_Geliebte, letzter Zugriff: 24.3.2020).
3 Feier für treuen Winnender Mops, in: https://www.welt.de/ vom 19.04.2017.
4 Teutsch 2015, S. 20.
5 Commedia 2001.
6 Noeske 2001, S. 58.
7 ebd., S. 52.
8 https://de.wikipedia.org/wiki/Trump_(Mops)
9 Krüger 2011.
10 Ein drittes Exemplar von 1745 in Privatbesitz mit der Provenienz Sammlung Max Hoffmann, wurde 1999 im Museum Ariana in Genf ausgestellt. Porcelain Pugs: A Passion 2019, S. 171, Kat.-Nr. 31. Siehe auch Kändlers Arbeitsberichte von 1738, beide Stücke sind dort erwähnt.
11 https://www.mops.de/mops-geschichte/

1 Bahn 2011.
2 Lauer, Welt online, 9 November 2014 (https://www.welt.de › Print › WELT AM SONNTAG › Wissen (Print WAMS); Leyen, Die ZEIT, No. 33/2002 (8 August 2002) (http://www.zeit.de/2002/33/Der_Geliebte).
3 Feier für treuen Winnender Mops, https://www.welt.de/, 19 April 2017
4 Teutsch. p. 20.
5 Commedia 2001.
6 Noeske 2001, p. 58.
7 Ibid., p. 52.
8 https://de.wikipedia.org/wiki/Trump_(Mops)
9 A third example from 1745, privately owned, provenance Max Hoffmann Collection, was exhibited in Museum Ariana in Geneva in 1999. Porcelain Pugs: A Passion 2019, p. 171, Cat. No. 31. See also Kändler's 1938 Arbeitsberichte [Work Logs], where both pieces are mentioned.
10 Krüger. 2011.
11 https://www.mops.de/mops-geschichte/

Der Mopsorden

The Order of the Pug

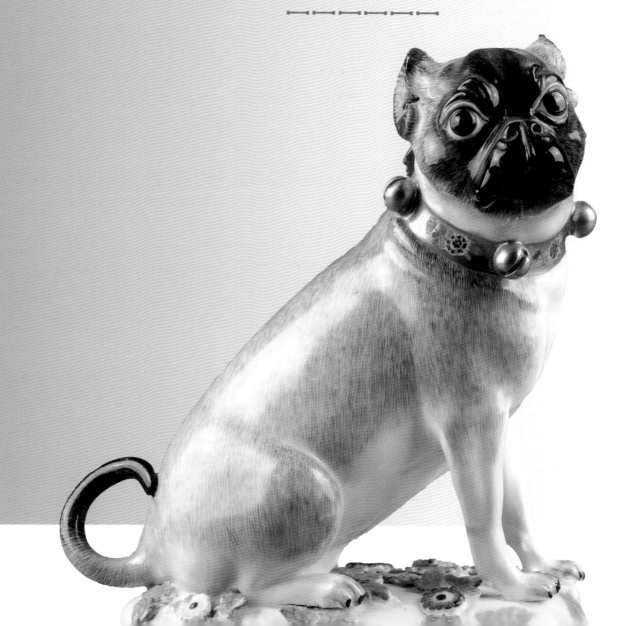

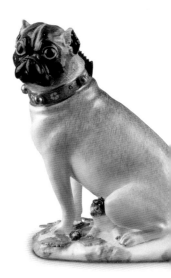

Der größte Impuls für den Mopskult war die Gründung der sogenannten „Mopsorden".

Das Schlüsseljahr war 1738, als Papst Clemens XII. (1652–1740) unter Androhung der Exkommunikation die Mitgliedschaft in Freimaurerlogen verboten hatte, weil sie aus Sicht der katholischen Kirche gegenüber anderen Religionen zu tolerant waren und nicht kontrollierbare, sich in zahlreichen Ländern Europas immer stärker ausbreitende „Geheimbünde" darstellten. Infolge dessen gründeten sich die Mopsorden als elitäre Gesellschaften, die nach dem Vorbild der Freimaurer aufklärerisches Gedankengut vertraten.[1] Ein maßgeblicher Anteil soll 1740 Clemens August aus dem Hause Wittelsbach (1700–1761), Herzog von Bayern und Kurfürst von Köln zugekommen sein. Er – ein begeisterter Anhänger der schönen Künste und holden Weiblichkeit – setzte sich mit dem Bau von Schloss Augustusburg bei Brühl, unterstützt durch die genialen Architekten Francoise Cuivillés (1695–1768) und Balthasar Neumann (1687–1753), ein bezauberndes Denkmal. Schirmherr der Mopsorden war König Friedrich August II., Kurfürst von Sachsen, später König von Polen. Somit standen zwei der mächtigsten Männer des Reiches Pate, kein Wunder, dass ihnen mit Begeisterung nachgeeifert wurde, so beispielsweise am Hof der Herzogin Anna Amalia in Weimar, auch von ihr gibt es ein Porträt mit Mops (siehe S. 22, Abb. 11, und generell Kapitel 2), dann in Braunschweig, Jena, Frankfurt am Main, Schwerin, Hamburg, Greifswald, Marburg, Göttingen und Bayreuth sowie in zahlreichen weiteren Fürstentümern des aus Kleinstaaten bestehenden Reiches.

Ob die Mopsorden tatsächlich als Ersatz für die verbotenen Freimauerlogen gedeutet werden können, wird heute zumindest angezweifelt.[2] Es gab sie keineswegs nur an katholischen Königs- und Fürstenhöfen. Wahrscheinlicher wurde ein Ordnungsprinzip übernommen, um dem ganzen einen geheimen Zauber zu geben, auf den man auf keinen Fall verzichten wollte. Das höfische Zeremoniell war in der Zeit des Barock und Rokoko bis ins kleinste Detail reglementiert, starr und mitunter langweilig. Die geheimen Treffen waren eine gute Gelegenheit, dem zu entfliehen. Gleichzeitig wollte man zeigen, wessen Geistes Kind man war, als Anhänger der Aufklärung und offen für Neues. Jetzt waren auch katholische Frauen zugelassen, was diesen Gesellschaften sicher einen besonderen Reiz gegeben hat.

The paramount driver behind the cult of the pug was the foundation of what was known as the Order of the Pug.

The key year was 1738, when Pope Clement XII (1652–1740) forbade membership of the fraternity of Freemasons under threat of excommunication because the Freemasons were, as the Holy See saw it, too tolerant of other religions and the 'secret societies' that were springing up across Europe and spreading out of control like wildfire. In response, the Order of the Pug was founded as a group of elitist societies that, taking Freemasonry as their model, advocated Enlightenment thinking.[1] Clement Augustus of the House of Wittelsbach (1700–1761), Duke of Bavaria and Elector of Cologne, is supposed to have played a major role in this development in 1740. A keen art lover and connoisseur of feminine beauty, he raised a delightful monument to himself by having Augustusburg Palace built near Brühl, supported by the brilliant architects François Cuivilliés the Elder (1695–1768) and Balthasar Neumann (1687–1753). The patron of the Order of the Pug was Frederick Augustus II, Elector of Saxony, and later also King of Poland. Hence two of the most powerful men in the Holy Roman Empire were the force behind the launch of the Order of the Pug. No wonder they found throngs of emulators – for instance, at the court of the Duchess Anna Amalia in Weimar, of whom there is a portrait with a pug (see p. 22, fig. 11, and chapter 2 in general), followed by Braunschweig, Jena, Frankfurt am Main, Schwerin, Hamburg, Greifswald,

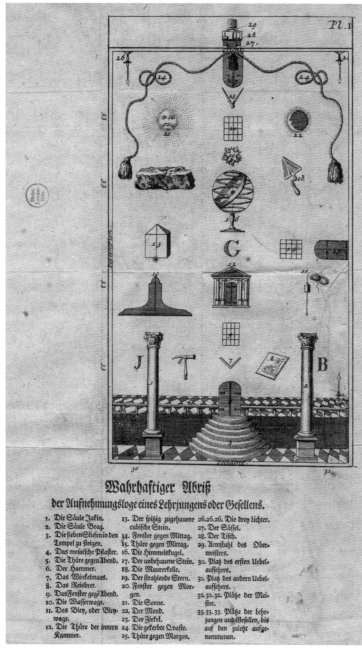

20 Plan einer Freimauerloge aus: Perau, 1745 Plan of a Freemasons' lodge in Pérau 1745

Da jedes Ordensmitglied ein Schweigegelübde ablegen musste, verwundert es nicht, dass es kaum schriftliche Überlieferungen gibt. Einzig ein 1745 anonym in Amsterdam erschienenes Werk mit dem Titel: „L'ordre des Francs-Macon trahi, et le secret des Mopses revelé" hat uns die Zeremonien eines Mopsordens übermittelt. Der Verfasser ist Abbé Gabriel Louis Calabre Perau (1700–1767), der von sich selbst sagt, er sei von unbändiger Neugierde nach allem Geheimnisvollen getrieben.

Marburg, Göttingen and Bayreuth, not to mention numerous other constituent principalities of the Holy Roman Empire.

Nowadays there is some doubt about whether the Order of the Pug should be interpreted as a substitute for the prohibited Freemasons' lodges.[2] The Order did not simply exist at Catholic royal and princely courts. What is more likely is that an ordering principle was taken over to lend the whole thing a touch of the arcane, which was a quality no one wanted to forgo. In the Baroque and Rococo eras, court ceremony was regulated down to the last detail, leaving it rigid and often utterly tedious. Clandestine meetings provided a good opportunity for escaping it. At the same time, people wanted to show where they belonged, intellectually speaking, as adherents of the Enlightenment who were receptive to new developments. Now women were also admitted, if they were Catholics, which must have made such societies particularly attractive.

Since every initiate of the Order of the Pug had to take a vow of silence, it is hardly surprising that there are virtually no written sources dealing with it. The only one known is a work published anonymously in Amsterdam in 1745 as *L'Ordre des francs-maçons trahi, et le secret des Mopses revelé*, which is instructive on the ceremonies performed in an Order of the Pug lodge. The author was the abbé Gabriel-Louis Calabre Pérau (1700–1767), who said of himself that he was driven by unbridled curiosity about all things arcane and mysterious.

However, the interminable accessories and insignia of membership that were presented, carried about by initiates and displayed in their own dwellings blatantly contradict the professed desire for secrecy. Initiates showed the way they thought and

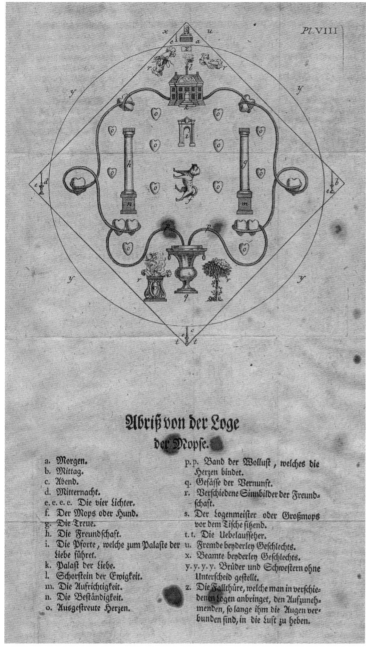

Pl. VIII

Abriß von der Loge der Möpse.

a. Morgen.
b. Mittag.
c. Abend.
d. Mitternacht.
e. e. e. e. Die vier Lichter.
f. Der Mops oder Hund.
g. Die Treue.
h. Die Freundschaft.
i. Die Pforte, welche zum Palaste der Liebe führet.
k. Palast der Liebe.
l. Schornstein der Ewigkeit.
m. Die Aufrichtigkeit.
n. Die Beständigkeit.
o. Ausgestreute Herzen.

p. p. Band der Wollust, welches die Herzen bindet.
q. Gefässe der Vernunft.
r. Verschiedene Sinnbilder der Freundschaft.
s. Der Logenmeister oder Großmops vor dem Tische sitzend.
t. t. Die Uebelaufseher.
u. Fremde beyderley Geschlechts.
x. Beamte beyderley Geschlechts.
y. y. y. y. Brüder und Schwestern ohne Unterscheid gestellt.
z. Die Fallthüre, welche man in verschiedenen Logen anbringet, den Aufnehmenden, so lange ihm die Augen verbunden sind, in die Lust zu heben.

21 Plan einer Loge des Mopsordens aus: Perau, 1745 Plan of an Order of the Pug lodge in Pérau 1745

Die unendlichen Accessoires und Zeichen der Zugehörigkeit, die präsentiert, mit sich herumgetragen und in den eigenen Räumen platziert wurden, stehen einem Willen zur Geheimhaltung allerdings völlig entgegen. Man zeigte, was man dachte, und hatte seinen Spaß dabei. Alles diente in erster Linie dem Divertissement an den Höfen, der Lust, dem Spiel. Man wusste, wo sich die Möpschen tummelten, traf man Freunde und Gleichgesinnte.

how they enjoyed doing so. The whole thing served primarily as a welcome distraction at court – in short, fun and games. It was a known fact that friends and kindred spirits could be found wherever Pug initiates were amusing themselves.

Order of the Pug lodges represented a playful take on the symbolism of Freemasonry. Freemasons are concerned with perfecting the individual in the community whereas initiates of the Order of the Pug celebrated love, faithfulness and above all friendship, including friendships between men and women (Figs. 20, 21).

The 1745 Masonic tracing board shows the arrangement of a lodge to which an Entered Apprentice Mason sought admission. The emphasis is on the number 3, the angle stands for the right measure and the compasses stand for human creative powers. At the end of the developmental process stands the mature man (Fig. 20).

The other tracing board, also from 1745, is for the Order of the Pug. On it couples determine the ritual. The female circle symbolises the quality of perfection, the infinite. The square represents the male ordering principle of rationality. The whole is linked by the bond of pleasure, with the pug at the centre as a symbol of faithfulness and friendship (Fig. 21). All members called themselves Pugs while the male and female Masters of a Lodge had the title Grand Pug.

Admission to the Order entailed a number of bizarre rituals. Novices had to scratch on the door like dogs and were led blindfolded into the lodge on leads. Their tongues were examined and applicants had to kiss the behind of a porcelain pug under its tail. There was a great blaring of trumpets and beating of drums to frighten novices – court antics resorting to every trick in the book (Figs. 22, 23).

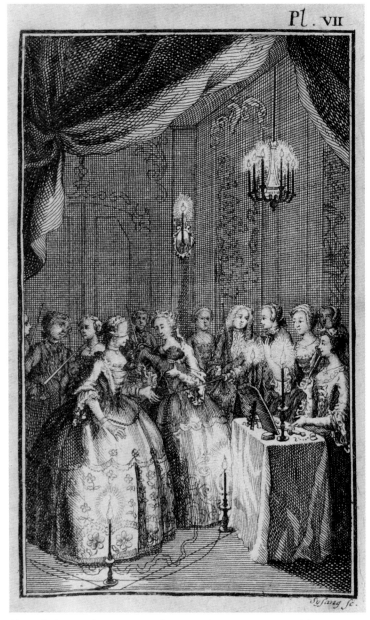

22 Aufnahmeritual einer Dame in den Mopsorden aus: Perau, 1745 A lady novice being ritually initiated into the Order of the Pug, in Pérau 1745

But why a pug? In the eighteenth century, it was not viewed in the slightest as the clownish canine that would be mocked in later centuries. The pug was viewed in the eighteenth century as a symbol of faithfulness, friendship, love, tenderness and constancy and was the object of deep devotion. This fashion has bequeathed a wonderful array of trinkets and small ornaments. Pugs were carved of gemstones, and there are pug pipe bowls, inkstands, seals and candlesticks. Potpourri bowls boasted pug decoration, and pugs were, of course, modelled in

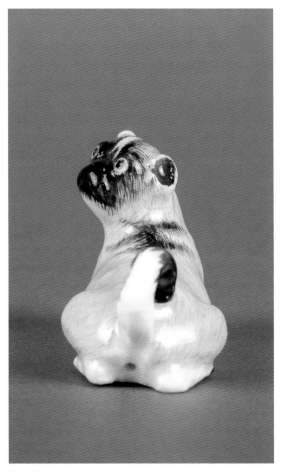

23 Liegender Mops, Meissen, um 1750 Pug lying down, Meissen, c. 1750

In den Mopsorden wird mit der Symbolik der Freimaurer gespielt. Es geht um die Vervollkommnung des Einzelnen in der Gemeinschaft, die Mitglieder des Mopsordens feiern Liebe, Treue und vor allem Freundschaft, auch die zwischen Männern und Frauen (Abb. 20, 21).

Die freimaurerische Arbeitstafel von 1745 zeigt die Anordnung der Aufnahmeloge eines Lehrjungen. Betont wird die Dreiheit, der Winkel sorgt für das rechte Maß, der Zirkel steht für die Gestaltungskraft des Menschen. Am Ende des Entwicklungsprozesses steht der gereifte Mensch (Abb. 20).

Auf der anderen Arbeitstafel des Mopsordens, ebenfalls von 1745, bestimmen die Paare das Ritual. Der weibliche Kreis symbolisiert das Vollkommene, Unendliche, das Quadrat die Ordnung des männlichen Verstandes. Verbunden wird das Ganze durch das Band des Vergnügens, der Mops im Zentrum als Sinnbild von Treue und Freundschaft (Abb. 21). Alle Mitglieder nannten sich „Möpse", männliche und weibliche Logenmeister hatten den Titel „Großmöpse".

Zur Aufnahme in den Orden wurden verschiedene skurrile Rituale durchgeführt. Der Anwärter musste an der Tür kratzen wie ein Hund und wurde mit verbundenen Augen an einer Leine hereingeführt. Die Zunge wurde untersucht und der Bewerber musste den Hintern eines Porzellanmopses küssen. Es wurde getrommelt und gepfiffen, um den Anwärter zu erschrecken. Ein höfischer Schabernack nach allen Regeln der Kunst (Abb. 22, 23).

Doch warum ein Mops? Er wurde im 18. Jahrhundert keineswegs als der Hanswurst angesehen, wie in den späteren Jahrhunderten. Er galt als Symbol der Treue, Freundschaft, Liebe, Zärtlichkeit, Beständigkeit und man war ihm von Herzen zugetan. Beschert hat uns diese Mode eine wunderbare Fülle an Preziosen. Möpse wurden in Edelstein geschnitten, es gibt Pfeifenköpfe, Schreibtischgarnituren, Petschaften und Kerzenständer. Potpourris wurden mit ihnen verziert und natürlich formte man sie in Keramik aus, das dankbarste aller Materialien, quasi prädestiniert, jede gewünschte Form herzustellen. Großartige Modelleure haben sich des Themas angenommen und die Ergebnisse erfreuen uns bis heute.

clay, that most ductile of materials, predestined, as it were, to reproduce any form desired. Brilliant modellers addressed the motif and the results of their labours still delight to this day.

1 Köllmann 1970, p. 50f.
2 Treue Freunde 2019.

1 Köllmann 1970, S. 50f.
2 Treue Freunde 2019.

Einzeltiere

❦·—·—·—·❦

Individual
Pug Figurines

❦·—·—·—·❦

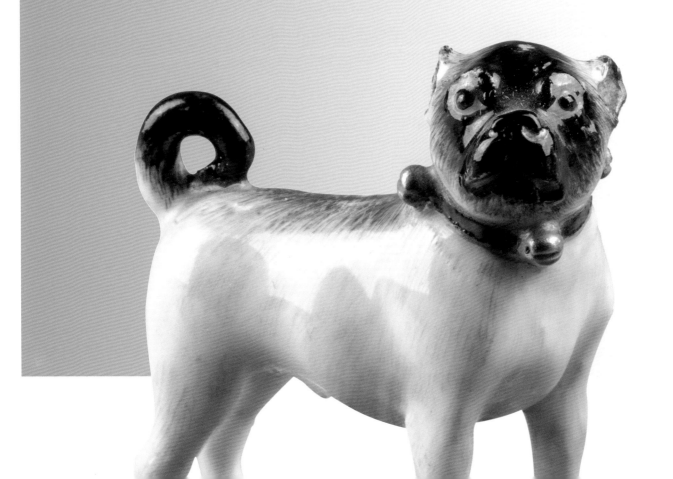

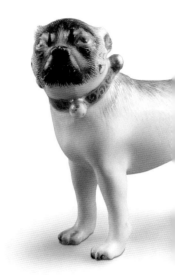

Die größte Gruppe der Mopsdarstellungen sind einzelne Tiere, die meist auf einem reich verzierten Kissen oder Blumensockel platziert sind. Aus den Arbeitsberichten von Johann Joachim Kändler und Peter Reinicke erfahren wir, dass um 1750 die erstaunliche Menge von etwa 60 verschiedenen Mopsmodellen in Meissen entstand.[1]

Ganz in der Tradition des 18. Jahrhunderts sind sie in der Regel als Paar angelegt, ein weiblicher und ein männlicher Mops, beide einander zugewandt. Manchmal tummeln sich auch kleine Welpen bei der Mutter.[2] Oft sind die Tiere in der Farbgebung aufeinander abgestimmt, zudem korrespondiert die Halsbandfarbe oder das Kolorit der Schleife. Es muss eine Fülle an Accessoires gegeben haben – Paradekissen, Halsbänder, Schellen, Schleifen –, die sich in den keramischen Darstellungen wiederfinden. Schließlich war der Mops ein Statussymbol und den galt es standesgemäß auszustatten.[3] Es gibt sogar ein einzigartiges Museum, das „Dogs Collar Museum" auf Leeds Castle in Kent (GB), das die Vielfalt der Halsbänder zeigt.

In Meissen wurden verschiedene Mopsgrößen ausgeformt. Die etwa 15 cm hohen größeren Tiere, sorgfältig naturalistisch bemalt, waren offenbar besonders beliebt. Meist sitzen sie auf einem reich verzierten Kissen in leuchtenden Farben oder auf einer mit plastischen Blüten verzierten Blumeninsel (Abb. 24).

Die nächst größere Ausformung misst etwa 20 cm in der Höhe. Wieder als Paar angelegt, lugt unter dem Bauch der Mutter ein Welpe hervor, den sie z.T. mit der erhobenen Pfote beschützt (Abb. 25). Die Ohren sind noch nicht kupiert, also ein sehr junger Hund. Die Tiere sind beeindruckend naturalistisch dargestellt: Sie zeigen ein fein gestricheltes Fell, die Gesichter und Schwanzspitzen sind dunkel staffiert. Beide blicken mit gewendetem Kopf zum Betrachter.[4] Sie sitzen auf keinem Kissen und tragen auch keine Halsbänder, so dass nichts von den Hunden selbst ablenkt. Manche dieser Ausformungen wurden jedoch später auf einen Bronzesockel montiert, um die besondere Wertschätzung auszudrücken (Abb. 26).

Zur zweiten Hauptgruppe gehören wesentlich kleinere Tiere, etwa 3–5 cm hoch, die alle möglichen Kapriolen ausführen. Meistens stehen oder sitzen sie oder versuchen, sich mit fantasievoller Bewegungsvielfalt zu kratzen (Abb. 26–28). Ein Hinweis auf Flöhe? Möglicherweise, denn das kleine Ungeziefer war damals in den voluminösen Federbetten und Matratzen ebenso verbreitet wie in der vielschichtigen Kleidung. Es gibt eine Reihe von kleinen Kapseln, die man bei sich trug und die als Flohfänger

Individual figurines comprise the largest group of representations of pugs. Most are depicted on sumptuously decorated cushions or placed on floral stands. The *Works Logs* left by Johann Joachim Kändler and Peter Reinicke reveal that about sixty different pug models were in production *c.*1750 – an astonishing number.[1]

Conforming to eighteenth-century tradition, they are usually conceived as pairs – a male and a female pug – turned towards each other. Sometimes tiny puppies are playing about a mother pug.[2] The animals are often attuned to one another colourwise, with matching or corresponding collars or bows. A wealth of opulent accessories must have been available to the discerning pug – showy cushions, collars, bells, bows – that are mirrored in the porcelain representations. After all, the pug was a status symbol and had to be fitted out with appropriate accessories.[3] There is even a unique museum, the 'Dog Collar Museum' at Leeds Castle in Kent (GB).

Figurines were modelled and cast in various sizes. Animals about 15 centimetres high, meticulously painted in naturalistic colours, were evidently particularly popular. Most of these are sitting on cushions richly decorated in brilliant colours or perched on an islet with flowers in high relief (Fig. 24).

The next model in ascending order by size is about 20 centimetres high. The animals are again presented as a pair, with a puppy peeking out from beneath its mother's belly while she holds a protective paw over it (Fig. 25). It is still a very young dog since

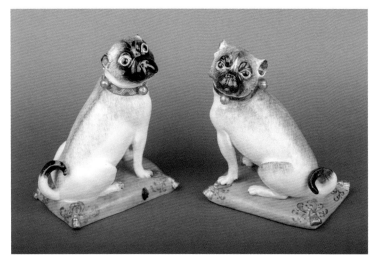

24 Mopspaar, Meissen, Modell J. J. Kändler, um 1745 → Kat.-Nr. 15, 16 A pair of pugs,
Meissen, model by J. J. Kändler, c.1745 → Cat. Nos. 15, 16

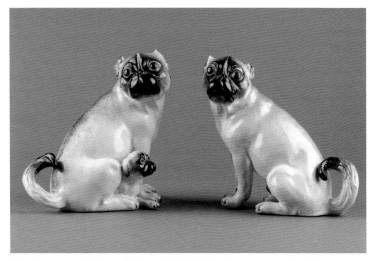

25 Mopspaar mit Welpen, Meissen, Modell J. J. Kändler, um 1745 → Kat.-Nr. 42, 43
A pair of pugs with puppy, Meissen, model by J. J. Kändler, c.1745 → Cat. Nos. 42, 43

the puppy's ears are not cropped. The animals are de-
picted with impressive naturalism: the dark-tipped
hairs and markings on their coats are rendered by fine
hatching while their faces and the tips of their tails are
painted dark. Both the male and the female pug stare
directly at the viewer.[4] They are not seated on cushions
nor do they wear collars; hence nothing distracts from
the dogs themselves. Some casts of this model were,
however, later given bronze mounts to underscore
how highly prized they were (Fig. 26).

The second main group comprises much small-
er animal figurines, about 3–5 centimetres high,
which are shown cutting all sorts of capers. Most are
standing on four legs or sitting down, expending an
incredible amount of inventiveness on finding ways
of relieving an itch by scratching (Figs. 26–28). A hint
at flees? Possibly because the tiny pest was just as
widespread in the thick feather duvets and mattress-
es of the time as it was in all the layered clothing.
Quite a number of little perforated cylindrical tubes
have survived that were used as portable flea traps

dienten. Sich mit Wasser zu waschen galt als gefährlich, man glaubte,
sich dadurch mit allgegenwärtigen Keimen anstecken zu können.

Neben der spezifischen Haltung stellte sicher die Ausformung der
dünnen Beine eine technische Herausforderung dar, die die Porzelliner
reizte.[5]

Meist überwiegt bei diesen Tieren die helle Porzellanfarbe. Farbig
staffiert wurden die Gesichtszeichnung, Pfoten und Schwanzspitze
sowie das meist in Blau oder Purpur gehaltene Halsband. Die serielle
Fertigung in den Manufakturen erlaubte es, größere Mengen dieser
kleinen Kerle herzustellen. Es bedurfte nur des genialen Entwurfs des
meisterhaften Kändlers oder anderer talentierter Modelleure, die Aus-
führung wurde dann arbeitsteilig von geschultem Personal in verschie-

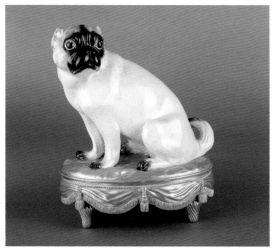

26 Sitzender Mops auf Bronzesockel, Meissen, Modell
J. J. Kändler, um 1750 → Kat.-Nr. 40 A sitting pug on a bronze
pedestal, Meissen, model by J. J. Kändler, c.1750 → Cat. No. 40

denen Produktionsschritten durchgeführt. Die kleineren Modelle waren sicher etwas für den schmaleren Geldbeutel, aber auch ein Artikel, der sich in bürgerlichen Kreisen gut verkaufen ließ (Abb. 30). Die kleinen Möpse blieben bis weit ins 19. Jahrhundert im Programm.

Ein Unikat stellt allerdings ein kleiner, sitzender Mops auf einem goldgemusterten Prunkkissen dar, das auf ein goldenes Tabouret montiert ist (Abb. 29). Keck schaut er den Betrachter an. Vielleicht ist diese Ausformung eine Anspielung auf das Hündchen von Maria Josepha von Österreich, Kürfürstin von Sachsen und Königin von Polen (Abb. 17), das als einziges auf ihrem Hocker sitzen durfte.

Zur gleichen Zeit wurden aber nicht nur in der wegweisenden Meissener Werkstatt, sondern auch in den Porzellanmanufakturen in Höchst, Nymphenburg, Frankenthal, Fürstenberg und Ludwigsburg etc. Möpse ins Programm aufgenommen. Überall da, wo es prächtige Höfe mit entsprechenden Divertissements, Bällen und Salons sowie den Wunsch nach Aufbruch gab. Auch in Wien, England und Frankreich entstanden Mopsdarstellungen in jeder Form. Der Adel war europäisch und dieses Thema kannte keine Grenzen. Die meisten Darstellungen kamen jedoch aus Deutschland, dem Gründungsland der Mopsorden.

1761 starb Clemens August. Es gibt kaum Aufzeichnungen, wann und wie viele Orden es zu dieser Zeit gab. Das Thema ebbte spürbar ab

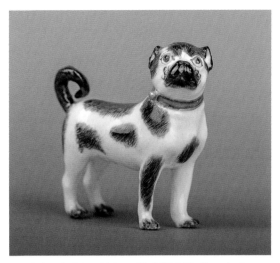

28 Stehender Mops, Meissen, Modell J. J. Kändler oder Peter Reinicke, um 1750 → Kat.-Nr. 1 A pug on all fours, Meissen, model by J. J. Kändler or Peter Reinicke, c.1750 → Cat. No. 1

carried on one's person for catching flees. Washing with water was deemed dangerous because it was believed to spread the miasma of contagion. Apart from capturing a specific pose, casting the thin legs must have presented a technical challenge that would have appealed to the makers of fine porcelain ornaments.[5]

The light colour of the porcelain paste predominates on these animal figurines. Facial markings, paws and tips of tails as well as collars, which are usually blue or purple, were painted on in realistic colour. Serial production at porcelain factories made it possible to turn out quite large numbers of these little creatures. All that was needed was a brilliant design by Kändler, a consummate master of his medium, or any other talented modeller. The work was then carried out by trained personnel in several stages of production according to a precise division of labour. The smaller models must have been intended for the less affluent but were nonetheless an item that would have sold well among middle-class aficionados (Fig. 30). The small china pug models remained in production well into the nineteenth century.

One piece that is a one-off, however, is a small pug sitting on an ornate gold-patterned cushion mounted on a golden stool (Fig. 29). He is cheekily confronting

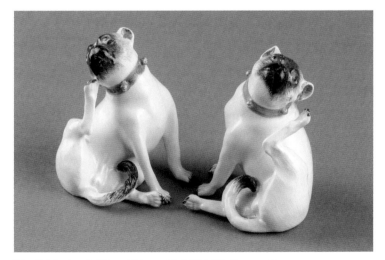

27 Sich kratzende Möpse, Meissen, Modell J. J. Kändler, um 1750 → Kat.-Nr. 55, 56 Pugs scratching themselves, Meissen, model by J. J. Kändler, c.1750 → Cat. Nos. 55, 56

und die Fertigung keramischer Möpse ist am Ende des 18. Jahrhunderts nur noch in einigen wenigen Fayence- und kleineren Porzellanmanufakturen nachzuweisen. Es entstanden keine neuen Porzellanentwürfe mehr, so dass man davon ausgehen kann, dass sich diese Mode zumindest in Adelskreisen inzwischen überlebt hatte. Dennoch hielten sich die Mopsdarstellungen noch über lange Zeit, weil diese inzwischen auch in gehobenen Bürgerkreisen ihren Platz gefunden hatten.

Auch die Fayencemanufakturen nahmen sich noch weiter des Themas an. Es entstanden eigene ganz besonders bezaubernde Stücke, die zugleich gerne mit einem praktischen Nutzen versehen wurden (Abb. 31). So gibt es aus der thüringischen Manufaktur Abtsbessingen kleine Deckeldosen für Pasteten oder Butter in Form liegender Möpse.

Das Bürgertum hatte sich dieser eigenwilligen Hunde bemächtigt, ein Schicksal, dass den Mops die nächsten Jahrzehnte begleiten wird bis letztlich zur Missachtung und fast Ausrottung.

Der schönste Fayencemops kommt zweifellos aus Höchst, um etwa 1746/50. Knuddelig, weich, treuherzig. Ebenfalls als Paar angelegt, es

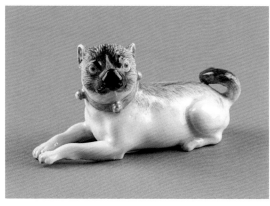

30 Liegender Mops, Meissen, Modell J. J. Kändler, um 1750
→ Kat.-Nr. 49 Pug lying down but alert. Meissen, model by
J. J. Kändler, c.1750 → Cat. No. 49

the viewer. This model may be an allusion to the pug owned by Maria Josepha of Austria, Queen of Poland and Electress of Saxony (Fig. 17), whose pug was the only animate being permitted to sit on her footstool.

At the same time, pugs were not only being made at the groundbreaking Meissen workshop but were also being added to the range of figurines produced at the porcelain factories in Höchst, Nymphenburg, Frankenthal, Fürstenberg, Ludwigsburg and such – wherever splendid courts were providing ambitious entertainment, balls and salons as well as harbouring a desire for setting trends. Pug figurines were also made in Vienna, England and France in a wide variety of shapes and sizes. The nobility was pan-European and the motif crossed borders unchecked. Still, most representations continued to come from Germany, where the Order of the Pug was founded.

Clement Augustus died in 1761. There are hardly any records indicating when Order of the Pugs lodges were established and how many of them there were at that time. By the close of the eighteenth century, interest in the subject had perceptibly subsided, and china pugs were verifiably only being made at a handful of faience and smaller porcelain manufactories. Since no new designs were being created by then, it is safe to assume that this fashion had survived, at least among the nobility.

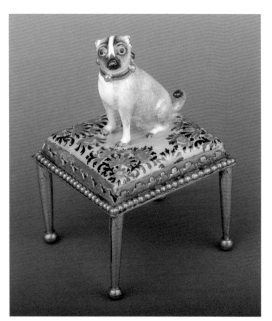

29 Mops auf Kissen als Bronzehocker montiert, Meissen,
Modell J. J. Kändler, um 1740 → Kat.-Nr. 41 Pug on a cushion
mounted as a bronze stool. Meissen, model by J. J. Kändler.
c.1740 → Cat. No. 41

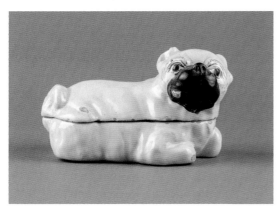

31 Mopsdose, Abtsbessingen, Fayence, um 1760 → Kat.-Nr. 64
Pug jar, Abtsbessingen, *c.*1760 → Cat. No. 64

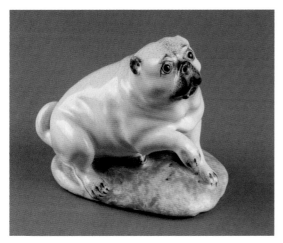

32 Mops, Höchst, Fayence, um 1750 → Kat.-Nr. 25
Pug, faience, Höchst, *c.*1750 → Cat. No. 25

gibt einen weiblichen und einen männlichen, gegenläufig die Pfote zum Gruß erhoben (Abb. 32). Mopsartige Tiere aus Fayence kamen aber auch aus Belgien und England.

Inwieweit sich die einzelnen Manufakturen beeinflusst und gegenseitig inspiriert haben, ist schwer zu sagen. Meissen, Höchst, Fürstenberg und Wien hatten eigene sehr gute Entwerfer und man erkennt die Eigenständigkeit jeder Manufaktur. Es war ein Thema, dass in die Zeit gehörte und das bedienten die Manufakturen, indem sie Strömungen und Moden aufnahmen und umsetzten.

1 Pietsch 2002
2 Rückert 1966, S. 268, 269.
3 Treue Freunde 2019, S. 173, 174.
4 Pietsch 2006, S. 191–193.
5 Kändler 1734: „erstlich 9 Stück kleine Mopshunde, ein jeder hatte eine andere Action: wie einer lieget und sich mit der linken hinteren Pfote die Flöhe abscharret … Noch sind zwei kleine stehende Mopshunde gefertigt worden."

Nonetheless, representations of pugs persisted for a long time, for they had meanwhile also found favour among the bourgeoisie. Faience manufactories continued adding them to their range, making some particularly enchanting pieces, which also often tended to be linked with practical uses (Fig. 31). Abtsbessingen, a faience manufactory in Thuringia, produced small lidded jars for pâté and butter in the form of pugs lying down.

The middle classes had laid claim to these idiosyncratic dogs, a fate that clung to them in subsequent decades, leading ultimately to contempt for, and the virtual extinction of, the breed and replicas of it.

The finest faience pugs definitely came from Höchst, produced about 1746–50 – cuddly, soft, faithful companions, also represented as pairs, with a male and female pug raising their paws to one another in greeting (Fig. 32). Pug-like animal figurines in faience were also made in Belgium and England.

It is difficult to ascertain how far the individual factories influenced and inspired each other. Meissen, Höchst, Fürstenberg and Vienna all had very good designers, and the signature features of each factory are easily recognisable. The pug was a motif that belonged to its time, and the porcelain and faience factories made the most of it of it by keeping abreast of trends and following fashions to create such desirable art objects.

1 Pietsch 2002
2 Rückert 1966, p. 268, p. 269.
3 Treue Freunde 2019, p. 173, p. 174.
4 Pietsch 2006, pp. 191–193.
5 Kändler 1734: 'first of all 9 little pug-dogs, each performing a different act: such as one lying and scratching fleas with its left hind foot. [...] Two more small pugs standing on four feet were then made.'

Figurengruppen mit Mops

·—·—·—·—·

Figurative Groups with Pugs

·—·—·—·—·

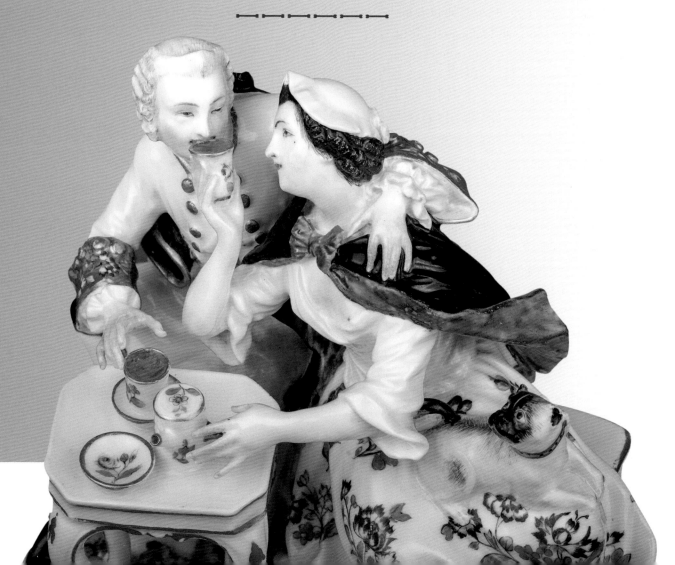

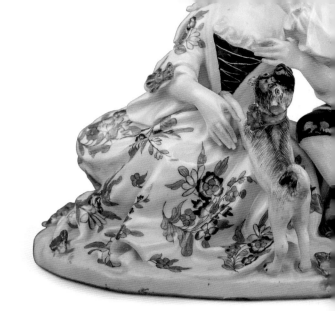

Johann Joachim Kändler notiert 1744 folgende Arbeit in seinem Taxa-Buch:

„Frey Maurer Grouppgen, 2 Frey Maurer vorstellend, deren einer steht und einen Glubum ausmisset, zugleich aber eine Hand auf den Mund hält, dero anderer aber daneben sitzt und speculieret, beyde haben ihre Schurz Felle und Orden angehangen."

Zu Füßen der beiden Herren befinden sich Möpse, die jedoch unerwähnt bleiben.[1]

Vor allem in der ersten Hälfte der vierziger Jahre des 18. Jahrhunderts entstanden vor dem Hintergrund freimaurerischen Gedankenguts verschiedene Meissner Porzellanmodelle. Kändler nennt diese Gruppen explizit Freimaurer, wohlgemerkt sechs Jahre nach dem Bannfluch von 1738 durch Clemens XII. Hat man das Dekret also gar nicht so ernst genommen? Vor allem die Kavaliere sind durch die Utensilien eindeutig als Freimaurer zu erkennen. Die hinzugefügten Möpse stellen den Bezug zu den Mopsorden her. Da es sich eindeutig um Paare und Pendantfiguren handelt, zeigt sich offenkundig die rituelle und auch inhaltliche Verbindung der Orden zueinander.

In der Sammlung befindet sich die Figur eines Freimaurers, der in Zeremonialtracht neben einem Postament steht, auf dem maurerische Utensilien wie Winkelmaß und Senkblei liegen (Abb. 33). Die Maurerschürze hängt tief über der Bundhose, in der linken Hand hält er das gleichseitige Dreieck, in der vorgestreckten Rechten einen zusammengerollten Bauplan. Das Winkelmaß ist das wichtigste Utensil des Freimaurers und steht als Sinnbild für ein sittliches und geistig reifes Leben, sogar seine Schrittstellung weist darauf hin. Kändler war gelernter Steinbildhauer und kannte sich mit den Ritualen und Zeichen der Zunft sicher gut aus.[2]

Hinter dem Kavalier hockt ein Mops, der sich auf einer Freimaurerkelle erleichtert, die auf einer Freimaurerschürze liegt. Darauf die französische Aufschrift „Die wahre Medizin" (Abb. 34). Offensichtlich eine etwas rüde Persiflage auf den Mörtel der Freundschaft, der in Freimaurerkreisen eine große Rolle spielt. Man war in dieser sinnesfreudigen Zeit auch gern mal ein bisschen derb.

In 1744 Johann Joachim Kändler noted the following work in his *Taxa* book:

'Little group of Freemasons, 2 Freemasons introducing themselves, one of them standing and measuring a globe, at the same time holding a hand to his mouth, while the other sits next to him and speculates, both of them are wearing their leather aprons and insignia.'

Pugs are at the feet of both gentlemen yet are not mentioned.[1]

The first half of the 1740s saw a surge of Meissen porcelain models featuring Freemasonry-related subject matter. Kändler explicitly calls these groups 'Freemason groups', and this only six years after Pope Clement XII issued a papal decree against the Freemasons in 1738. Wasn't the papal decree taken so seriously after all? Gentlemen in particular are unequivocally recognisable as Freemasons from their working tools. The pugs added to these groups create a link to Order of the Pug lodges. Since these are obviously couples and pairs of figures as companion pieces, the ritual and semantic links between the Orders are patently obvious.

The collection contains a Freemason figurine in full ceremonial garb, standing next to a pedestal on which the working tools of Freemasonry, such as

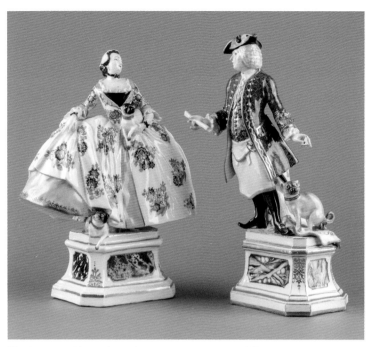

33 Dame vom Mopsorden und Freimaurer, Meissen, Modell J. J. Kändler, 1744 bzw. 1743 → Kat.-Nr. 96, 97 *A Lady from the Order of the Pug*, Meissen, model by J. J. Kändler, 1744 → Cat. No. 96, 97

an angle-measuring device and a plumb line, are laid out (Fig. 33). The Freemason's leather apron is slung low over his knee breeches. In his left hand he is holding an isosceles triangle, and in his right hand, which is stretched out, he grasps a rolled-up construction plan. The Freemason's most important working tool is the square, which stands for a way of life that is moral and intellectually mature. Even the figurine's striding pose is an indication that he meets those criteria. Kändler trained as a sculptor in stone and is sure to have been thoroughly versed in the guild rituals and signs.[2]

Behind the gentleman is a pug relieving itself on a Freemason's trowel lying on a Freemason's apron. On it is the inscription 'La vraie médicine' [The right medicine] (Fig. 34) – evidently somewhat crude mockery of the Trowel of Friendship that plays such an important role in Freemasonry. The Rococo was a sensuous era in which risqué humour was often resorted to.

Als Gegenstück schuf Kändler eine Krinolinendame in großer Robe, die von zwei Möpsen begleitet wird.[3] Kändler nennt sie selbst in seiner Taxa: „Dame vom Mops-Orden, auf einem Postament stehend in der lincken Hand einen Mopshund haltend auch einen zu Füssen liegend, vor die Prinzessin von Herford.", was die Figur zweifelsfrei als Auftragswerk benennt.[4] Der breit ausladende prächtige Rock mit Unterkleid bot den Künstlern einen wunderbaren Malgrund, um die kostbaren Stoffe und Muster echter Brokatkleider zu übertragen. Die beiden Hunde sind als Gegenstück zu dem von Aktion geprägten Begleiter des Freimaurers ruhig liegend dargestellt.

Eine intimere Szene stellt die Gruppe „Liebespaar mit Mops beim Schokoladetrinken" dar (Abb. 35). Durch die Öffnung in die Neue Welt wurden Tee, Kaffee und Schokolade zu den beliebtesten Modegetränken des 18. Jahrhunderts.[5] Es entstanden unzählige Service, die zum höfischen Leben gehörten. Als „Solitaire", einem Frühstücksservice für eine Person, als „Service à deux" oder „Tête-à-Tête" für zwei Personen bis hin zu kompletten mehrteiligen Servicen, für die oft ein mit Leder ausgeschlagener Koffer angefertigt wurde, um den kostbaren Besitz zu schützen und sicher transportieren zu können. Zuerst nur dem Adel vorbehalten, verbreiteten sich die Getränke aber bereits Ende des 18. Jahrhunderts in allen Schichten der Bevölkerung.

34 Ausschnitt aus Abb. 33 → Kat.-Nr. 97 Detail from Fig. 33 → Cat. No. 97

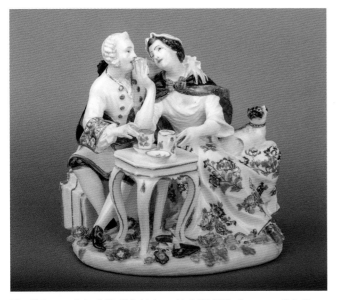

35 Liebespaar beim Frühstück, Meissen, Modell J. J. Kändler, 1744 → Kat.-Nr. 93
Lovers at Breakfast, Meissen, model by J. J. Kändler, 1744 → Cat. No. 93

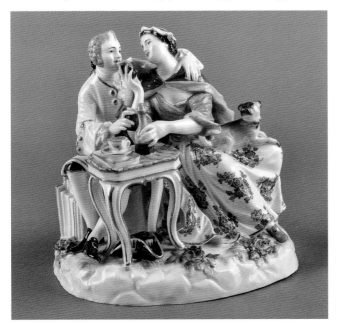

36 Liebespaar beim Weintrinken, gleiches Modell wie Abb. 35 in der veränderten Ausformung des 19. Jahrhunderts *Lovers Drinking Wine*, same model as Fig. 35, in a modified nineteenth-century form

In Kändlers Taxa ist die Gruppe unter dem Datum des 21. November 1744 eingetragen:

> „Frey Maurer Groupgen, da ein Frey-Maurer in seiner Kleidung und Schurz Fell neben einer Dame vom Mopß-Orden sizet, welche ihn mit einer Choccolate, die sie auf dem Tisch neben sich stehen hat, beehret, auf deren Schoß liegt ein Mopß."[6]

The companion piece Kändler made for his Freemason and pug is a formally dressed lady in crinolines, who is accompanied by two pugs.[3] In his *Taxa* Kändler calls this piece 'Lady of the Order of the Pug, standing on a pedestal, holding a pug-dog in her left hand also one lying at her feet, for the Princess of Herford.' This figurine was, therefore, definitely made on commission.[4] Such magnificently voluminous skirts buoyed up by crinolines provided artists with a wonderful ground on which to recreate the exquisite materials and patterns of real brocade clothing. The two dogs with the lady are, in contrast to the Freemason's actively engaged animal companion, quietly reposing beneath her skirts and on her arm.

A more intimate scene is shown in *Lovers with Pug and Drinking Chocolate* (Fig. 35). The opening up of the New World made coffee and chocolate along with Asian tea the most popular and fashionable drinks of the eighteenth century.[5] There were numerous services that belonged to court life: a 'solitaire', a breakfast setting for one person, a 'service á deux' or 'tête-à-tête' with settings for two on up to complete multi-piece services, for which leather-lined cases were often made to protect such precious possessions and transport them safely. At first the prerogative of nobility, these warm drinks had spread to all social classes by the late eighteenth century.

Kändler's *Taxa* has the following entry applying to the above group dated 21 November 1744: 'A little Freemason group with a Freemason in his apparel and apron sitting next to a Lady from the Order of the Pug, who is honouring him with a cup of chocolate, which she has on the table next to her; a pug is lying on her lap.'[6] Here is another combination of a clearly characterised Freemason with a lady from the Order of the Pug. The two are turned to each other, and the lady is letting her gallant drink from her own cup.

Auch hier findet sich wieder die Kombination von klar benanntem Freimaurer zusammen mit einer Dame vom Mopsorden. Beide sind einander zugewandt, die Dame lässt ihren Kavalier aus ihrer eigenen Tasse trinken.

Das Service auf dem Tisch zeigt durch die Kanne, dass es sich nur um Schokolade handeln kann. Schokoladenkannen haben einen Griff, keinen Henkel und einen flachen Deckel. Auf der Tasse des Herrn meint man sogar den Schaum zu erkennen, der durch das Aufschlagen des Getränks mit Milch entsteht. Es gibt mehrere Ausführungen dieses Liebespaares, die sich nicht in der Form, aber in der Bemalung unterscheiden. Sogar die Service tragen die unterschiedlichen Dekore, die in der Meissner Manufaktur zeitgenössisch angeboten wurden.[7] Die besondere Qualität der Gruppe wir durch die exquisite Aufglasurmalerei noch gesteigert.

Hier waren die besten Meister des 18. Jahrhunderts am Werk. Zum einen in der Feinheit der Modellierung, man betrachte nur die Hände, aber zum anderen auch die brillant abgestimmte Farbgebung, die man so nur im Rokoko findet. Man malte nicht einfach,

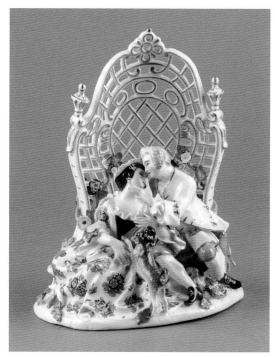

38 Liebespaar in einer Laube sitzend, Meissen, J. J. Kändler und P. Reinicke, um 1745 → Kat.-Nr. 94 *Lovers Seated in an Arbour, Meissen, J. J. Kändler and P. Reinicke, c.1745* → Cat. No. 94

The pot from the service on the table reveals that the drink served from it can only be chocolate. Chocolate pots usually have a straight handle projecting at a forty-five degree angle, instead of the curvilinear one familiar from teapots, and a flat lid. The gentleman's cup even looks as if it is topped with the froth whipped up when the chocolate is combined with milk. There are several casts of this loving couple that differ only in the way they are painted rather than in form. Even the miniature services are decorated with the various china patterns that were used by the Meissen factory at the time on their full-scale wares.[7] The high quality of this group was enhanced by superlative painting.

This is work by the leading eighteenth-century master modeller and a skilled china painter who was his equal. First, just look at the exquisitely fine modelling of the figures' hands. Then there is the dazzling artistry with which the colours are coordinated, encountered at this level only in the Rococo era,

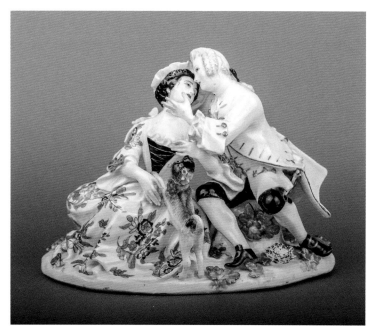

37 Liebespaar, Meissen, J. J. Kändler, um 1745 → Kat.-Nr. 95 *Lovers Seated in an Arbour, Meissen, J. J. Kändler, c.1745* → Cat. No. 95

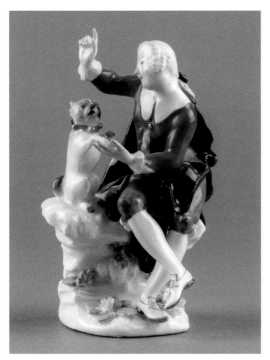

39 Mopsdressur, Meissen, Modell J. F. Eberlein, um 1743
→ Kat.-Nr. 99 *Training a Pug*, Meissen, model by J. F. Eberlein,
*c.*1743 → Cat. No. 99

when painters did not simply decorate at random. The palette always underscores the statement made by a piece, here the aspect of belonging together. The gentleman's cuffs are as exquisitely decorated as the lady's skirt. The blue bow fastening her cape picks up the blue edging of the Freemason's apron. Even the pug is included in the vibrant colour scheme: it is sporting a yellow bow on its collar to match the one on its mistress's cap.

This subtle awareness of correspondences was lost in the nineteenth century, when colour schemes became arbitrary and colours were simply bright.

This group in particular was changed in the nineteenth century even in respect of content. The intimate breakfast scene with hot chocolate became a little boozing session with wine. The fine breakfast

wie es einem gefiel. Die Farbgebung unterstreicht immer die Aussage des Stücks, hier den Moment des Zusammengehörens. So sind die Ärmelaufschläge des Herrn ähnlich prächtig bemalt, wie der Rock der Dame, die blaue Schleife ihres Umhangs greift die Randverzierrung seines Freimaurerschurzes auf. Ja sogar der Mops wird mit einbezogen, er trägt wie seine Herrin an der Kappe eine gelbe Schleife am Halsband.

Dieses feine Wissen um Korrespondenzen ging im 19. Jahrhundert verloren. Die Farbgebung wird beliebig und einfach bunt.

Auch inhaltlich wird gerade diese Gruppe im 19. Jahrhundert verändert. Aus der intimen Frühstücksszene mit Schokolade wird ein kleines Trinkgelage mit Wein. Das Service wurde durch Gläser und Flaschen ersetzt (Abb. 36).

Die Gruppe „Liebespaar" von Johann Joachim Kändler wurde in der ursprünglichen Form von Peter Reinicke mit einer Gitterlaube hinterfangen (Abb. 38).[8] Vermutlich war die Laube der fragilste Teil des Stücks, so dass sie auch ohne Rahmen angeboten wurde (Abb. 37).

Beide Gruppen sind von ähnlich qualitätvoller Ausführung wie das „Liebespaar beim Frühstück" und spiegeln den feinen kunstvollen Geist in der Mitte des 18. Jahrhunderts wider. Kändler hat die

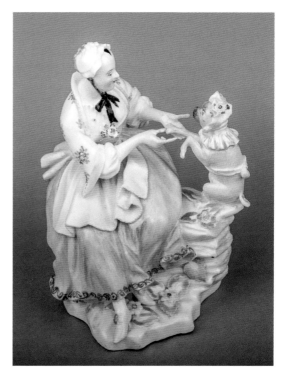

40 Mopsdressur, Wien, 1755/60 → Kat.-Nr. 101 *Training a Pug*,
Vienna, *c.*1755/60 → Cat. No. 101

Zuneigung galanter Liebespaare immer wieder thematisiert und weitere Gruppen geschaffen.[9]

Ein anderes beliebtes Thema war die „Mopsdressur", die in der Sammlung aus den Manufakturen Meissen und Wien vertreten ist (Abb. 39, 40).

Die Figuren sind mit ca. 12 bis 14 cm deutlich kleiner als die vorherigen Gruppen, wahrscheinlich eher für ein privates Boudoir gedacht, jedoch ebenso exquisit in der Ausformung und Bemalung. Der Mops wird als Spielgefährte und Freund des Menschen angesehen.

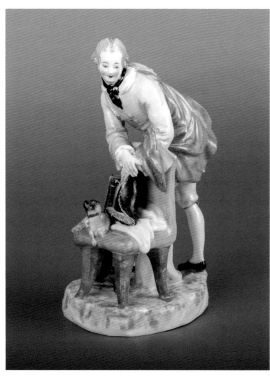

42 Kavalier mit Mops, Wien, 1760/65 → Kat.-Nr. 104 *Gentleman with Pug*, Vienna, 1760/65 → Cat. No. 104

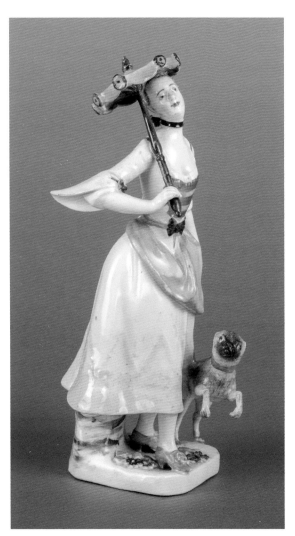

41 Dame im Schäferkostüm, Wien, 1760/655 → Kat.-Nr. 105 *Lady in Shepherdess Costume*, Vienna, 1760/65 → Cat. No. 105

service was replaced by glasses and bottles (Fig. 36). The *Lovers* group by Johann Joachim Kändler was left in its original form by Peter Reinicke but given a latticed arbour as a backdrop (Fig. 38).[8] Since the arbour was presumably the most fragile part of this piece, the group was also on offer without this framing element (Fig. 37).

Both groups have been executed to as high a quality standard as *Lovers at Breakfast* and reflect the exquisitely sophisticated eighteenth-century spirit. Kändler often addressed the theme of affectionate lovers in the gallant style and made more groups of this kind.[9]

Another popular subject was 'training a pug', which is represented in the collection by pieces from the Meissen and Viennese manufactories (Figs. 39, 40).

Measuring approximately 12 to 14 centimetres, these figures are noticeably smaller than the groups discussed above. They were probably made to be displayed in an intimate boudoir setting, but they are just as beautifully cast and painted as the larger ones. The pug as playmate and friend.

Der Kavalier aus der Meissner Manufaktur trägt keine Zeichen der Freimaurer, sondern nur einen eleganten blauen Anzug mit hellgelbem Kragen und Schleifen an den purpurfarbenen Hosen und hellen Schuhen. Der Mops wird natürlich passend zu seinem Herrn mit einem purpurnen Halsband ausgestattet. Treuherzig blickt er zu ihm auf und befolgt die Anweisung der gehobenen Hand.

Die Dame aus der Wiener Manufaktur geht noch einen Schritt weiter und macht ihren Hund zum Spielzeug oder Alter Ego. Sie sitzt inmitten duftiger Blumen auf einem Schemel, ihr Mops Männchen machend vor ihr auf einem Felsen. Sie hat ihm wie einem Baby eine Haube mit Blumen aufgesetzt, die um den Bauch gebunden ist. Der Modelleur der reizenden Dresseurin ist nicht bekannt, es gibt aber ein männliches Pendant eines ebenfalls sitzenden Herrn, der einen kleinen Jagdhund mit Dreispitz auf dem Kopf dressiert.[10]

Der Mops als Begleiter zeigt sich bei zwei Figuren, die in der Wiener Porzellanmanufaktur entstanden sind (Abb. 41, 42). Die im Schäferkostüm mit Sonnenschirm flanierende Dame wird von ihrem fröhlich nebenher springenden Mops begleitet, der sich offensichtlich über den Spaziergang freut. Der Kavalier steht ruhig hinter seinem Stuhl, den er seinem Mops überlässt. Da die Figuren deutlich in der Größe variieren, haben beide ursprünglich ein anderes Pendant gehabt.

1 Pietsch 2002, S. 103; Rückert 1966. In diesem grundlegenden Katalog der Ausstellung „Meissner Porzellan im Bayrischen Nationalmuseum" zitiert Rückert die Eintragungen Kändlers in seinem Taxa Buch.
2 Pietsch 2006, Kat.-Nr. 17, S. 22, 23.
3 Rückert 1966, Kat.-Nr. 873, S. 211.
4 Menzhausen 1993, S. 115.
5 „Ey! Wie schmeckt der Cofee süße" 1991, S. 9 ff.
6 Menzhausen 1993, S. 114.
7 Cassidy-Geiger 2008, Nr. 53, S. 265.
8 Rückert 1966, Kat.-Nr. 882, S. 170.
9 Pietsch 2006, Kat.-Nr. 22, S. 27.
10 Mrazek/Neuwirth 1971, Kat.-Nr. 347, 348, S. 126.

This gentleman from the Meissen factory sports no insignia of Freemasonry. He is instead clad in an elegant blue suit with a light yellow collar and bows on his lavender breeches and light shoes. The pug has, of course, been matched to his master with a lavender collar. The dog gazes trustingly up at him to follow the instructions conveyed by his raised hands.

A lady from the Viennese manufactory has gone a step further in making her pug into a toy or mini-me. She is ensconced on a footstool amid fragrant flowers with her pug sitting up and begging in front of her on a rock. She has dressed it up like a baby in a bonnet topped with flowers, its long lappets tied about the docile pet's belly.

The modeller of this charming instructress is unknown but she has a male companion, a seated gentleman who is training a small gun dog wearing a cocked hat.[10]

The pug as companion animal is featured in a pair of figurines made at the Viennese manufactory (Figs. 41, 42). The lady, dressed as a shepherdess and strolling beneath a parasol, is accompanied by a pug cavorting beside her, which is evidently loving being taken for a walk. A gentleman – the companion piece – is, by contrast, standing quietly behind his chair, which he has surrendered to his pug.

1 Pietsch 2002, p. 103; Rückert 1966. Rückert quotes Kändler's entries in his Taxa book in this groundbreaking catalogue accompanying the exhibition Meissner Porzellan im Bayrischen Nationalmuseum.
2 Pietsch 2006, Cat. No. 17, p. 22, 23.
3 Rückert 1966, Cat. No. 873, p. 211.
4 Menzhausen 1993, p. 115.
6 Menzhausen 1993, p. 114.
7 Cassidy-Geiger 2008, No. 53, p. 265.
8 Rückert 1966, Cat. No. 882, p. 170.
9 Pietsch 2006, Cat. No. 22, p. 27.
10 Mrazek/Neuwirth 1971, Cat. Nos. 347, 348, p. 126.

Galanterien

---·—·—·—·—·—·—·---

Trinkets
and Objets d'Art

---·—·—·—·—·—·—·---

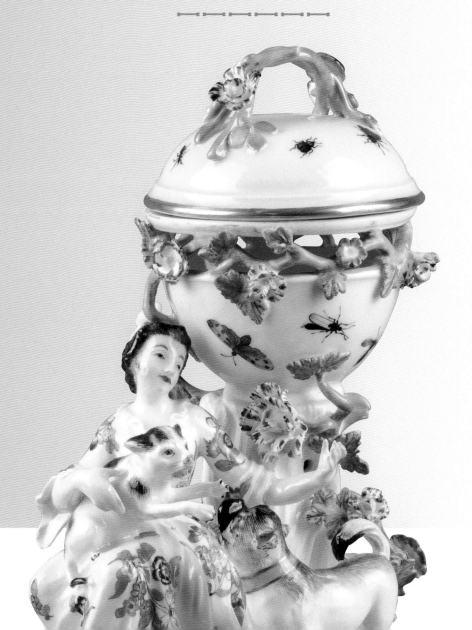

Mopsdarstellungen aus Porzellan wurden nicht nur als Einzelfigur oder als Begleiter galanter Damen und ihrer Kavaliere dargestellt, sie fanden ihren Platz auf vielen Gegenständen, die die Räume der höfischen Gesellschaft schmückten oder als nützliche kleine Accessoires, sogenannte Galanteriewaren, dienten.

Unter Galanterie versteht man ein höfisch geprägtes Verhaltensideal, das sich etwa im 17. Jahrhundert in Frankreich ausprägte. Durch bestimmte vorgegebene Verhaltensweisen sicherte man sich die Zugehörigkeit zu einer elitären Gesellschaftsschicht, man wollte dazugehören und gefallen, vor allem den Damen.

Sehr schnell übertrug sich der Begriff der Galanterie im Sinne von Benehmen auf die Gegenstände, mit der sich die höfische Gesellschaft des 18. Jahrhunderts umgab. Das Rokoko war eine Zeit, die fast alles einem artifiziellen Gestaltungstrieb unterordnete. Die Dinge waren nicht nur Gegenstände, sie waren Botschaften an die Gesellschaft, Zeichen, wessen Geistes Kind man war und wozu man gehörte. Kurz vor der französischen Revolution, die das alles hinwegfegen sollte, standen diese kunstvollen Gebilde in besonderer Blüte. Bis heute erzählen sie uns von den komplizierten Ritualen der höfischen Gesellschaft, von ihren Moden und auch Ausschweifungen.[1]

Es gab Etuis, Necessaires, Siegelbüchsen, Pfeifenköpfe, Petschaften, Flakons, Briefbeschwerer, Stockgriffe und vor allem Dosen in jedem denkbaren Material wie Gold und Silber, Glas, Email und natürlich Porzellan. Dosen, die in der Regel eine Metallmontierung hatten, die Deckel und Dose verbanden, benutzten die Damen für Schönheitspflästerchen, Schminke, Zahnstocher und Nadeln. Die wichtigste Funktion hatte die Dose aber für die Aufbewahrung des von beiden Geschlechtern gleichermaßen genossenen Schnupftabaks.

Mit der Tabatiere zelebrierte man das beliebte Laster in kunstvoller Art und Weise. Manche Kavaliere besaßen Tabatieren, passend zu jedem Anzug. Es entstand eine Gattung der Kleinkunst, bei der die verschiedenen Werkstätten arbeitsteilig zusammen wirkten, Metallschmiede mit Porzellinern, Steinschneider mit Lackkünstlern und Miniaturmalern. Zwar waren die Dosen klein, boten aber durch mindestens sechs bis sieben Flächen ideale Voraussetzungen zur Gestaltung (Abb. 43, 44).[2] Die Darstellung auf der ovalen Emaildose geht vermutlich auf eine grafische Vorlage zurück, da sich die Persiflage auf die

Pugs were not only produced in porcelain as individual figurines or groups accompanying lovely ladies and their gallants. They also became part of many objects that adorned rooms or represented useful little accessories in court circles.

The gallant style refers to an ideal of conduct shaped at European courts, which developed in seventeenth-century France particularly. Adherence to specific, prescribed codes of conduct ensured membership of a social elite. People wanted to belong and be popular, and this applied especially to the ladies.

The term 'gallant' as applied to behaviour was very soon transferred via metonymy to the objects with which court society surrounded itself in the eighteenth century. The Rococo era was a time when almost everything was subject to an urge to create an artificial living environment. Things were not just objects; they represented messages to society, signs indicating what sort of person one was and what one's affinities and affiliations were. Shortly before the French Revolution, which would sweep away the old order, the craze for such fanciful creations was at its height. Even today they are informative on the sophisticated rituals of court society, its fashions and also its excesses.[1]

There were cases, nail sets and sewing kits, seal and wax holders, flacons, paperweights, walking-stick handles and, above all, boxes and jars made of all materials imaginable, including gold and silver, enamel and, of course, porcelain. Jars and boxes,

immer höher werdenden, manieristischen Frisuren der Damen auch figürlich oder als Bemalung in den Manufakturen von Höchst, Marieberg und Frankenthal findet.

Die Dose (Abb. 44) mit geschweiftem Deckel und umlaufenden Landschaften und Genreszenen ist relativ groß. Sicher war sie nicht dafür gedacht, mitgeführt zu werden, sondern stand auf dem Schreibtisch oder auf Beistelltischen in den Salons.

Johann Joachim Kändler schreibt in seinem Arbeitsbericht von 1741:

„Für Ihro Hoch Reichsgraf. Des herrn Geheim Cabinets Minister de Brühls Excellenz eine Tabatiere in Gestalt eines Mopß Hündgens, wie er auf einem Rasen liegt nebst dazugehörigem Deckel in Ton poussiret." (Abb. 46).[3]

Natürlich dienten Tabatieren häufig als Geschenk, sei es aus politischen Gründen oder auch als Pfand der Liebe und Freundschaft. Dies belegen die vielfältigen Monogramme oder Porträts auf den Wandungen oder im Deckel.

Eine Besonderheit stellt die Mopsdose mit dem bezaubernden Innenbild einer Dame dar. Die Qualität der Bemalung grenzt mit feiner

44 Dose, Email auf Kupferkern, Malerei Georg Christoph Lindemann, deutsch, um 1760 → Kat.-Nr. 84 Box. enamel on copper core, painting Georg Christoph Lindemann, German, c.1760 → Cat. No. 84

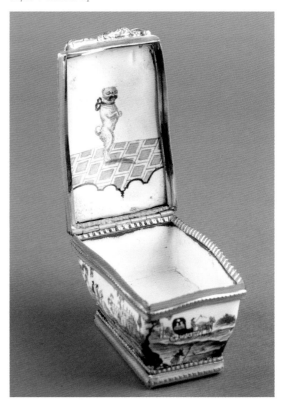

45 Dose von Abb. 44 mit geöffnetem Deckel Box (Fig. 44) with lid open

43 Ovale Tabatiere, Email auf Kupfer, um 1770 → Kat.-Nr. 85 Oval snuffbox, enamel on copper, c.1770 → Cat. No. 85

which usually featured metal mounts linking them with their lids, were used by ladies for keeping beauty spots, cosmetics, toothpicks and pins of various kinds. The most important function for boxes was storing snuff, which was a luxury enjoyed by both sexes.

Punktiertechnik an Lupenmalerei (Abb. 47, 48). Wegen seines ungewöhnlichen Materials gibt uns diese Dose allerdings ein Rätsel auf. Ist es eine Nuss oder doch Holz? Außen findet sich eine Art Lackmalerei. Möglicherweise versuchten sich die Künstler an einem neuen, unzerbrechlichen Material.

Diese Dosen in Form eines Mopskopfes waren außerordentlich beliebt. Außen naturalistisch gestaltet oder vermenschlicht dargestellt, waren sie in der Innenseite immer delikat bemalt (Abb. 49, 50).

Die meist figürlichen Dosen aus französischen Porzellanmanufakturen waren offenbar für Bonbons oder Pillen gedacht und wurden „Bonbonnières" oder „Drageoirs" genannt. Besonders die Manufaktur in Mennecy hatte sich darauf spezialisiert. Es gibt Möpse wie der aus der Sammlung, aber auch Löwen, Hunde, Schwäne, Pferde, Krebstiere etc.[4]

Für Damen boten auch die Parfüm- und Riechfläschchen ein weites Feld. Wie hier entweder in der Form einer Dame mit Mops oder als sitzender Mops, war meist der Kopf abnehmbar, mit einer Metallmontierung versehen und mit einem kleinen Kettchen gesichert (Ab. 51, 52).

Der halbrunde Sockel, auf dem der Mops sitzt, konnte, wenn man ihn umdrehte, auch zur Augenspülung verwendet werden.

47 Mopsdose → Kat.-Nr. 79 Pug pillbox → Cat. No. 79

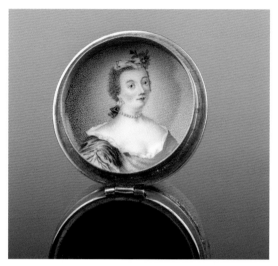

48 Porträt einer Dame im Innendeckel der Mopsdose (Abb. 47), wohl England 2. Hälfte des 18. Jahrhunderts → Kat.-Nr. 79
Portrait of a lady inside the lid of a pug pillbox (Fig. 47), presumably England latter half eighteenth century → Cat. No. 79

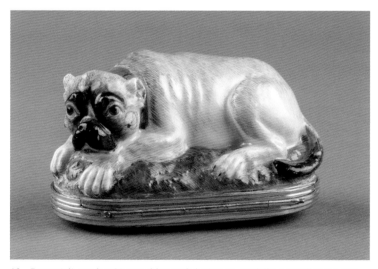

46 Dose mit liegendem Mops auf Grassockel, Meissen, Modell J. J. Kändler, um 1741 → Kat.-Nr. 88 Box with pug lying on a turf plinth, Meissen, model J. J. Kändler, c.1741 → Cat. No. 88

With the 'snuffbox' the popular vice was celebrated elegantly and stylishly. Many courtiers owned snuffboxes to match each suit of clothing. An art-object genre came into being which entailed a division of labour, with several specialist workshops collaborating: metalworkers with porcelain workers, and gem cutters with lacquer painters and miniaturists. The boxes and jars were small, but still they had six or seven surfaces that provided ideal opportunities for design (Figs. 43, 44).[2] The representation on the oval enamel box presumably derives from a print because the satirical rendering of the ladies' Mannerist

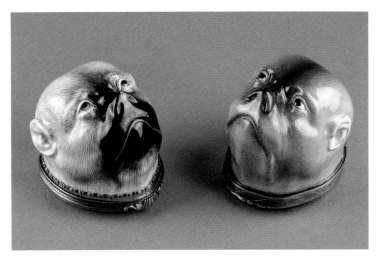

49 Dosen in der Form eines Mopskopfes, Meissen, um 1770 → Kat.-Nr. 80, 81
Pillboxes formed as pugs' heads, Meissen, c.1770 → Cat. Nos. 80, 81

50 Innenansicht der Mopskopfdose, Abb. 49 → Kat.-Nr. 81 Interior of a pug pillbox
(Fig. 49) → Cat. No. 81

Eines der wichtigsten Accessoires des 18. Jahrhunderts für den Kavalier war neben der Tabatiere der Flanierstock. Man lustwandelte durch Parks und Straßen. Es entstanden folgerichtig eine Fülle an Stockgriffen mit Mopskopf. Der Griff bot wieder eine willkommene Fläche, um die Dekore der Meissner Porzellanmanufaktur zu platzieren. Die Auswahl an Blumen, Landschaftsschilderungen und Kauffahrteiszenen war immens. Auf dem Schaft des Knaufs entfaltet sich perfekt gemalt eine

hairstyles recurs on figurines or as paintings on products from the Höchst, Marieberg and Frankenthal porcelain factories.

This box (Fig. 44) with a curved lid and painted all round with landscapes and genre scenes is relatively large. Definitely not made for a pocket or purse, it would have stood on a desk or an occasional table in a salon.

Johann Joachim Kändler writes in his 1741 *Works Log*:

'For His Excellency the Imperial Count. Modelled in clay for His Excellency Privy Councillor de Brühl a snuffbox in the form of a little pug-dog, as if lying on a lawn along with a matching lid'[3] (Fig. 46).

Snuffboxes were often given as presents, whether for political reasons or as tokens of love and friendship. This is shown by the wide variety of monograms and even portraits on the outside of boxes or inside their lids.

A pug box with an enchanting portrait of a lady inside the lid is a case in point. The quality of execution in fine stippling borders on painting through a magnifying glass (Figs. 47, 48). However, this box is puzzling. Is it a nut or wood after all? The outside is covered with a sort of lacquer painting. Artists may have been trying out a new, unbreakable material.

Boxes like these formed as pug's heads were extremely popular. Outside naturalistic in design or even anthropomorphic, they were always exquisitely painted inside (Figs. 49, 50).

Most figurative boxes from French porcelain factories were evidently intended to hold sweetmeats or pills and lozenges as they were called

kleine Welt der Hafenlandschaft mit Händlern, Seefahrern und Booten (Abb. 53).

Es gibt sogar Pfeifenköpfe in Mopsform (Abb. 54). Dabei ist der Kopf des Hundes als Deckel gebildet, der mit einem Scharnier am Hals befestigt ist. Unter dem Schwanz konnte der Pfeifenstil befestigt werden. Wie gut das tatsächlich funktionierte, ist nicht belegt, aber darum ging es ja in erster Linie auch nicht. Es war ein weiteres Accessoire, dass die Herren bei sich tragen konnten.[5]

Weitere alltägliche Accessoires der höfischen Gesellschaft waren Briefbeschwerer, Vasen, Duftvasen und Leuchter aus Porzellan oder

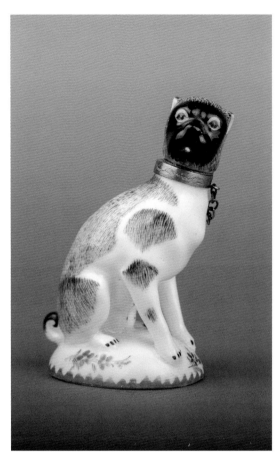

52 Sitzende Möpsin als Flakon, Chelsea, um 1755 → Kat.-Nr. 70
Flacon formed as a sitting female pug. Chelsea, *c*.1755 → Cat. No. 70

51 Riechfläschchen als Dame mit Mops unter dem Arm, Meissen, um 1750 → Kat.-Nr. 71 Vinaigrette formed as a lady with a pug under her arm, Meissen, *c*.1750 → Cat. No. 71

'bonbonnières' or 'drageoirs'. The porcelain factory in Mennency had specialised in them. It and others made pugs, like those in the collection, as well as lions, dogs, swans, horses, crustaceans and so forth.[4]

A broad range of scent bottles and vinaigrettes was available for ladies. Like the ones here, either formed as a lady with a pug or as a sitting pug, most of these have detachable heads, with metal mounts that secured them to the human figure or pug bodies by means of small chains (Figs. 51, 52).

The semicircular plinth on which this pug is sitting could also be used as an eyewash basin when turned around.

One of the most important accessories for the eighteenth-century courtier, besides the snuffbox, that is, was the walking stick. Gentlemen enjoyed

Fayence, die auch gern mit plastisch modellierten Möpsen versehen wurden. So findet sich eine Vielfalt an Briefbeschwerern in schmaler, längsrechteckiger Form und mit abgestuftem Sockel (Abb. 55). Diese waren mit den verschiedenen Dekoren der Meissner Manufaktur bemalt, es gibt Stücke mit Zwiebelmuster, Parkszenerien, Chinoiserien

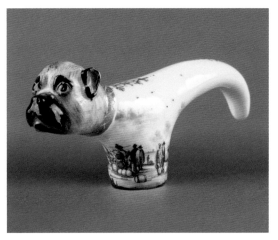

53 Stockgriff mit Mopskopf, Meissen, Modell J. J. Kändler, um 1740, → Kat.-Nr. 74 Walking-stick handle with pug's head, Meissen, model J. J. Kändler, c.1740 → Cat. No. 74

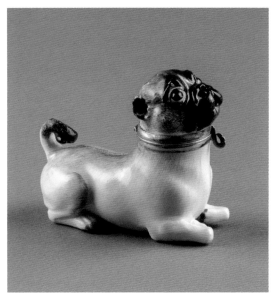

54 Pfeifenkopf als liegender Mops, Meissen, um 1750 → Kat.-Nr. 78 Pipe bowl formed as a pug lying down, Meissen, c.1750 → Cat. No. 78

strolling at a leisurely pace through parks and streets. Unsurprisingly, there were a lot of pug's-head walking-stick handles on the market. The handle provided the Meissen porcelain factory with yet another welcome surface to decorate. The Meissen range of floral decoration as well as landscape and trading-port scenes was vast. Executed with consummate artistry, a miniature world of port scenes with traders, mariners and messengers unfolded on the shaft of walking-stick knobs (Fig. 53).

There are even pipe bowls formed as pugs (Fig. 54). The dog's head forms the lid, which is attached to its neck by a hinge. The pipe stem could be attached beneath the pug's tail. How well that actually worked is not recorded, but after all that wasn't what really mattered. This was just another accessory for gentlemen to carry about with them.[5]

Other mundane accessories favoured by court society were paperweights, vases, scent vases and candlesticks made of porcelain or faience, which were often decorated with pugs modelled in the round. There was a wide variety of paperweights in a narrow, elongated rectangular shape with a stepped plinth (Fig. 55). They were painted with the various Meissen factory patterns: there are pieces with the Onion Pattern, park scenes, chinoiserie and even individual flowers. A naturalistically rendered pug on top was axially aligned and served as a handle.

Candlesticks, of which an astonishing number is extant, were also very popular (Fig. 56). A floriform nozzle rises above a foliate drip-pan. The centre of the piece is surrounded by delicate flowers, minor masterpieces of porcelain-making. In the front is a pug from the Kändler repertory: standing on all fours, sitting, scratching – any number of combinations was possible.[6]

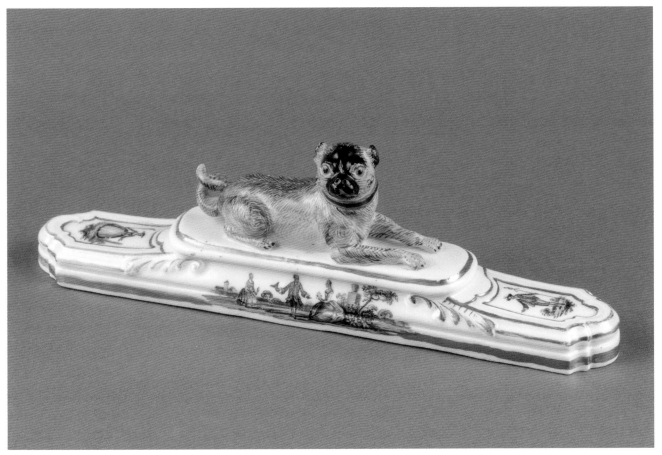

55 Briefbeschwerer mit liegendem Mops, Meissen, um 1750 → Kat.-Nr. 106 Paperweight featuring a pug lying down, Meissen. *c.*1750 → Cat. No. 106

oder auch einzelnen Blüten. Oben mittig liegt ein naturalistisch ge-fasster Mops, der gleichzeitig als Griff diente.

Sehr beliebt waren auch Kerzenständer, von denen sich eine erstaun-lich hohe Zahl erhalten hat (Abb. 56). Über einem Rocaillesockel erhebt sich ein blütenförmiger Kelch mit einem Tropfenfänger in Blattform. Umfangen wird die Mitte von filigranen Blüten, kleinen Meisterwerken der Porzellankunst. Vorne ein Mops aus Kändlers Repertoire, stehend, sitzend, sich kratzend, die Kombinationsmöglichkeiten waren groß.[6]

Die kleinen Möpse der Meissner Manufaktur wurden offenbar auch von anderen Manufakturen gekauft, um sie weiter zu verwenden. Es gibt eine Reihe von feuervergoldeten Kerzenständern (Ormolu) aus französischen Manufakturen, die ihre Stücke mit Blüten aus Weich-porzellan und kleinen Möpsen aus Sachsen schmückten (Abb. 58).

Neben Kerzenständern spielten Vasensätze und Duftvasen, so-genannte Potpourri, im höfischen und später auch bürgerlichen Am-biente des 18./19. Jahrhunderts eine große Rolle.

The small pugs made by the Meissen factory were evidently also bought in by other factories for further use. There are a number of fire-gilt candlesticks (ormolu) from French factories, which adorned their pieces with flowers of soft-paste porcelain and small pugs (Fig. 58).

Apart from candlesticks, sets of vases and scent vases, known as potpourri vases, played a major role in court circles and later also in middle-class homes during the eighteenth and nineteenth centuries.

A distinction must be drawn: vases with or without covers were as a rule not single pieces but rather part of a set or garniture comprising three to seven units. Such garnitures included covered, baluster, narrow-necked and double-gourd vases, garlic-mouth vases, and stalk and single-stem vases.

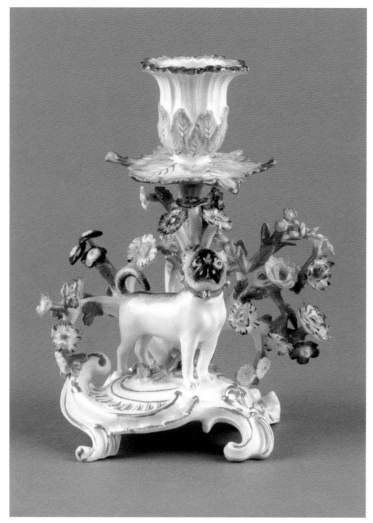

56 Kerzenständer mit stehendem Mops, Meissen, um 1750 → Kat.-Nr. 107
Candlestick with pug standing on all fours, Meissen, c.1750 → Cat. No. 107

The centrepiece of a garniture was usually a larger covered vase with the vases flanking it decreasing in size in descending order. Various types of vase might also be combined. Their purpose was to decorate cabinet tops and chimney pieces.

Potpourri vases, on the other hand, might also stand alone. They always had a perforated lid or a pierced-work shoulder and were used to disseminate fragrance (Fig. 57). They contained a mixture of water, flower petals, fruits and aromatic herbs. The fragrant blend was exposed in a clay pot all year long. The pot was called 'rotten'; the exact trans-

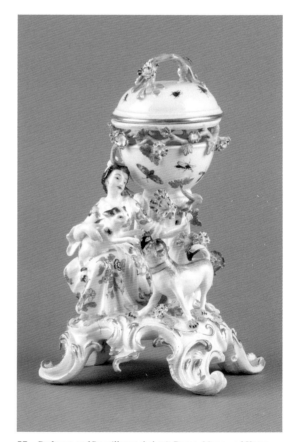

57 Duftvase auf Rocaillensockel mit Dame, Mops und Katze, um 1750 → Kat.-Nr. 110 Scent vase with lady, pug and cat, c.1750 → Cat. No. 110

Dabei muss man unterscheiden, denn Vasen mit oder ohne Deckel waren in der Regel keine Einzelstücke, sondern Bestandteil eines Vasensatzes, der aus drei bis sieben Vasen bestand. Dazu zählten Deckel- und Baluster-, Enghals-, Doppelkürbis-, Knoblauch- und Stangenvasen. Meist bildete eine größere Deckelvase den Mittelpunkt und die flankierenden nahmen in der Größe stufenweise ab, oder verschiedene Vasentypen wurden miteinander kombiniert. Sie dienten zur repräsentativen Verzierung von Schränken und Kaminen.

Potpourri dagegen konnten auch alleine stehen, hatten immer einen perforierten Deckel oder eine durchbrochene Schulter und dienten als Duftspender (Abb. 57). Sie enthielten eine Mischung aus Wasser, Blütenblättern, Früchten und aromatischen Kräutern. Diese Mischung

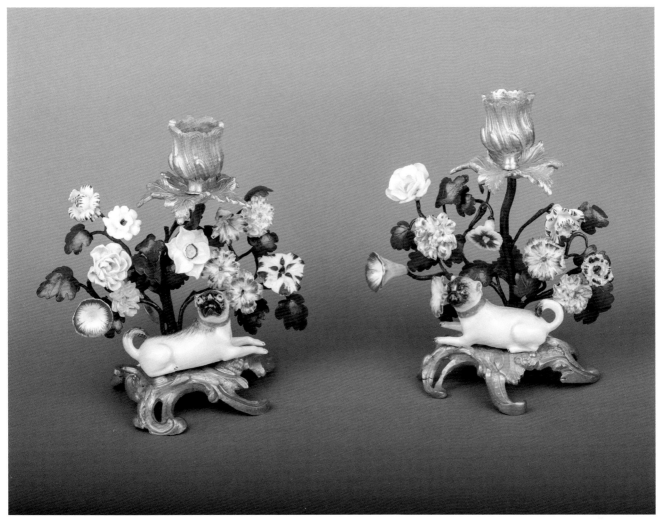

58 Ormolu-Leuchter mit Mops, Frankreich und Meissen → Kat.-Nr. 111 Ormolu candlestick with pugs, France and Meissen → Cat. No. 111

wurde in einem Tontopf das ganze Jahr über angesetzt. Dieser Topf war danach „verdorben", die genaue Übersetzung von Potpourri lautet deshalb „verdorbener Topf".[7] Die fertige Mischung wurde später in die wesentlich kostbareren Gefäße umgefüllt. Fast alle Porzellan- und Fayencemanufakturen in Europa hatten Potpourri in ihr Programm aufgenommen, der Form und Gestaltung waren keine Grenzen gesetzt.

lation of 'potpourri' is 'rotten pot'.[7] Ready-mixed potpourri blends were later put into considerably more expensive vessels. Almost all European porcelain and faience factories had by then added potpourri vases to their range. Form and design knew no bounds.

1 Bursche 1996, S. 7 ff.
2 Beaucamp-Markowski 1985, S. 14.
3 ebd., Kat.-Nr. 187, S. 235.
4 ebd., S. 16, 472, 473–477.
5 Illgen 1973, Kat-Nr. 102, Tafel VII.
6 Rückert 1966, Kat-Nr. 1097, S. 270.
7 Zubeck 1985, S. 3828–3832.

1 Bursche 1996, p. 7f.
2 Beaucamp-Markowski 1985, p. 14.
3 Ibid., Cat. No. 187, p. 235.
4 Ibid., p. 16, p. 472, pp. 473–477.
5 Illgen 1973, Cat. No. 102, Plate VII.
6 Rückert 1966, Cat. No. 1097, p. 270.
7 Zubeck 1985, pp. 3828–3832.

Andere
Hunderassen

⊶━┅━┅━┉━┅━┅━⊷

Other Breeds of Dog

⊶━┅━┅━┉━┅━┅━⊷

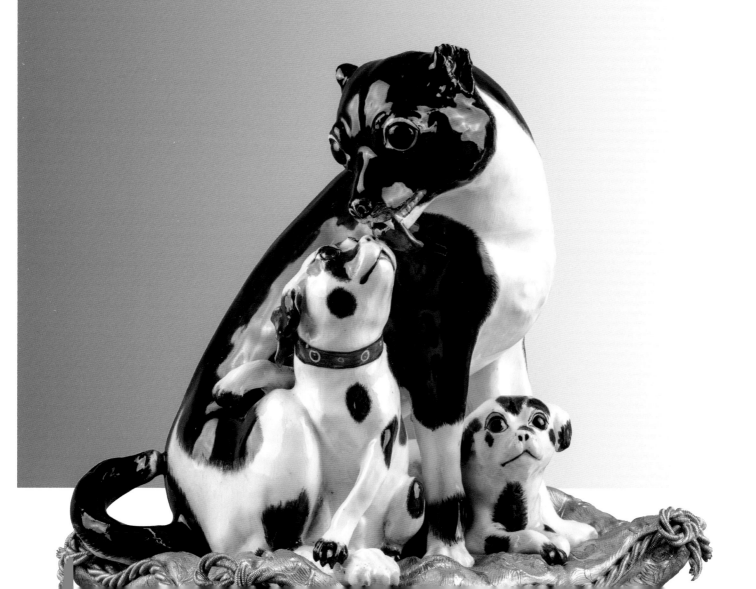

Für die Keramiken des 18. Jahrhunderts standen neben Möpsen verschiedene Hunderassen Modell.

Bekanntermaßen liegt der Ursprung aller heutigen Hunde beim Wolf. Man geht davon aus, dass es in der Steinzeit zu einer Symbiose kam, bei der die Menschen den Instinkt der Tiere für Beute und Feinde als Frühwarnsystem nutzten. Die Wölfe wiederum suchten die Nähe zu den Lagerplätzen, um Essensreste aufzustöbern und damit ihre Futtersuche zu erleichtern.[1] So entstand eine Gemeinschaft, die mit der Sesshaftwerdung des Menschen einherging und im Haushund, lateinisch *Canis Lupus forma familia* (zur Familie gehörig), mündete. Die ältesten Knochenfunde dieser Tiere stammen aus der Zeit um 15.000 v. Chr.[2] Schon vor 12.000 Jahren wurden domestizierte Hunde auf Steinsäulen verewigt und in den Armen ihrer Besitzer bestattet.

Wölfe waren auf der gesamten Nordhalbkugel mit etwa 40 Unterarten verbreitet. Sie passten sich durch unterschiedliche Fellbeschaffenheit, Größe und Körperbau perfekt an Klima, Futterangebot und spezifische Naturgegebenheiten des jeweiligen Lebensraumes an. Diese abweichenden Merkmale haben sich über Jahrtausende weitervererbt. So sieht man das charakteristische Erscheinungsbild des nordamerikanischen Wolfs heute noch im Husky und das Aussehen des indischen Wolfs in Windhund-Rassen.

Mit der Zeit verloren die Tiere ihre Raubtiereigenschaften und übernahmen Aufgaben im „Menschenrudel": Sie wurden Wächter von Haus und Hof, Hüter der Herden, Jagdhelfer oder sogar Zug- und Tragetier, später auch Kampfhund. Erste gezielte Züchtungen setzten im Jahrtausend um die Zeitenwende ein. Im 13. Jahrhundert entwickelten sich dann die ersten „echten" Rassen.[3] Erst seit der zweiten Hälfte des 19. Jahrhunderts gelten festgelegte Standards für die Zucht. Der erste Zuchtverein – der Kennel Club – wurde 1873 in Großbritannien gegründet. Dort erfasste man die Stammbäume von rund 4000 Hunden und unterteilte sie in 40 Rassen, die erstmals in einem Zuchtbuch festgehalten wurden. Außerdem setzte sich die reinrassige Zucht durch. Zahlreiche Länder folgten diesem Beispiel. Seitdem galten willkürliche Kreuzungen viele Jahrzehnte als nicht standesgemäß. Erst in den letzten Jahren erfreuen sich reinrassige Kreuzungen – sogenannte Designerhunde mit Kunstnamen – wie Puggle (Mops und Beagle) oder Labradoodle (Labrador und Großpudel) großer Beliebtheit. 2016 waren 359 Rassen offiziell anerkannt.

It wasn't just pugs. Other dog breeds were models for eighteenth-century ceramics too.

It is well-known that all modern-day dogs descend from the wolf. A symbiosis is assumed to have taken place in the Stone Age, with man exploiting those animals' instinct for prey and enemies as an early warning system. Wolves in turn sought closeness to human camps to track down scraps and leftovers, in doing so facilitating their search for food.[1] Thus a community grew up concomitantly with man becoming sedentary and the domestic dog, *Canis lupus familiaris* in Latin (meaning 'domesticated of the wolf') ultimately emerging. The oldest bones found of such animals date from about 15,000 BC.[2] Twelve thousand years ago domesticated dogs were being immortalised on stone stelae and were buried in their owners' arms.

Wolves and some forty subspecies spread throughout the northern hemisphere. They adapted perfectly to habitats that varied widely in respect of climate, food availability and specific natural conditions by developing different coats, body size and build. These divergent features were transmitted down through the millennia. Hence the characteristic appearance of the North American wolf is still reflected in the husky while the various breeds of whippet and greyhound resemble the Indian wolf.

Schaut man ins 18. Jahrhundert zurück, geben vor allem Gemälde und Kleinplastiken aus Porzellan, Bronze oder Holz Auskunft über die damals bevorzugten und geschätzten Hunderassen der gehobenen Gesellschaft. Besonders gern bildete man Jagdhunde ab, aber auch Wind-, Kampf- und Krafthunde sowie die schon damals beim weiblichen Adel beliebten Gesellschafts- und Schoßhunde. Diese Tiere hatten eine wichtige Rolle als Statussymbol und wurden seit dem Mittelalter zum Adelsprivilegium, Zeichenträger und Repräsentanten sozialer Beziehungen in der streng reglementierten, höfischen Hierarchie.[4] Man zeigte sich mit seinen Hunden oder demonstrierte durch die Anzahl der Tiere seinen Rang. Je höher der Stand innerhalb des Adels war, desto mehr Hunde und Hundeknechte leistete man sich und stellte sie besonders bei Jagden zur Schau. Große Bedeutung kam Hunden als Geschenk zu. Die Wahl der Rasse hing von der Stellung des Beschenkten und vom Status des Schenkenden ab. Je edler die Wahl ausfiel – beispielsweise mit einem reinen Windspiel –, desto deutlicher war die Wertschätzung. Entweder wurde der bestehende gesellschaftliche Rang bestätigt oder sogar überboten. Dies veranschaulichte die persönlichen Beziehungen der betreffenden Personen untereinander oder deutete auf eine anvisierte Stellung hin. Durch die Wahl eines einfacheren Hundes, z.B. eines sogenannten Bauernhundes, konnte der Beschenkte hingegen entwürdigt oder gekränkt werden.[5] Auch Schoßhunde waren beliebte Geschenke, die die emotionalen Beziehungen zwischen Beschenktem und Stifter widerspiegelten.

Diese Funktion lässt sich sehr eindrucksvoll in der Porträtmalerei ablesen. Häufig ließen sich Herrscher mit einem großen, kräftigen, gehorsamen Gebrauchshund oder einem edlen Windspiel darstellen. Diese Hunde symbolisierten Macht und Stärke, verwiesen aber auch auf den Landsitz und das Jagdrecht. Regentinnen wurden dagegen kleine Gesellschaftshunde zur Seite gestellt. Sie versinnbildlichten eheliche Treue, Güte, Emotionalität und Nähe zum Hofstaat.[6] Außerdem stehen die kleinen, Ratten und Mäuse jagenden Hunde stellvertretend für einen guten, ordentlichen Hausstand und eine souverän agierende Hausherrin. Ein frühes Beispiel ist das sogenannte Arnolfini-Porträt in der Londoner National Gallery. Es gilt als erstes Bildnis mit Hund. Jan van Eyck (1390–1441) stellte 1434 den italienischen Kaufmann Giovanni Arnolfini (1400–1470) mit seiner Frau Giovanna Cenami dar und malte zu ihren Füßen einen kleinen, fidelen Brüsseler Griffon, der

With time these animals lost their predatory characterics to assume a range of tasks in the 'human pack': they became guardians of house and home, custodians and protectors of flocks, helpers on the hunt or even draught animals and beasts of burden, later also attack and combat dogs. Deliberate breeding programmes began in the last millennium BC. By the thirteenth century the first 'pure-blood' breeds had evolved.[3] Established and maintained breeding standards have only existed since the latter half of the nineteenth century. The first association for monitoring breeding standards – the Kennel Club – was founded in Great Britain in 1873. It registered the pedigrees of some 4,000 dogs and subdivided them into forty breeds, the first to be entered in a written record of breeding. In addition, breeding pure-bred dogs caught on. Numerous countries followed Britain's example. After that, arbitrary crossbreeds were condemned as not befitting gentlemen owners. Only in recent years have crosses, pure-bred ones, of course – known as designer dogs with portmanteau names, such as puggle (pug plus beagle) or labradoodle (Labrador and standard poodle) – become enormously popular. In 2016 359 breeds were officially recognised.

To return to the eighteenth century, paintings and small statues of porcelain, bronze or wood are the chief sources of information on the dog breeds favoured and prized by the upper classes. Hunting dogs were particularly often portrayed, along with greyhounds and whippets, and attack and combat dogs, as well as the statement companion pets and lapdogs already fashionable among female aristocrats. All these animals played an important role as status symbols and, since the Middle Ages, had been the prerogative of the nobility and aristocracy as sign vehicles for, and representatives of, social relations

keck zum Betrachter schaut.[7] Auch auf fürstlichen Kinderbildnissen sind Gesellschaftshündchen zu sehen, die sich ungezwungen bewegen. Sie waren die innig geliebten Spielkameraden künftiger Potentaten, die meist wenig Umgang mit Gleichaltrigen hatten.

Auch in anderen Gebieten der Malerei ist die gezielt eingesetzte Hierarchie der Hunderassen zu beobachten. So ordnete Jan Brueghel d. Ä. (1568–1625) in seinen 1598 entstandenen Gemälden *Landschaft mit dem jungen Tobias* und *Anbetung der Könige* die kultivierten Rassehunde den vornehmen Adligen beziehungsweise den Drei Weisen aus dem Morgenland zu, die Mischlinge dagegen den untergebenen Begleitfiguren und Hirten.[8]

Jagd- und Hütehunde

Das Privileg zur Hohen Jagd, bei der Hochwild wie Hirsche und Wildschweine gehetzt wurden, war seit dem Mittelalter dem Adel sowie staatlichen und kirchlichen Würdenträgern vorbehalten. Der Niederen Jagd auf Hasen, Fasanen und Rehe durften auch der niedere Klerus und im Laufe der Zeit das gehobene Bürgertum nachgehen. Unerlässlich war jedoch immer der Hund als Jagdassistent. Der größten Wertschätzung erfreute sich die Hetzjagd auf Hirsche, die besonders viele Teilnehmer und die umfangreichste Meute umfasste. Die Zusammenstellung der Jagdgemeinschaft war ein Zeichen fürstlicher Gunst und zugleich eine gemeinsame Herrschaftsrepräsentation von Fürst und Potentaten, wobei die riesige zusammengestellte Meute als zentraler Bestandteil angesehen werden kann.[9] Als besonderes Ritual, das den Zusammenhalt der Hofgesellschaft betonen sollte, wurde die Fütterung der gesamten Meute mit den Innereien des erlegten Hirsches zelebriert. Es spielte keine Rolle, welcher Hund welchem Besitzer zuzuordnen war, da die Gemeinschaft der Jagdgruppe im Vordergrund stand. In der Folge entwickelten sich Jagddarstellungen rasch zum eigenständigen Thema in der Kunst. Maler und Skulpteure studierten intensiv Aussehen, Statur und Bewegung der Hunde, wie eine Studie Jan Brueghels d. Ä. aus dem Jahr 1616 eindrucksvoll zeigt (Abb. 59).

Die Aufgaben von Jagdhunden waren sehr vielseitig: Entweder hetzten sie die Beute einzeln oder in der Meute, stöberten das Wild auf,

in the strictly regulated court hierarchy.[4] Nobles and aristocrats showed off with their dogs or demonstrated their status by the number of dogs they owned. The higher one's rank in the nobility, the more dogs and dog handlers one could afford, and hunts provided the best settings for flaunting these societal assets. Dogs were very important as presents. The choice of breed depended on the recipient's social ranking and the giver's social status. The nobler the dog chosen – a pure-bred whippet or greyhound, for instance – the more obvious the esteem in which the recipient was held. Existing social status was either affirmed or even outbid. Such interactions revealed the state of relations between the persons concerned or suggested the status aimed at by the giver. The choice of a simpler dog, including what was known as a farm dog, on the other hand, might degrade or offend the recipient.[5] Lapdogs were also popular presents that mirrored the emotional relationship between recipient and giver.

This function can be very memorably read in portrait painting. Reigning princes often had their portraits painted with a large, powerful but obedient working dog or, alternatively, with an elegant whippet. Both types of dog symbolised power and strength as well as proprietorship of domains and possession of the privilege of hunting. Reigning princesses, on the hand, were portrayed in the company of small statement dogs as animal companions. They symbolised marital fidelity, benevolence, emotional awareness and closeness to the court and its entourage.[6] Moreover, little dogs that hunted rats and mice were symbolic representatives of a good, orderly household and a lady of the house who had her priorities right. An early example is the painting known as *The Arnolfini Portrait*, or *The Arnolfini Marriage*, in the National Gallery, London. It is believed to be the first

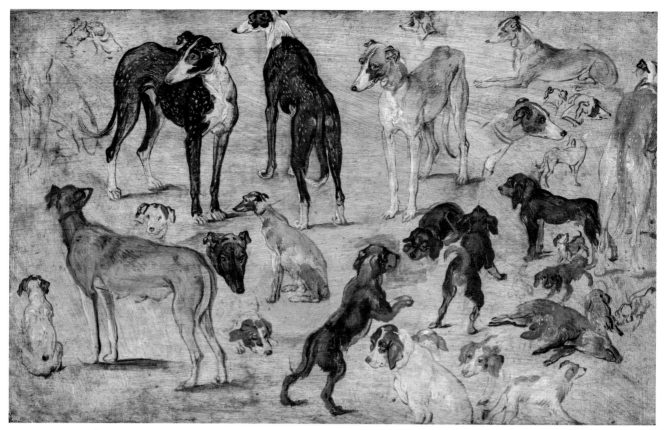

59 Jan Brueghel d. Ä., Hundestudie, 1616, Tusche auf Papier Jan Brueghel the Elder, *Studies of Dogs*, 1616, ink on paper

trieben es aus seinem Bau oder apportierten das geschossene Federwild zum Jäger. Für all diese Verrichtungen wurden spezielle Hundetypen mit verschiedenen Unterarten gezüchtet und ausgebildet. So kann man im Hundeführer von 1781 lesen:

> „Am meisten ist der Jagdhund ausgeartet [d. h. Rasse entwickelt]. Seine langen herabhängenden Ohren, seine Freundlichkeit, Gelehrigkeit und Schüchternheit zeugen davon, daß er durch die Kultur verbessert worden."[10]

Ein repräsentativer Überblick über die im 18. Jahrhundert beliebten Jagdhundarten findet sich auch in der Sammlung mit unterschiedlichsten Hundeskulpturen aus Porzellan und Fayence.

So scheint die große liegende Bordeaux-Dogge (Kat.-Nr. 113) regelrecht auf das nächste Kommando zu warten. Diese kräftigen und unerschrockenen Hunde wurden zur Jagd auf das Wild eingesetzt, das nicht von vornherein die Flucht ergriff, sondern sich kraftvoll zur Wehr setzte, so etwa Wildschweine und Wölfe (Abb. 60).

portrait with a dog. Jan van Eyck (1390–1441) portrayed the Italian merchant Giovanni Arnolfini (1400–1470) with his wife, Giovanna Cenami, in 1434, and at her feet in the foreground he painted a little toy dog, a Brussels griffon, staunchly standing its ground as it looks out at the viewer.[7] Naturally behaving animal companions are also shown in portraits of royal children. These dogs were the adored playmates of future reigning princes, who rarely had any contact with their peers while growing up.

Strict adherence to a status hierarchy of dog breeds can also be observed in other genres of painting. Jan Brueghel the Elder (1568–1625) assigned specially bred pure-blood dogs to the elegant nobles and aristocrats in *Landscape with the Young Tobias* and the *Three Wise Men* in *The Adoration of the Kings* (both painted in 1598) but mongrels to the subordinate accompanying figures and the shepherds.[8]

Ebenso mutig waren die sogenannten Bärenbeißer, später auch Bullen-
beißer genannt (Abb. 61). Sie zählen wie die großen Doggen zu den
Molossen-Hunden, sind aber deutlich gedrungener als diese. Es gibt
zwei Hauptarten, den großen Danziger- und den kleinen Brabanter
Bärenbeißer (Kat.-Nr. 119), die in Gruppen auf Bären und Wildschweine
gehetzt wurden und diese beharrlich zur Strecke brachten.[11] Eine
treffende Charakterisierung schreibt George Franz Dietrich aus dem
Winckell 1820 in seinem *Handbuch für Jäger, Jagdberechtigte und Jagdlieb-
haber* über „die auf Bären anzuwendenden Hetzhunde":

> „Bullen- oder Bärenbeißer, eine nicht gar zu große, aber starke,
> beherzte Hunderace mit dicken, kurzen Köpfen. Sie packen Alles,
> worauf sie gehetzt werden, sind aber schwer. Man pflegt sie zu
> mäuseln, d. h. die Ohren zu verstutzen; auch die Ruthe kurz ab-
> zuschlagen. Beides geschieht, ehe sie sechs Wochen alt werden.
> Ihrer Tücke und Bosheit wegen können sie Menschen und Thieren
> leicht gefährlich werden; aus diesem Grunde ist es in mehreren
> Ländern nicht erlaubt, sich derselben zu bedienen."[12]

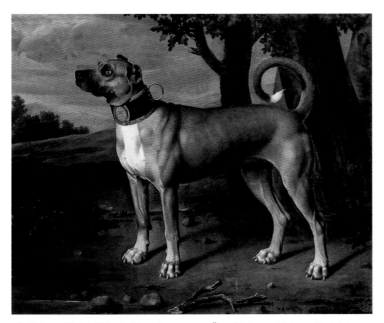

60 Johann Christof Merck, Ulmer Dogge, 1705, Öl auf Leinwand Johann Christof
Merck, *Great Dane*, 1705, oil on canvas

Hunting and herding dogs

Since the Middle Ages the privilege of hunting cloven-
hoofed game animals, including stags and boar, had
been reserved for the nobility and state and ecclesi-
astical dignitaries. The lower ranks of the clergy and,
with time, patricians were permitted to engage in the
less prestigious hunt for hares, pheasants and roe
deer. A dog was, however, always an indispensable
aid to hunting. The highest status was accorded to stag
hunting, which entailed a particularly large number
of participants and the biggest pack of dogs. Receiving
an invitation to participate in a hunting party was a
sign of princely favour and, at the same time, an ef-
fective show of ostensible power-sharing by princes
and potentates, of which the huge packs of dogs as-
sembled by all participants in a hunt can be viewed
as a major part.[9] Feeding the entire pack with the en-
trails of a slain stag was celebrated as a special ritual
that underscored the cohesion of court society. As-
signing any particular dog to an owner was unimpor-
tant since it was the community of hunters that took
priority. The upshot was that hunting scenes became
an art genre in their own right. Painters and sculptors
devoted intensive study to the appearance, size and
movements of dogs, as is vividly shown in a study of
them by Jan Brueghel the Elder in 1616 (Fig. 59).

Hunting dogs performed a wide variety of tasks:
they pursued prey either individually or in a pack,
flushed out game driving it from its lair or retrieved
shot birds, carrying them back to the hunter. Spe-
cialist dogs with various subspecies were bred for all
these tasks. In the 1781 *Hundeführer* [German guide
to dogs], it says:

> 'The hunting dog is the most developed breed.
> Its long, drooping ears, its gentle nature, amena-

Dagegen verließen sich die Jäger zum Aufstöbern des Wildes im weiten Gelände seit alters her auf die Deutsche Bracke, weswegen diese spezielle Jagdform auch Brackieren genannt wird. Mit lautem Gebell scheuchen diese Hunde – meist als Meute – Schalenwild, Hasen und Füchse auf und treiben es ausdauernd zu dessen Bau oder Sasse zurück, wo bereits der Jäger wartet. Die unterschiedlichen Töne des Gebells verraten ihm die Entfernung und Phase der Jagd. Auch für die Parforcejagd, bei der das Wild mit einer bis zu 400 Hunden umfassenden Meute und berittenen Jägern gehetzt wird, wurden gern Bracken eingesetzt (Abb. 62). Typisch ist das gefleckte Fell und die langen, hängenden Ohren, wie die Beispiele Kat.-Nr. 120–127 anschaulich zeigen, auch wenn die Umsetzung in die

61 Johann Elias Ridinger, Größere arth der Baehrenbeißer. Nr. 2., 1738, Radierung
Johann Elias Ridinger, *Large Bear-Baiter Species*, No. 2, 1738, etching

bility to instruction and reticence attest that it has been improved through selective breeding.'[10]

The collection also incorporates a representative survey of the types of hunting dog popular in the eighteenth century exemplified by a variety of dog figurines in porcelain and faience.

A large *dogue de Bordeaux* or French mastiff (Cat. No. 113) is lying down but looks as if it is alertly awaiting the next command. These powerful and courageous dogs were used in the hunt against game that did not immediately flee but defended itself fiercely, such as boar and wolves (Fig. 60).

The German bulldog, called the *Bärenbeißer*, later also known as the *Bullenbeißer*, was just as courageous. Like Great Danes, they were related to the Molossian hound but were considerably more stocky and compact in build than the latter. There are two main types, the large Danzig bear-baiter and the smaller Brabant bear-baiter (Cat. No. 119), which were set in packs on bears and boar, persisting tenaciously in the attack until they brought their prey down.[11] George Franz Dietrich aus dem Winckell wrote an apt characterisation of the 'attack dogs to be set on bears' in his *Handbuch für Jäger, Jagdberechtigte und Jagdliebhaber*' (1820):

'Bull- or bear-baiter, a not all that large but strong, stout-hearted dog breed with heavy, short heads. They grapple anything they are set on, but are also heavy. Their ears are usually cropped – that is, a good part of the outer ear is cut away; the tail is also docked. Both operations are carried out before they are six weeks old. Because of their malice and malevolence, they can easily become dangerous to human beings and animals; for this reason it is not permitted to use them in several countries.'[12]

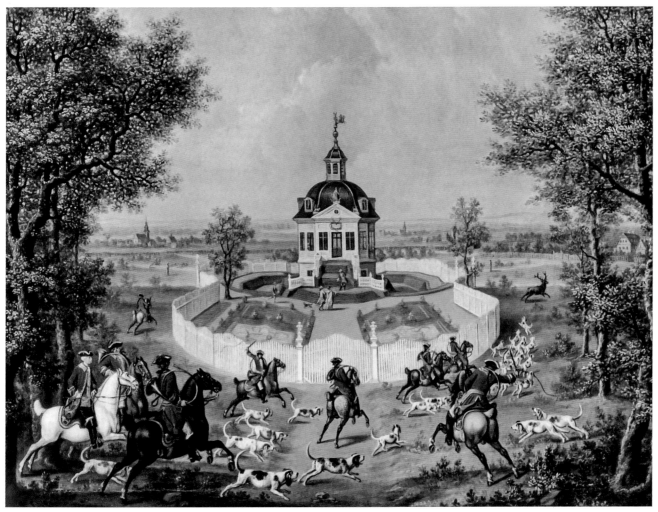

62 Georg Adam Eger, Blick auf die Dianaburg von Osten, 1765, Öl auf Leinwand Georg Adam Eger, *View of Dianaburg from the East*, 1765, oil on canvas

Keramik deutliche Abstraktionen aufweist. Ein wunderbares Beispiel einer dramatisch bewegten Jagdszene erschuf Johann Joachim Kändler etwa 1770 aus Meissner Porzellan (Abb. 63). Bewegungsabläufe, Aussehen, Körperspannung und die bewährte Strategie, den Angriff in der Gruppe zu wagen, sind äußerst naturalistisch dargestellt.

Im Gegensatz dazu eignen sich sogenannte Vorsteherhunde zum Aufstöbern und Anzeigen von Wild. Das Deutsche Kurzhaar wird als älteste Rasse in Deutschland beschrieben.[13] Mit Kraft, Ausdauer und Schnelligkeit bewegen sich diese Hunde im Gelände. Wenn sie Beute wahrgenommen haben, verharren sie erstarrt und halten die Witterung (Abb. 64). Der Jäger kann dadurch das Wild lokalisieren und ins Visier nehmen. Das in Kat.-Nr. 137 abgebildete Tier verfolgt konzentriert eine aufgenommene Fährte. Die typische Gangart mit der Nase am Boden sowie das gescheckte weiß-braune Fell wurden sehr naturgetreu dargestellt.

By contrast, hunters have since time immemorial relied on the *Deutsche Bracke*, or German hound, to track down – usually in a pack – cloven-hoofed game, hares and foxes by scent in the open field and, barking and baying loudly, to chase their prey untiringly back to its den or lair, where the hunter is already waiting. This special form of hunt goes by the French term *battue*. The different baying and barking sounds reveal to the posted hunter how far away the hunt is and what phase it has reached. These dogs were even used for the chase, where game is pursued by packs of up to 400 dogs and hunters are mounted (Fig. 62). Typical features of the German hound are its spotted, short-haired coat and long,

63 Kleine Stierhatz, Meissen, Modell J. J. Kändler, um 1770 → Kat.-Nr. 112
Small Bull-Baiting Scene. Meissen, model by J. J. Kändler, *c.*1770 → Cat. No. 112

Weiterhin gab es für das Aufstöbern und Fangen kleinerer Tiere speziell ausgebildete Rassen wie Terrier, Pinscher, Shiba Inu, Dackel und Teckel. Sie sind durch ihre kleine und wendige Statur bestens geeignet, in die engen, langen Zugänge der Behausungen von Marder, Waschbär, Marderhund, Fuchs, Dachs, Iltis und Hermelin zu gelangen. Unerschrockenheit und ein feiner Spürsinn zeichnen sie aus. Die von ihnen attackierte Beute war einerseits wegen der schönen Pelze hoch begehrt. Andererseits bedrohten einige dieser kleinen Raubtierarten das größere Wild oder töteten es sogar, weswegen sie dem Jäger und Wildhüter ein Dorn im Auge waren. Neben den Haupteinsatzgebieten sollten diese kleinen Hunde außerdem Ratten und Mäusen nachsetzen, von denen es in Schlössern, Burgen, Landsitzen und Höfen immer reichlich gab.

Gehören Pinscher und Terrier (Kat.-Nr. 128, 134, 135) zur selben Herkunft, kann man den Shiba Inu zur Gruppe der Spitze zählen. Im Gegensatz zu ersten beiden Rassen liegen die Wurzeln des Dritten in Asien. Shiba Inus (Kat.-Nr. 136, 139, 140) gehören zu den ältesten Hunderassen der Welt. Seit dem 3. Jahrhundert v. Chr. wurde diese Rasse als Jagd- und Vorstehhund in den Bergen Japans gezüchtet. Vor Jahrtausenden kamen sie vom asiatischen Festland nach Japan und gehören heute dort zu den beliebtesten Familienhunden.[14] Inzwischen wird die Rasse weltweit gern gehalten. Der Namen bedeutet „kleiner Hund" oder „Buschhund" und verweist auf seinen Einsatz als Jagdhund auf Vögel und kleines Wild im Unterholz. Den charakteristischen buschigen Schwanz, die spitzen aufrechten Ohren, den typischen Gesichtsausdruck und die hellbraun-weiße Fellfärbung haben die Meißner Porcelliner des

drooping ears, as compellingly exemplified by Cat. Nos. 120–127, even though translation into the medium of ceramics has entailed considerable abstraction. Johann Joachim Kändler created a marvellously dramatic and lively hunting scene in Meissen porcelain *c.*1770 (Fig. 63). Sequences of movement, appearance, muscle tension and the tried and tested strategy of attacking as a pack have been depicted with extreme naturalism.

The dog breeds classified as pointers, on the other hand, are suitable for scenting game and pointing – that is, indicting its presence to the hunter. The German short-haired pointer is described as Germany's oldest breed of dog.[13] Performing in the field, these dogs show strength, endurance and speed. When they have scented their prey, they stand still on the spot and point, enabling the hunter to spot the game and get it in his sights (Fig. 63). The dog shown in Cat. No. 137 is concentrating on following a scent it has caught. The typical lolloping German short-haired pointer gait with the dog keeping its nose to the ground and the brown-and-white spotted coat have been rendered with touching naturalism.

Then there were specialist dogs, such as terriers, pinschers, shiba inu, dachshunds and hunting dachshunds, bred to track down and catch smaller game. Their small size and agile habit make them ideally suited to creeping into the burrows, dens and setts of martens, raccoons in the New World, foxes, badgers, European polecats and stoats. They are known for hardiness and a fine sense of smell. The game they were bred to attack was, on the one hand, highly prized for beautiful pelts. On the other, some of these predators, although small, threatened or even killed larger game, which made them an annoyance to hunters and gamekeepers alike. Apart from their main uses, these little dogs were also expected to hunt rats and mice, which

18. Jahrhunderts treffend festgehalten, wie die Miniaturplastik in der Sammlung zeigt (Kat.-Nr. 136).

Hütehunde sollten ursprünglich durch ein ständiges Umkreisen die Herde zusammenhalten und die Bewegungen der Tiere steuern. Dazu mussten sie sehr viel laufen, also flink und ausdauernd sein, so wie z. B. der Schäferhund. Erste Berichte zur Verwendung abgerichteter Hütehunde stammen aus Italien, kurz vor Christi Geburt, nachdem die Römer einige Tiere aus Britannien mitgenommen hatten.

Parallel zu den Hütehunden gab es Herdenschutzhunde, deren Aufgabe vor allem darin bestand, Angreifer wie beispielsweise Wölfe oder Bären abzuwehren. Sie mussten stark und angriffsbereit sein. Beide Funktionen wurden durch Züchtung im Hirtenhund vereint, so in den Rassen Border Collie, Bearded Collie *oder* Australian Shepherd.

64 Johann Elias Ridinger, Vorsteherhund auf Rebhühner, 1758, Radierung Johann Elias Ridinger, *Pointer upon a Partridge*, 1758, etching

were always abundant in palaces, castles, manor houses and at courts.

Whereas pinschers and terriers (Cat. Nos. 128, 134, 135) have the same origins, the shiba inu belongs to the spitz family. Unlike the first two breeds, the shiba inu has Asian roots. The shiba inu (Cat. Nos. 136, 139, 140) is among the most ancient dog breeds in the world. Since the third century BC, these dogs have been bred in the mountainous regions of Japan as hunting and pointing dogs. Thousands of years ago they were brought from the continent of Asia to Japan, where they are the most popular family dogs.[14] By now this breed is popular worldwide. Its name means 'small dog' or 'brushwood dog' and indicates its use as a dog to hunt birds and small game in underbrush. Eighteenth-century Meissen porcelain workers have deftly captured the dog's characteristic bushy tail, its alert pointed ears, typical facial expression and light brown-and-white coat, as the figurine in the Collection shows (Cat. No. 136).

Herding or shepherd dogs were originally expected to keep a herd together by constantly circling it and to guide the movement of the animals in it. To perform these tasks they had to run a great deal, which meant they had to be both quick and persistent, traits that distinguish the German shepherd, or Alsatian, for instance. The earliest reports of using trained herding dogs are Roman after some dogs of this kind had been introduced to Italy from the province of Britannia in the late first century BC.

Along with herding dogs there were herd guard dogs, whose duty consisted chiefly in warding off attackers such as wolves or bears. These dogs had to be strong and aggressive. Both traits were united by selective breeding in herding dogs such as the border collie, the bearded collie and the Australian shepherd. The first to write on the use of border

Die ersten Überlieferungen zum Einsatz der Border Collies stammten von John Caius (1510–1573), Leibarzt der Königin Elisabeth I. (1533–1603), festgehalten im Buch *Of Englishe Dogges* aus dem Jahre 1576.[15] Caius schreibt über Border Collies:

> „Sobald dieser Hund die Stimme seines Herrn oder das Schütteln seiner Faust wahrnimmt, bringet er die umher irrenden Schafe an eben jenen Ort, den sein Meister wünscht, so dass der Schäfer mit nur wenig Arbeit und Mühe, ohne Beanspruchung seiner Füße, seine Herde beherrschen und leiten kann ... ob sie nun vorwärts gehen, still stehen oder sich zurückziehen soll, oder hierhin abbiegen, oder jenen Weg nehmen."[16]

Ein Border Collie ist auch in dem gespannt auf das nächste Kommando des Schäfers wartenden Hund von Kändler zu sehen (Abb. 65). Er gehörte ursprünglich zu einer Schafherde.[17] Das lange Fell, die aufmerksamen spitzen Ohren und die markante schlanke Schnauze lassen eine eindeutige Identifizierung zu.

collies was John Caius (1510–1573), physician to Elizabeth I (1533–1603), in *Of Englishe Dogges: The Diuersities, the Names, the Natures, and the Properties* (1576).[15] Caius writes as follows on border collies:

> 'This dogge either at the hearing of his masters voyce, or at the wagging and whisteling in his fist [...] bringeth the wandring weathers and straying sheepe, into the selfe same place where his masters will and wishe [...] wherby the shepherd reapeth this benefite, namely, that with little labour and no toyle or mouing of his feete he may rule and guide his flocke [...] either to haue them go forward, or to stand still, or to drawe backward, or to turne this way, or to take that way.'[16]

One Kändler model of a dog attentively awaiting instructions from a shepherd represents a border collie (Fig. 65). The figurine originally belonged to a herd of china sheep.[17] The dog's long, rough coat, its ears pricked to catch the shepherd's words and the distinctive slender muzzle make possible instant identification of the breed this model depicts.

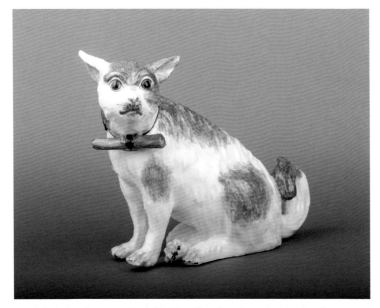

65 Schäferhund, Meissen, Modell J. J. Kändler oder P. Reinicke, März/April 1747
→ Kat.-Nr. 146 *Sheepdog*, model by J. J. Kändler or P. Reinicke, March/April 1747
→ Cat. No. 146

Dog racing, animal baiting and lapdogs

Apart from hunting, the nobility and aristocracy indulged in a variety of other pleasurable pursuits, in which dogs again played an important role. As early as the sixteenth century, courses were laid out for dog racing. Greyhounds were the breed that usually raced down such tracks, and they were also used in hunting. In the 1781 *Ausführliche Geschichte der Hunde*, the comment on greyhounds is admiring:

Hunderennen, Tierkämpfe und Schoßhunde

Außer der Jagd frönte der Adel verschiedenen anderen Vergnügungen, bei denen ebenfalls Hunde eine wichtige Rolle spielten. Bereits im 16. Jahrhundert wurden Bahnen gebaut, auf denen Hunderennen stattfanden. Insbesondere die Windhund-Rassen sprinteten die Parcours entlang, wurden aber auch zur Jagd eingesetzt. In der Ausführlichen Geschichte der Hunde von 1781 heißt es bewundernd über Windhunde:

> „Ihre Stärke und Kräfte beruhen auf ihrem langen Wuchs und der geschmeidiger Schnelligkeit … In Curland sind sie größer als die Doggen, und man hetzt mit ihnen Bären und Elendthiere [Elchwild].“[18]

Prädestiniert war der hochbeinige, schlanke Greyhound, der bereits im alten Ägypten verehrt und auf Grabreliefs verewigt wurde. Direkte Vorfahren sind jedoch eher im keltischen Raum zu suchen, ehe sich die Rasse ab dem 4. Jahrhundert in Großbritannien etablierte.

Zielte die Zucht anfänglich auf die Hasenjagd ab, sprach die enorme Schnelligkeit der Tiere seit der Neuzeit für den Einsatz bei Wettrennen. Auf den neu entwickelten Bahnen des 16. Jahrhunderts konnten die Greyhounds mit bis zu 70 km/h die Zuschauer begeistern.[19] Die Schönheit dieser Hunde ließen Herrscher wie Friedrich II. von Preußen (1712–1786) und Louis XV. (1710–1774), König von Frankreich und Navarra, zu Liebhabern der Windspiele werden. Die beiden grazilen Lieblingshunde des Letztgenannten, *Misse* und *Turlu*, verewigte Jean Baptiste Oudry (1696–1755) in einem Gemälde (Abb. 66). Nicht nur von Malern, sondern auch von geschickten Modelleuren der Berliner KPM-Manufaktur und Meissener Porzellanfabrique wurden sie als Kleinplastiken naturalistisch nachgebildet (Kat.-Nr. 152, 154, 155). Die Berliner Dose in Form eines Greyhound-Kopfes zeigt alle charakteristischen Merkmale mit der langen, schlanken Schnauze, den markanten Kieferknochen sowie den wachen, treuen Augen.

Neben den Laufduellen erfreuten sich Tierkämpfe seit der Antike großer Beliebtheit. Dazu gehörte das „Bullenbeißen“, wozu spezielle Hunde gezüchtet wurden, die zäh, unerschrocken und kraftvoll waren:

'Their strength and prowess rest in their long build and sinuous fleetness. [...] In Courland they are larger than Great Danes, and they are used to bait bear and elk.'[18] The slender, long-legged greyhound, which was venerated in ancient Egypt and immortalised in tomb reliefs there, was predestined to perform such tasks. Its direct ancestors, however, probably came from Celtic lands before the breed became established in Great Britain in the fourth century.

Greyhounds were originally bred as coursers to hunt hares, but the enormous speeds they could reach also ensured that these dogs have been raced since the early modern age. Greyhounds enthused sixteenth-century audiences on the newly developed race courses by clocking speeds of up to 70 kph (44 mph).[19] The beauty of these sleek dogs turned monarchs such as Frederick II (the Great) of Prussia (1712–1786) and Louis XV (1710–1774), King of France and Navarre, into aficionados of whippets and greyhounds. The French king's two graceful favourite dogs, Misse and Turlu, were immortalised by Jean Baptiste Oudry (1686–1755) in a painting (Fig. 66). Not only did greyhounds feature in paintings, they were also naturalistically depicted as figurines by skilled modellers at the Berlin KPM Factory and the Meissen Porcelain Manufactory (Cat. Nos. 152, 154, 155). A Berlin pillbox or comfit box formed as a greyhound head displays all the characteristic features of the breed: the long, thin muzzle, the strong cheekbones and alert but soulful eyes.

Along with dog racing, animal fighting has been popular since antiquity. Blood sports included 'bull-baiting', with dogs bred specially for the purpose to be tenacious, bold and powerful: old English bulldogs (Fig. 68, Cat. Nos. 115, 116). These dogs were expected to bite a tied-up bull in the nose until it sank to the

66 Jean Baptiste Oudry, Misse und Turlu, Zwei Greyhounds von Louis XV., Öl auf Leinwand Jean Baptiste Oudry, *Misse and Turlu, Two Greyhounds Belonging to Louis XV*, oil on canvas

die Englischen Bulldoggen (Abb. 68, Kat.-Nr. 115, 116). Die Hunde hatten die Aufgabe, angebundenen Bullen so lange in die Nase zu beißen, bis diese zu Boden gingen. Da sich die körperlich überlegenen und attackierten Rinder wehrten, entstand ein Kampf, der als Volksbelustigung über Jahrhunderte gängig war. Im London des 16. und 17. Jahrhunderts gab es sorgar zwei getrennte Arenen, eine für das Bullenbeißen, die andere für das Bezwingen von Bären durch diese speziell gezüchtete Hunderasse (Abb. 67, 68). Zu diesen Hunden mit den starken Muskeln, der dicken, kurzen Schnauze und der stumpfen Nase erfährt man aus der Literatur des 18. Jahrhunderts:

> „Bullenbeißer, Wachhund, Bärenhund auch Schweißhund genannt ... stammt vom Hirtenhund in seitwärtser Linie rechter Hand ab ... Wenn sie frey herumlaufen, sind sie zahm und gutherzig, an Ketten gelegt, werden sie furchtbar, sie fallen Menschen an und reißen sie nieder.“[20]

ground. Since the bulls were physically superior to the dogs baiting them, the fight between them was a popular form of public entertainment for centuries (Figs. 67, 68). Eighteenth-century publications describe these dogs, which were very muscular, had stout, short muzzles and blunt noses, as follows:

> 'Bull-baiter, guard dog, bear dog, also called sweat dog [...], descends by cross-breeding in the paternal line from herding dogs. [...] When they are left free to roam, they are placid and docile, but once chained up, they become terrible; they attack people and bear them to the ground.'[20]

Blood-sport events entailing bull-baiting were not forbidden in England until 1835. From then on the old

Erst 1835 wurden die martialischen Veranstaltungen des Bullenbeißens verboten. Fortan wurde diese Rasse kaum noch gezüchtet und wäre fast ausgestorben. Spätere Nachzüchtungen sind wesentlich sanfter und weniger gedrungen.[21]

English bulldog was so rarely bred that it almost died out. Dogs bred later are considerably more gentle and less compact in build.[21]

> 'The bull-baiter, when it was brought to Denmark from England, changed into the small Danish dog. [...] Changes can be ascribed solely to the climate, good care, the effect of feed and careful training.'[22]

In the eighteenth century the small Danish dog was trained differently from its ancestors. It was not used in blood sports but instead captured the hearts of elegant ladies as a companion animal, particularly because of its large, soulful eyes.[23] Many ceramic dog figurines – notably from the Meissen Porcelain Manufactory – bear witness to this trend (Cat. Nos. 141, 142, 144, 145, 147–149). In his *Ausführliche Geschichte der Hunde* (1781), Johann Georg Friedrich Franz points out its large eyes and pointed muzzle. He goes on to add: '

> They are usually black and white spotted in appearance. If they are flecked in this way, they are generally called harlequin because of their piebald coat. The latter are often sent to Germany and France from Denmark, just as Danish ladies are devoted to Bolognese, Spanish and English dogs for pleasure and send for them.'[24]

Along with these ladies' companions, showy porcelain dog figurines entered salons and boudoirs. The large Meissen group in the collection is, unsurprisingly, worked out in noticeably exquisite detail and is also mounted on bronze-gilt cushions (Cat. Nos. 147–149). Here Johann Joachim Kändler has demonstrated his consummate mastery of his craft in his own inimitable way.

67 Bullen- und Bärenbeißer Arenen auf einer Karte von London (die Hunde kommen aus den seitlichen Zwingern), Agas Map of London, Holzschnitt, 1560 Bull- and bear-baiting arenas shown on a map of London (the dogs are coming out of pens to each side), Agas Map of London, woodcut, 1560

68 Francis Barlow 1626–1704, A bull and a bulldog are about to attack each other. „Bull-baiting" scene, 17. Jahrhundert, Holzschnitt Francis Barlow (1626–1704), *A Bull and a Bulldog about to Attack Each Other*, 'bull-baiting' scene, seventeenth century, woodcut

„Der Bullenbeißer, als er von England nach Dänemark gebracht worden, verwandelte sich in den Kleinen dänische Hund ...Änderungen sind bloß dem Einfluß des Himmelstrichs, der guten Wartung, der Wirkung des Futters und einer sorgfältigen Abrichtung zuzuschreiben."[22]

Im Gegensatz zur Ausrichtung seiner Vorfahren wurde der Kleine Dänische Hund im 18. Jahrhundert nicht zu blutigen Kämpfen eingesetzt, sondern begeisterte vornehme Frauen als Gesellschafts- oder Schoßhund, vor allem wegen seiner großen, treuen Augen.[23] Viele keramische Hundeplastiken – besonders aus der Meißener Porzellanmanufaktur – zeugen davon (Kat.-Nr. 141, 142, 144, 145, 147–149). In seiner Ausführlichen Geschichte der Hunde verweist Johann Georg Friedrich Franz 1781 auf die großen Augen und die spitze Schnauze. Weiterhin heißt es:

From the Early Renaissance to the Rococo era, small white Bolognese were popular as companion dogs in court society and with influential patrician families. Their history, however, goes back to classical antiquity, when they spread throughout the Mediterranean countries.[25] In Bologna breeding was stepped up, and these cheerful companion dogs with their fluffy coats became highly prized as presents to express reciprocal esteem, especially at the Medici, Borgia and d'Este courts. Clarissa Strozzi (1540–1581) from the powerful patrician Medici family was one Italian noblewoman who owned a little Bolognese, which was portrayed with her by Titian (c.1485/90–1576) when she was a two-year-old child in Venice (Fig. 69).[26] This painting is one of the most beautiful Renaissance children's portraits, which entranced contemporaries with its naturalness and intimacy.[27] Titian's thematic focus was on the loving relationship between a child and her dog.

Philip II of Spain (1527–1598) was given two Bolognese by the Duke of Este and appreciated them as a truly royal present. Other painters besides Titian who immortalised Bolognese in paintings and prints include Anthony van Dyck (1599–1641) and Francisco de Goya (1746–1828). Bolognese feature in royal portraits throughout Europe, revealing that Catherine the Great of Russia (1729–1796) and Maria Theresia (1717–1780), Archduchess of Austria and Queen of Hungary and Bohemia, as well as Madame de Pompadour (1721–1764), duchesse de Menars and mistress of Louis XV, were all proud owners of these little white dogs with coats like silky cotton wool. Although their main function was to serve as companions and lapdogs, these little creatures are agile and sturdy and made themselves useful by hunting rats and mice.[28]

The popularity of the breed in the mid-eighteenth century is also attested by recreations in porcelain (Fig. 70 and Cat. No. 150).

„Meistens erscheinen sie schwarz und weiß gefleckt. Sind sie auf diese Art gesprenkelt, so pflegt man sie wegen ihres schäckigen Felles, Harlekine zu nennen. Diese letztern werden aus Dänemark häufig nach Deutschland und Frankreich verschickt, so wie die dänischen Frauenzimmer zu ihren Vergnügen bologneser, spanische und englische Hunde sich verschreiben und kommen lassen."[24]

Neben den Begleiterinnen der Damen hielten repräsentative Porzellanhunde Einzug in die Salons und Boudoirs. So ist die große Meissener Gruppe in der Sammlung ausgesprochen fein und detailliert gearbeitet und zusätzlich auf vergoldete Bronzekissen montiert (Kat.-Nr. 147–149). In besonderer Weise zeigt sich hier die Meisterschaft des Modelleurs Johann Joachim Kändler.

In der höfischen Gesellschaft wie bei einflussreichen Bürgerfamilien waren die kleinen weißen Bologneserhunde von der Frührenaissance bis zum Rokoko beliebt. Ihre Geschichte geht jedoch bis ins klassische Altertum zurück, wo sie in allen Mittelmeerländern verbreitet waren.[25] In Bologna intensivierte sich die Zucht, und die fröhlichen Gesellschaftshunde mit dem flauschigen Fell wurden hochgeschätzte Geschenke, die insbesondere an den Höfen der Medici, Borgia und d'Este gegenseitige Wertschätzung ausdrückten. Die aus dem mächtigen Florentiner Patriziergeschlecht der Medici stammende Clarissa Strozzi (1540–1581) hatte beispielsweise ein Bologneserhündchen, mit dem sie von Tizian (um 1485/90–1576) als zweijähriges Kind in Venedig porträtiert wurde (Abb. 69).[26] Mit diesem Gemälde entstand eines der schönsten Kinderbildnisse der Renaissance, das schon Zeitgenossen wegen seiner Natürlichkeit, Privat- und Ungezwungenheit beeindruckte.[27] Die innigliche Beziehung zwischen Kind und Hund fokussierte Tizian und erhob sie somit zum Bildthema.

Philipp II., König von Spanien (1556–1598), erhielt vom Herzog d'Este zwei Bologneser, die er als königliches Geschenk würdigte. Neben Tizian verewigten Anthonis van Dyck (1599–1641) und Francisco de Goya (1746–1828) Bologneserhunde in Gemälden und Grafiken. Herrscherporträts quer durch Europa zeigen sie und weisen sowohl die russische Kaiserin Katharina die Große (1729–1796) und Maria Theresia (1717–1780), Erzherzogin von Österreich sowie Königin von Ungarn und Böhmen, als auch die Herzogin von Menars und Mätresse Ludwig XV., Marquise

70 Bologneser Hund, Meissen, Modell J. J. Kändler, um 1775
A Bolognese, Meissen, *c.*1775, model by J. J. Kändler, porcelain

Dog collars

Apart from the various breeds of dogs, the accessories made for them are also interesting cultural artefacts. The first verifiable example is a painting in Egypt, dating from about 3500 BC, of a man with a dog on a lead, which is fastened to a collar. Collars have special historical status. On the one hand, when equipped with massive iron spikes and studs they protected their wearers from wolves and other wild animals. On the other, dog collars were decorated to advertise a dog's close relationship to its owner. Dog-collar decoration might include family coats of arms, initials or a motto. Even an illusion to a lady's confidante or best friend was commonly encountered on dog collars, as portraits with the faithful quadrupeds attest. Collars worn by companion animals were often colour-coordinated with their owners' dresses or matched their lace collars and cuffs to flaunt reciprocal attachment and demonstrate how highly prized the pets were, as demonstrated in a portrait of Henriette Marie von Brandenburg-Schwedt

de Pompadour (1721–1764), als stolze Besitzerinnen dieser wollig-weißen Hunde aus. Neben der Hauptfunktion als Gesellschaftshund machten sich die flinken und robusten Hunde bei der Jagd auf Mäuse und Ratten nützlich.[28]

Auch Darstellungen dieser Rasse in Porzellan zeugen von ihrer Beliebtheit um die Mitte des 18. Jahrhunderts (Abb. 70 und Kat.-Nr. 150).

Halsbänder

Kulturgeschichtlich interessant sind neben den Hunderassenzüchtungen die Accessoires. Das erste Mal nachweisbar ist etwa 3500 v. Chr. eine Malerei aus Ägypten, die einen Mann mit einem Hund an der Leine zeigt. Diese ist an einem Halsband befestigt. Halsbänder haben einen besonderen Stellenwert. Einerseits dienten sie den Hunden als Schutz vor Wölfen und anderen wilden Tieren, indem sie mit massiven Eisenstacheln an der Außenseite ausgestattet waren. Andererseits trugen sie Verzierungen, die die enge Verbindung zum/r Besitzer/in sichtbar machten. Dies konnten Familienwappen, Initialen oder ein Spruch sein. Auch ein Hinweis auf die vertraute Freundin war im 18. Jahrhundert üblich, wie Porträts mit den treuen Vierbeinern zeigen. Oftmals war das Halsband des Gesellschaftshundes im Farbton oder Spitzenbesatz auf die Robe der Besitzerin abgestimmt, so dass die Zusammengehörigkeit und Wertschätzung deutlich gezeigt wurden, so beispielsweise im Bildnis von Henriette Marie von Brandenburg-Schwedt (Abb. 3, 71). Beliebt waren natürlich auch Verzierungen mit Ornamenten und Edelsteinen sowie angehängte goldene Schellen oder Schlösser, die die Symbolik der Treue betonen sollten (Abb. 60). Einen einmaligen Überblick über Halsbänder seit dem Mittelalter bietet *The Dog Collar Museum* im Leeds Castle in der englischen Grafschaft Kent.

Ein besonderes Halsband zeigt die Darstellungen eines Hütehundes, entstanden 1747 in Meissen (Abb. 65, Kat.-Nr. 146). Johann Joachim Kändler fertigte dieses Hundemodell laut seinen Arbeitsberichten für die Brühl'sche Tafeldekoration einer „Fontaine" mit einer umfangreichen Schafherde und bezeichnete ihn als Schäfer-Hund.[29] Einerseits spricht die dargestellte Rasse eines Border Collis für diese Arbeitsfunktion des Hundes. Andererseits lässt das Halsband interessante

(Figs. 3, 71). Of course decorations with ornaments and gemstones as well as little golden bells or padlocks attached that pointedly symbolised fidelity were also popular (Fig. 60). The Dog Collar Museum in Leeds Castle in Kent provides a unique survey of dog collars from the Middle Ages to the present day.

A special kind of collar is sported by a herding dog figurine made in Meissen in 1747 (Fig. 65, Cat. No. 146). According to his Works Logs, Johann Joachim Kändler made this dog model for the Brühl table decoration, which consisted of a 'fountain' with a large herd of china sheep, and called it a 'shepherd dog'.[29] On the one hand, the breed recognisably represented here, a border collie, argues for this working function. On the other, the collar permits interesting conclusions to be drawn about the age of this particular dog: it must be a young dog that is still in training.

The animal has a horizontally placed wooden rod in its collar beneath its head, making this collar what is known as a toggle collar. This was used on young dogs while they were in training to prepare them for herding tasks and curtail their urge to bolt and run after wild animals. If a dog ran too quickly around his herd or wanted to chase wild animals, the rod would smack its lower jaw and legs smartly, which hurt and taught it a lesson. As soon as a dog showed that it had mastered the tasks needed in its working life and behaved more circumspectly, the toggle was superfluous. This method was very widespread down through sheep-herding history. Nowadays, however, toggle collars are, as far as is known, only used in the Balkan countries.[30]

Rückschlüsse zu, dass es sich hier um einen jungen, in der Ausbildung befindlichen Hund handeln muss.

Das Tier hat unterhalb seines Kopfes im Halsband einen horizontal ausgerichteten Holzstab, ein sogenanntes Knebelhalsband. Dieses wurde eingesetzt, um junge Hunde in der Zeit der Abrichtung auf ihre Hüteaufgaben vorzubereiten und in ihrem Laufdrang zu drosseln. Rennt der Hund zu schnell um die Herde oder möchte Wildtieren nachstellen, schlägt der Stock an Unterkiefer und Beine, was unangenehm schmerzt. Sobald der Hütehund seiner Aufgabe gewachsen ist und sich ruhiger bewegt, ist der Knebel überflüssig. In der Geschichte der Schäferei war diese Methode sehr verbreitet. Heute werden diese Halsbänder nur noch in Balkanstaaten eingesetzt.[30]

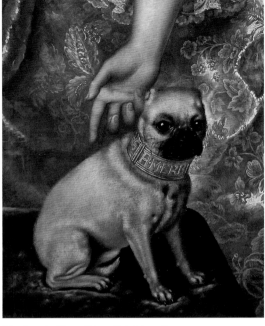

71 Ausschnitt aus Abb. 3 Detail from Fig. 3

1 Wegmann/Schmitz 2016, S. 6.
2 ebd.
3 ebd., S. 10.
4 Teuscher 1998, S. 347–369.
5 ebd., S. 360–361.
6 Treue Freunde 2019, S. 44–46.
7 ebd., S. 42.
8 ebd., S. 143.
9 Teuscher 1998, S. 362–366.
10 Franz 1781, S. 64.
11 Fleming 1749, S. 170–171.
12 Winckell 1858, S. 188.
13 Wegmann/Schmitz 2016, S. 184.
14 ebd., 2016, S. 81.
15 Caius 1570.
16 ebd., S. 24: „This dogge either at the hearing of his masters voice, or at the wagging and whisteling in his fist ... bringeth the wandring weathers and straying sheepe, into the selfe same place where his masters will and wishe ... wherby the shepherd reapeth this benefite, namely, that with little labour and no toyle or moving of his feete he may rule and guide his flocke ... either to have them go forward, or to stand still, or to drawe backward, or to turne this way or to take that way."
17 Möller 2006, Kat.-Nr. 22.
18 Franz 1781, S. 70. Kurland war von 1561 bis 1795 ein eigenständiger Staat im Baltikum. Das Gebiet gehört heute zu Lettland.
19 ebd., S. 231.
20 ebd., S. 84.
21 Wegmann/Schmitz 2016, S. 84.
22 Franz 1781, S. 66.
23 Bertuch/Kraus 1789, S. 281.
24 Franz 1781, S. 82–83.
25 Wegmann/Schmitz 2016, S. 40.
26 Die Eltern waren Roberto Strozzi (1520–1566) und Maddalena de' Medici (1522–1583).
27 Gersdorff 1986, S. 110.
28 Wegmann/Schmitz 2016, S. 40.
29 Möller 2006, Kat.-Nr. 22.
30 Für die Informationen zur Verwendung des Knebelhalsbandes danke ich herzlich Frank Hahnel vom Bundesverband der Berufsschäfer in Berlin-Brandenburg.

1 Wegmann/Schmitz 2016, p. 6.
2 Ibid.
3 Ibid., p. 10.
4 Teuscher 1998, pp. 347–369.
5 Ibid., pp. 360–361.
6 Treue Freunde 2019, pp. 44–46.
7 Ibid., p. 42.
8 Ibid., p. 143.
9 Teuscher 1998, pp. 362–366.
10 Franz 1781, p. 64.
11 Fleming 1749, p. 170–171.
12 Winckell 1858, p. 188.
13 Wegmann/Schmitz 2016, p. 184.
14 Ibid., p. 81.
15 Caius 1576; Caius 1570.
16 Caius 1576, p. 24; Caius 1570, p. 93.
17 Möller 2006, Cat. No. 22.
18 Franz 1781, p. 70. Courland was an autonomous Baltic country from 1561 to 1795. The region is now part of Latvia.
19 Ibid., p. 231.
20 Ibid., p. 84.
21 Wegmann/Schmitz 2016, p. 84.
22 Franz 1781, p. 66.
23 Bertuch/Kraus 1789, p. 281.
24 Franz 1781, pp. 82–83.
25 Wegmann/Schmitz 2016, p. 40.
26 Her parents were Roberto Strozzi (1520–1566) and Maddalena de' Medici (1522–1583).
27 Gersdorff 1986, p. 110.
28 Wegmann/Schmitz 2016, p. 40.
29 Möller 2006, Cat. No. 22.
30 I am indebted to Frank Hahnel of the Bundesverband der Berufsschäfer in Berlin-Brandenburg for the information on the use of the toggle collar.

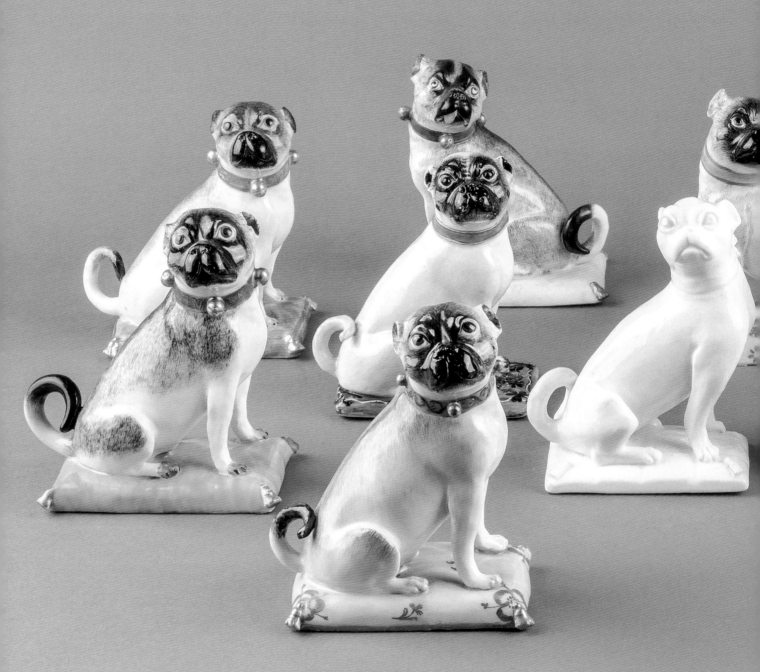

Sammlungskatalog

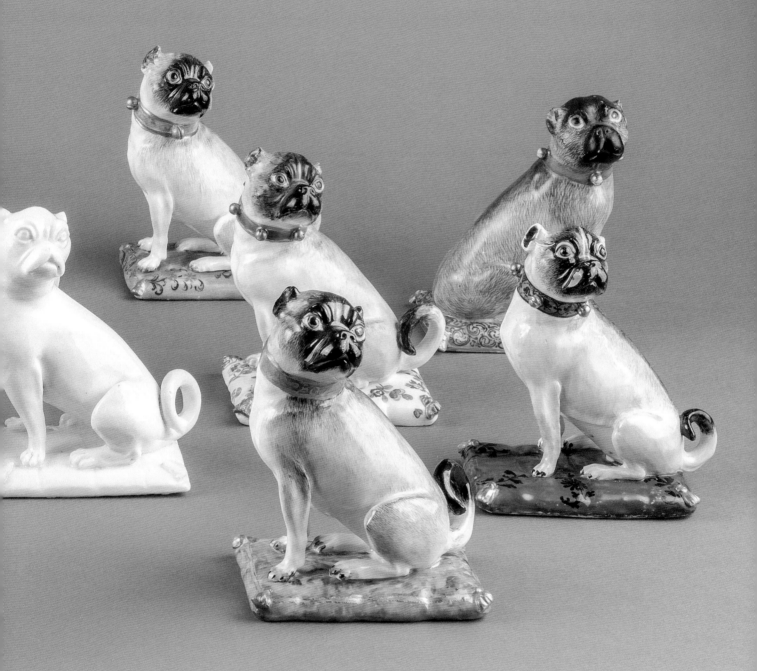

Catalogue to the Collection

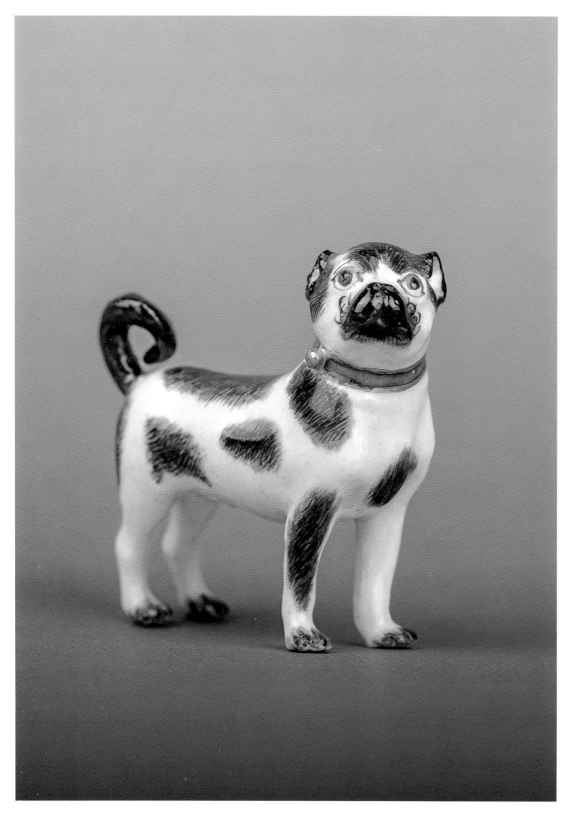

1 Stehende Möpsin

Meissen, um 1750
Modell: Johann Joachim Kändler
oder Peter Reinicke
Porzellan, polychrome Bemalung
in Aufglasurtechnik, Goldmalerei
Signatur/Marke: keine
5 × 5,5 × 2,5 cm, 34 g
Inv.-Nr. A 548
Literatur: Arbeitsbericht J. J. Känd-
ler, Mai 1734: „Erstlich 9 Stück
kleine Mopshunde, ein jeder hatte
eine andere Action"; Arbeitsbericht
P. Reinicke, November 1744: „1 klein
stehend Mopß Hündgen in thon
bossirt" (Pietsch 2002); Rückert
1966, S. 195 f., S. 268 f.; Kunze-
Köllensperger 1999, S. 48 f.; Kunze-
Köllensperger 2008, S. 82 f; Treue
Freunde 2019, S. 214/215; Porcelain
Pugs: A Passion 2019, S. 158–171.

Stehende Möpsin, nach rechts
schauend, helles Fell mit schwarz-
braunen Flecken, blaues Halsband
mit purpurfarbener Schleife und
goldener Schelle, flache, trichter-
förmige Ohren, geringelte Rute;
Brennloch unterm Schwanz.

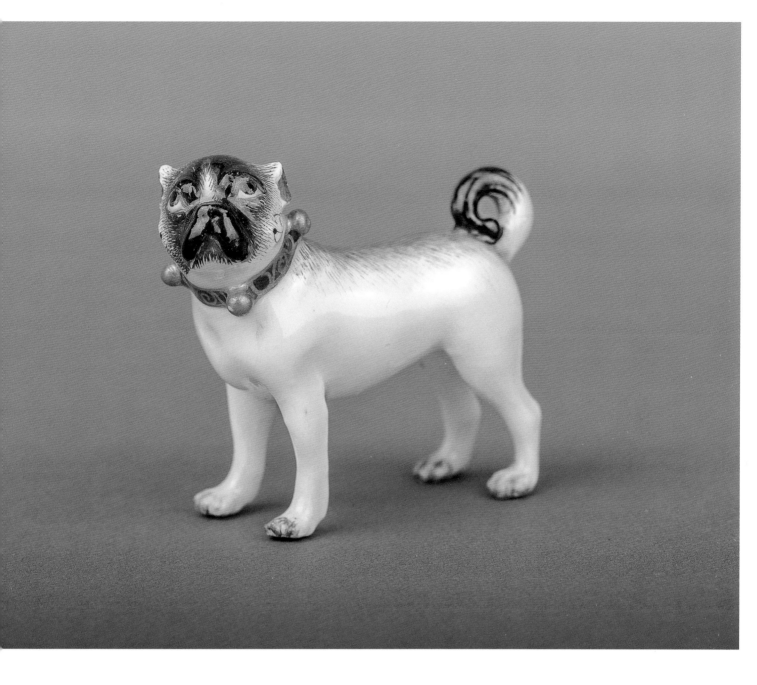

2 Stehender Mops

Meissen, 18. Jahrhundert
Porzellan, polychrome Bemalung
in Aufglasurtechnik, Goldmalerei
Signatur/Marke: keine
4,7 × 5,3 × 2,3 cm, 29 g
Inv.-Nr. A 557
Literatur: s. Kat.-Nr. 1

Stehender Mops, nach links
schauend, hellgrau-braunes Fell,
purpurfarbenes Halsband mit
goldenen Ranken, blauer Schleife
und goldenen Schellen, flache,
trichterförmige Ohren, geringelte
Rute; Brennloch unterm Schwanz.

3 Stehender Mops

Meissen, 18. Jahrhundert
Porzellan, polychrome Bemalung
in Aufglasurtechnik, Goldmalerei
Signatur/Marke: Schwerter in Blau
4,3 × 5 × 2,5 cm, 23 g
Inv.-Nr. A 550
Literatur: s. Kat.-Nr. 1

Stehender Mops auf grün staffier-
tem Terrainsockel, nach rechts
schauend, hellbraun-graues Fell,
blaues Halsband mit blauer Schleife,
flache, trichterförmige Ohren,
geringelte Rute; unglasierter Boden
mit Brennloch, Standhilfe unterm
Bauch.

4 Stehende Möpsin

Meissen, 18. Jahrhundert
Porzellan, polychrome Bemalung
in Aufglasurtechnik, Goldmalerei
Signatur/Marke: keine
4 × 5,3 × 2 cm, 23 g
Inv.-Nr. A 551
Literatur: s. Kat.-Nr. 1

Stehende Möpsin auf grün staffier-
tem Terrainsockel, nach links
schauend, hellbraun-graues Fell,
türkisgrünes Halsband mit gelber
Schleife, flache, trichterförmige
Ohren, geringelte Rute; unglasier-
ter Boden mit Brennloch, Stand-
hilfe unterm Bauch.

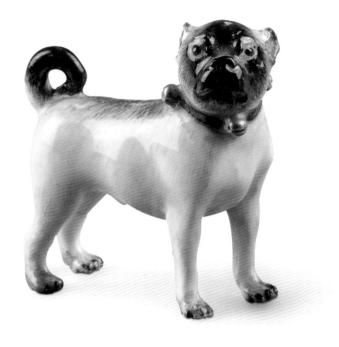

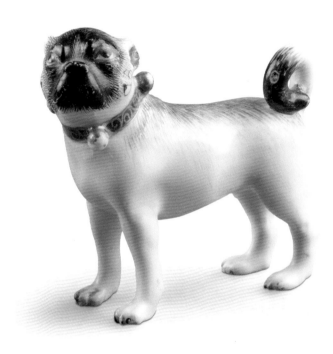

5 Stehende Möpsin

Meissen, 18. Jahrhundert
Porzellan, polychrome Bemalung
in Aufglasurtechnik, Goldmalerei
Signatur/Marke: keine
5 × 5 × 2 cm, 26 g
Inv.-Nr. A 552
Literatur: s. Kat.-Nr. 1

Stehende Möpsin, nach rechts
schauend, hellbrau-graues Fell,
blaues Halsband mit blauer
Schleife und goldenen Schellen,
flache, trichterförmige Ohren,
geringelte Rute; Brennloch
unterm Schwanz.

6 Stehender Mops

Meissen, 18. Jahrhundert
Porzellan, polychrome Bemalung
in Aufglasurtechnik, Goldmalerei
Signatur/Marke: keine
4,8 × 5 × 2 cm, 24 g
Inv.-Nr. A 553
Literatur: s. Kat.-Nr. 1

Stehender Mops, nach links schau-
end, hellgraues Fell, purpurfarbe-
nes Halsband mit goldenen Ran-
ken, blauer Schleife und goldenen
Schellen, flache, trichterförmige
Ohren, geringelte Rute; Brennloch
unterm Schwanz.

7 Stehender Mops auf Terrainsockel

wohl Straßburg, um 1760
Modell: wohl Johann Wilhelm Lanz
Porzellan, polychrome Bemalung
in Aufglasurtechnik
Signatur/Marke: keine
7 × 6 × 3,5 cm, 75 g
Inv.-Nr. A 620
Literatur: s. Kat.-Nr. 1

Stehender Mops, mit geöffnetem
Maul nach rechts schauend, hell-
braune Fellzeichnung, blaues
Halsband, flache, trichterförmige
Ohren, geringelte Rute, Terrain-
sockel mit Baumstupf unter dem
Bauch; unglasierter Boden.

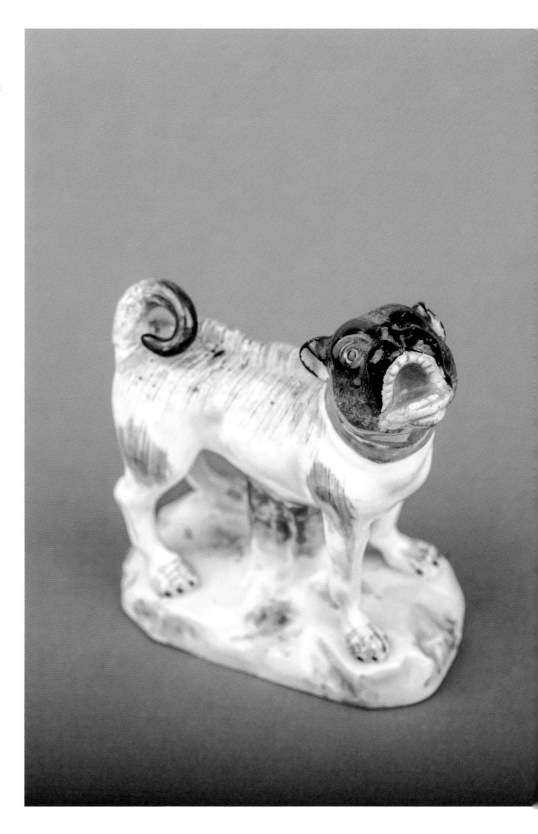

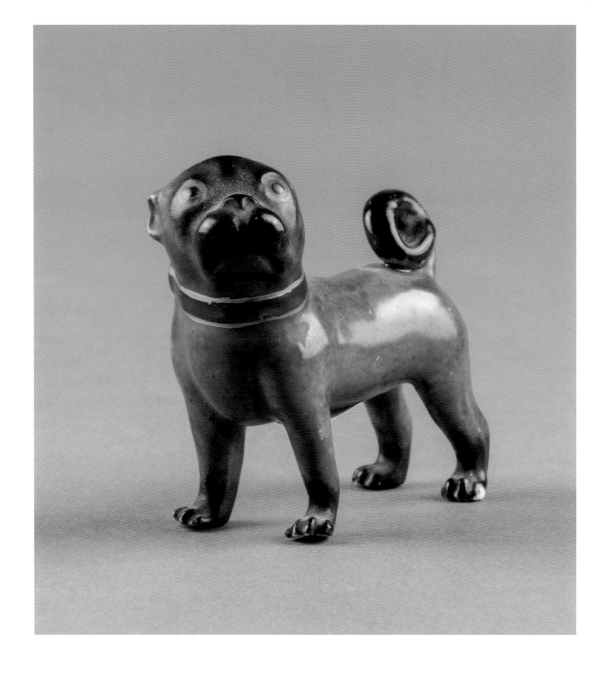

8 Stehender, blauer Mops

Meissen, 18. Jahrhundert
Porzellan, schwarze Bemalung in
Aufglasurtechnik, Goldmalerei
Signatur/Marke: „52" in Rot
5 × 5,5 × 2,5 cm, 43 g
Inv.-Nr. A 617
Literatur: s. Kat.-Nr. 1

Stehender Mops, nach links oben
schauend, blaues Fell mit schwar-
zen Partien, orange Augenzeich-
nung, blau-goldenes Halsband,
flache, trichterförmige Ohren,
geringelte Rute.

9 Sitzender Mops auf purpurfarbenem Kissen

Meissen, 1745–1750
Modell: Johann Joachim Kändler
Porzellan, polychrome Bemalung
in Aufglasurtechnik, Goldmalerei
Signatur/Marke: Schwerter in Blau
11,3 × 9 × 5 cm, 296 g
Inv.-Nr. A 542
Literatur: s. Kat.-Nr. 1

Sitzender Mops auf rechteckigem,
als purpurfarbenes Kissen mit
Rankenornamentik staffiertem
Sockel, Kopf nach rechts gewandt,
beiges Fell mit schwarzen Partien,
blaues Halsband mit roter Schleife,
flache, trichterförmige Ohren,
geringelte Rute; unglasierter
Boden.

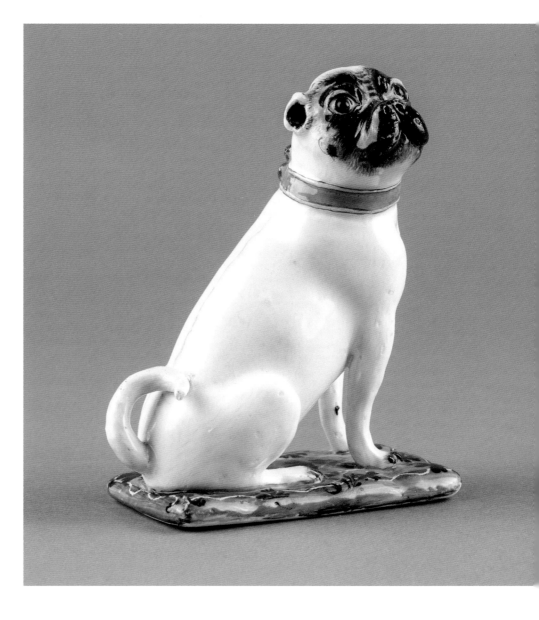

10 Sitzender Mops auf Kissen

Meissen, 1742–1750
Porzellan, unbemalt
Signatur/Marke: keine
11,5 × 9,5 × 5,3 cm, 297 g
Inv.-Nr. A 521
Literatur: Rückert 1966, S. 269,
Nr. 1093.

Sitzender Mops auf flacher, als
Kissen gestalteter, unbemalter
Plinthe, Kopf nach rechts gewandt,
große Augen, flache, trichter-
förmige Ohren, geringelte Rute;
unglasierter Boden.

11 Sitzender Mops auf Kissen

Meissen, 1742–1750
Porzellan, unbemalt
Signatur/Marke: keine
11,5 × 9,5 × 5,3 cm, 291 g
Inv.-Nr. A 522
Literatur: s. Kat.-Nr. 10

Sitzender Mops auf flacher, als
Kissen gestalteter, unbemalter
Plinthe, Kopf nach links gewandt,
große Augen, flache, trichter-
förmige Ohren, geringelte Rute;
unglasierter Boden.

12 Sitzender Mops auf purpurfarbenem Kissen

Meissen, 1743–1745
Modell: Johann Joachim Kändler
Porzellan, polychrome Bemalung
in Aufglasurtechnik, Goldmalerei
Signatur/Marke: keine
12 × 10 × 5,5 cm, 276 g
Inv.-Nr. A 536
Literatur: s. Kat.-Nr. 1
Provenienz: Collection of Sir
Gawaine and Lady Baillie.

Sitzender Mops auf rechteckigem,
als purpurfarbenes Kissen mit
Rankenornamentik und goldenen
Quasten staffiertem Sockel, Kopf
nach links gewandt, hellbraunes
Fell mit schwarzen Partien, türkis-
grünes Halsband mit grüner
Schleife und goldenen Schellen,
flache, trichterförmige Ohren,
geringelte Rute; unglasierter Boden
mit Brennloch.

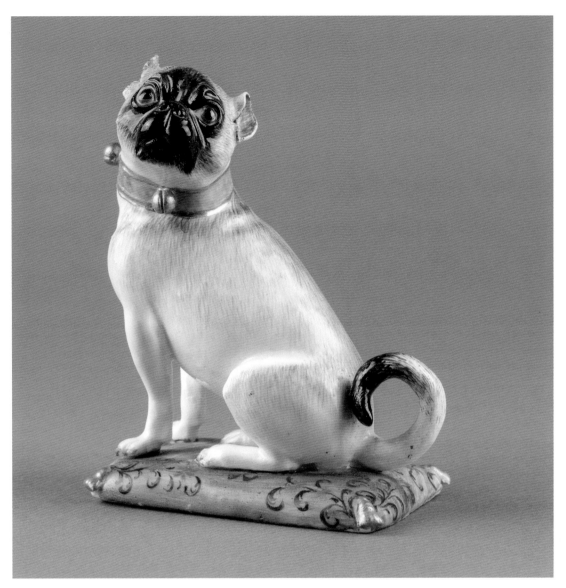

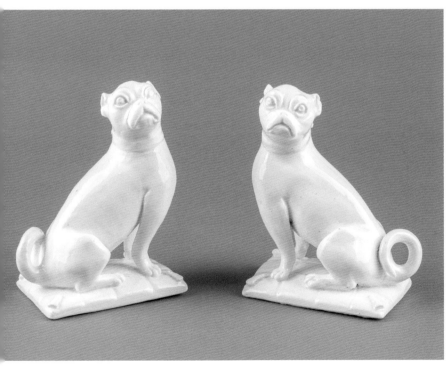

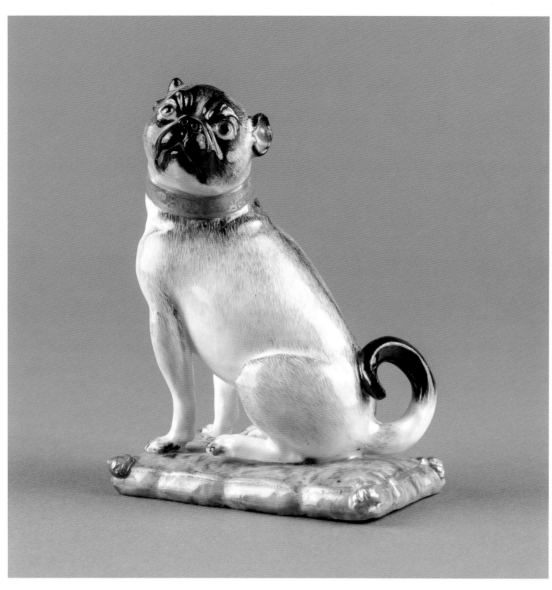

**13 Sitzender Mops
auf grünem Kissen**

Meissen, 1743–1745
Modell: Johann Joachim Kändler
Porzellan, polychrome Bemalung
in Aufglasurtechnik, Goldmalerei
Signatur/Marke: Schwerter in Blau
12 × 9 × 5,5 cm, 289 g
Inv.-Nr. A 538
Literatur: s. Kat.-Nr. 1

Sitzender Mops auf rechteckigem,
als grünes Kissen mit goldenen
Quasten staffiertem Sockel, Kopf
nach links gewandt, hellbraunes
Fell mit schwarzen Partien, rosa
Halsband mit goldenen Ranken
und türkisgrüner Schleife, flache,
trichterförmige Ohren, geringelte
Rute; unglasierter Boden mit
Brennloch.

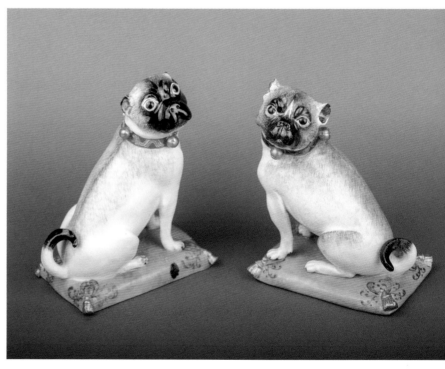

**14 Sitzender Mops
auf grünem Kissen**

Meissen, 1745–1750
Modell: Johann Joachim Kändler
Porzellan, polychrome Bemalung
in Aufglasurtechnik, Goldmalerei
Signatur/Marke: keine
11,5 × 10,5 × 5,3 cm, 309 g
Inv.-Nr. A 544
Literatur: s. Kat.-Nr. 1

Sitzender Mops auf rechteckigem,
als grünes Kissen mit goldenen
Quasten staffiertem Sockel, Kopf
nach rechts gewandt, hellbraunes
Fell mit schwarzen Partien, rosa
Halsband mit goldenen Ranken,
purpurfarbener Schleife und
goldenen Schellen, flache, trichter-
förmige Ohren, geringelte Rute;
unglasierter Boden mit Brennloch.

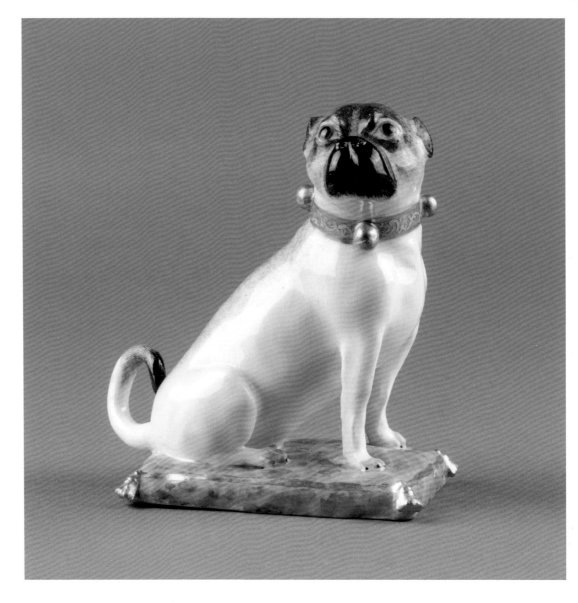

**15 Sitzender Mops
auf türkisgrünem Kissen**

Meissen, 1745–1750
Modell: Johann Joachim Kändler
Porzellan, polychrome Bemalung
in Aufglasurtechnik, Goldmalerei
Signatur/Marke: Schwerter in Blau
12 × 9 × 6 cm, 315 g
Inv.-Nr. A 618
Literatur: s. Kat.-Nr. 1

Sitzender Mops auf rechteckigem,
als türkisgrünes Kissen mit Ranken-
ornamentik und goldenen Quasten
staffiertem Sockel, Kopf nach
rechts gewandt, hellbraunes Fell
mit schwarzen Partien, mangan-
goldenes Halsband mit Wellen,
blauer Schleife und goldenen
Schellen, flache, trichterförmige
Ohren, geringelte Rute; unglasierter
Boden.

**16 Sitzender Mops
auf türkisgrünem Kissen**

Meissen, 1745–1750
Modell: Johann Joachim Kändler
Porzellan, polychrome Bemalung
in Aufglasurtechnik, Goldmalerei
Signatur/Marke: keine
12 × 9 × 6 cm, 309 g
Inv.-Nr. A 619
Literatur: s. Kat.-Nr. 1

Sitzender Mops auf rechteckigem,
als türkisgrünes Kissen mit Ranken-
ornamentik und goldenen Quasten
staffiertem Sockel, Kopf nach links
gewandt, hellbraunes Fell mit
schwarzen Partien, mangan-
violetter Schleife und goldenen
Schellen, flache, trichterförmige
Ohren, geringelte Rute; unglasier-
ter Boden.

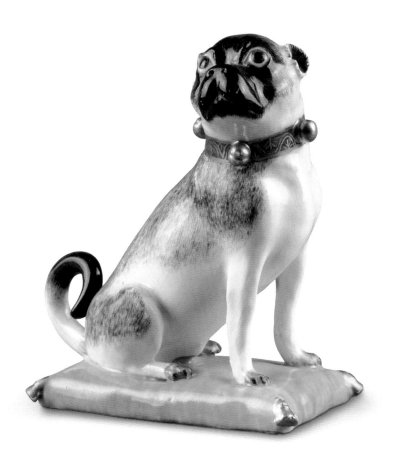

**17 Sitzender Mops
auf türkisgrünem Kissen**

Meissen, 1745–1750
Modell: Johann Joachim Kändler
Porzellan, polychrome Bemalung
in Aufglasurtechnik, Goldmalerei
Signatur/Marke: keine
11,8 × 11 × 5,4 cm, 326 g
Inv.-Nr. A 545
Literatur: s. Kat.-Nr. 1

Sitzender Mops auf rechteckigem,
als türkisgrünes Kissen mit Ranken-
ornamentik und goldenen Quasten
staffiertem Sockel, Kopf nach
rechts gewandt, hellbraunes Fell
mit schwarzen Partien, orange-
rotes Halsband mit goldenen Ran-
ken, türkisgrüner Schleife und
goldenen Schellen, flache, trichter-
förmige Ohren, geringelte Rute;
unglasierter Boden.

**18 Sitzender Mops
auf gelbem Kissen**

Meissen, 1743–1745
Modell: Johann Joachim Kändler
Porzellan, polychrome Bemalung
in Aufglasurtechnik, Goldmalerei
Signatur/Marke: Schwerter in Blau
11,8 × 9,5 × 5,5 cm, 308 g
Inv.-Nr. A 539
Literatur: s. Kat.-Nr. 1

Sitzender Mops auf rechteckigem,
als gelbes Kissen mit goldenen
Quasten staffiertem Sockel, Kopf
nach links gewandt, hellbraunes
Fell mit schwarzen Partien, orange-
rotes Halsband mit blauer Schleife
und goldenen Schellen, flache,
trichterförmige Ohren, Zungen-
spitze sichtbar, geringelte Rute;
unglasierter Boden mit Brennloch.

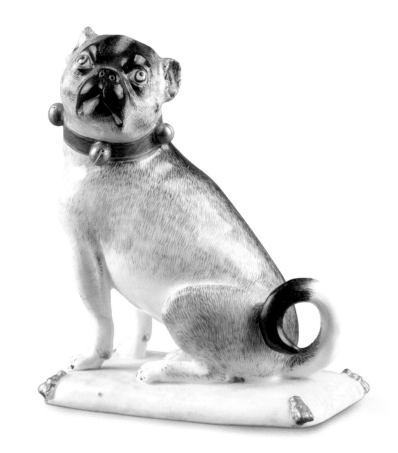

**19 Sitzender Mops
auf weißem Kissen
mit Streublumen**

Meissen, 1743–1745
Modell: Johann Joachim Kändler
Porzellan, polychrome Bemalung
in Aufglasurtechnik, Goldmalerei
Signatur/Marke: Schwerter in Blau
11,8 × 9 × 5,5 cm, 277 g
Inv.-Nr. A 540
Literatur: s. Kat.-Nr. 1

Sitzender Mops auf rechteckigem,
als Kissen mit Streublumen und
goldenen Quasten staffiertem
Sockel, Kopf nach links gewandt,
hellbraunes Fell mit schwarzen
Partien, blaues Halsband mit
purpurfarbener Schleife und
goldenen Schellen, flache, trichter-
förmige Ohren, geringelte Rute;
unglasierter Boden mit Brennloch.

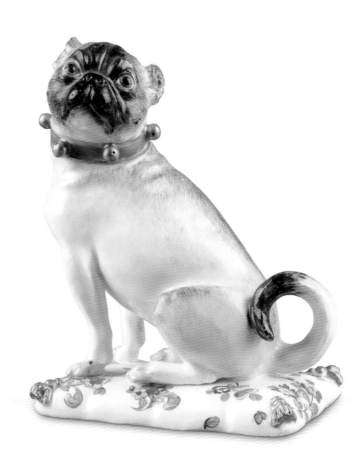

**20 Sitzender Mops
auf rosa Kissen**

Meissen, 1745–1750
Modell: Johann Joachim Kändler
Porzellan, polychrome Bemalung
in Aufglasurtechnik, Goldmalerei
Signatur/Marke: Schwerter in Blau
11,8 × 9,5 × 5,2 cm, 281 g
Inv.-Nr. A 546
Literatur: s. Kat.-Nr. 1

Sitzender Mops auf rechteckigem,
als rosa Kissen mit goldenen Streu-
blumen und Quasten staffiertem
Sockel, Kopf nach rechts gewandt,
hellbraunes Fell mit schwarzen
Partien, grünes Halsband mit
manganvioletten Ranken, grüner
Schleife und goldenen Schellen,
flache, trichterförmige Ohren,
geringelte Rute; unglasierter Boden
mit Brennloch.

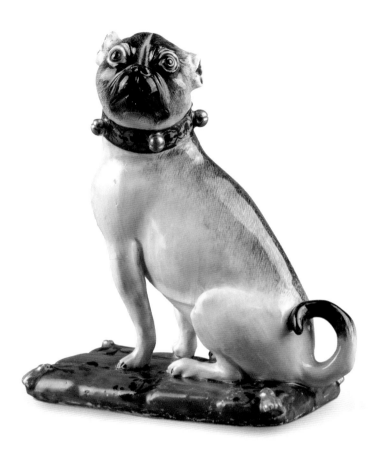

21 Sitzende Möpsin auf rotem Kissen

Meissen, 1743–1745
Modell: Johann Joachim Kändler
Porzellan, polychrome Bemalung
in Aufglasurtechnik, Goldmalerei
Signatur/Marke: Schwerter in Blau
11,4 × 10 × 5,4 cm, 273 g
Inv.-Nr. A 541
Literatur: s. Kat.-Nr. 1

Sitzende Möpsin auf rechteckigem,
als rotes Kissen mit schwarzen
Blumenranken und goldenen
Quasten staffiertem Sockel, Kopf
nach links gewandt, hellbraunes
Fell mit schwarzen Partien, purpur-
farbenes Halsband mit Blüten, roter
Schleife und goldenen Schellen,
flache, trichterförmige Ohren,
geringelte Rute; unglasierter
Boden mit Brennloch.

22 Sitzender Mops auf blauem Kissen

Meissen, 1745–1750 (Malerei etwas
später)
Modell: Johann Joachim Kändler
Porzellan, polychrome Bemalung
in Aufglasurtechnik, Goldmalerei
Signatur/Marke: Schwerter in Blau
12 × 8,5 × 5,3 cm, 275 g
Inv.-Nr. A 543
Literatur: s. Kat.-Nr. 1

Sitzender Mops auf rechteckigem,
als blaues Kissen mit Rankenorna-
mentik und goldenen Quasten
staffiertem Sockel, Kopf nach
rechts gewandt, braunes Fell mit
schwarzen Partien, purpurfarbenes
Halsband mit purpurfarbener
Schleife und goldenen Schellen,
flache, trichterförmige Ohren,
geringelte Rute; unglasierter Boden
mit Brennloch.

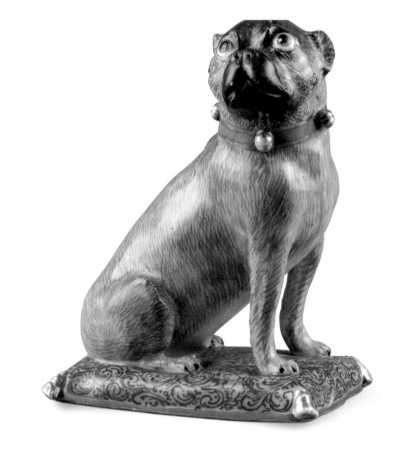

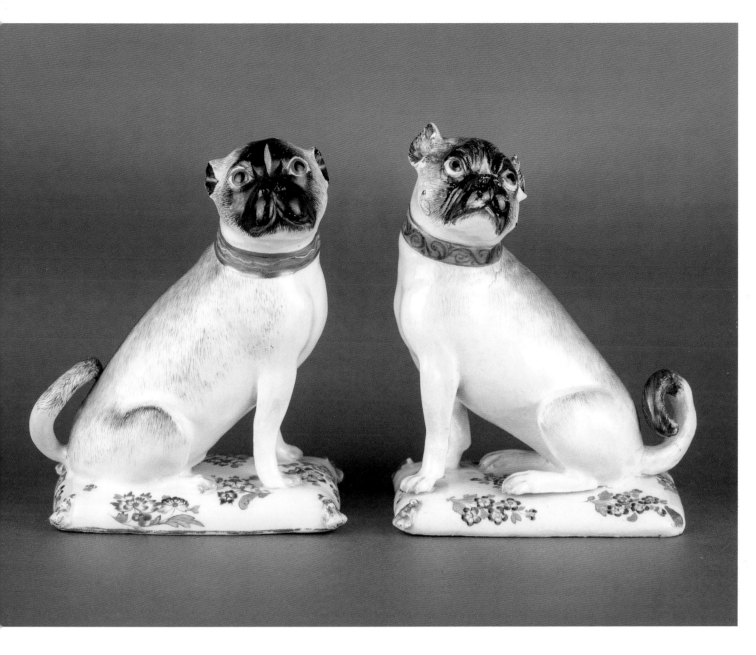

**23 Sitzender Mops
auf Blumenkissen**

Meissen, um 1750
Modell: Johann Joachim Kändler
Porzellan, polychrome Bemalung
in Aufglasurtechnik, Goldmalerei
Signatur/Marke: Schwerter in Blau
10,5 × 9 × 5 cm, 288 g
Inv.-Nr. A 614
Literatur: s. Kat.-Nr. 1

Sitzender Mops auf rechteckigem,
als weißes Kissen mit Blütendekor
und goldenen Quasten staffiertem
Sockel, Kopf nach rechts gewandt,
naturalistisch hellgrau bemaltes
Fell, purpurfarben-goldenes Hals-
band mit Wellendekor und blauer
Schleife, flache, trichterförmige
Ohren, geringelte Rute; unglasier-
ter Boden mit Brennloch.

**24 Sitzender Mops
auf Blumenkissen**

Meissen, um 1750
Modell: Johann Joachim Kändler
Porzellan, polychrome Bemalung
in Aufglasurtechnik, Goldmalerei
Signatur/Marke: Schwerter in Blau
10,5 × 9 × 5 cm, 278 g
Inv.-Nr. A 615
Literatur: s. Kat.-Nr. 1

Sitzender Mops auf rechteckigem,
als weißes Kissen mit Blütendekor
und goldenen Quasten staffiertem
Sockel, Kopf nach links gewandt,
naturalistisch hellgraues Fell, blau-
goldenes Halsband mit Voluten-
dekor und blauer Schleife, flache,
trichterförmige Ohren, geringelte
Rute; unglasierter Boden mit
Brennloch.

**25 Sitzender Mops
auf Grassockel**

Höchst, um 1750
Fayence, polychrome Bemalung
in Scharffeuertechnik, niedrig
gebrannt
Signatur/Marke: Radmarke in
Schwarz
10,5 × 13 × 7 cm, 243 g
Inv.-Nr. A 517
Literatur: Reber 1986, S. 81.

Sitzender Mops auf flachem, grün-
staffiertem Terrainsockel, Kopf
emporgerichtet, rechte Vorderpfote
erhoben, hellgelbes Fell, im Gesicht
schwarz, flache trichterförmige
Ohren, leicht geöffnetes Maul,
geringelte Rute; glasierter Boden
mit großem Loch in die Hohlfigur,
unglasierter Rand, Brennloch in
der Brust.

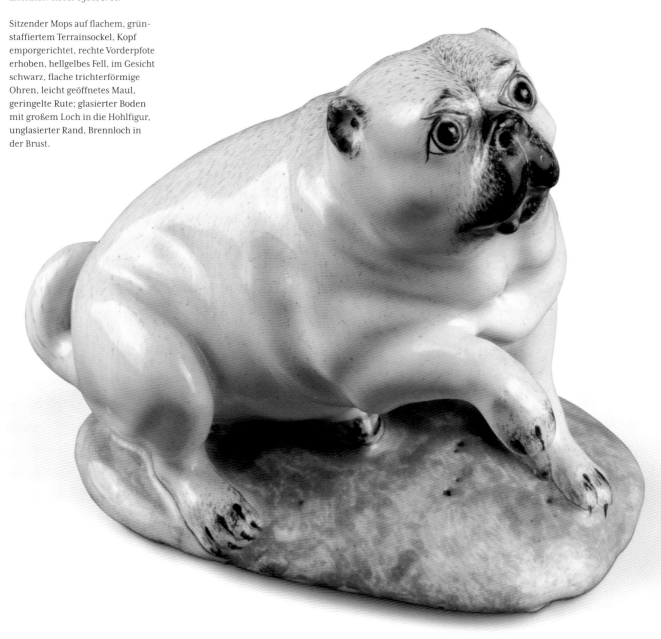

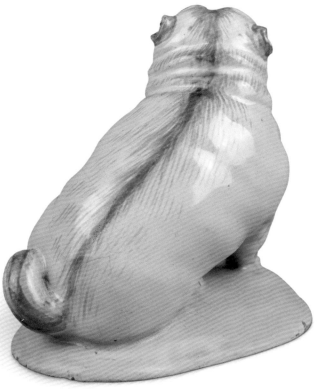

26 Sitzender Mops
auf Grassockel

Höchst, um 1750
Fayence, polychrome Bemalung
in Scharffeuertechnik
Signatur/Marke: keine
10,5 × 12 × 6,5 cm, 180 g
Inv.-Nr. A 593
Literatur: s. Kat.-Nr. 25

Sitzender Mops auf gewölbtem,
grünstaffiertem Terrainsockel,
Kopf emporgerichtet, linke Vorder-
pfote erhoben, hellgelbes Fell, im
Gesicht schwarz, flache trichter-
förmige Ohren, geringelte Rute;
glasierter Boden mit großem Loch
in die Hohlfigur, unglasierter
Rand.

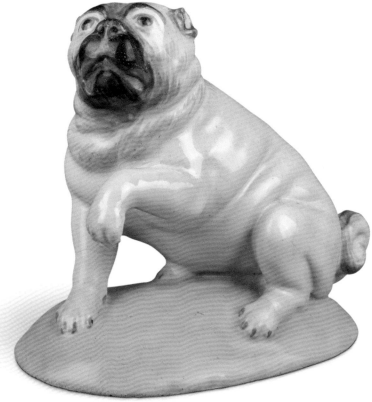

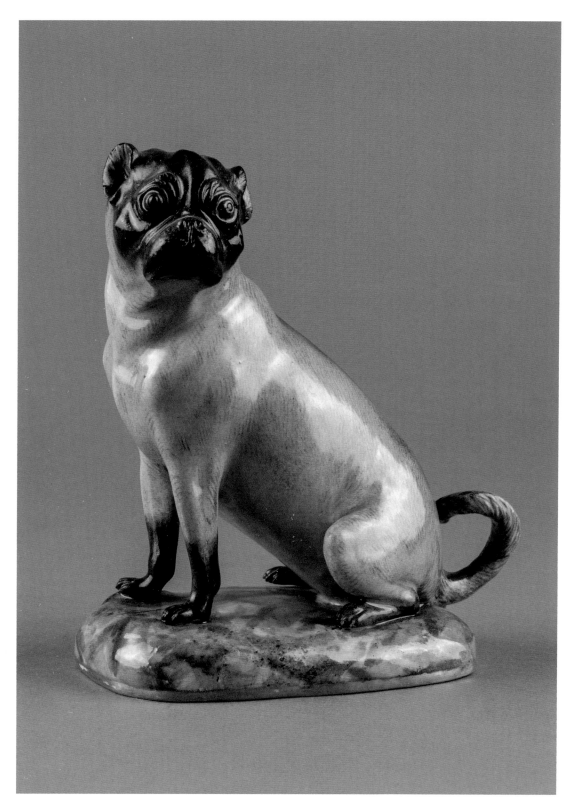

**27 Sitzender Mops
auf Sockel**

Meissen, Anfang des 19. Jahrhunderts
Modell: Johann Joachim Kändler
Porzellan, polychrome Bemalung
in Aufglasurtechnik, Goldmalerei
Signatur/Marke: Schwerter in Blau,
Pressnummer „M 91.‟
15,5 × 14 × 7,5 cm, 587 g
Inv.-Nr. A 547
Literatur: s. Kat.-Nr. 1

Sitzender Mops auf bräunlichem
Terrainsockel, Kopf nach links
gewandt, braunes Fell mit schwar-
zen Partien, flache, trichterförmige
Ohren, geringelte Rute; unglasierter
Boden mit Brennloch.

28 Sitzender Mops auf ovalem Sockel

Süddeutschland, um 1770
Fayence, polychrome Bemalung
in Scharffeuertechnik
Signatur/Marke: keine
14 × 12,3 × 7 cm, 364 g
Inv.-Nr. A 578

Sitzender Mops auf ovaler, gestufter,
manganviolett staffierter Plinthe,
umlaufend mit Streublumen, linke
Vorderpfote hebend, gelbes Fell
mit manganvioletten Partien,
gelbes Halsband mit blauer Schelle,
flache, trichterförmige Ohren,
geringelte Rute; gelblich-sand-
farbener Scherben, unglasierter
Boden, Brennloch unterm Schwanz.

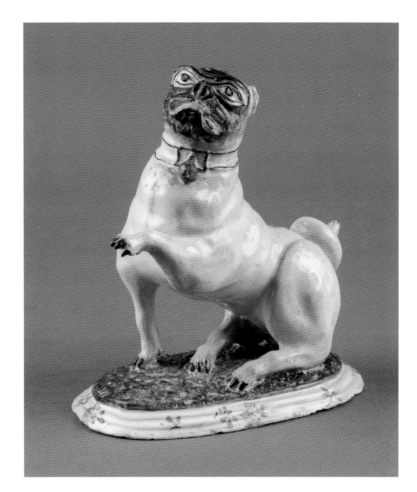

29 Sitzender Mops auf blauem Sockel

Tournai, wohl 1770
Fayence, Bemalung in Scharf-
feuertechnik in Manganviolett,
Antimongelb und Kobaltblau
Signatur/Marke: keine
9,5 × 9,5 × 3 cm, 331 g
Inv.-Nr. A 586
Literatur: Mariën-Dugardin/
Duphénieux 1966, S. 71, Nr. 50.

Sitzender Mops auf ovalem, blau
staffiertem Sockel, Kopf nach links
gewandt, manganviolettes, ge-
schwämmeltes Fell, blaues Hals-
band mit blauer Schleife und
zwei gelben Schellen; nach innen
gewölbter, unterseitig offener,
glasierter Sockel, Glasur innen
blaustichig.

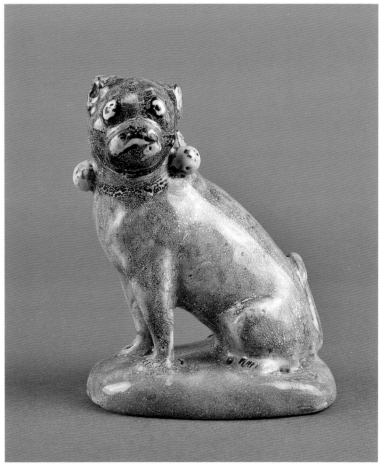

**30 Sitzender Mops
auf Blumensockel**

Meissen, um 1745
Modell: Johann Joachim Kändler
Porzellan, polychrome Bemalung
in Aufglasurtechnik, Goldmalerei
Signatur/Marke: Schwerter in Blau
15 × 14,5 × 9 cm, 657 g
Inv.-Nr. A 612
Literatur: s. Kat.-Nr. 1

Sitzender Mops auf weißem
Terrainsockel mit aufgelegten
plastischen, farbig staffierten
Blüten und Blättern, Kopf nach
rechts gewandt, braunes Fell mit
schwarzen Partien, goldenes Hals-
band mit Blumen und Schloss,
flache, trichterförmige Ohren,
geringelte Rute; unglasierter Boden
mit Brennloch.

**31 Sitzende Möpsin
mit saugendem Welpen
auf Blumensockel**

Meissen, um 1745
Modell: Johann Joachim Kändler
Porzellan, polychrome Bemalung
in Aufglasurtechnik, Goldmalerei
Signatur/Marke: Schwerter in Blau
15 × 15 × 9 cm, 660 g
Inv.-Nr. A 613
Literatur: s. Kat.-Nr. 1

Sitzende Möpsin auf weißem
Terrainsockel mit aufgelegten
plastischen, farbig staffierten
Blüten und Blättern, Kopf nach
links gewandt, Welpe liegt saugend
unter dem Bauch, hellbraunes Fell
mit schwarzen Partien, gelb-golde-
nes Halsband mit Blumen und
Schloss, flache, trichterförmige
Ohren, geringelte Rute; unglasier-
ter Boden mit Brennloch.

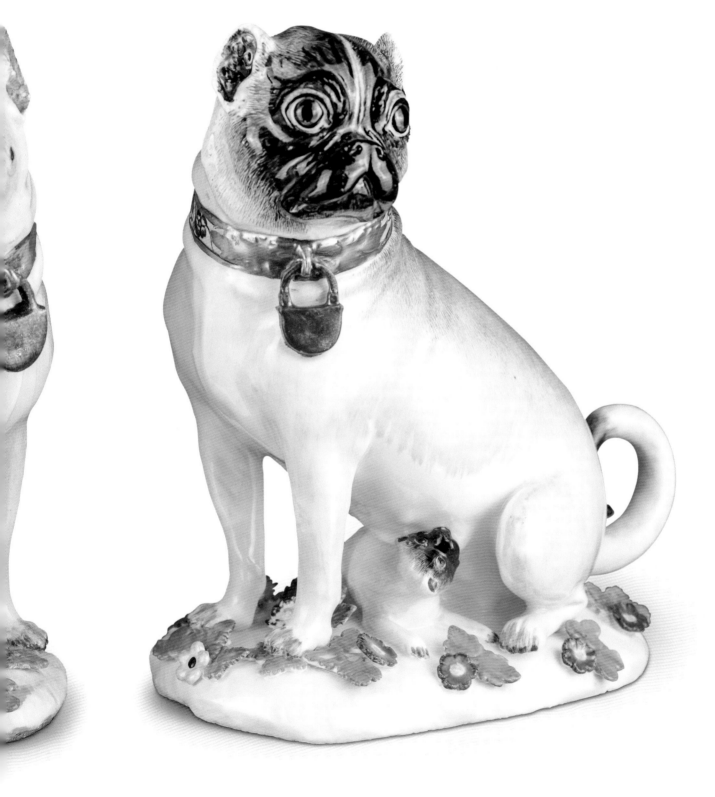

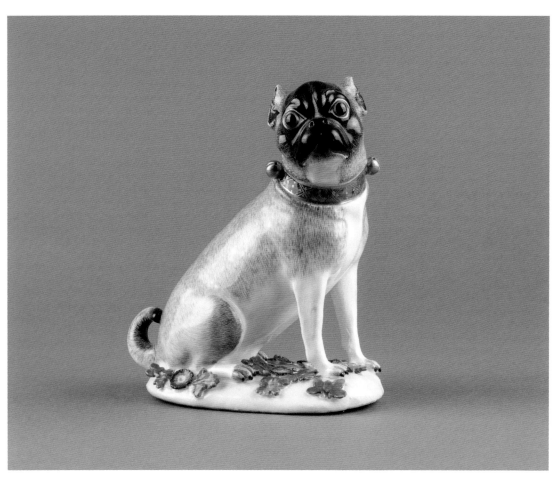

32 Sitzender Mops auf Blumensockel

Meissen, 1745–1750
Modell: Johann Joachim Kändler
und Peter Reinicke
Porzellan, polychrome Bemalung
in Aufglasurtechnik, Goldmalerei
Signatur/Marke: keine
15 × 13 × 7 cm, 664 g
Inv.-Nr. A 533
Literatur: s. Kat.-Nr. 1

Sitzender Mops auf ovalem, flachem
Sockel mit aufgelegten plastischen,
farbig staffierten Blüten und Blättern,
Kopf nach rechts gewandt, hellbrau-
nes Fell mit schwarzen Partien, pur-
purfarbenes Halsband mit goldenen
Rauten, türkisgrüner Schleife und
goldenen Schellen, flache, trichter-
förmige Ohren, geringelte Rute;
unglasierter Boden mit Brennloch.

33 Sitzende Möpsin mit saugendem Welpen auf Blumensockel

Meissen, um 1750
Modell: Johann Joachim Kändler
und Peter Reinicke
Porzellan, polychrome Bemalung
in Aufglasurtechnik, Goldmalerei
Signatur/Marke: keine
15,5 × 13 × 7 cm, 713 g
Inv.-Nr. A 532
Literatur: s. Kat.-Nr. 1

Sitzende Möpsin auf ovalem, flachem
Sockel mit aufgelegten plastischen,
farbig staffierten Blüten und Blät-
tern, Kopf nach links gewandt,
Mopswelpe liegt unter dem Bauch,
hellbraunes Fell mit schwarzen
Partien, rosa Halsband mit golde-
nem Blattwerk, blauer Schleife und
goldenen Schellen, flache, trichter-
förmige Ohren, geringelte Rute;
unglasierter Boden mit Brennloch.

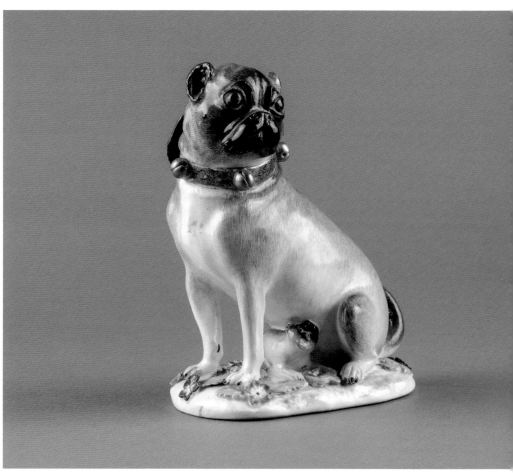

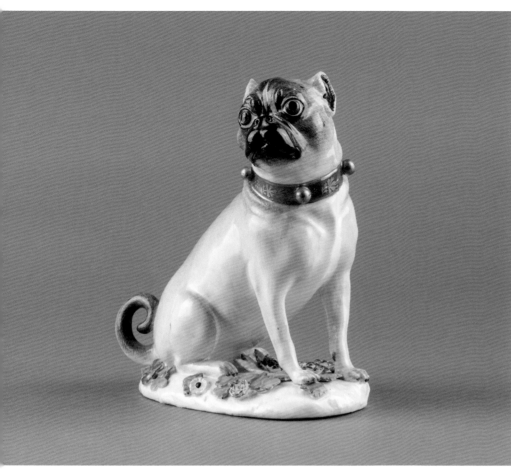

34 Sitzender Mops auf Blumensockel

Meissen, 1745–1750
Modell: Johann Joachim Kändler
und Peter Reinicke
Porzellan, polychrome Bemalung
in Aufglasurtechnik, Goldmalerei
Signatur/Marke: Schwerter in Blau
15,5 × 14 × 7 cm, 602 g
Inv.-Nr. A 534
Literatur: s. Kat.-Nr. 1

Sitzender Mops auf ovalem, flachem
Sockel mit aufgelegten plastischen
und staffierten Blüten und Blättern,
Kopf nach rechts gewandt, hellbrau-
nes Fell mit schwarzen Partien,
oranges Halsband mit goldenem
Blattwerk, grüner Schleife und
goldenen Schellen, flache, trichter-
förmige Ohren, geringelte Rute;
unglasierter Boden mit Brennloch.

35 Sitzende Möpsin mit saugendem Welpen auf Blumensockel

Meissen, um 1750
Modell: Johann Joachim Kändler
und Peter Reinicke
Porzellan, polychrome Bemalung
in Aufglasurtechnik, Goldmalerei
Signatur/Marke: keine
15,5 × 13 × 7 cm, 638 g
Inv.-Nr. A 531
Literatur: s. Kat.-Nr. 1

Sitzende Möpsin auf ovalem, flachem
Sockel mit aufgelegten plastischen,
farbig staffierten Blüten und Blät-
tern, Kopf nach links gewandt,
Mopswelpe liegt unter dem Bauch,
hellbraunes Fell mit schwarzen
Partien, rosa Halsband mit golde-
nen Rauten, grüner Schleife und
goldenen Schellen, flache, trichter-
förmige Ohren, geringelte Rute;
unglasierter Boden mit Brennloch.

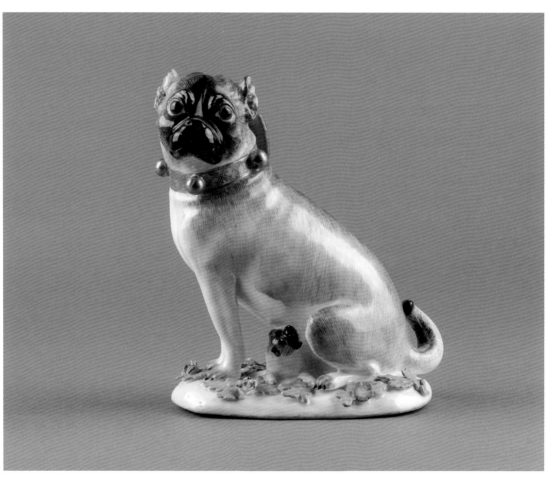

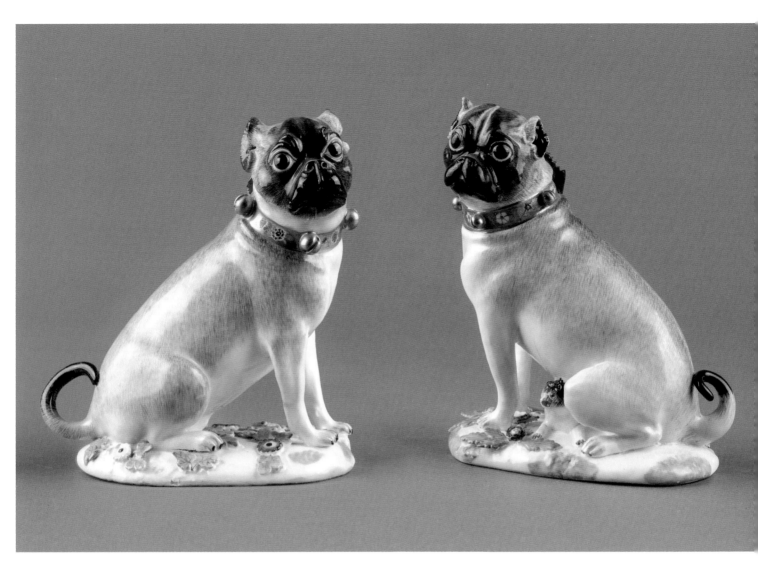

**36 Sitzender Mops
auf Blumensockel**

Meissen, 1745–1750
Modell Johann Joachim Kändler
und Peter Reinicke
Porzellan, polychrome Bemalung
in Aufglasurtechnik, Goldmalerei
Signatur/Marke: keine
15 × 14 × 7 cm, 603 g
Inv.-Nr. A 535
Literatur: s. Kat.-Nr. 1

Sitzender Mops auf ovalem, flachem
Sockel mit aufgelegten plastischen,
farbig staffierten Blüten und Blät-
tern, Kopf nach rechts gewandt,
hellbraunes Fell mit schwarzen
Partien, goldenes Halsband mit
roten und purpurfarbenen Blüten,
blauer Schleife und goldenen
Schellen, flache, trichterförmige
Ohren, geringelte Rute; unglasier-
ter Boden mit Brennloch.

**37 Sitzende Möpsin
mit saugendem Welpen
auf Blumensockel**

Meissen, um 1750
Modell: Johann Joachim Kändler
und Peter Reinicke
Porzellan, polychrome Bemalung
in Aufglasurtechnik, Goldmalerei
Signatur/Marke: keine
15,5 × 13 × 7 cm, 658 g
Inv.-Nr. A 530
Literatur: s. Kat.-Nr. 1

Sitzende Möpsin auf ovalem, fla-
chem Sockel mit aufgelegten plasti-
schen, farbig staffierten Blüten und
Blättern, Kopf nach links gewandt,
Mopswelpe liegt unter dem Bauch,
hellbraunes Fell mit schwarzen
Partien, blaues Halsband mit roten
und gelben Blüten, purpurfarbener
Schleife und goldenen Schellen,
flache, trichterförmige Ohren,
geringelte Rute; unglasierter Boden
mit Brennloch.

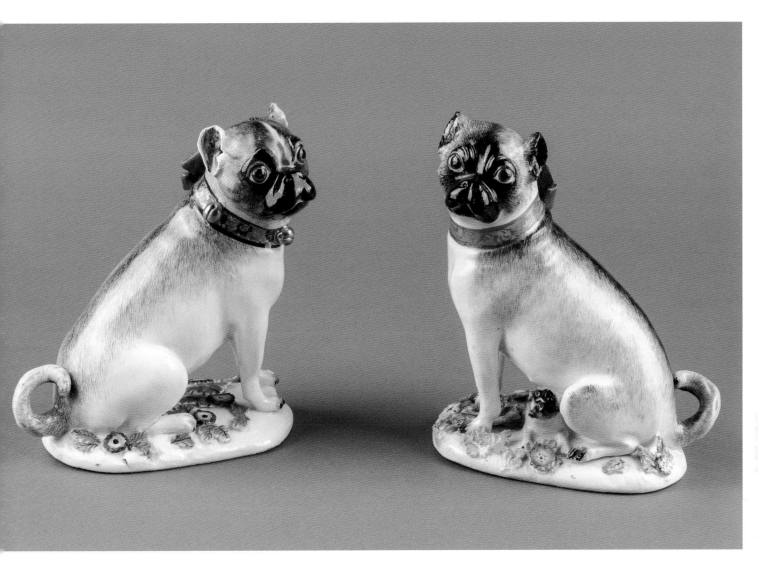

**38 Sitzender Mops
auf Blumensockel**

Meissen, 1745–1750
Modell: Johann Joachim Kändler
und Peter Reinicke
Porzellan, polychrome Bemalung
in Aufglasurtechnik, Goldmalerei
Signatur/Marke: keine
15 × 14 × 7 cm, 592 g
Inv.-Nr. A 528
Literatur: s. Kat.-Nr. 1

Sitzender Mops auf ovalem, flachem
Sockel mit aufgelegten plastischen,
farbig staffierten Blüten und Blät-
tern, Kopf nach rechts gewandt,
hellbraunes Fell mit schwarzen
Partien, goldenes Halsband mit
roten und blauen Blumen, blauer
Schleife und goldenen Schellen,
flache, trichterförmige Ohren,
geringelte Rute; unglasierter Boden
mit Brennloch.

**39 Sitzende Möpsin
mit saugendem Welpen
auf Blumensockel**

Meissen, 1745–1750
Modell: Johann Joachim Kändler
und Peter Reinicke
Porzellan, polychrome Bemalung
in Aufglasurtechnik, Goldmalerei
Signatur/Marke: keine
15,5 × 13,5 × 7 cm, 697 g
Inv.-Nr. A 529
Literatur: s. Kat.-Nr. 1

Sitzende Möpsin auf ovalem, flachem
Sockel mit aufgelegten plastischen,
farbig staffierten Blüten und Blät-
tern, Kopf nach links gewandt,
Mopswelpe liegt unter dem Bauch,
hellbraunes Fell mit schwarzen
Partien, rosa Halsband mit golde-
nen Ranken und blauer Schleife,
flache, trichterförmige Ohren,
geringelte Rute; unglasierter Boden
mit Brennloch.

**40 Sitzender Mops
auf Bronzesockel**

Meissen, um 1750
Modell: Johann Joachim Kändler
Porzellan, schwarze Bemalung
in Aufglasurtechnik
Signatur/Marke: keine sichtbar
(Montierung)
20 × 16 × 12 cm, 1610 g mit Montie-
rung, Mops: 13 × 14 × 10 cm
Inv.-Nr. A 611
Literatur: s. Kat.-Nr. 1; Pietsch
2006, S. 192, 193.

Sitzender Mops nach links schau-
end, schwarze Fellzeichnung
mit markantem Aalstrich, flache,
trichterförmige Ohren, geringelte
Rute; montiert auf vergoldetem
Bronzesockel in Gestalt eines ovalen,
gepolsterten Hockers mit Quasten-
behang.

**41 Sitzender Mops
auf Hocker**

Meissen, um 1740
Modell: Johann Joachim Kändler
Porzellan, polychrome Bemalung
in Aufglasurtechnik, Goldmalerei
Signatur/Marke: keine sichtbar
(Montierung)
10 × 6,5 × 6 cm, 160 g mit Montie-
rung, Mops: H 4,8 cm
Inv.-Nr. A 582
Literatur: s. Kat.-Nr. 1

Sitzender Mops auf rechteckigem,
mit gold-schwarzen Blumen staf-
fiertem Kissen, Kopf nach links
gewandt, hellbraunes Fell mit
dunklen Partien, rotes Halsband
mit goldenen Schellen, flache,
trichterförmige Ohren, geringelte
Rute; vergoldete Montierung
in Form eines Hockers.

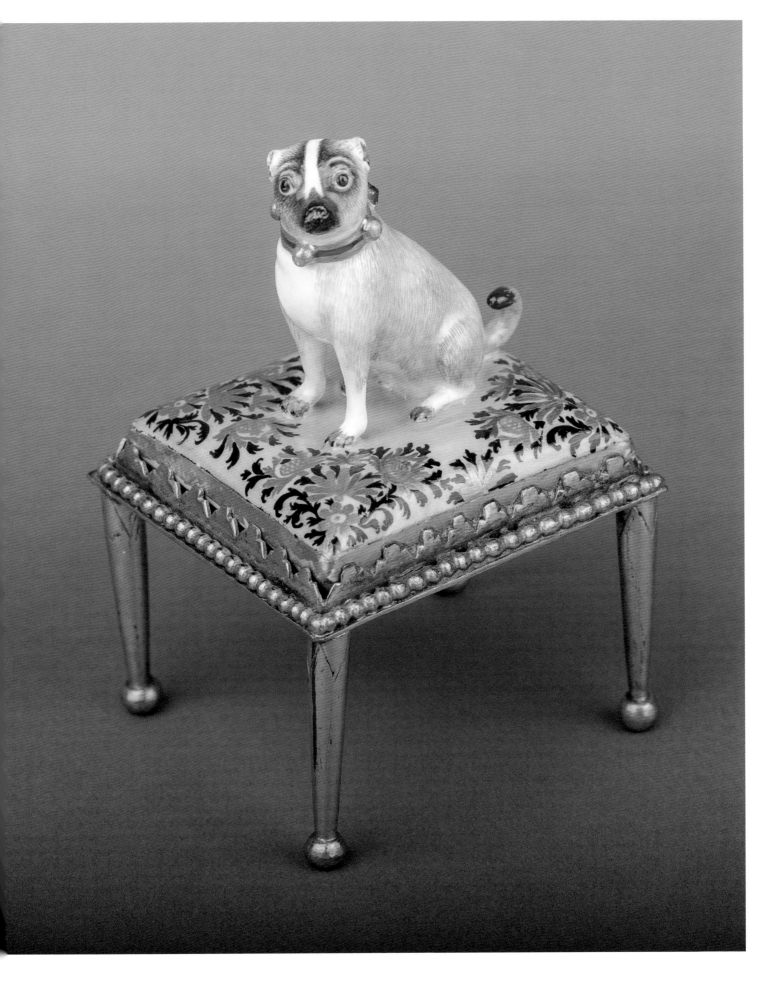

42 + 43 Sitzende Möpsin
mit Welpen und Mops

Meissen, Ende des 18./Anfang des
19. Jahrhunderts
Porzellan, polychrome Bemalung
in Aufglasurtechnik
Signatur/Marke: Presszeichen
(Möpsin)
18 × 17 × 11 cm, 1050 g
17,3 × 18 × 10 cm, 1006 g
Inv.-Nr. A 567, 560
Literatur: s. Kat.-Nr. 1, 40

Sitzender Mops und Möpsin mit
Welpen, nach links bzw. rechts
schauend, hellbraunes Fell mit
dunklen Partien, flache, trichter-
förmige Ohren, geringelte Rute;
unglasierter Boden, bei Möpsin
mit Brennloch.

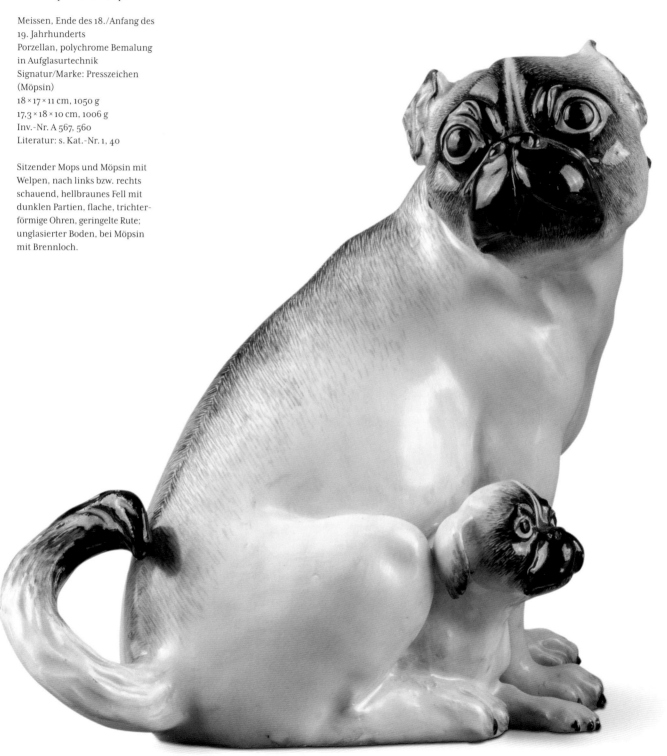

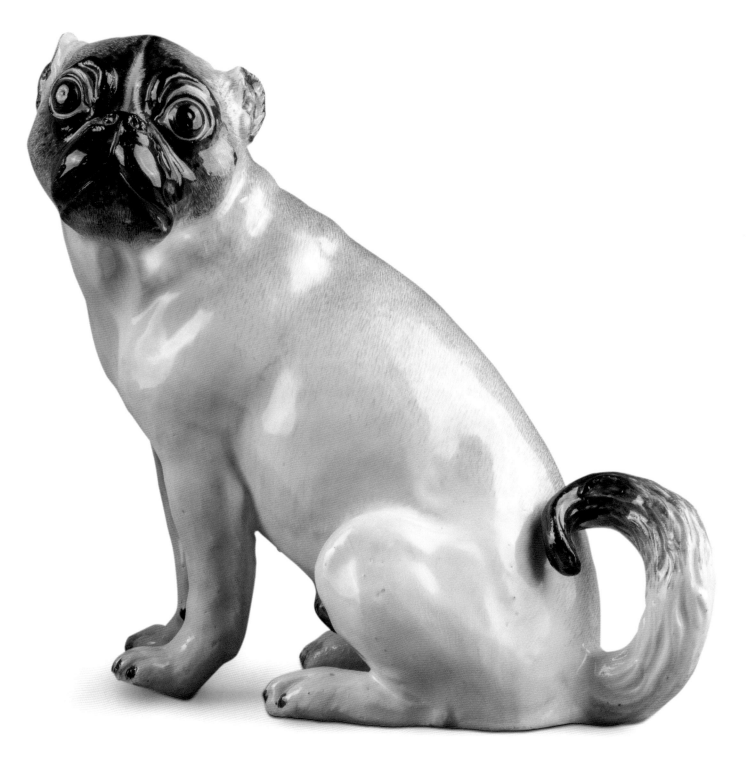

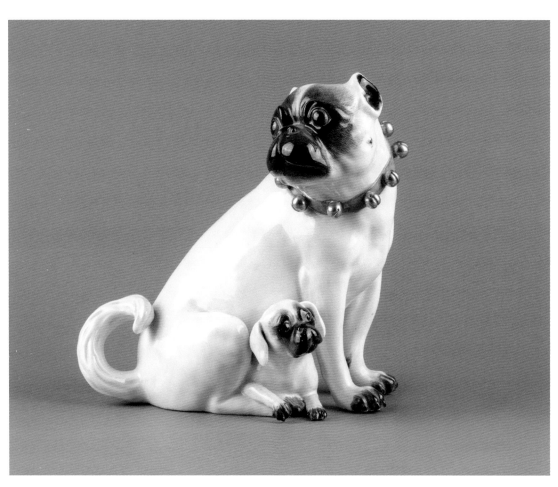

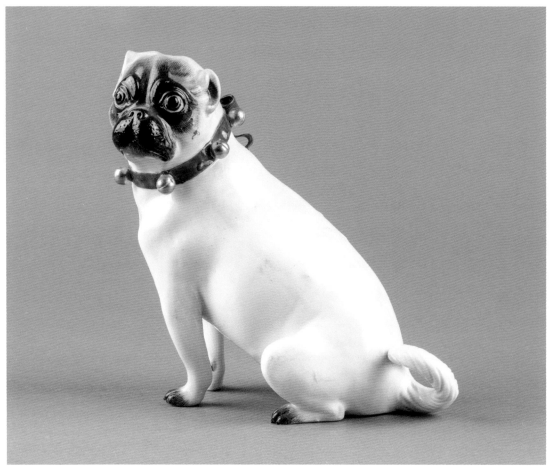

**44 + 45 Sitzende Möpsin
mit Welpen und Mops**

Meissen, Ende des 18. Jahrhunderts
Porzellan, polychrome Bemalung
in Aufglasurtechnik
Signatur/Marke: Schwerter mit
Knauf in Blau, Pressnummer „M 91."
(Mops), Schwerter in Blau, Press-
nummer „315.", „58"
14 × 12 × 8 cm, 1077 g
18 × 17 × 11 cm, 526 g
Inv.-Nr. A 565, 564
Literatur: s. Kat.-Nr. 1, 40

Sitzende Möpsin mit einem Welpen
und Mops, nach rechts bzw. links
zurückschauend, Welpe schaut
unterm Bauch der Mutter hervor,
hellbraunes Fell, schwarzgraues
Gesicht und Pfotenspitzen, blaues
Halsband mit goldenen Schellen,
flache, trichterförmige Ohren,
geringelte Rute; unglasierter Boden
mit Brennloch.

46 Sitzende Möpsin mit saugendem Welpen auf hohem Terrainsockel

Tournai, um 1780
Fayence, polychrome Bemalung
in Aufglasurtechnik
Signatur/Marke: keine
18 × 17 × 11 cm, 614 g
Inv.-Nr. A 566
Literatur: Mariën-Dugardin/
Duphénieux 1966, S. 71, Nr. 50.

Sitzende Möpsin, einen Welpen
säugend auf rosa-braunem
Terrainsockel mit aufgelegten
plastischen Blättern und Beeren,
Kopf nach links gewandt, Welpe
saugend am Bauch der Mutter,
helles Fell mit braunen Flecken,
Möpsin mit purpurfarbenem Hals-
band mit purpurfarbener Schleife
und gelben Schellen, flache,
trichterförmige Ohren, geringelte
Rute; unglasierte Standfläche,
Sockel hohl und innen glasiert.

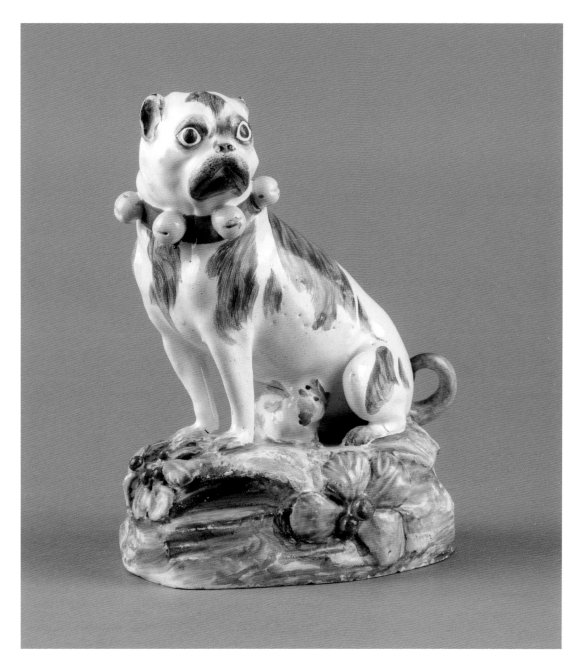

47 Sitzende Möpsin mit saugendem Welpen

Potschappel, Dresden, 19. Jahrhundert
Porzellan, polychrome Bemalung in
Aufglasurtechnik
Signatur/Marke: PS ligiert Dresden,
Malerzeichen „Z"
23 × 24 × 17 cm, 1700 g
Inv.-Nr. A 558

Sitzende Möpsin, Kopf nach
links gewandt, linke Vorderpfote
angehoben, um das Junge zu
Säugen, Welpe liegt saugend am
Bauch der Mutter, helles Fell
mit braunen Flecken, flache,
trichterförmige Ohren, gerin-
gelte Rute; unglasierter Boden,
Brennloch neben dem Schwanz
über der Marke.

48 Liegender Mops

Meissen, Mitte des 18. Jahrhunderts
Porzellan, polychrome Bemalung
in Aufglasurtechnik, Goldmalerei
Signatur/Marke: Schwerter in Blau
3,8 × 7,8 × 3 cm, 44 g
Inv.-Nr. A 574
Literatur: s. Kat.-Nr. 1

Liegender Mops nach rechts schau-
end, braunes Fell mit schwarzbrau-
nen Partien, gestreckte Vorderbei-
ne, purpurfarbenes Halsband mit
goldenem Rand, flache, trichter-
förmige Ohren, geringelte Rute;
unglasierter Boden mit Brennloch.

49 Liegender Mops

Meissen, um 1740
Modell: Johann Joachim Kändler
Porzellan, polychrome Bemalung
in Aufglasurtechnik, Goldmalerei
Signatur/Marke: Schwerter in Blau
4 × 7,5 × 3,5 cm, 44 g
Inv.-Nr. A 570
Literatur: s. Kat.-Nr. 1

Liegender Mops nach links schau-
end, graues Fell mit schwarzbrau-
nen Partien, gestreckte Vorder-
beine, hellblaues Halsband mit
goldenen Ornamenten, purpur-
farbener Schleife und goldenen
Schellen, flache, trichterförmige
Ohren, geringelte Rute; unglasier-
ter Boden mit Brennloch.

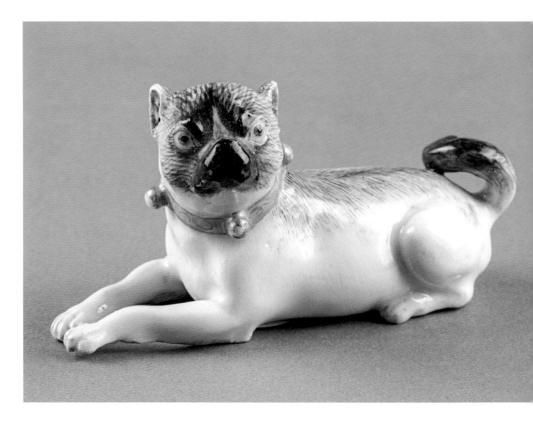

**50 Liegender Mops
auf achteckiger Plinthe**

wohl Fulda, um 1760
Fayence, polychrome Bemalung in
Scharffeuer- und Aufglasurtechnik
Signatur/Marke: keine
12,5 × 14,5 × 8,5 cm, 398 g
Inv.-Nr. A 595

Liegender Mops auf achteckiger
Plinthe mit grünem Rand, Kopf
nach links erhoben, angewinkelte
Vorderbeine, hellgrau-braunes Fell
mit schwarzen Partien, grünes
Halsband, flache, trichterförmige
Ohren, geringelte Rute; unglasier-
ter Boden, Brennloch unterm
Schwanz.

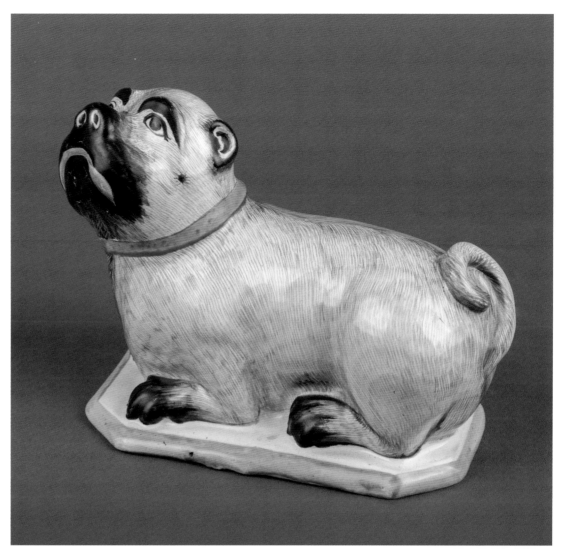

**51 + 52 Zwei liegende Möpse
auf Kissen**

Nymphenburg, Mitte des
18. Jahrhunderts
Porzellan, unbemalt
Signatur/Marke: Nymphenburg
mit bayrischem Wappen in Grün,
Pressmarke: Wappen „76.4" „5"; „764"
3,2 × 4,2 × 3,3 cm, 23 g
3,2 × 4,2 × 3,3 cm, 23 g
Inv.-Nr. A 577, 576

Liegende Möpse, jeweils auf recht-
eckiger, als Kissen mit Quasten
gestalteter Plinthe, Kopf erhoben,
gestreckte Vorderbeine, flache,
trichterförmige Ohren, geringelte
Rute; unglasierter Boden mit
Brennloch.

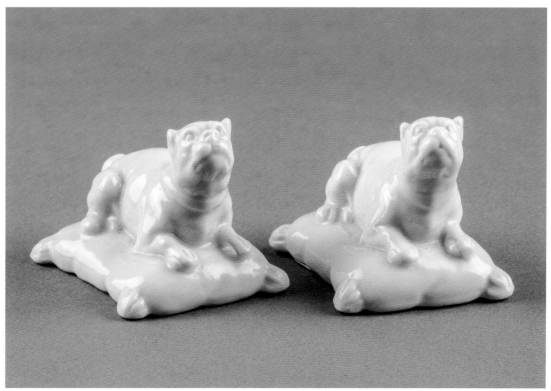

53 Hundehütte mit
Hofhund und Mops

Meissen, um 1745
Porzellan, polychrome Bemalung
in Aufglasurtechnik, Goldmalerei
Signatur/Marke: Schwerter in Blau
12,5 × 7,5 × 7,5 cm, 407 g
Inv.-Nr. A 592
Literatur: Arbeitsbericht J. J. Kändler,
Mai 1734: „Oben auf dieser Hunde
Hütte befinden sich 2 Mops hünd-
gen, wie sie sich auf der Hütte
herum beißen, der alte Budel Hund
aber welcher mit seiner anhaben-
den Kette aus dem Hunde Haus
herraus gekrpochen kömbt, siehet
auf seine Hütte was passiret mit
aufgesperrtem Maule als bellete er,
Neben der Hunde Hüttze befindet
sich ein Freß Tröglein, worin aller-
ley Knochen liegen." (Pietsch 2002).

Hundehütte mit herausschauen-
dem, angekettetem Hofhund, auf
dem Dach ein sich kratzender Mops
nach links gewandt; seitlich ange-
hängter Futternapf; Dachziegel in
zartem Manganviolett; beide Hun-
de naturalistisch staffiert in hellem
Grau, Mops mit purpurfarben-
goldenem Halsband mit goldenen
Schellen und türkisfarbener
Schleife; unglasierter Boden.

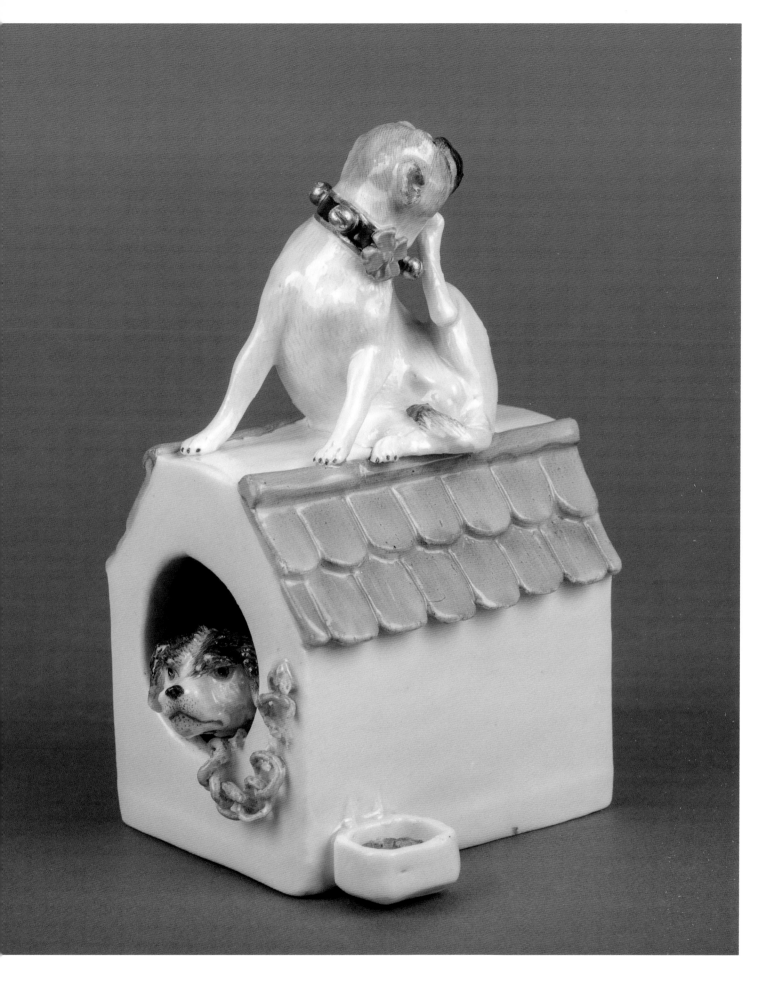

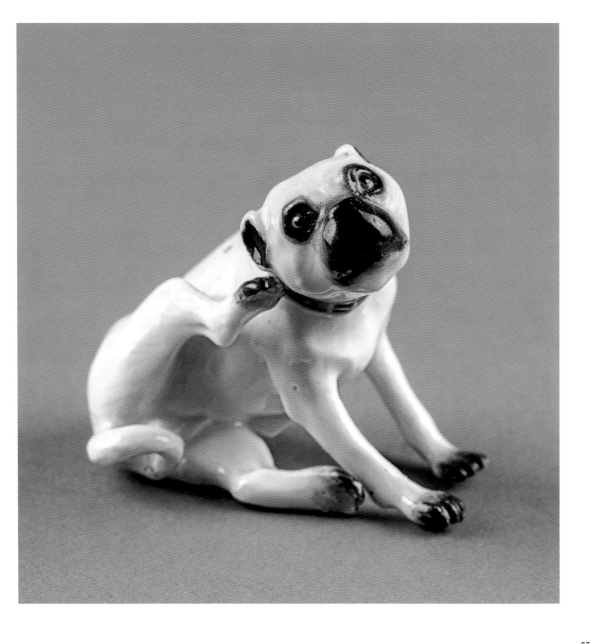

54 Sitzender, sich kratzender
Mops

Meissen, um 1750
Porzellan, polychrome Bemalung
in Aufglasurtechnik, Goldmalerei
Signatur/Marke: Schwerter in Blau,
Pressnummer „85", „2679"
4 × 4 × 3 cm, 18 g
Inv.-Nr. A 575
Literatur: s. Kat.-Nr. 56

Sitzender Mops, Kopf rechts
empor gewandt, mit rechter
Hinterpfote unterm Ohr kratzend,
helles Fell mit dunklen Partien,
blaues Halsband, flache, trichter-
förmige Ohren, geringelte Rute;
unglasierter Boden.

55 + 56 Zwei sitzende,
sich kratzende Möpse

Meissen, um 1750
Porzellan, polychrome Bemalung
in Aufglasurtechnik, Goldmalerei
Signatur/Marke: keine
6 × 5,5 × 5,5 cm, 60 g
6 × 4,8 × 4,5 cm, 68 g
Inv.-Nr. A 568, 569
Literatur: Rückert 1966, S. 268,
S. 195 f.

Sitzende Möpse, Kopf rechts bzw.
links empor gewandt, je eine Hin-
terpfote zum Kratzen erhoben,
helles Fell mit dunklen Partien,
purpurfarben-goldenes Halsband
mit goldenen Schellen bzw. rosa
Halsband mit Goldrand, türkis-
grüner Schleife und goldenen
Schellen, flache, trichterförmige
Ohren, geringelte Rute; unglasierter
Boden mit Brennloch.

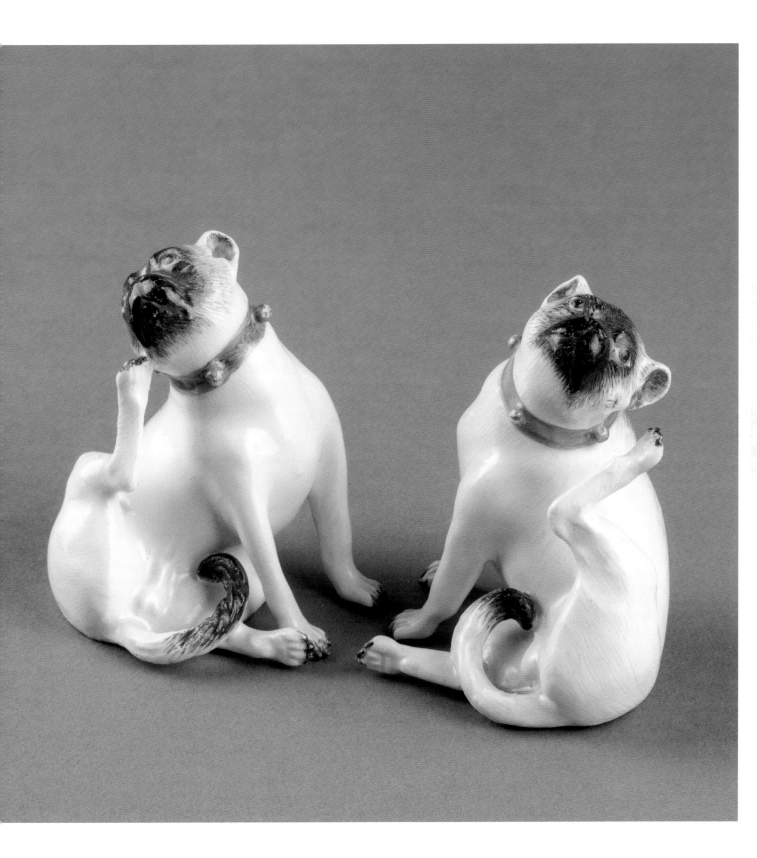

57 Sitzender, sich kratzender
Mops auf Grassockel

Höchst, um 1760
Fayence, polychrome Bemalung
in Aufglasurtechnik
Signatur/Marke: keine
9 × 18,5 × 6,5 cm, 216 g
Inv.-Nr. A 598
Literatur: s. Kat.-Nr. 58

Sitzender Mops auf grün staffier-
tem Grassockel, Kopf nach rechts
gewandt, rechte Hinterpfote zum
Kratzen erhoben, helles Fell mit
dunklen Partien, flache, trichter-
förmige Ohren, geringelte Rute;
hohler Boden.

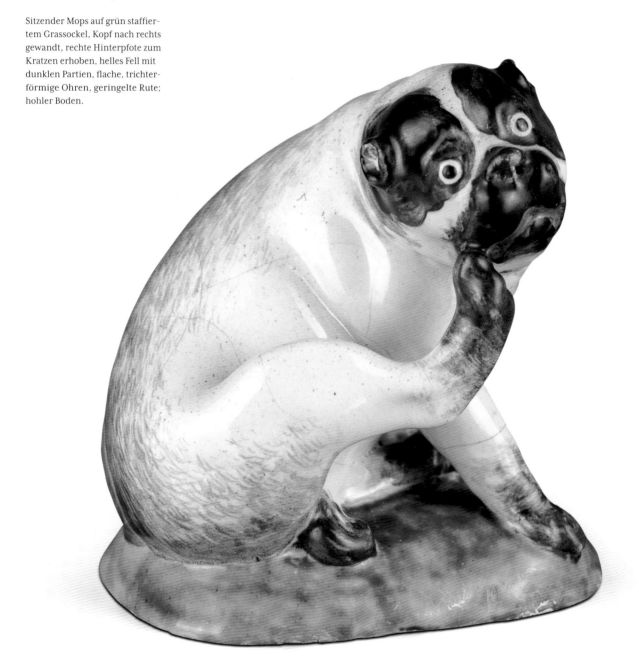

58 Sitzender, sich kratzender
Mops auf gewölbtem Sockel

Höchst, um 1750
Fayence, unbemalt
Signatur/Marke: keine
10 × 9,5 × 7 cm, 310 g
Inv.-Nr. A 523
Literatur: Reber 1986, S. 82.

Sitzender Mops auf ovalem, flachem
Sockel, Kopf nach rechts gewandt,
um sich mit der rechten Hinter-
pfote am Maul zu kratzen, flache,
trichterförmige Ohren, geringelte
Rute; glasierter Boden mit großer
Öffnung zur Hohlfigur.

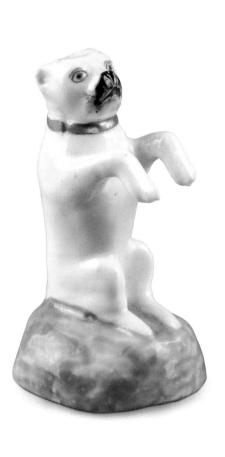

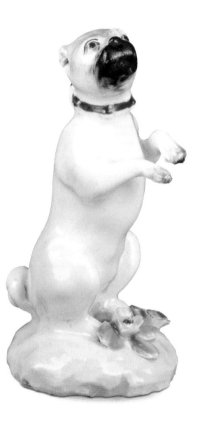

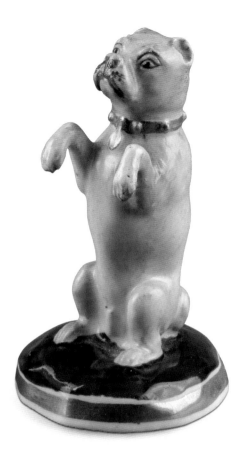

60 Männchen machender
Mops auf Blütensockel

59 Männchen machender
Mops auf ovalem Grassockel

Derby, um 1830
Porzellan, polychrome Bemalung
in Aufglasurtechnik, Goldmalerei
Signatur/Marke: keine
5,5 × 3,4 × 3 cm, 28 g
Inv.-Nr. A 579

Sitzender Mops auf ovalem, glasier-
tem und grün staffiertem Sockel,
beide Vorderbeine zum „Männchen
machen" erhoben, weißes Fell,
schwarz staffierte Schnauze, golde-
nes Halsband; hohler, innen glasier-
ter Sockel, Standfläche unglasiert.

Bow, um 1758
Porzellan, polychrome Bemalung
in Aufglasurtechnik
Signatur/Marke: keine
9 × 4 × 4 cm, 72 g
Inv.-Nr. A 623

Sitzender Mops auf glasiertem
Terrainsockel mit aufgelegter Blüte,
beide Vorderbeine zum „Männchen
machen" erhoben, weißes Fell,
schwarz staffierte, nach oben
gerichtete Schnauze, purpur-
farbenes Halsband; hohler, innen
glasierter Sockel, Standfläche
unglasiert.

61 Männchen machender
Mops auf Sockel

Derby, um 1830
Porzellan, polychrome Bemalung
in Aufglasurtechnik, Goldmalerei
Signatur/Marke: keine
6 × 3,4 × 3,4 cm, 29 g
Inv.-Nr. A 580

Sitzender Mops auf ovalem, rot
glasierten Sockel mit Goldrand,
beide Vorderbeine zum „Männchen
machen" erhoben, hellbraunes Fell,
goldenes Halsband mit goldenen
Schellen; hohler, innen glasierter
Sockel, Standfläche unglasiert.

62 Drei spielende Möpse auf Terrainsockel

Meissen, 19. Jahrhundert
Modell: August Ringler
Porzellan, polychrome Bemalung
in Aufglasurtechnik, Goldmalerei
Signatur/Marke: Knaufschwerter in
Blau, Pressnummer „F 186." „97"
„163"
9 × 16 × 10 cm, 633 g
Inv.-Nr. A 527

Dreiergruppe spielender Möpse
auf ovalem Terrainsockel mit Gold-
staffierung; braunes Fell mit dunk-
len Stellen, blaue Halsbänder mit
Schleifen und goldenen Schellen,
geöffnete Mäuler, geringelte Ruten;
glasierter Boden.

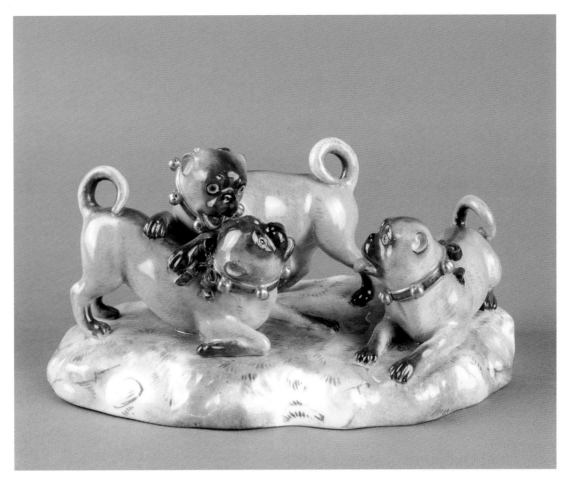

63 Drei spielende Möpse auf Terrainsockel

Meissen, 19. Jahrhundert
Modell: August Ringler
Porzellan, polychrome Bemalung
in Aufglasurtechnik, Goldmalerei
Signatur/Marke: Knaufschwerter in
Blau, Pressnummer „F 186." „66"
9 × 16 × 10 cm, 591 g
Inv.-Nr. A 526

Dreiergruppe spielender Möpse
auf ovalem Terrainsockel mit Gold-
staffierung; helles Fell mit dunkeln
Stellen, blau-goldene Halsbänder
mit blauen Schleifen und goldenen
Schellen, geöffnete Mäuler, gerin-
gelte Ruten; glasierter Boden mit
Brennloch.

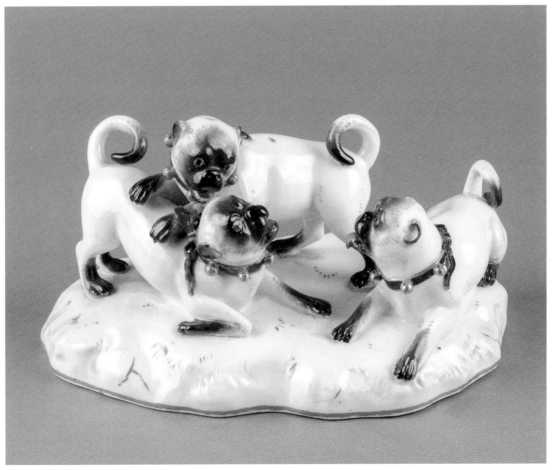

64 Deckeldose in Form eines Mopses

Abtsbessingen, um 1760
Fayence, polychrome Bemalung
in Scharffeuertechnik
Signatur/Marke: keine
9,7 × 15,8 × 9 cm, 424 g
Inv.-Nr. A 500 a, b
Literatur: Rudi 1998, Kat.-Nr. 19,
S. 92; Mahnert 1993, Kat.-Nr. 67, 68

Deckeldose in Form eines liegenden
Mopses, nach rechts schauend,
gelbes Fell, schwarze Schnauze,
angezogene Vorderbeine; obere
Hälfte des Rumpfes und Kopf als
Deckel abnehmbar; glasierter
Boden.

65 Deckeldose in Form eines Mopses

Abtsbessingen, um 1750
Fayence, polychrome Bemalung
in Scharffeuertechnik
Signatur/Marke: Schwarze Pinsel-
marke „λ. / v.“
10,5 × 17 × 9,5 cm, 470 g
Inv.-Nr. A 597 a, b
Literatur: s. Kat.-Nr. 64

Deckeldose in Form eines liegenden
Mopses, nach links schauend,
gelbes Fell, schwarze Schnauze,
angezogene Vorderbeine; obere
Hälfte des Rumpfes und Kopf als
Deckel abnehmbar; glasierter
Boden, starkes gleichmäßiges
Craquelé.

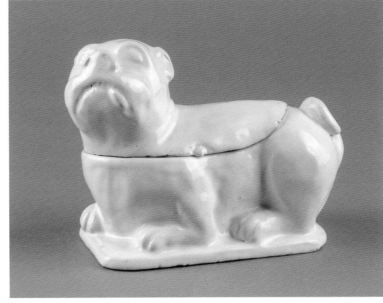

66 Liegender Mops auf Plinthe

wohl Dorotheenthal, 18. Jahrhundert
Fayence, unbemalt
Signatur/Marke: keine
11 × 16 × 8 cm, 398 g
Inv.-Nr. A 525

Liegender Mops auf rechteckiger
Plinthe, links emporschauend,
schwarze Staffierung im Gesicht,
angezogene Vorderbeine, flache,
trichterförmige Ohren, geringelte
Rute; unglasierter Boden, Brennloch
unterm Schwanz.

**67 Deckeldose in Form eines
liegenden Mopses**

Dorotheenthal, Abtsbessingen oder
Amberg, um 1770
Fayence, unbemalt
Signatur/Marke: AB: ligiert
10,8 × 16 × 7 cm, 433 g
Inv.-Nr. A 524
Literatur: s. Kat.-Nr. 64

Deckeldose in Form eines liegenden
Mopses auf rechteckiger Plinthe, links
emporschauend, angezogene Vorder-
beine, flache, trichterförmige Ohren,
geringelte Rute; oberes Drittel des
Rumpfes und Kopf als Deckel ab-
nehmbar; unglasierter Boden.

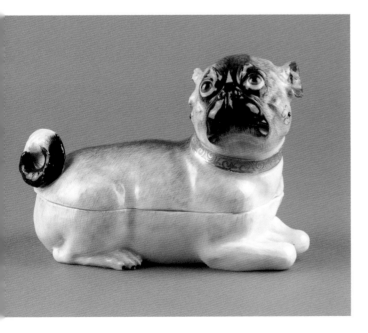

**68 Deckeldose in Form
eines liegenden Mopses**

Meissen, 1820–1830
Modell: Johann Joachim Kändler
Porzellan, polychrome Bemalung in
Aufglasurtechnik, Goldmalerei
Signatur/Marke: Schwerter in Blau
Pressnummern: „2809", „60 I"
12,8 × 18 × 9 cm, 753 g
Inv.-Nr. A 581 a, b

Deckeldose in Form eines liegenden
Mopses, nach rechts schauend,
graues Fell, schwarze Schnauze und
Schwanzspitze, rosa Halsband mit
goldenen Ranken, angezogene
Vorderbeine; obere Hälfte des
Rumpfes und Kopf als Deckel
abnehmbar; unglasierter Boden.

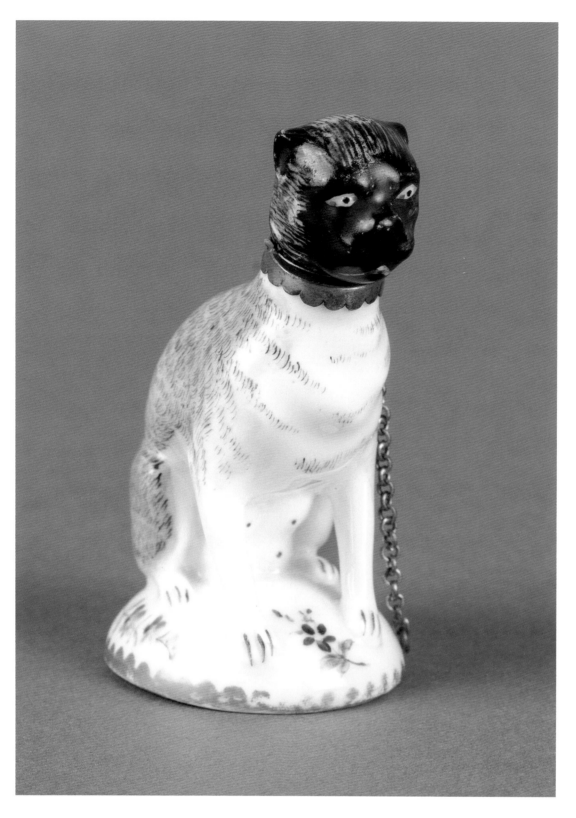

**69 Sitzende Möpsin
als Riechfläschchen**

Chelsea, 1755
Porzellan, polychrome Bemalung
in Aufglasurtechnik, Goldmalerei
Signatur/Marke: keine
6,5 × 3,5 × 4 cm, 30 g
Inv.-Nr. A 605
Literatur: Illgen 1973, Kat.-Nr. 93,
94, Abb. Tafel XIV

Aufrecht sitzende Möpsin auf
ovalem gewölbtem, innen und
außen mit Blüten bemaltem Sockel,
gezackter Goldrand, naturalistische
graue Fellzeichnung, Kopf dunkler
und als Stöpsel gearbeitet, mit
Kette am Metallhalsband befestigt.

70 Sitzende Möpsin
als Riechfläschchen

Chelsea, 1755
Porzellan, polychrome Bemalung
in Aufglasurtechnik, Goldmalerei
Signatur/Marke: keine
6,5 × 3,5 × 4 cm, 26 g
Inv.-Nr. A 621
Literatur: Porcelain Pugs:
A Passion, Nr. 131

Aufrecht sitzende Möpsin auf
ovalem gewölbtem, innen und
außen mit Blüten bemaltem Sockel,
gezackter Goldrand, naturalistische
graue Fellzeichnung, Kopf dunkler
und als Stöpsel gearbeitet, mit
Kette am Metallhalsband befestigt.

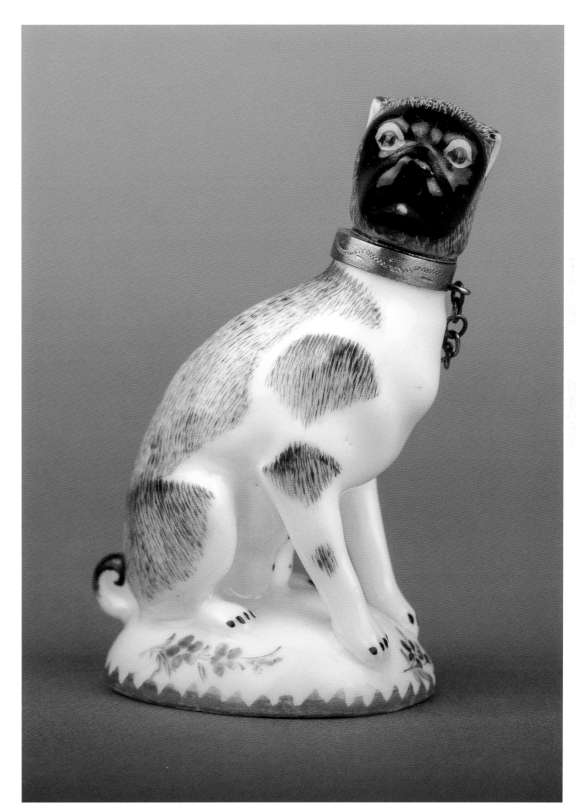

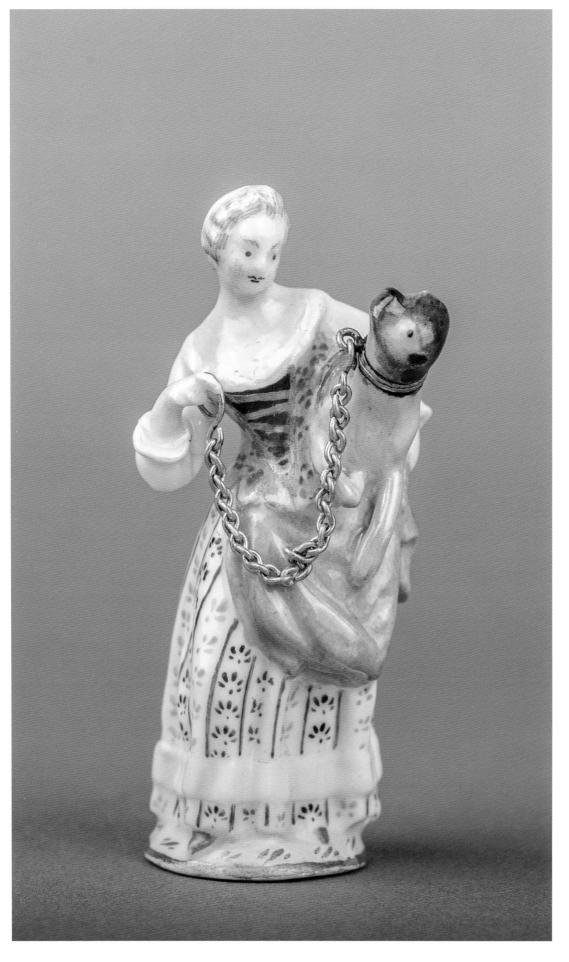

71 Miniaturfigur Dame mit Mops als Riechfläschchen

Meissen, 1755
Porzellan, polychrome Bemalung
in Aufglasurtechnik, Goldmalerei
Signatur/Marke: Schwerter in Blau
7,2 × 3 × 3 cm, 38 g
Inv.-Nr. A 606
Literatur: s. Kat.-Nr. 70

Stehende, leicht nach rechts ge-
beugte Dame mit Mops unter dem
linken Arm, auf flacher, gold-
gesäumter runder Platte, bunt
gestreifter Rock, blaues Mieder mit
rot-goldenem Einsatz, weiße Bluse,
purpurfarbene Schürze, rote Schuhe;
Mops mit naturalistischer brauner
Fellzeichnung, Kopf als Stöpsel
gearbeitet, Goldmontierung mit
Kette befestigt am Halsband und
ihrer rechten Hand.

72 Miniaturfigur Dame mit Mops als Riechfläschchen

Meissen, um 1750
Modell: Johann Joachim Kändler
Porzellan, polychrome Bemalung in
Aufglasurtechnik, Goldmalerei
Signatur/Marke: Schwerter in Blau
8 × 3 × 3 cm, 46 g
Inv.-Nr. A 622
Literatur: s. Kat.-Nr. 70

Stehende Dame auf rundem Ter-
rainsockel mit Mops unter dem
linken Arm, mit der rechten Hand
auf das Tier weisend, Dame mit
langem, floral gemustertem Rock,
rot-blau-goldenem Mieder über
weißer Bluse, purpurfarbener
Schürze, blauen Schuhen, Mops
mit naturalistisch brauner Fell-
zeichnung, rechte Vorderpfote
angewinkelt, Hundekopf als Stöpsel
abnehmbar und mit kleiner, an der
Montierung befestigter Kette.

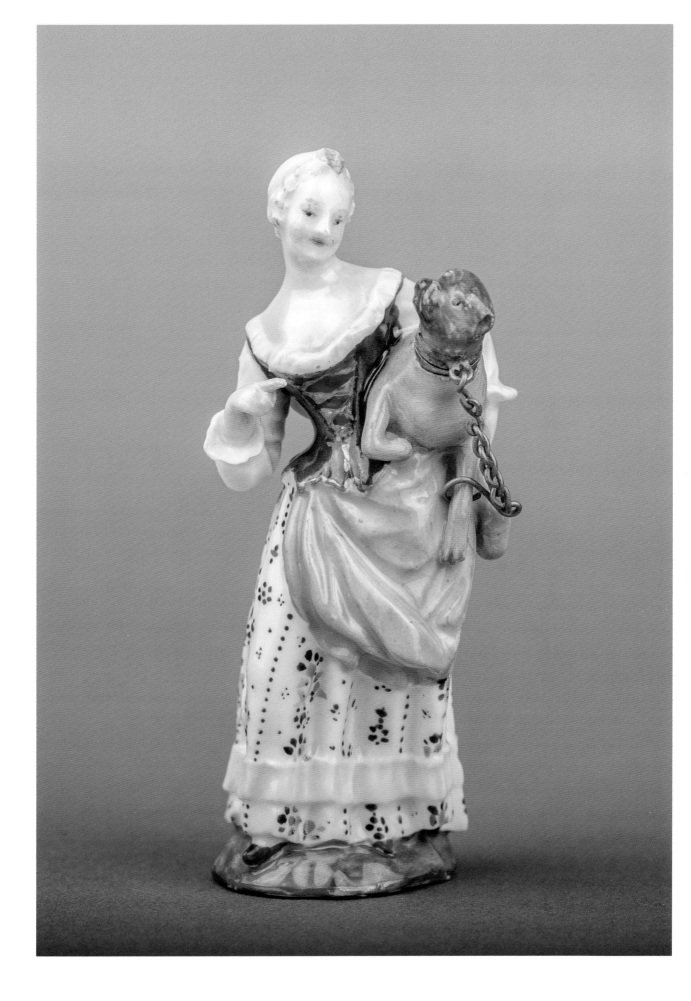

73 Stockgriff mit Mopskopf
und Genreszenen

Meissen, um 1740
Porzellan, polychrome Bemalung
in Aufglasurtechnik
Signatur/Marke: keine
6 × 13 × 3 cm, wegen Montierung
nicht wiegbar
Inv.-Nr. A 502
Literatur: s. Kat.-Nr. 74

Purpurfarbener Stockgriff mit
plastisch modelliertem Mopskopf,
geschweifter Handgriff mit Genre-
szenen in passigen Reserven,
Hundekopf naturalistisch model-
liert und staffiert, flache trichter-
förmige Ohren, goldenes Halsband
mit ornamentalem Dekor; zylindri-
scher Einsatz für den Stock, auf
dem der Griff mit einer Metall-
montierung befestigt ist.

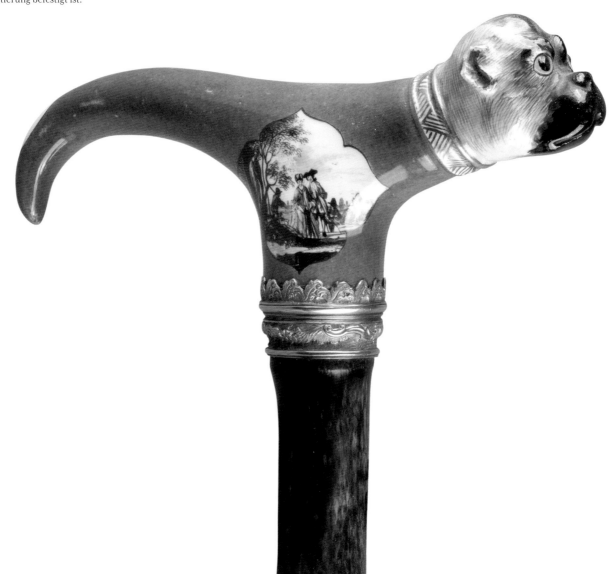

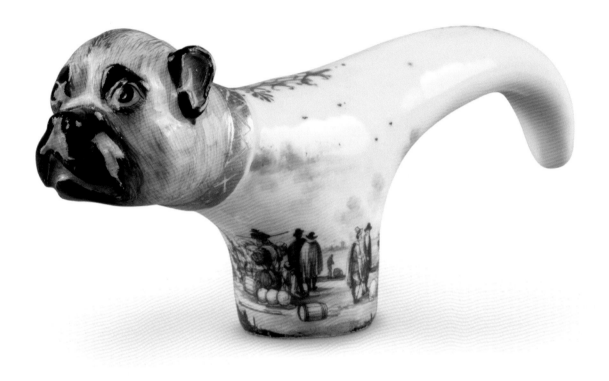

74 Stockgriff mit Mopskopf
und Kauffahrteiszenen

Meissen, um 1740
Modell: Johann Joachim Kändler
Porzellan, polychrome Bemalung in
Aufglasurtechnik
Signatur/Marke: Innenseite „ASS"
6 × 12,5 × 3,5 cm, 83 g
Inv.-Nr. A 501
Literatur: Newmann 1977, S. 87;
Blaauwen 2000, S. 295, Kat-Nr. 216;
Pietsch/Banz 2010, Nr. 448, S. 362.

Heller Stockgriff mit plastisch
modelliertem Mopskopf, geschweif-
ter Handgriff mit ornamentalem
Dekor, umlaufend mit filigranen
farbigen Kauffahrteiszenen, Hunde-
kopf naturalistisch modelliert und
staffiert, Maul leicht geöffnet,
flache trichterförmige Ohren
innen rosé, goldenes Halsband;
zylindrischer Einsatz für den Stock.

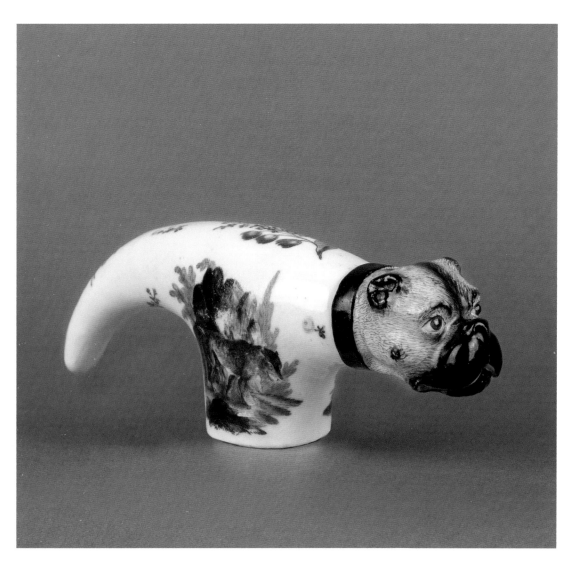

75 Stockgriff mit Mopskopf und Waldszene

Ludwigsburg, um 1770
Porzellan, polychrome Bemalung
in Aufglasurtechnik
Signatur/Marke: keine
4,5 × 12 × 3 cm, 81 g (mit Holzstopfen)
Inv.-Nr. A 588
Literatur: s. Kat.-Nr. 74

Heller Stockgriff mit plastisch
modelliertem Mopskopf mit
schwarzem Halsband, gebogener,
schlanker Handgriff bemalt mit
felsigem Waldstück, davor Gämse
und Wolf sowie Blumen auf den
Schmalseiten, zylindrischer Einsatz
für den Stock, Hundekopf natura-
listisch modelliert und grau staf-
fiert, flache trichterförmige Ohren,
schwarzes Halsband.

76 Stockgriff mit Mopskopf und Kauffahrteiszenen

Meissen, um 1750
Porzellan, polychrome Bemalung
in Aufglasurtechnik, Goldmalerei
Signatur/Marke: keine
6 × 12,8 × 3 cm, G 74 g
Inv.-Nr. A 609
Literatur: s. Kat.-Nr. 74

Heller Stockgriff mit plastisch
modelliertem Mopskopf mit
purpur-goldenem Halsband, vier
Kartuschen mit Kauffahrteiszenen
umgeben von Lambrequindekor
in Purpur und Gold, Hundekopf
naturalistisch modelliert und
grauschwarz staffiert, flache trich-
terförmige Ohren.

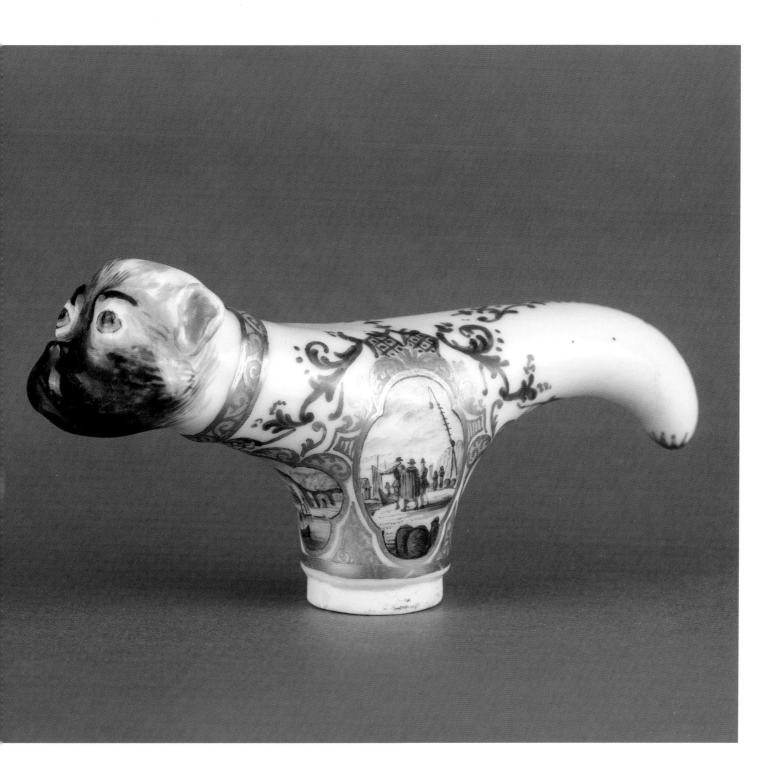

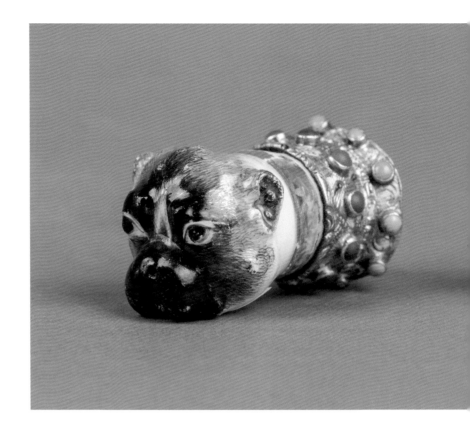

77 Mopskopf als Petschaft

Meissen, um 1740
Porzellan, polychrome Bemalung in
Aufglasurtechnik, Goldmalerei
Signatur/Marke: keine
3 × 5,5 × 3,5 cm, 42 g
Inv.-Nr. A 596

Grauschwarzer Mopskopf, naturalis-
tische Staffierung, flache, trichter-
förmige Ohren, purpurfarben-
goldenes Halsband mit goldenen
Ranken; Metallmontierung mit
umlaufenden Bändern, darin
Korallen und Türkise, im Stand ein
großer transparenter Bergkristall.

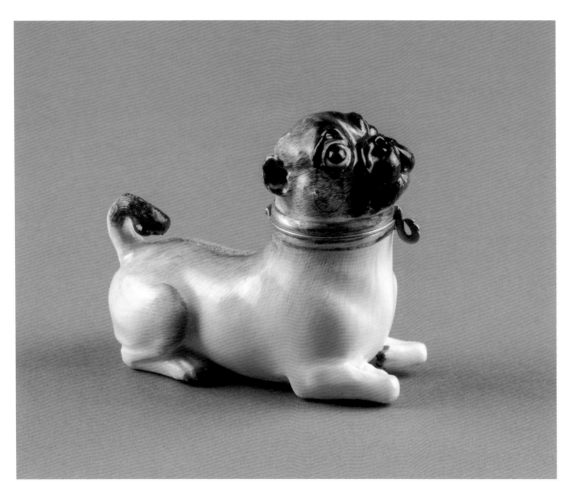

78 Pfeifenkopf in Form eines liegenden Mopses

Meissen, 18. Jahrhundert
Porzellan, polychrome Bemalung
in Aufglasurtechnik
Signatur/Marke: keine
5,7 × 7,2 × 3,3 cm, 93 g
Inv.-Nr. A 504
Literatur: Illgen 1973, Kat.-Nr. 102,
Tafel VII.

Pfeifenkopf in Form eines liegenden
Mopses, hellgraues Fell, im Gesicht
schwarzbraun mit heraushängender
roter Zunge, angezogene Vorderbeine,
flache, trichterförmige Ohren, gerin-
gelte Rute, Kopf mit Rauchlöchern in
Nase, Maul und Ohren; Halsband als
Montierung zum Aufklappen des
Kopfes, am hinteren Ende Öffnung
zum Einschieben der Pfeife.

79 Mopskopf als Dose

England, Anfang des 19. Jahrhunderts
Holz oder Nuss polychrom bemalt
(Mopskopf); Porzellan, polychrome
Bemalung in Aufglasurtechnik
(Deckel), Metallmontierung
Signatur/Marke: keine
5,5 × 5 × 5 cm, 49 g
Inv.-Nr. A 608

Brauner Mopskopf mit schwarzer
Schnauze und roter heraus gestreck-
ter Zunge; im Deckel Miniaturporträt
einer Dame in purpurfarbener Robe
und mit floralem Hut (Punktiertech-
nik), außen galante Szene mit drei
Damen im Park; Metallmontierung.

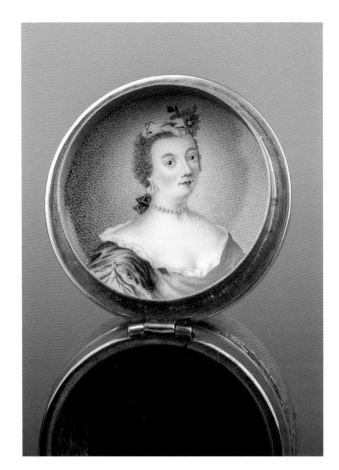

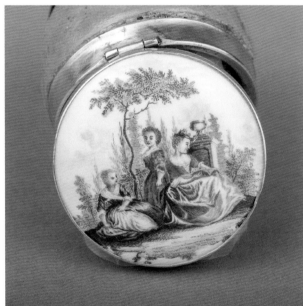

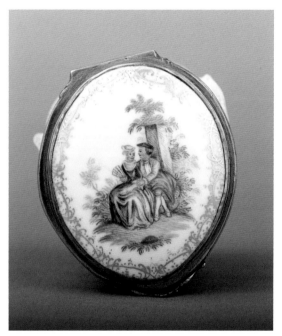

Details Kat.-Nr. 80

Details Kat.-Nr. 81

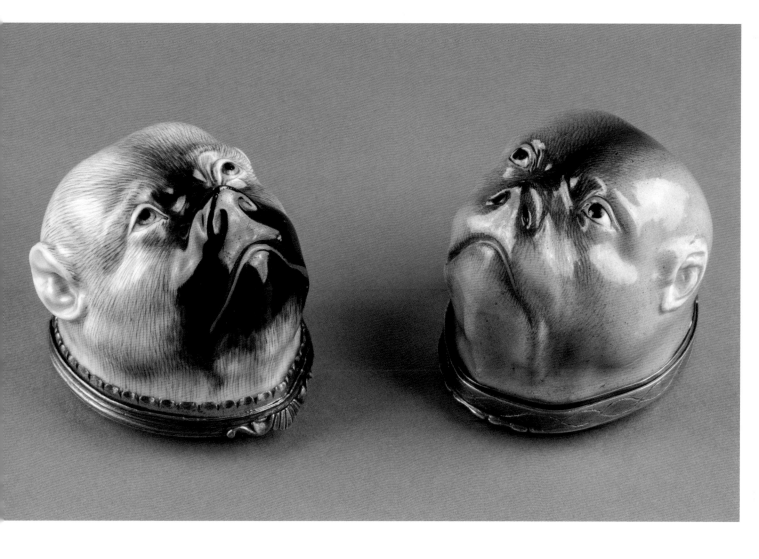

80 Tabatière in Form eines Mopskopfes

Meissen, frühes 19. Jahrhundert
Porzellan, polychrome Bemalung
in Aufglasurtechnik
Signatur/Marke: keine
8 × 6 × 5 cm, 107 g
Inv.-Nr. A 508
Literatur: s. Kat.-Nr. 81

Runde Dose in Form eines Mops-
kopfes, hellgraues Fell, flache,
trichterförmige Ohren, Gesichts-
züge vermenschlicht; beidseitig
glasiertes Bodenteil als Deckel,
bemalt mit Genreszenen im Park;
beide Teile verbunden durch ver-
goldete Metallmontierung.

81 Tabatière in Form eines Mopskopfes

wohl Kopenhagen, 1770–1780
Porzellan, polychrome Bemalung
in Aufglasurtechnik
Signatur/Marke: keine, Silber-
montierung mit Altonaer Beschau
6,5 × 6,5 × 5,5 cm, 121 g
Inv.-Nr. A 507
Literatur: Illgen 1973, Kat.-Nr. 111,
Tafel XVI; Blaauwen 2000, S. 37,
Kat.-Nr. 271.

Runde Dose in Form eines Mops-
kopfes, hellbraunes Fell, flache,
trichterförmige Ohren, Gesichts-
züge vermenschlicht; beidseitig
glasiertes Bodenteil als Deckel,
bemalt mit Jagdszene (innen) und
Pfauenpaar (außen); beide Teile
verbunden durch vergoldete
Silbermontierung, innen Gold
gefasst.

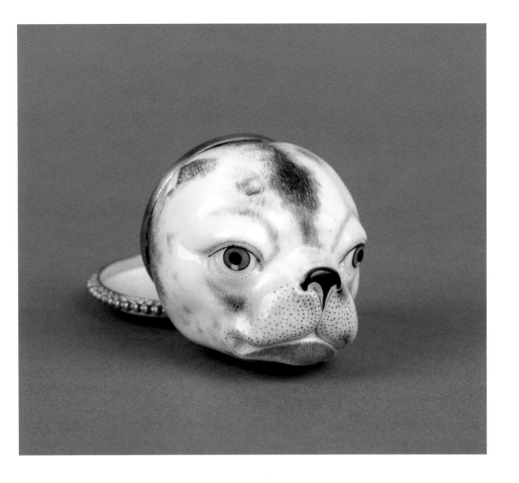

82 Tabatière in Form eines Mopskopfes

Deutsch oder Kopenhagen,
18./frühes 19. Jahrhundert
Porzellan, polychrome Bemalung
in Aufglasurtechnik
Signatur/Marke: keine
6,5 × 6,5 × 5,5 cm, 72 g
Inv.-Nr. A 594
Literatur: s. Kat.-Nr. 81

Runde Dose in Form eines Mops-
kopfes, weißes Fell mit rotbraunen
und dunkelgrauen Flecken, flache,
trichterförmige Ohren; beidseitig
glasiertes Bodenteil als Deckel,
bemalt mit Flusslandschaft in
Rotbraun (außen); beide Teile
verbunden durch vergoldete
Metallmontierung.

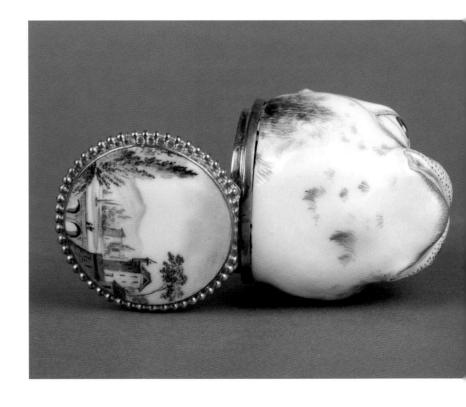

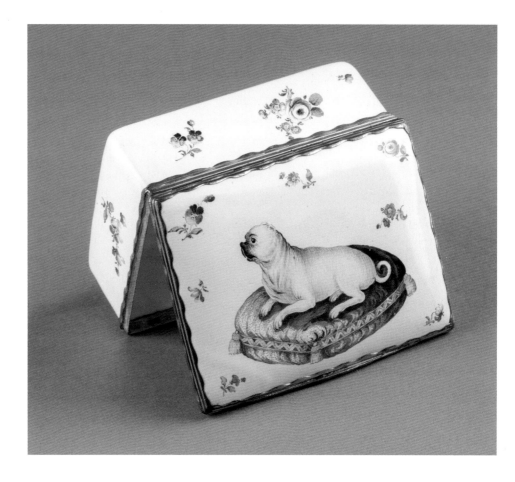

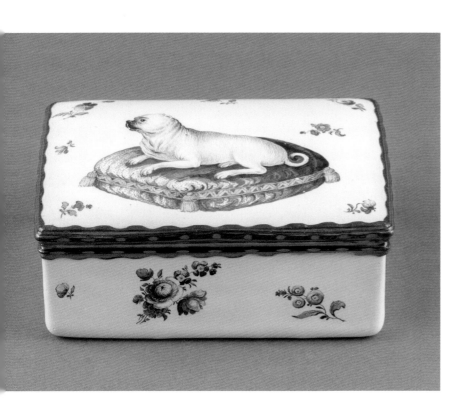

83 Tabatière mit liegendem Mops auf rotem Samtkissen

Battersea, 1735–1756
Email auf Kupfer, polychrome Bemalung in Aufglasurtechnik
Signatur/Marke: keine
3,3 × 9 × 6,5 cm, 162 g
Inv.-Nr. A 514

Rechteckige Dose, Seiten, Boden und Innenseite des Deckels glasiert und mit Streublumen bemalt, Deckel mit liegendem Mops auf purpurfarbenem Kissen bemalt; beide Teile verbunden durch vergoldete Metallmontierung.

84 Tabatière
mit Genreszenen

Süddeutschland, um 1760
Georg Christoph Lindemann
(Maler)
Email auf Kupfer, polychrome
Bemalung in Aufglasurtechnik
Signatur/Marke: keine
5,5 × 7,5 × 5 cm, 142 g
Inv.-Nr. A 587
Literatur: Porcelain Pugs: A Passion
2019, S. 212, Kat.-Nr. 110.

Dose, alle Seiten glasiert, bemalt
mit Genreszenen in Landschaft;
Deckel innen mit Männchen
machendem Mops; vergoldete
Metallmontierung.

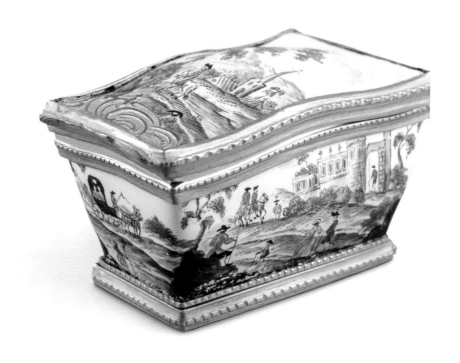

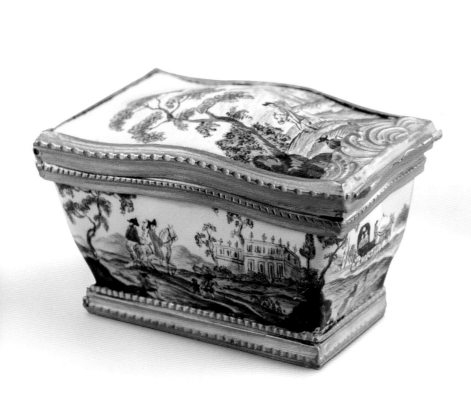

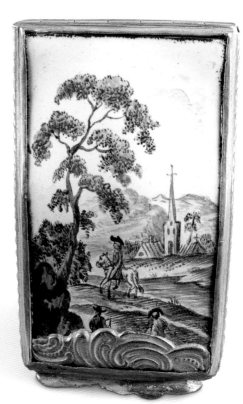

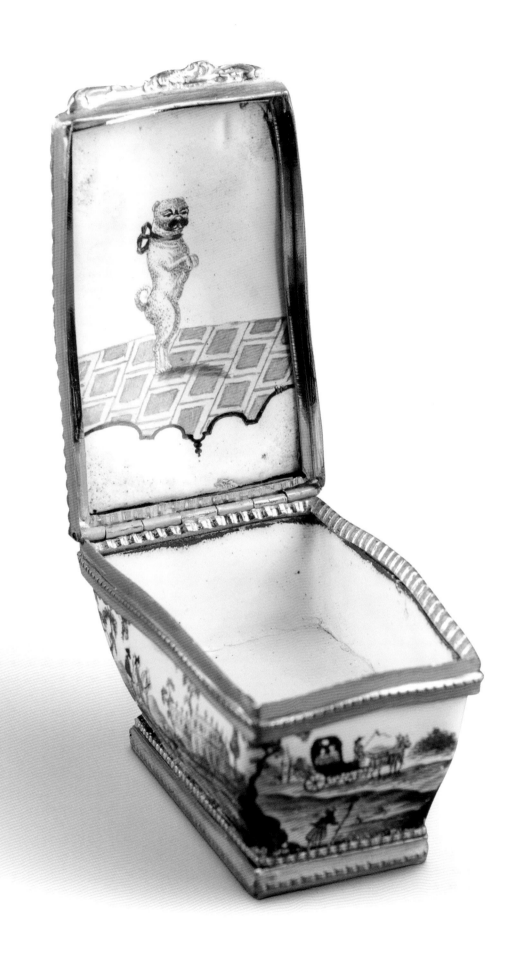

85 Ovale Tabatière mit Frisier- und Genreszenen

Süddeutschland, um 1770
Email auf Kupfer, polychrome
Bemalung in Aufglasurtechnik
Signatur/Marke: keine
4,5 × 13 × 6,5 cm, 151 g
Inv.-Nr. A 513

Ovale Dose, alle Seiten glasiert und bemalt, Deckel mit persiflierender Frisierszene mit Mops, umgeben von reicher Architekturschilderung, beide Längsseiten mit Genreszenen im Park, Boden mit schmaler Landschaftsdarstellung; beide Teile verbunden durch vergoldete Metallmontierung.

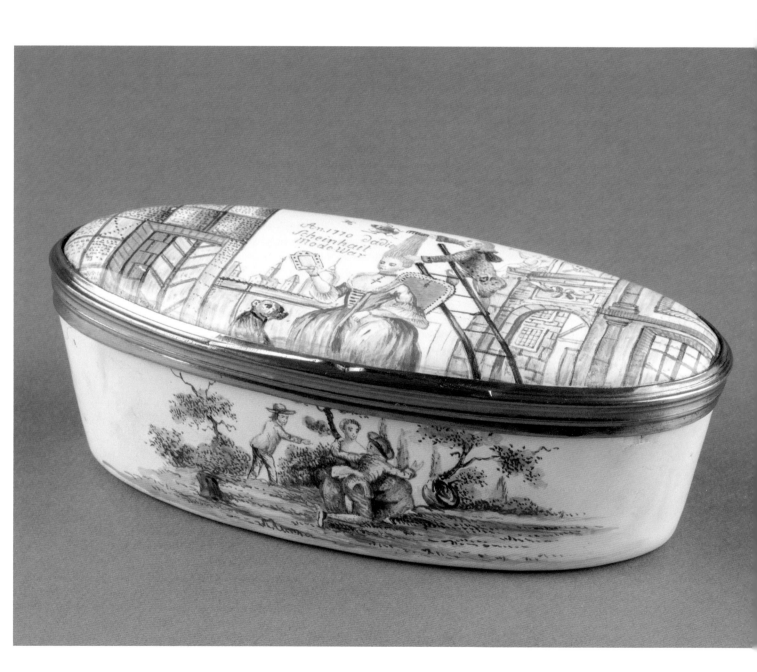

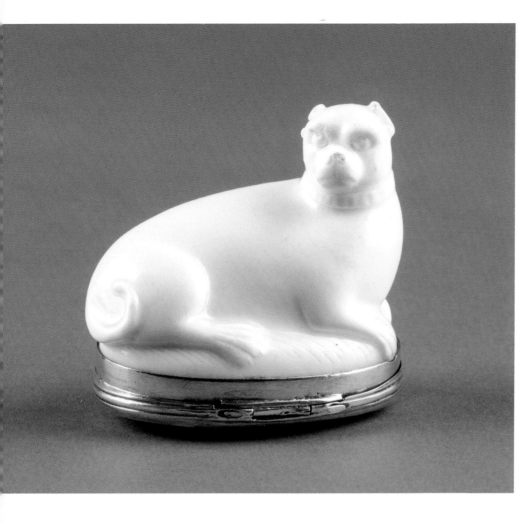

86 Dose in Form eines liegenden Mopses auf Grassockel

Mennecy, um 1760
Weichporzellan, unbemalt
(glasartig)
Signatur/Marke: keine
4,4 × 4,5 × 3,4 cm, 38 g
Inv.-Nr. A 583
Literatur: Porcelain Pugs: A Passion
2019, S. 215, Kat.-Nr. 118, 119.

Ovale Dose mit liegendem Mops
auf Grassockel, Kopf nach rechts
gewandt, angezogene Vorderbeine,
genopptes Halsband, flache, trich-
terförmige Ohren, geringelte Rute;
beidseitig glasiertes Bodenteil als
Deckel mit plastisch aufgelegte
Blumen (außen); beide Teile ver-
bunden durch Silbermontierung.

87 Dose mit liegendem Mops auf Grassockel

Mennecy, um 1760
Weichporzellan, polychrome
Bemalung in Aufglasurtechnik
Signatur/Marke: keine
5,4 × 5,7 × 4 cm, 58 g
Inv.-Nr. A 512
Literatur: s. Kat.-Nr. 86

Ovale Dose mit liegendem Mops auf
grün staffiertem Grassockel, Kopf
nach rechts zurückgewandt, hell-
braunes Fell, im Gesicht schwarz-
braun, purpurfarbenes Halsband,
gestreckte Vorderbeine, flache,
trichterförmige Ohren, geringelte
Rute; beidseitig glasiertes Bodenteil
als Deckel mit gemalten Blumen
(innen) und plastisch aufgelegten
und bemalten Blumen (außen);
beide Teile verbunden durch
Silbermontierung.

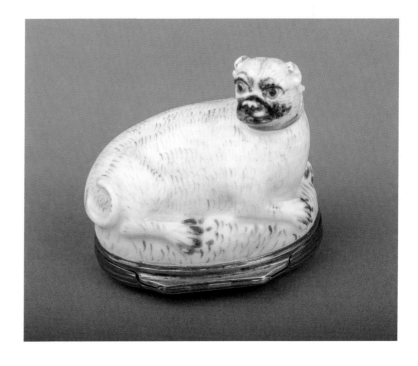

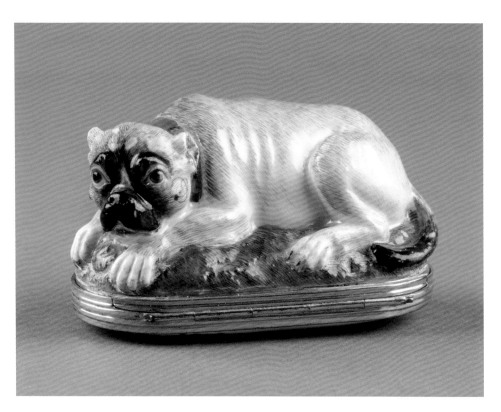

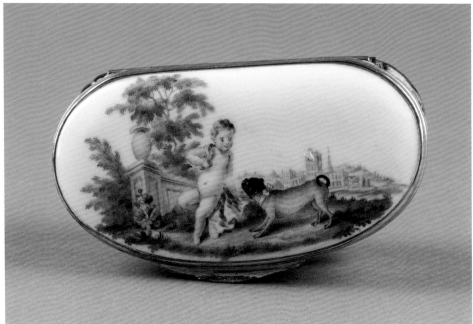

88 Dose mit liegendem Mops auf Grassockel

Meissen, datiert 1741
Modell: Johann Joachim Kändler
Porzellan, polychrome Bemalung
in Aufglasurtechnik
Signatur/Marke: keine
5 × 8 × 4,5 cm, 111 g
Inv.-Nr. A 506
Literatur: Porcelain Pugs: A Passion
2019, S. 214, Kat.-Nr. 114.

Ovale Dose mit liegendem Mops
auf grün staffiertem Grassockel,
hellbraun-graues Fell, im Gesicht
schwarz, sehr naturalistische Model-
lierung, Kopf und Schwanz abgelegt,
flache, trichterförmige Ohren,
purpur-goldenes Halsband mit
Wellenbandmotiv; beidseitig glasier-
tes Bodenteil als Deckel, Malerei auf
der Außenseite mit Putto und Mops
in arkadischer Landschaft; beide
Teile verbunden durch vergoldete
Metallmontierung.

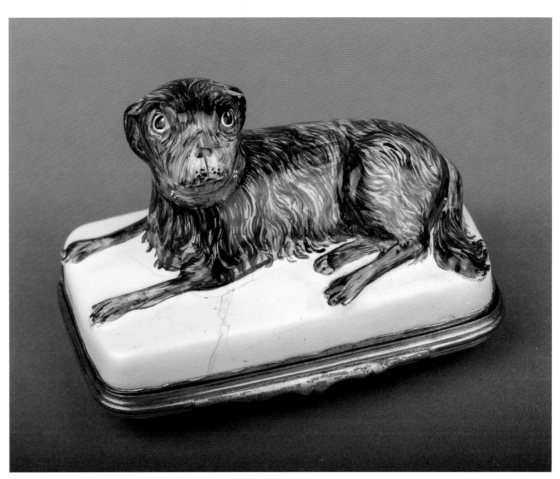

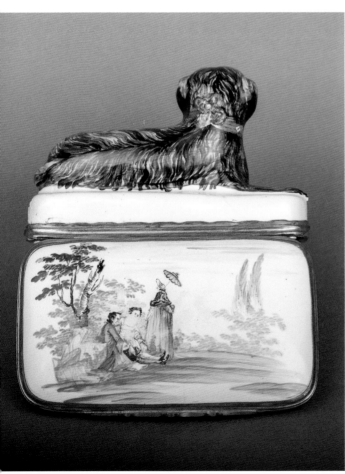

89 Dose mit liegendem
Hund auf Kissen

Süddeutschland, um 1760
Email auf Kupfer, polychrome
Bemalung in Aufglasurtechnik
Signatur/Marke: keine
6,7 × 10 × 6 cm, 171 g
Inv.-Nr. A 510

Rechteckige Dose mit liegendem
Hund auf unbemaltem Sockel,
schwarzes langhaariges Fell, Kopf
nach links gewandt, gestreckte
Vorderbeine, lange hängende
Ohren, purpurfarbenes Halsband;
beidseitig glasiertes Bodenteil als
Deckel mit arkadischer Ruinen-
landschaft in Purpurcamaieu
(innen) und polychrome Genre-
szene im Park (außen); beide Teile
verbunden durch vergoldete
Metallmontierung.

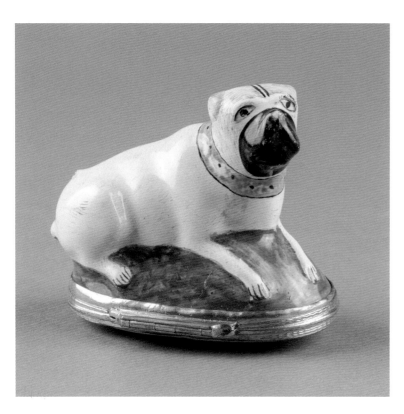

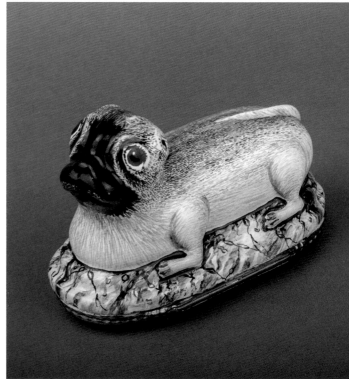

90 Dose in Form eines liegenden Mopses auf purpurfarbenem Kissen

Schrezheim, 1761–1763
wohl Johann Andreas Bechdolff
(Maler)
Porzellan, polychrome Bemalung
in Aufglasurtechnik
Signatur/Marke: keine
6,8 × 7,5 × 5 cm, 89 g
Inv.-Nr. A 509

Ovale Dose mit liegendem Mops auf
purpurfarbenem Sockel, helles Fell,
im Gesicht schwarz, gestreckte
Vorderbeine, flache, trichterförmi-
ge Ohren, grünes Halsband; beid-
seitig glasiertes Bodenteil als Deckel
mit Streublumen auf der Innen-
und Außenseite; beide Teile ver-
bunden durch feuervergoldete
Metallmontierung.

91 Dose mit liegendem Mops auf Sockel

Süddeutschland, 1760–1770
Umkreis Johann Andreas Bechdolff
(Maler)
Fayence, polychrome Bemalung in
Aufglasurtechnik, Email auf Kupfer
Signatur/Marke: keine
6,5 × 9,5 × 5,3 cm, 141 g
Inv.-Nr. A 505
Literatur: Beaucamp-Markowsky
1985, Nr. 316.

Ovale Dose mit liegendem Mops auf
marmoriertem Sockel, hellbraun-
graues Fell, im Gesicht schwarz,
verkürzte Beine, flache, trichter-
förmige Ohren, Schwanz auf dem
Rücken abgelegt; beidseitig glasiertes
Bodenteil mit Genreszenen im Park
als Deckel; beide Teile verbunden
durch vergoldete Metallmontierung.

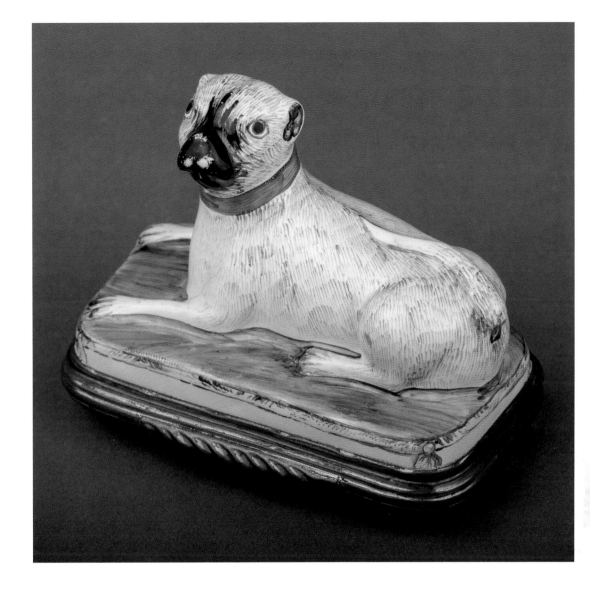

92 Dose mit liegendem
Mops auf Kissen

Süddeutschland, um 1760
Email auf Kupfer, polychrome
Bemalung in Aufglasurtechnik
Signatur/Marke: keine
6 × 7,7 × 4,5 cm, 104 g
Inv.-Nr. A 511

Rechteckige Dose mit liegendem
Mops auf purpurfarbenem Kissen,
hellgraues Fell, im Gesicht schwarz,
hochgereckter Kopf nach links
gewandt, blaues Halsband, ge-
streckte Vorderbeine, flache, trich-
terförmige Ohren, Schwanz auf dem
Rücken abgelegt; beidseitig glasier-
tes Bodenteil als Deckel mit arkadi-
scher Landschaftsszene in Purpur-
camaieu (innen) und polychrome
Genreszene im Park (außen); beide
Teile verbunden durch vergoldete
Metallmontierung.

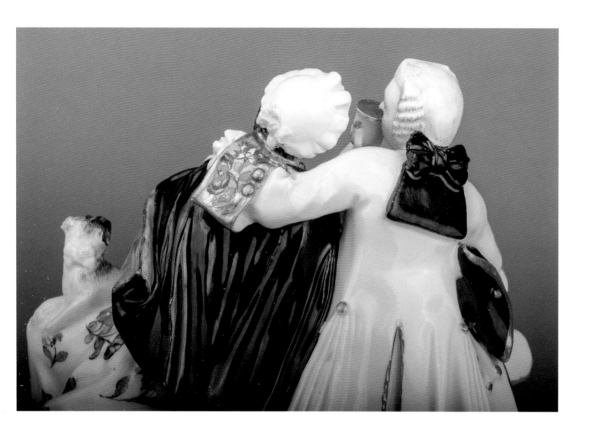

93 Liebespaar mit Mops beim Schokoladetrinken

Meissen, um 1765
Modell: Johann Joachim Kändler
Porzellan, polychrome Bemalung in
Aufglasurtechnik, Goldmalerei
Signatur/Marke: Schwerter in Blau
14,5 × 14,5 × 14,2 cm, 1365 g
Inv.-Nr. A 808
Literatur: Menzhausen/Karpinski
1993, S. 114: „Taxa Kändler vom
21. Nov. 1744: 1. Frey Maurer Group-
gen, da ein Frey-Maurer in seiner
Kleidung und Schurz Fell neben
einer Dame vom Mopß-Orden sizet,
welche ihm mit einer Choccolate,
die sie auf dem Tische neben sich
stehen hat, beehret, auf deren
Schoß liegt ein Mopß."; Cassidy-
Geiger 2008, Nr. 53, S. 265.

Figurengruppe auf ovalem Sockel
mit aufgelegten plastischen Blüten
und Blättern, Paar auf einer
„Bank" sitzend, davor ein Tisch
mit geschwungenen Beinen, dar-
auf eine blumenstaffierte Schoko-
ladenkanne, eine Tasse mit Unter-
schale, eine zweite Tasse reicht die
Dame dem Kavalier zum Mund,
auf dem Schoss der Dame liegt ein,
sich von der Szene abwendender
Mops mit rosa Halsband, Kavalier
in heller Kleidung mit schwarzer
Kniehose und ebensolchen Schu-
hen sowie Dreispitz, Dame mit
weißem geblümten Kleid,
schwarz-purpurfarbenem Um-
hang und purpurnen Schuhen,
unter dem Tisch eine Freimaurer-
kelle; unglasierter Boden mit
Brennloch.

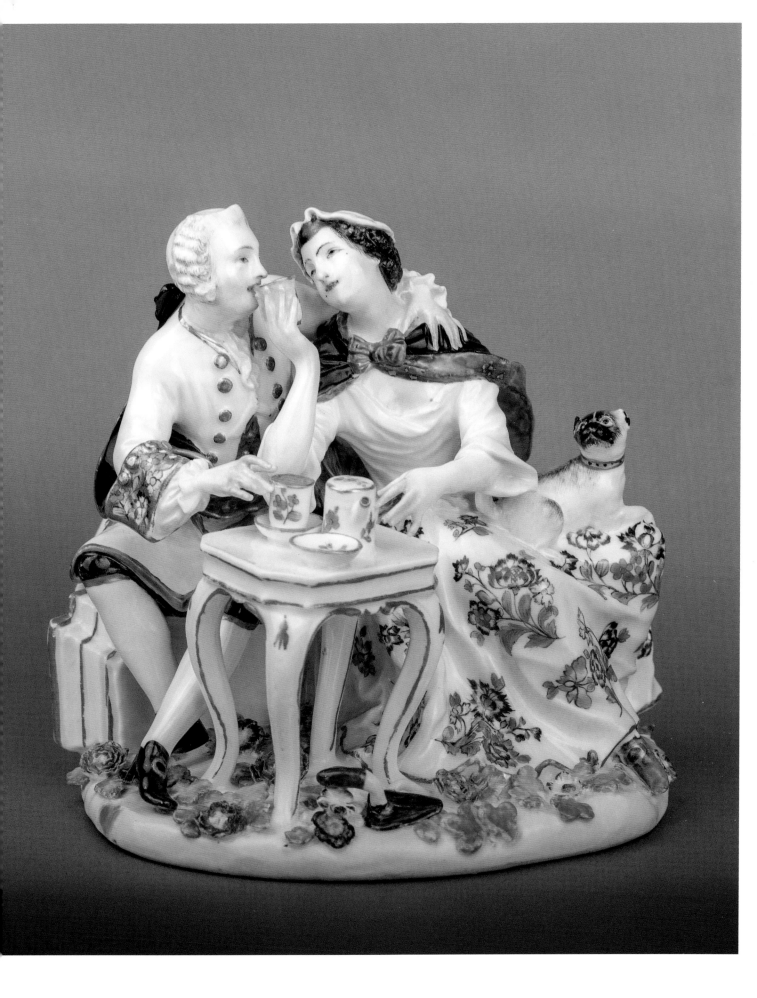

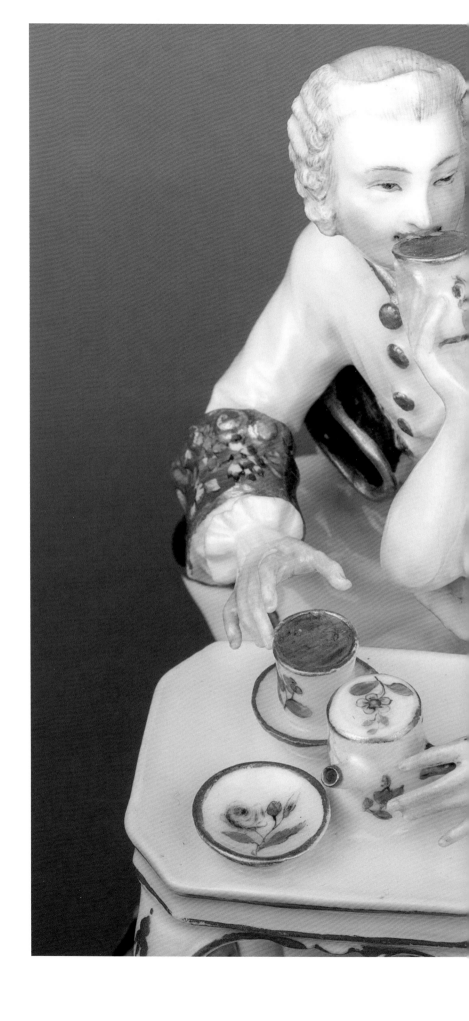

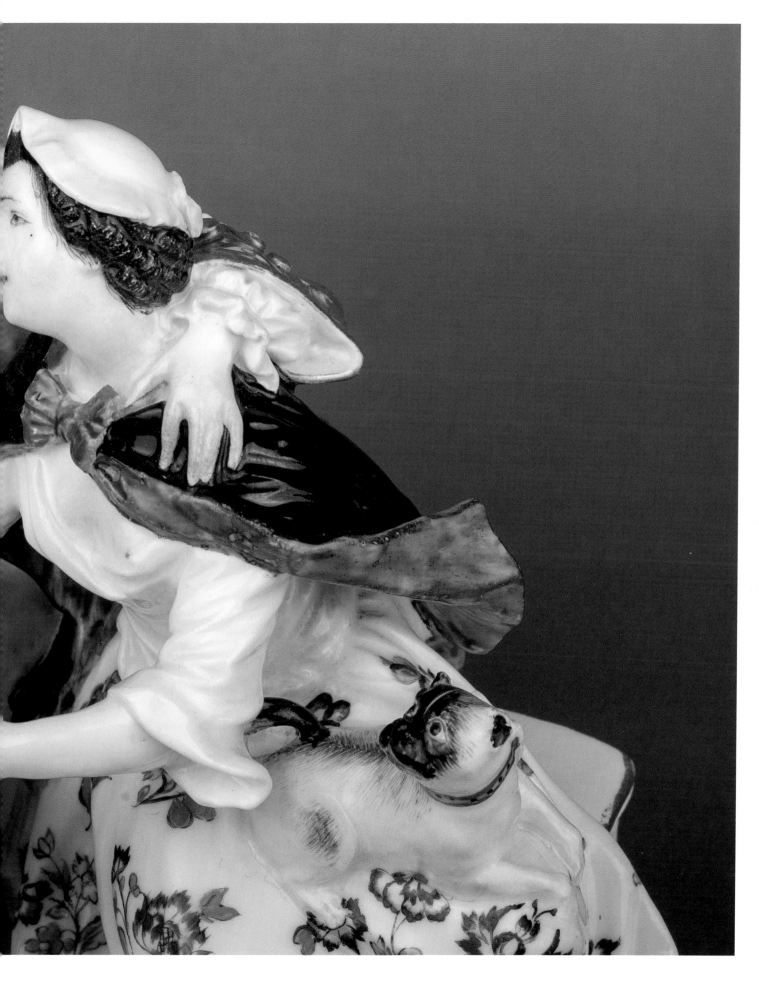

94 Liebespaar mit Mops in einer Laube sitzend

Meissen, um 1765
Modell: Johann Joachim Kändler
Porzellan, polychrome Bemalung
in Aufglasurtechnik, Goldmalerei
Signatur/Marke: Pressnummer
„34"
19,5 × 15 × 10 cm, 933 g
Inv.-Nr. A 815
Literatur: Pietsch 2006, S. 27,
Kat.-Nr. 22.
Provenienz: Sammlung Oppenheim
(handschriftlich auf Boden ver-
merkt)

Einander zugeneigtes Liebespaar
auf ovalem, mit aufgelegten plasti-
schen Blüten und Blättern verzier-
tem Sockel, dahinter aufragende
Laube aus Gitter- und Rocaille-
Elementen mit Goldstaffierung,
Dame in geblümten Kleid, schwar-
zem Mieder und weißem Hut,
Kavalier mit weißem Schoßrock,
Weste und Strümpfen, purpur-
farbener Kniehose und schwarzen
Schnallenschuhen; mittig springt
ein Mops an ihrem Rock empor,
helles Fell mit dunklen Partien,
purpurnes Halsband mit gelber
Schleife und goldenen Schellen,
flache, trichterförmige Ohren,
geringelte Rute; unglasierter Boden
mit Brennloch.

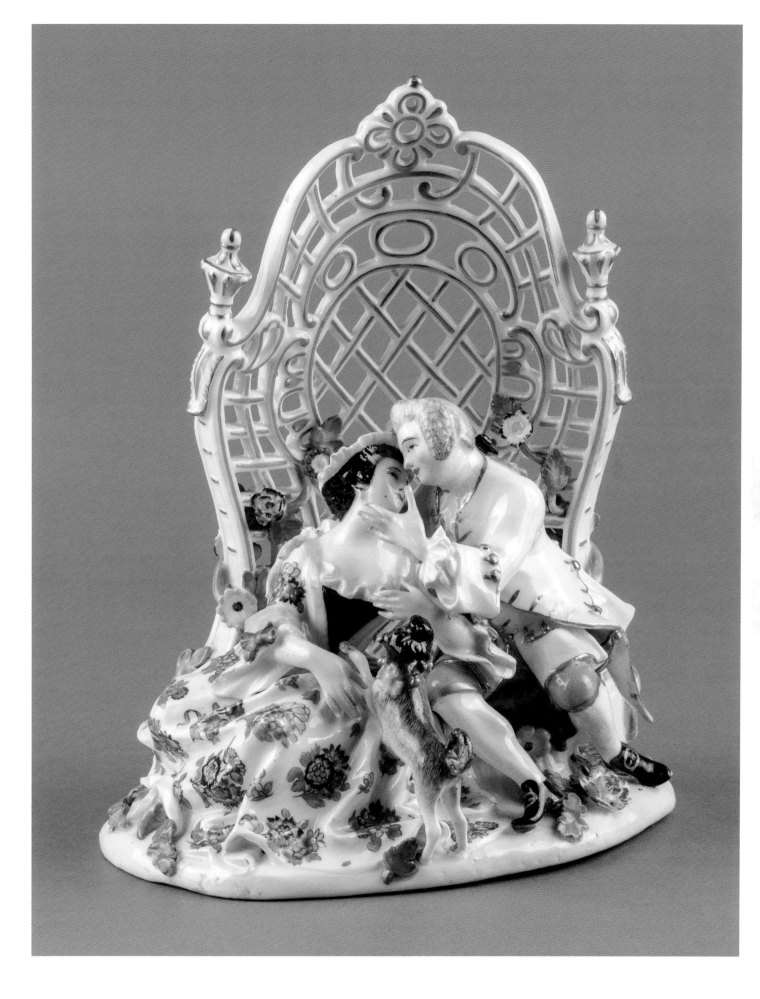

95 Liebespaar mit Mops

Meissen, um 1765
Modell: Johann Joachim Kändler
Porzellan, polychrome Bemalung in
Aufglasurtechnik, Goldmalerei
Signatur/Marke: keine
11,5 × 16 × 10 cm, 743 g
Inv.-Nr. A 826
Literatur: s. Kat.-Nr. 94

Einander zugeneigtes, sich umar-
mendes Liebespaar auf ovalem, mit
aufgelegten plastischen Blüten und
Blättern verziertem Sockel, Dame
in geblümten Kleid, schwarzem
Mieder und weißem Hut, Kavalier
mit weißem Schoßrock, Weste und
Strümpfen, schwarze Kniehose und
schwarzen Schnallenschuhen;
mittig springt ein Mops an ihrem
Rock empor, helles Fell mit dunklen
Partien, purpurnes Halsband
mit roter Schleife, flache, trichter-
förmige Ohren, geringelte Rute;
unglasierter Boden mit Brennloch.

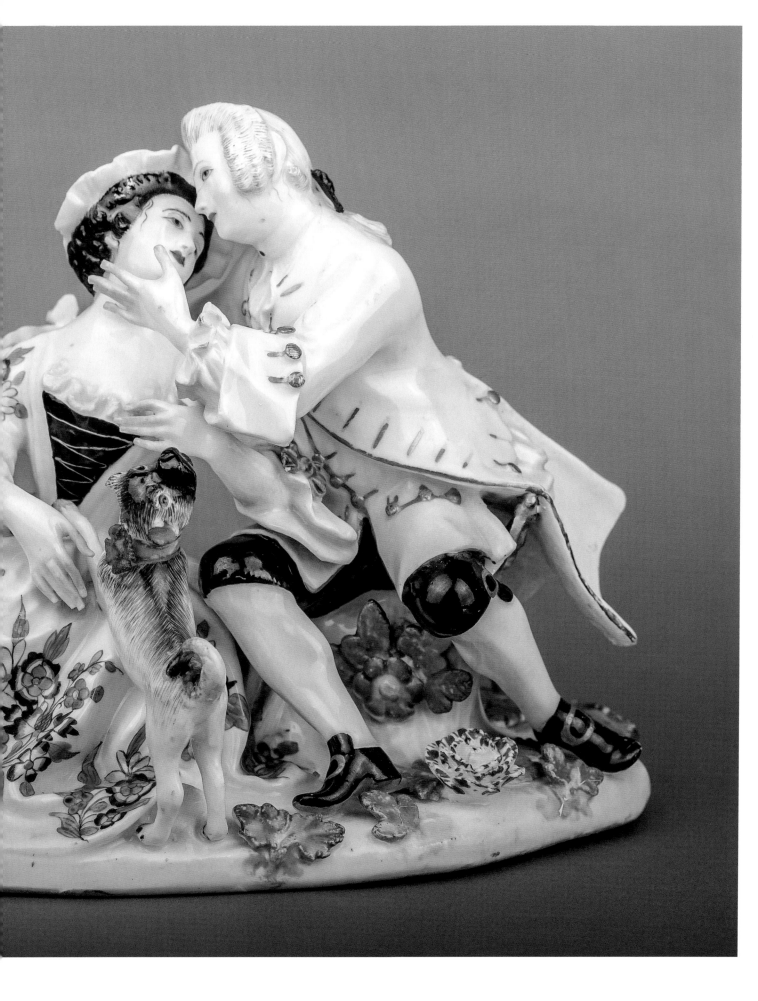

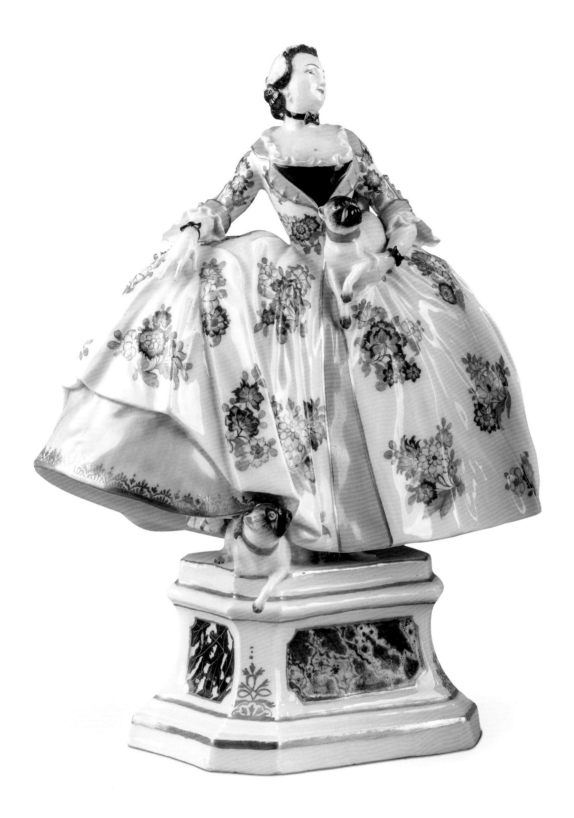

96 Dame vom Mopsorden mit zwei Möpsen

Meissen, um 1743
Modell: Johann Joachim Kändler
Porzellan, polychrome Bemalung in
Aufglasurtechnik, Goldmalerei
Signatur/Marke: Schwerter in Blau
28,5 × 21 × 14,5 cm, 2210 g
Inv.-Nr. A 813
Literatur: Jedding 1982, S. 208;
Menzhausen/Karpinski 1993, S. 115:
„Arbeitsbericht Kändler vom Juni
1744: 5) Ein Frauenzimmer Wie
solche auf einem Postament Wohl
angekleidet stehet gehörigermaßen
zerschnitten sambt denen 2. Bey
sich habenden Mopßhündgen, und
solches Modell gehöriger Weise
zum abformen zubereitet." (Pietsch
2002).

Dame mit breitem, ausschwingen-
dem Reifrock auf marmoriertem
Sockelpostament, unter dem linken
Arm einen Mops haltend, rechter
Arm auf dem Rock abgelegt, Kopf
nach links gewandt, weißes Kleid
mit bunten Blumen, türkis-rosa
Unterrock, schwarzes Band um den
Hals, weiße Haube mit purpurner
Schleife; Mops mit blau-goldenem
Halsband, zweiter liegender Mops
mit blauem Halsband schaut unter
dem Rock hervor und lässt die
Vorderbeine ausgestreckt über den
Sockelrand hängen; unglasierter
Boden mit Brennloch.

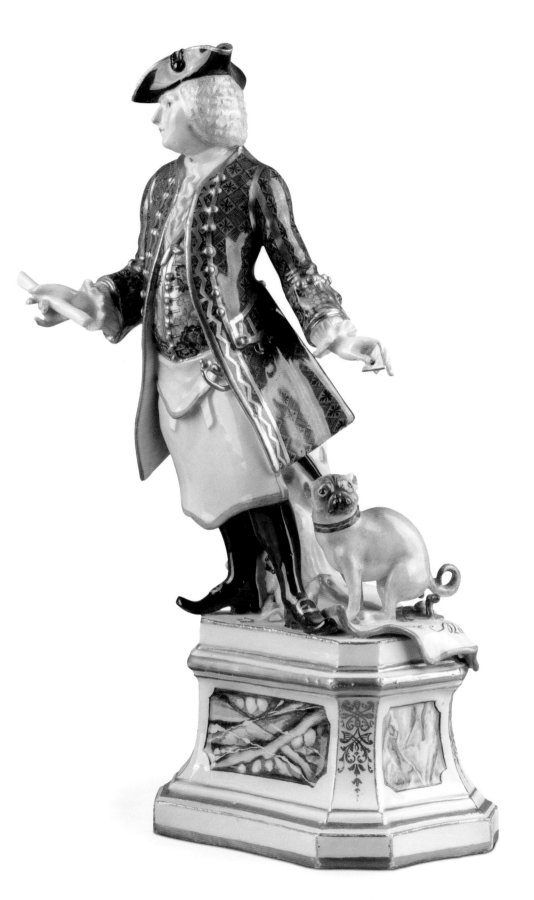

97 Freimaurer mit Mops

Meissen, um 1743
Modell: Johann Joachim Kändler
Porzellan, polychrome Bemalung in
Aufglasurtechnik, Goldmalerei
Signatur/Marke: keine
28,5 × 18 × 13 cm, 1769 g
Inv.-Nr. A 814
Literatur: s. Kat.-Nr. 96; Arbeitsbe-
richt Kändler vom September 1743:
„An einem Frey Mäurerer Poussie-
ret Welcher einen Mopßhund
neben sich stehen hat, Nebst Sturz-
fell und gewöhnlichen Investemen-
ten." (Pietsch 2002); Pietsch 2006,
S. 22, 23.

Stehender Freimaurer auf marmo-
riertem Sockelpostament, Stand-
hilfe in Form eines Baumstammes
mit aufgelegten, plastischen Blüten
und Blättern, Kopf nach rechts
gewandt, in der rechten Hand eine
Papierrolle, links ein goldgeränder-
tes Dreieck mit schwarzer Kugel,
langer brauner Schoßrock mit
Schachbrettmuster, bunt geblümte
Weste mit goldenem Winkeleisen
an blauem Halsband darüber,
schwarzer Dreispitz, Strümpfe und
Schuhe, heller Lederschurz, reiche
Goldstaffierung; daneben hocken-
der Mops mit purpur-goldenem
Halsband nach links schauend,
verrichtet gerade seine Notdurft
auf einer Freimaurerkelle und
einem Teil des Schurzes mit der
Aufschrift „La vraye Medicine";
unglasierter Boden.

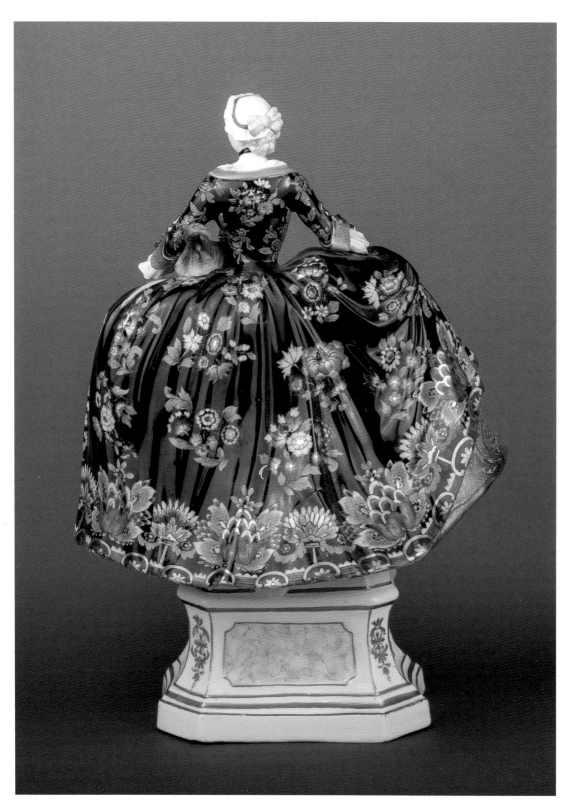

98 Dame vom Mopsorden mit zwei Möpsen

Meissen, um 1743
Modell: Johann Joachim Kändler
Porzellan, polychrome Bemalung in
Aufglasurtechnik, Goldmalerei
Signatur/Marke: keine
30,5 × 20 × 14 cm, 2081 g
Inv.-Nr. A 812
Literatur: s. Kat.-Nr. 96, 97

Dame mit breitem ausschwingen-
dem Reifrock auf rosa-gold staffier-
tem Sockelpostament, unter dem
linken Arm einen Mops haltend,
rechter Arm auf den Rock gelegt,
Kopf nach links gewandt, schwarzes
Kleid mit indianischen bunten
Blumen, türkis-purpurfarbener
Unterrock, weiße Haube mit gelber
Schleife, schwarzes Band um den
Hals; Mops mit rot-goldenem Hals-
band mit roter Schleife, zweiter
liegender Mops mit lila Halsband
schaut unter dem Rock hervor und
lässt die Vorderbeine ausgestreckt
über den Sockelrand hängen; un-
glasierter Boden mit Brennloch.

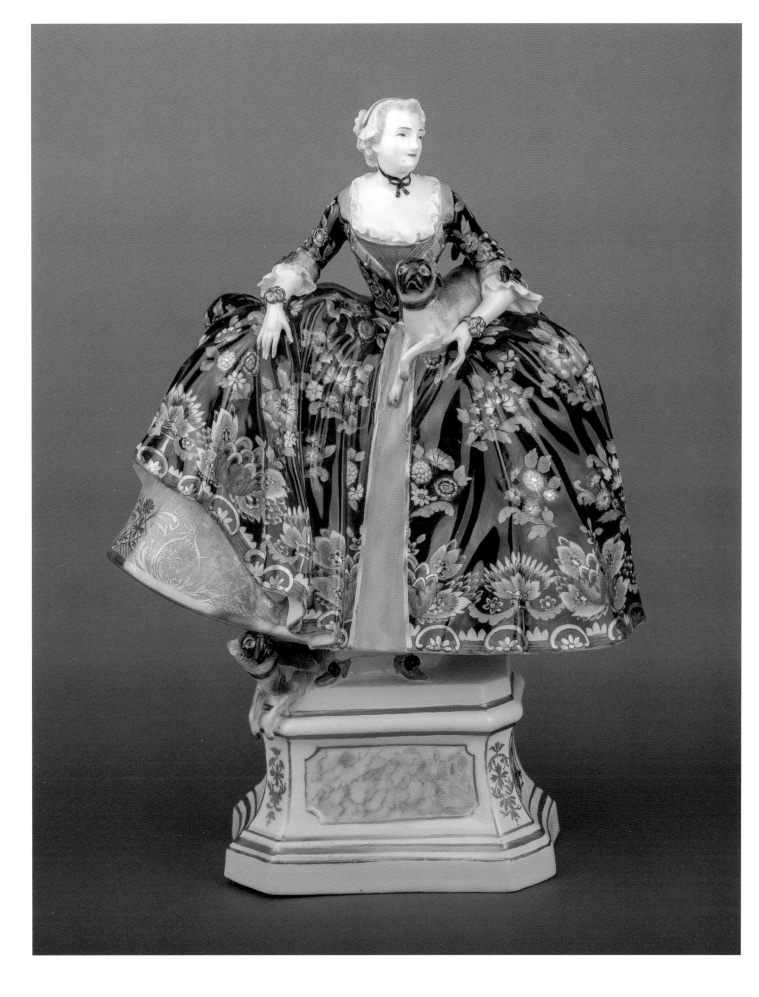

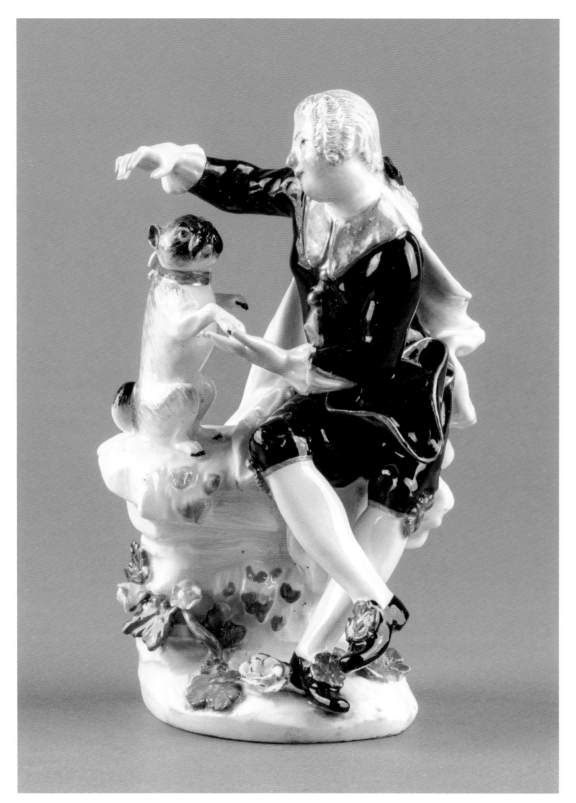

99 Mopsdressur mit Kavalier

Meissen, um 1745
Modell: Johann Joachim Kändler
Porzellan, polychrome Bemalung in
Aufglasurtechnik, Goldmalerei
Signatur/Marke: Schwerter in Blau
12,5 × 7 × 7 cm, 313 g
Inv.-Nr. A 801
Literatur: Porcelain Pugs: A Passion
2019, S. 177, Kat.-Nr. 41.

Kavalier auf Felssockel, einen Mops
dressierend, männliche Figur in
eleganter Kleidung mit überge-
schlagenen Beinen, den rechten
Arm erhoben, mit der linken Hand
die Vorderpfoten des Hundes
haltend, schwarze Jacke mit pur-
purnem Kragen, schwarzer Drei-
spitz und ebensolche Kniehose und
Schuhe mit purpurnen Schleifen
über weißen Strümpfen, weißer
Umhang, aufrecht sitzender Mops
mit hellem Fell und schwarzen
Partien, purpurfarbenes Halsband
mit goldenem Wellenmotiv und
gelber Schleife, flache, trichterför-
mige Ohren, geringelte Rute, Sockel
mit aufgelegten plastischen Blüten
und Blättern, Goldakzente an der
Kleidung; unglasierter Boden.

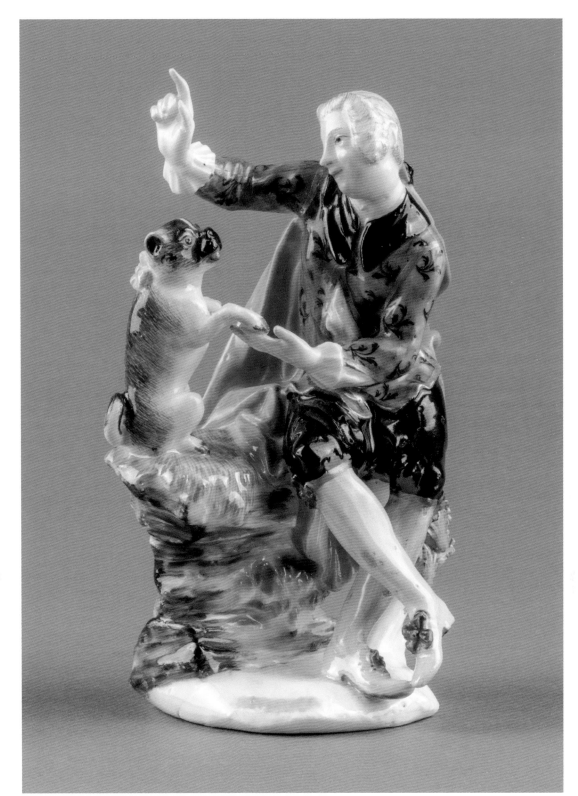

100 Mopsdressur mit Kavalier

Meissen, um 1745
Modell: Johann Joachim Kändler
Porzellan, polychrome Bemalung in
Aufglasurtechnik, Goldmalerei
Signatur/Marke: Schwerter in Blau
12 × 8 × 6,8 cm, 281 g
Inv.-Nr. A 802
Literatur: s. Kat.-Nr. 99

Kavalier auf Felssockel, einen Mops
dressierend, männliche Figur in
eleganter Kleidung mit überge-
schlagenen Beinen, den rechten
Arm erhoben, mit der linken Hand
hält er die Vorderpfoten des vor
ihm Männchen machenden Hun-
des, purpurfarbene Jacke mit
Brokatdekor und schwarzem Kra-
gen, schwarze Kniehose mit roten
Schleifen über weißen Strümpfen,
türkisfarbener Umhang, gelbe
Schuhe mit blauen Schleifen,
Goldakzente an der Kleidung,
aufrecht sitzender Mops mit hellem
Fell und schwarzen Partien, gelbes
Halsband mit gelber Schleife,
flache, trichterförmige Ohren,
geringelte Rute; braun-schwarz-
grün staffierter Sockel mit anbos-
sierten, plastischen Blättern; un-
glasierter Boden mit Brennloch.

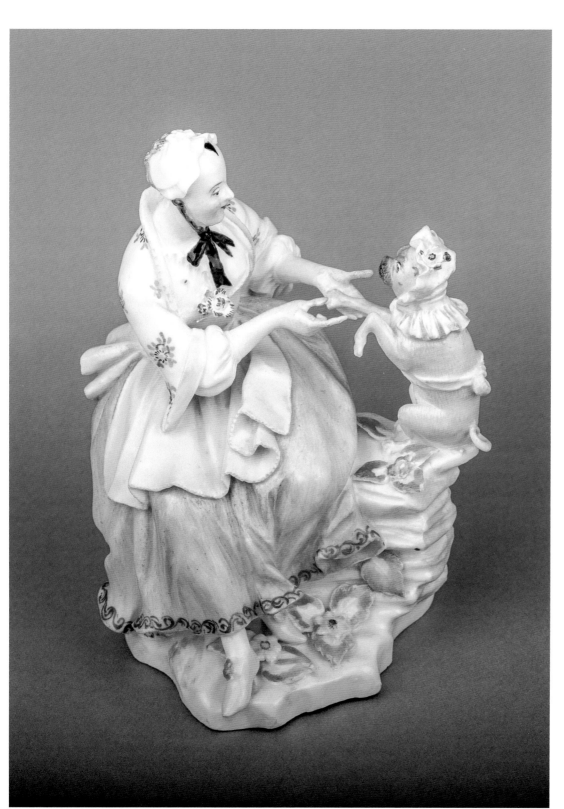

101 Mopsdressur mit Dame

Wien, um 1760
Porzellan, polychrome Bemalung
Signatur/Marke: Bindenschild
in Blau
14,5 × 10 × 10 cm, 470 g
Inv.-Nr. A 825
Literatur: Mrazek/Neuwirth 1970,
Nr. 347, S. 126, Tafel 58; Sturm-
Bednarczyk 2007, Nr. 302,
S. 197–199.

Sitzende Dame auf Landschafts-
sockel mit Fels und Blüten, mangan-
violetter Rock, gelbe Schürze,
geblümte Jacke, weiße Haube mit
schwarzer Schleife, mit Rüschen-
häubchen ausstaffierter Mops
macht vor ihr Männchen, sie hält
seine rechte Pfote; unglasierter
Boden.

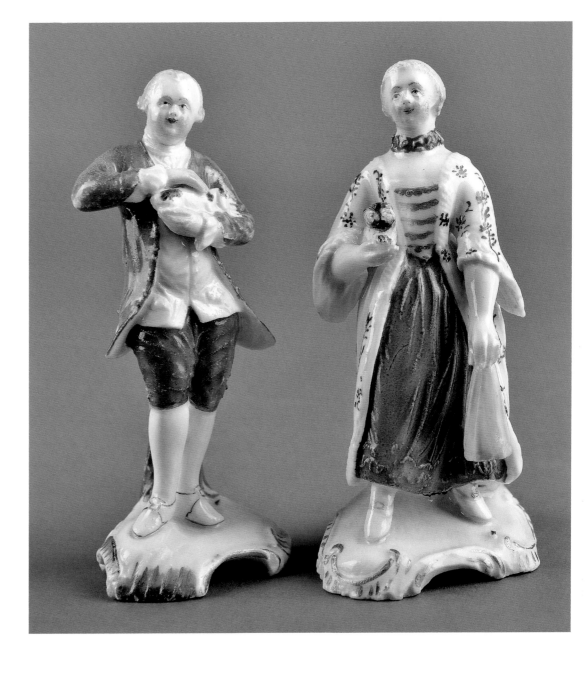

**102 Galanter Herr
mit Hund**

Höchst, 1750–1763
Modell: Laurentius Russinger
Porzellan, polychrome Bemalung
in Aufglasurtechnik, Goldmalerei
Signatur/Marke: Radmarke in Rot
9 × 4 × 3 cm, 48 g
Inv.-Nr. A 817
Provenienz: Sammlung Loosen-
Grillo

Stehender Herr auf Rocaillen-
sockel, Hund auf dem linken Arm,
purpurner Rock und Hose, Gold-
staffierung; glasierter Boden.

**103 Galante Dame
mit Mops**

Höchst, 1750–1763
Modell: Laurentius Russinger
Porzellan, polychrome Bemalung
in Aufglasurtechnik, Goldmalerei
Signatur/Marke: keine
9 × 4 × 4,2 cm, 74 g
Inv.-Nr. A 816
Provenienz: Sammlung Loosen-
Grillo

Stehende Dame auf Rocaillensockel,
Mops auf dem rechten Arm haltend,
purpurner Rock, Mantel mit pur-
purnen Strohblumen, in der linken
Hand wohl einen Sonnenschirm, der
am Griff abgebrochen ist; offener,
glasierter Boden, Figur hohl.

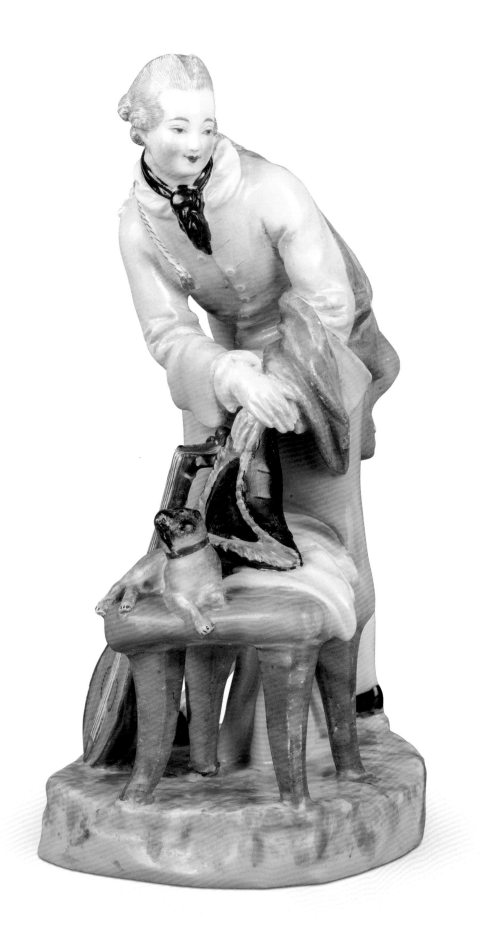

104 Kavalier mit Mops

Wien, 1760–1765
Porzellan, polychrome Bemalung
in Aufglasurtechnik
Bossierer: H für Paul Painstingel
(1762–1771 in den Verdienstlisten
belegt)
Maler: 24. in Purpur für Konrad
Haab (1762–1787 in den Verdienst-
listen belegt), T in Purpur
Signatur/Marke: Bindenschild
unterglasurblau, H, 24., T
20 × 9 × 10,5 cm, 760 g
Inv.-Nr. A 835
Literatur: Sturm-Bednarczyk/
Sladek 2007, S. 184, Abb. 291;
Ahrens 2017, S. 370.

Stehender Kavalier auf rundem,
grün-braun staffiertem Sockel,
darauf Stuhl mit grünem Bezug, auf
dem ein Mops mit rotem Halsband
liegt und der Kavalier seinen Um-
hang und Dreispitz abgelegt, seine
Laute angelehnt hat und sich auf
der Lehne abstützt, Jacke und Hose
in Purpur, schwarze Schuhe und
Tuch; glasierter Boden.

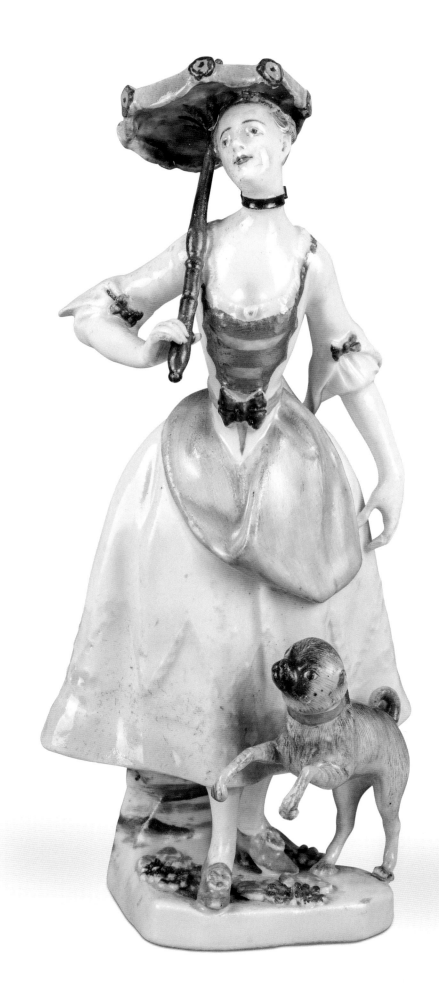

105 Dame im Schäferkostüm
mit Sonnenschirm und Mops

Wien, 1760–1765
Porzellan, polychrome Bemalung in
Aufglasurtechnik
Bossierer: E für Joseph Gmandtner
(in Verdienstlisten 1762–1804)
Maler: 20. in Purpur für Christian
Kremser (in Verdienstlisten
1762–1787),
wohl Goldmaler: H in Purpur
Marke/Signatur: Bindenschild
in Blau; E / 20. / H
18 × 7 × 7,5 cm, 260 g

Stehende Dame im Schäferinnenkos-
tüm auf ovalem Sockel mit aufgeleg-
ten Blüten, gelbes Kleid mit hochge-
schlagener purpurfarbener Schürze
und Schuhen sowie goldenem Mie-
der, mit der Rechten einen grünen
Sonnenschirm über den Kopf hal-
tend; an ihre linke Seite springt ein
hellbrauner Mops mit schwarzen
Partien sowie Halsband und Schleife
in Purpur empor; glasierter Boden,
Brennloch unterm Kleid.

**106 Briefbeschwerer
mit liegendem Mops**

Meissen, um 1750
Porzellan, polychrome Bemalung in
Aufglasurtechnik, Goldmalerei
Signatur/Marke: Schwerter in Blau,
Pressmarke „1695"
6 × 19,8 × 3 cm, 279 g
Inv.-Nr. A 518

Längsrechteckiger Briefbeschwe-
rer, schmaler abgestufter Sockel
mit geschweifter Rahmung, mittig
darauf liegender Mops, hellbraunes
Fell mit schwarzen Partien, Kopf
nach rechts gewandt, purpur-
goldenes Halsband, gestreckte
Vorderbeine, geringelte Rute, am
Sockel umlaufend Genreszenen
à la Watteau und Goldstaffierung;
unglasierter Boden.

Nächste Doppelseite:

**107 Kerzenleuchter
mit Mops**

Meissen, um 1750
Modell: Johann Joachim Kändler
Porzellan, polychrome Bemalung
in Aufglasurtechnik, Goldmalerei
Signatur/Marke: keine
15 × 11,5 × 9,5 cm, 244 g
Inv.-Nr. A 805
Literatur: Rückert 1966,
Kat.-Nr. 1097.

Leuchter auf niedrigem Rocaillen-
sockel mit Goldstaffierung, plasti-
sche Blütenzweige neben dem
Schaft, darüber mittels Bronze-
schraube montierter Kerzenhalter
in Form einer Blüte mit ausladen-
den Kelchblättern und purpurfar-
benem Rand, mittig auf dem Sockel
stehender Mops, Kopf leicht nach
rechts gedreht, helles Fell mit
dunkeln Partien, purpurfarben-
goldenes Halsband mit goldenen
Schellen, flache, trichterförmige
Ohren, geringelte Rute; unglasier-
ter Boden und Standflächen.

**108 Kerzenleuchter
mit Mops**

Meissen, um 1750
Modell: Johann Joachim Kändler
Porzellan, polychrome Bemalung in
Aufglasurtechnik, Goldmalerei
Signatur/Marke: Schwerter in Blau
15 × 10,5 × 10,2 cm, 239 g
Inv.-Nr. A 807
Literatur: s. Kat.-Nr. 107

Leuchter auf niedrigem Rocaillen-
sockel mit Goldstaffierung, plasti-
sche Blütenzweige neben dem
Schaft, darüber mittels Bronze-
schraube montierter Kerzenhalter
in Form einer Blüte mit ausladen-
den Kelchblättern mit gelb-
manganviolettem Rand, mittig
auf dem Sockel stehender Mops,
Kopf leicht nach links gedreht,
hellbraunes Fell mit dunkeln
Partien, purpurfarben-goldenes
Halsband mit goldenen Schellen,
flache, trichterförmige Ohren,
geringelte Rute; unglasierter
Boden und Standflächen.

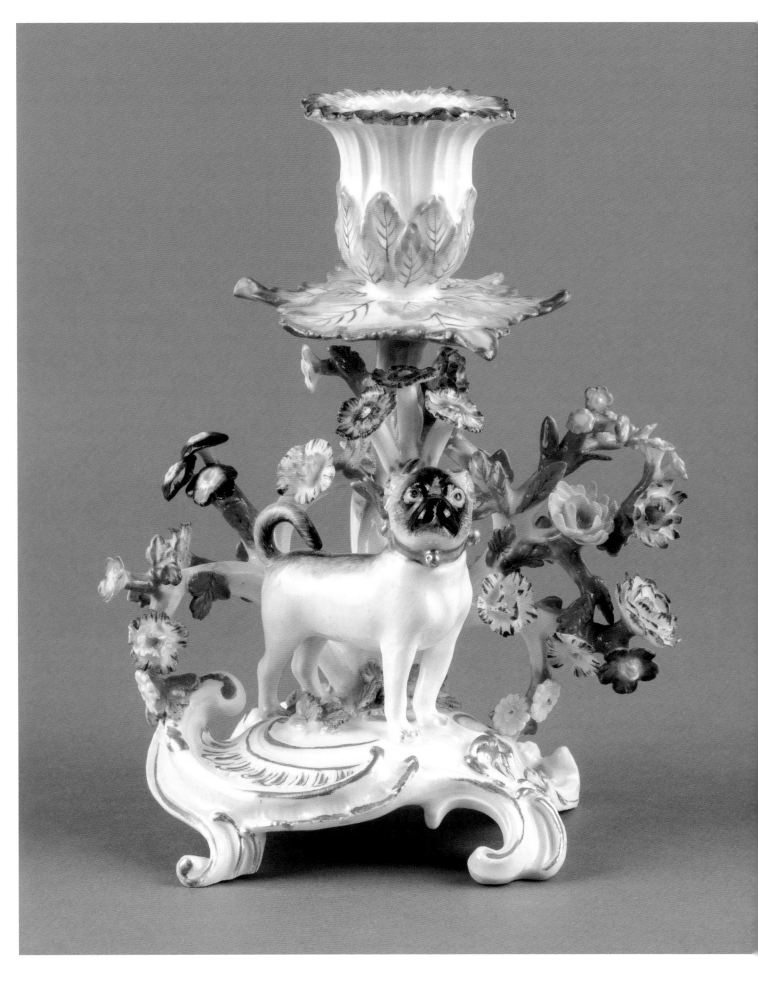

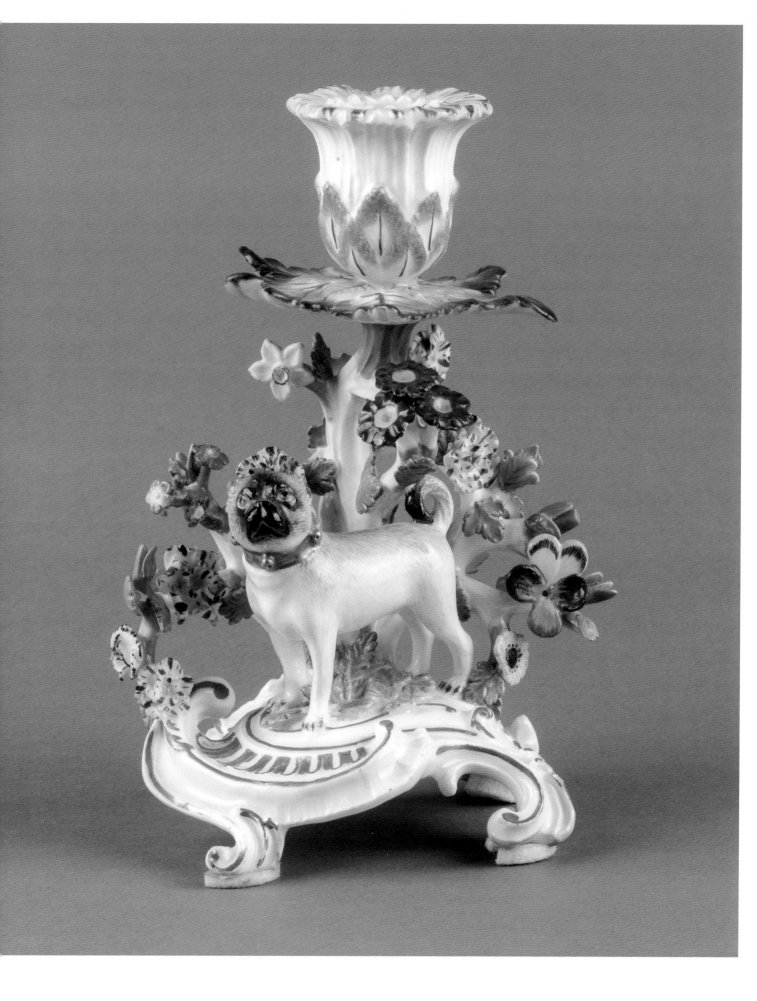

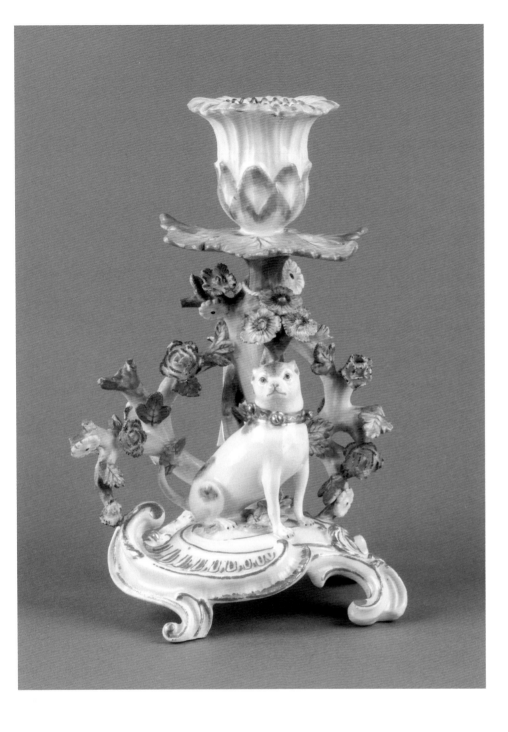

109 Kerzenleuchter mit Kleinem Dänischen Hund

Meissen, um 1750
Modell: Johann Joachim Kändler
Porzellan, polychrome Bemalung in
Aufglasurtechnik, Goldmalerei
Signatur/Marke: Schwerter in Blau
15 × 10 × 9,5 cm, 218 g
Inv.-Nr. A 806

Leuchter auf niedrigem Rocaillen-
sockel mit Goldstaffierung, plasti-
sche Blütenzweige neben dem
Schaft, darüber mittels Bronze-
schraube montierter Kerzenhalter
in Form einer Blüte mit ausladenden
Kelchblättern mit gelbgrünem
Rand, mittig auf dem Sockel sitzen-
der Hund nach rechts schauend,
helles Fell mit braunen Flecken,
purpurfarbenes Halsband mit
goldenem Wellenband und goldenen
Schellen, flache, trichterförmige
Ohren, geringelte Rute; unglasierter
Boden und Standflächen,

110 Duftgefäß mit Dame, Mops und Katze

Meissen, um 1750
Modell: Johann Joachim Kändler
Porzellan, polychrome Bemalung in
Aufglasurtechnik, Goldmalerei
Signatur/Marke: Schwerter in Blau
22,6 × 14 × 12,2 cm, 998 g
Inv.-Nr. A 803
Literatur: Porcelain Pugs: A Passion
2019, S. 178, 179.

Runde Duftvase mit Blütenranken
auf Rocaillensockel, der in Baum-
stamm und Blüten übergeht, umlau-
fend, aufgelegte plastische Blüten
und Blätter sowie gemalte Insekten,
Deckel mit Griff aus Blütenranken
und goldenem Randstreifen, auf
dem Sockel sitzende Dame mit Katze
auf dem Schoß, stehender Mops
mit hellbraunem Fell und purpur-
goldenem Halsband daneben, Dame
in weißem Kleid mit farbigen Blüten,
Goldstaffierung am Sockel; ungla-
sierter Boden.

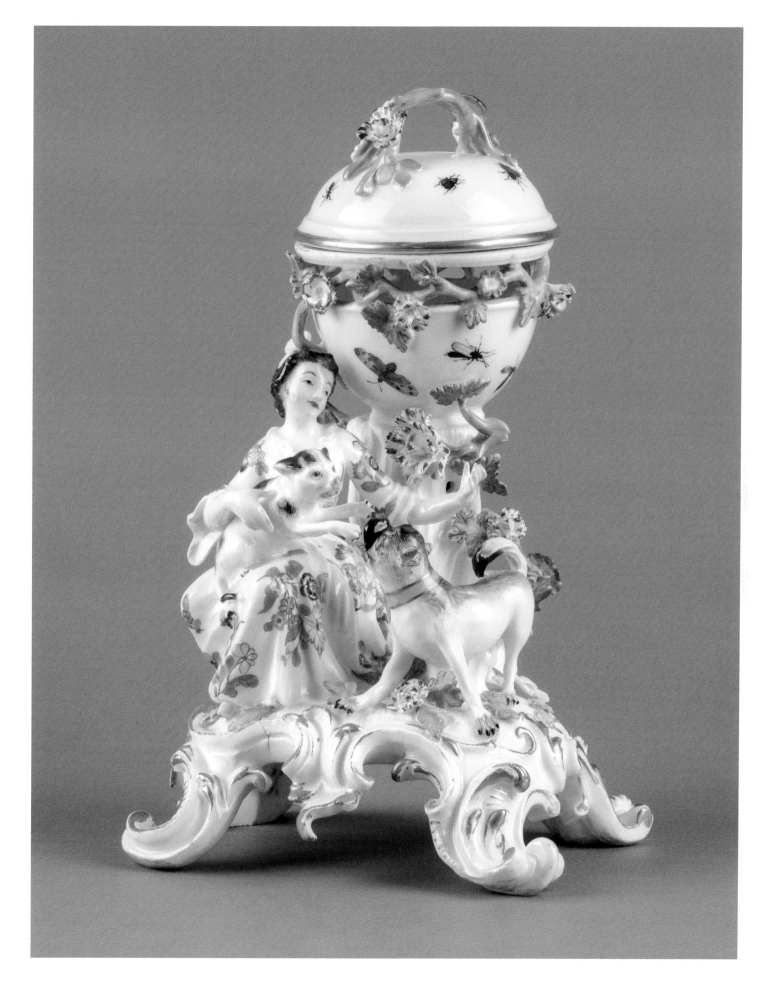

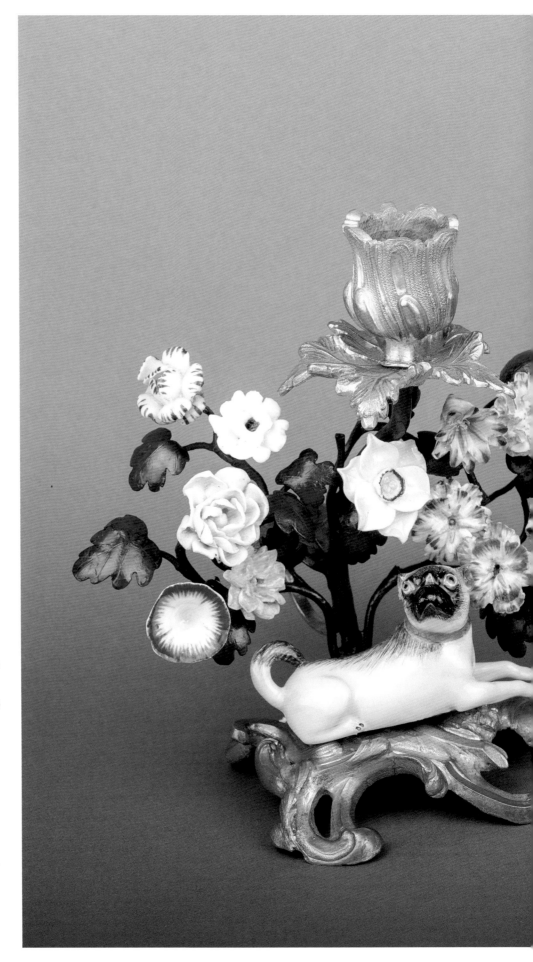

111 Kerzenleuchter-Paar mit Möpsen

Meissen, um 1760; Montierung
Paris, 19. Jahrhundert
Porzellan, polychrome Bemalung in
Aufglasurtechnik, feuervergoldete
Bronze, Draht, Metall
Signatur/Marke: keine (Montierung)
14 × 12 × 12 cm, 415 g
14,5 × 16 × 11 cm, 383 g
Inv.-Nr. A 829 a, b

Zwei filigrane Bronzeleuchter in
Form von Blütensträuchern, der
mittlere Zweig je als Kerzentülle
ausgearbeitet, Strauch mit golde-
nen Blättern und elf bzw. neun
plastischen, farbig staffierten
Porzellanblüten, mittig auf dem
Bronzerocaillensockel je ein liegen-
der Mops, a) nach rechts gewandt
mit grauer Fellzeichnung, oranges
Halsband mit blauer Schleife
b) nach links gewandt mit grauer
Fellzeichnung, purpurfarbenes
Halsband mit gelber Schleife.

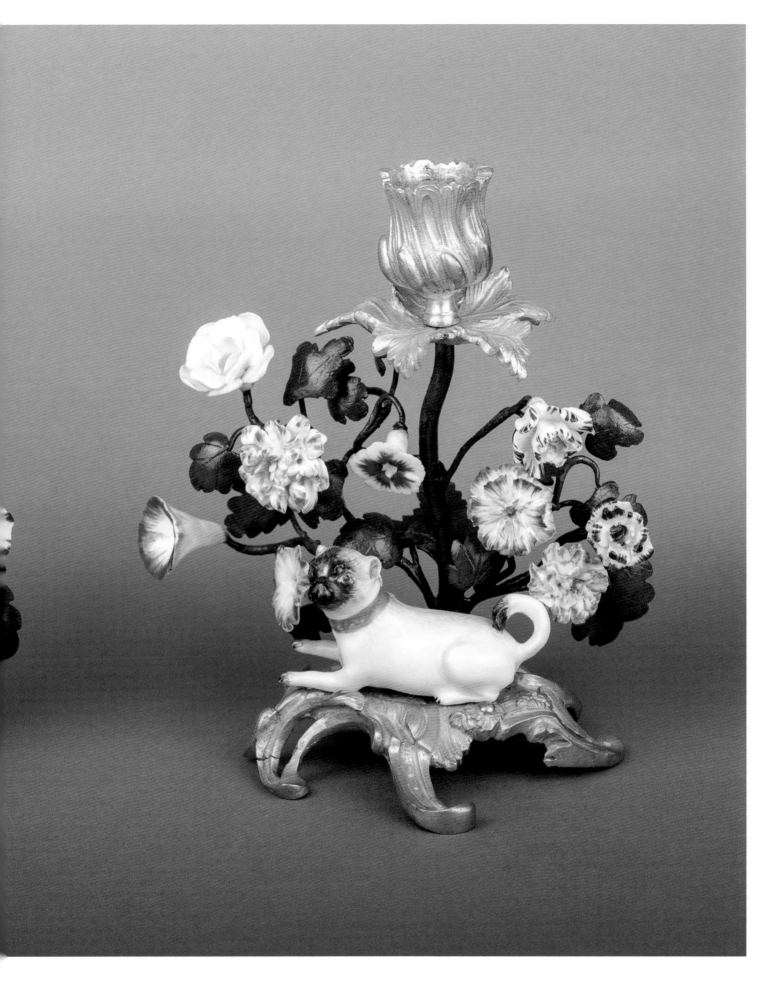

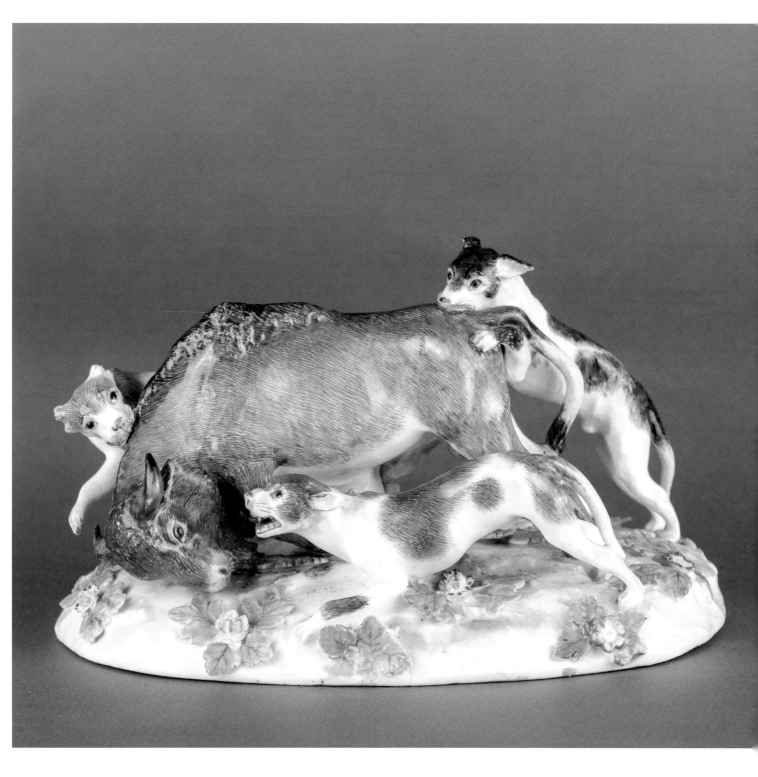

112 Kleine Stierhatz

Meissen, um 1770
Modell: Johann Joachim Kändler
Porzellan, polychrome Bemalung in
Aufglasurtechnik, Goldmalerei
Signatur/Marke: Schwerter in Blau
9 × 17 × 10 cm, 621 g
Inv.-Nr. A 93
Literatur: Albiker 1959, Kat.-Nr. 193;
Menzhausen/Karpinski 1993, S. 197;
Kunze-Köllensperger 1999, Kat.-Nr. 13,
S. 35; Pietsch 2005, Kat. Nr. 14, S. 71.

Jagdgruppe auf ovalem Terrain-
sockel mit Blüten und Blättern,
drei Hunde fallen einen Stier an;
zwei mit grauem Fell, einer braun
gefleckt, Stier naturalistisch in
Braun; glasierter Boden mit Brenn-
loch, Standhilfe.

113 Liegender Jagdhund

Ludwigsburg, 1762–1772
Modell: wohl Johann Jacob Louis
Porzellan, polychrome Bemalung in
Aufglasurtechnik
Signatur/Marke: bekröntes Doppel
C in Blau
5,2 × 9,5 × 4,7 cm, 123 g
Inv.-Nr. A 76
Literatur: Flach 1997, Kat.-Nr. 718,
S. 161.

Liegender Jagdhund auf Gras-
plinthe, nach links schauend;
weißes Fell mit braunen Flecken;
unglasierter Boden; Darstellung
einer Bordeaux-Dogge.

114 Stehender Jagdhund

wohl Ludwigsburg, 18. Jahrhundert
Porzellan, polychrome Bemalung
in Aufglasurtechnik
Signatur/Marke: keine
6 × 13 × 3 cm, 29 g
Inv.-Nr. A 22

Stehender Jagdhund, nach vorn
schauend, helles Fell mit grauen
Partien, langer Schwanz; Darstel-
lung einer Deutschen Bracke.

115 Sitzender Hund auf ovalem und rechteckigem Sockel

Delft, 2. Hälfte des 18. Jahrhunderts
Fayence, polychrome Bemalung in
Scharffeuertechnik
Signatur/Marke: IVL legiert
20 × 9 × 7,5 cm, 606 g
Provenienz: Sammlung Loosen-
Grillo
Inv.-Nr. A 105

Sitzender Hund auf glasiertem,
hohlem Sockel mit ornamentaler
Randdekoration, Hund nach links
schauend, weißes Fell mit stilisier-
ter blauer Staffierung, geöffnetes
Maul, rotes Halsband mit gelben
Schellen; glasierter Boden, Brenn-
loch unterm Schwanz; stilisierte
Darstellung der Hunderasse Engli-
scher Bullenbeißer.

116 Sitzender Hund auf flacher Plinthe

Delft, 1. Hälfte des 18. Jahrhunderts
Fayence, blaue Bemalung in Scharf-
feuertechnik
Signatur/Marke: keine
15,5 × 10,5 × 6,5 cm, 342 g
Inv.-Nr. A 115

Sitzender Hund auf flacher Plinthe;
blau staffiertes Fell, blaues Hals-
band; Sockel mit blauer Staffie-
rung; glasierter Boden mit großem
Loch in den Hohlraum; Darstellung
eines Bärenbeißers oder Englischen
Bullenbeißers.

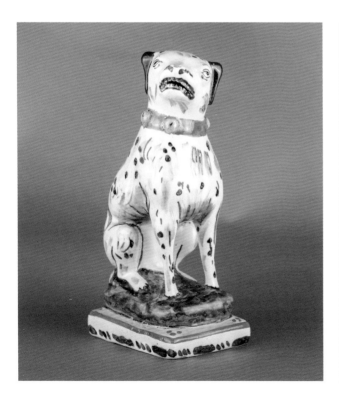

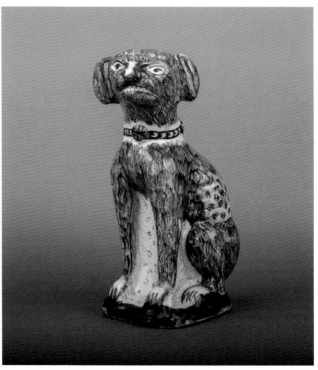

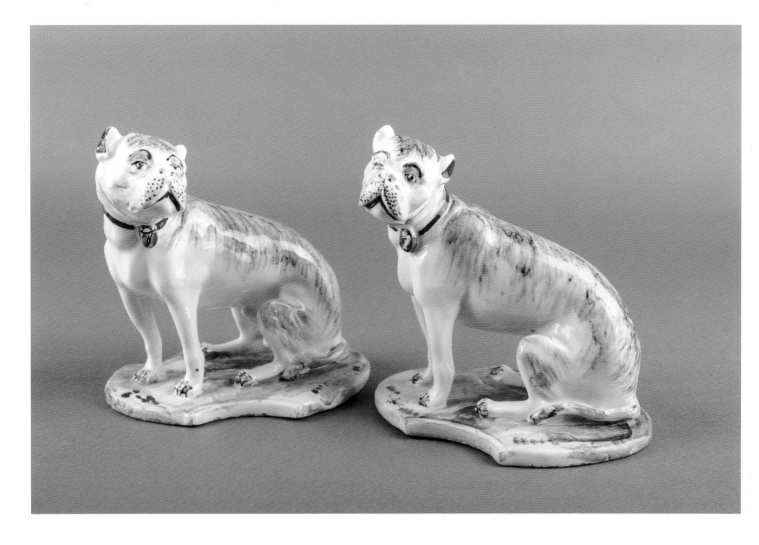

117 + 118 Zwei sitzende Doggen auf flachen Sockeln

Belgien oder Niederlande, um 1800
Fayence, polychrome Bemalung in
Scharffeuertechnik
Signatur/Marke: keine
12,5 × 12,5 × 9 cm, 317 g
12,5 × 12,5 × 9 cm, 330 g
Inv.-Nr. A 35, 36

Sitzende Hunde auf flachem Wie-
sensockel nach links schauend,
weißes Fell mit rotbraunen Akzen-
ten, hellblau umrandete Augen,
rotes Halsband mit Glöckchen,
flache, trichterförmige Ohren,
seitlich gebogener Schwanz; schild-
förmiger unglasierter Boden;
Dargestellt sind zwei Englische
Bulldoggen, die vor 250 Jahren
deutlich langbeiniger waren als
heute.

119 Sitzender Hund

wohl Crailsheim, um 1760
Fayence, Bemalung in Scharffeuer-
technik in Manganviolett, Anti-
mongelb und Kupfergrün
Signatur/Marke: keine
9,5 × 9,5 × 3 cm, 150 g
Inv.-Nr. A 74

Sitzender Hund auf grün staffier-
tem Grassockel, Kopf nach rechts,
geflecktes Fell, gelbes Halsband,
glasierter Boden mit Brennloch;
stilisierte Darstellung der Hunde-
rasse Kleiner Bärenbeißer.

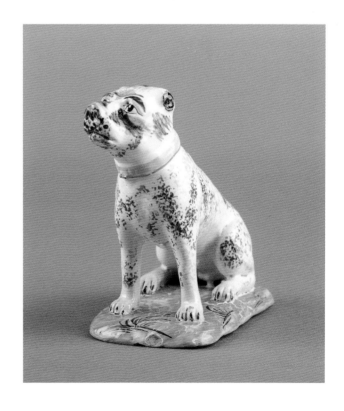

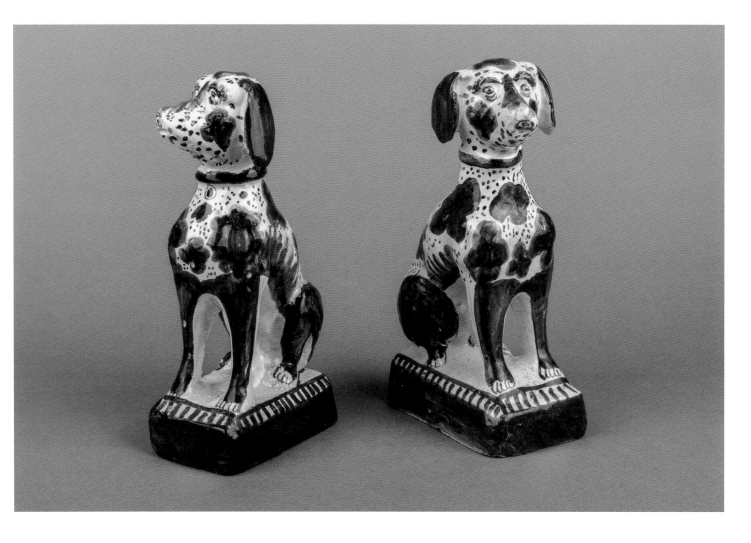

**120 + 121 Zwei sitzende
Hunde auf Sockeln**

Niederlande oder Friesland,
1. Hälfte des 18. Jahrhunderts
Fayence, blaue Bemalung in Scharf-
feuertechnik
Signatur/Marke: keine
19 × 10 × 6,5 cm, 537 g
18 × 11 × 6,5 cm, 576 g
Inv.-Nr. A 40, 41
Provenienz: Sammlung Schmitz-
Eichhoff

Sitzende Hunde auf je einem acht-
eckigen, hohen Sockel, weißes Fell
mit blauen Flecken, Schnauze und
Augen blau staffiert, blaues Hals-
band; Sockel mit blauer Staffie-
rung; glasierter Boden mit großem
Loch in den Hohlraum; stilisierte
Darstellung der Rasse Deutsche
Bracke.

**122 Sitzender Hund
auf Sockel**

Brüssel, 18. Jahrhundert
Fayence, manganviolette und gelbe
Bemalung in Scharffeuertechnik
Signatur/Marke: keine
19,5 × 14 × 9,5 cm, 920 g
Inv.-Nr. A 114

Sitzender Hund auf hohem Sockel;
weißes Fell mit manganvioletten
Flecken, gelbes Halsband mit der
Aufschrift „LOUDRO.", Sockel mit
manganvioletter Staffierung; gla-
sierter Boden mit großem Loch in
den Hohlraum; stilisierte Darstel-
lung der Rasse Deutsche Bracke.

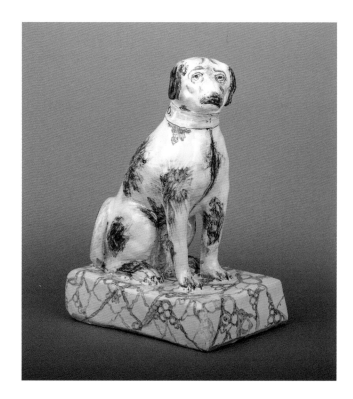

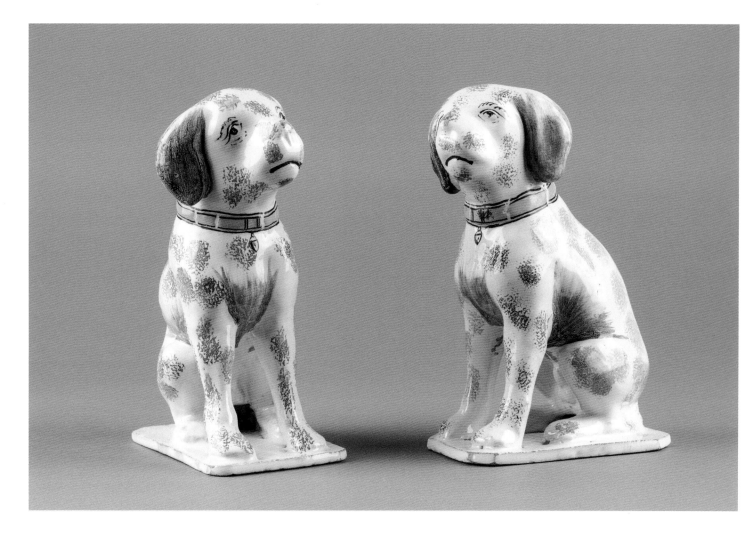

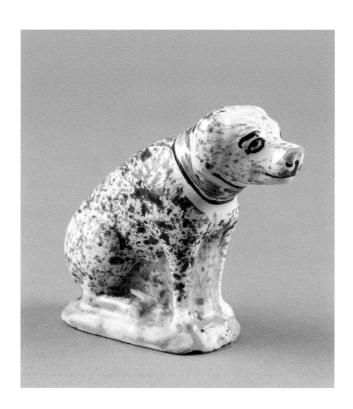

**123 Sitzender Hund
auf Grassockel**

Süddeutschland, 1750–1760
Fayence, polychrome Bemalung in
Scharffeuertechnik
Signatur/Marke: keine
6,3 × 8 × 3,3 cm, 59 g
Inv.-Nr. A 57

Sitzender Hund auf grün staffier-
tem Terrainsockel, weißes Fell mit
manganvioletten Tupfen, gelb-
schwarzes Halsband, lange hängen-
de Ohren; Hohlplastik mit unglas-
ierter Standfläche; stilisierte
Darstellung der Hunderasse Deut-
sche Bracke.

**124 + 125 Zwei sitzende
Hunde**

Hannoversch-Münden, 1775–1780
Fayence, polychrome Bemalung in
Scharffeuertechnik
Signatur/Marke: keine
18,5 × 14,5 × 7,5 cm, 500 g
18,5 × 14 × 8 cm, 514 g
Inv.-Nr. A 49, 50
Literatur: Schandelmaier 1993,
Kat.-Nr. 171, S. 188.

Zwei sitzende Hunde, je auf flacher
rechteckiger Plinthe, weißes Fell
mit getupften manganvioletten
Flecken, gelb-schwarzes Halsband,
große hängende Ohren; unglasier-
ter Boden; ähnlich stilisierte Dar-
stellungen von Hunden der Rasse
Deutsche Bracke wurden auch in
den Niederlanden gefertigt.

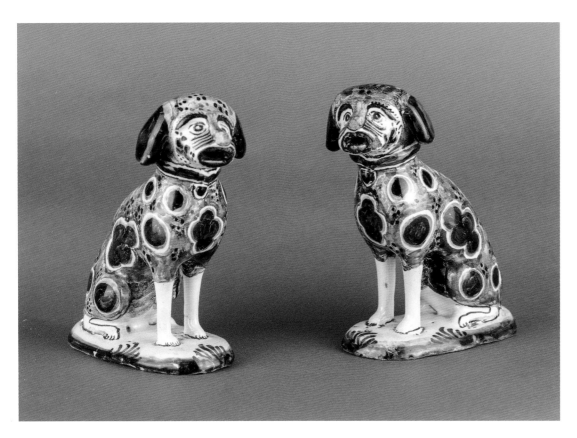

126 Zwei sitzende Hunde auf ovaler Plinthe

Braunschweig oder Niederlande,
um 1750
Fayence, polychrome Bemalung in
Scharffeuertechnik
Signatur/Marke: keine
12 × 10 × 5 cm, 247 g
Inv.-Nr. A 106 a, b

Zwei sitzende Hunde auf flacher
ovaler, grünblau staffierter Plinthe,
stilisierte Fellzeichnung in Mangan-
violett mit blauen Flecken, blaue
Halsbänder; glasierter Boden;
stilisierte Darstellungen der Rasse
Deutsche Bracke.

127 Sitzender Hund auf rechteckigem Sockel

Delft, 2. Hälfte des 18. Jahrhunderts
Fayence, polychrome Bemalung in
Scharffeuertechnik
Signatur/Marke: keine
12 × 9 × 5 cm, 162 g
Provenienz: Sammlung Loosen-
Grillo
Inv.-Nr. A 104

Sitzender Hund auf glasiertem,
hohlem Sockel mit ornamentaler
Randdekoration, Hund nach links
schauend, weißes Fell mit stilisier-
ter blauer Staffierung, geöffnetes
Maul mit herausgestreckter Zunge,
gelb-schwarzes Halsband; glasier-
ter Boden, Brennloch unterm
Schwanz; stilisierte Darstellung
der Rasse Bracke.

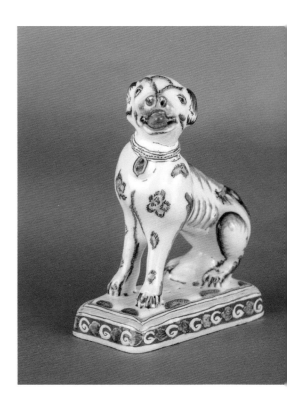

**128 Sitzender Hund
auf flacher blauer Plinthe**

Niederlande, um 1750
Fayence, polychrome Bemalung in
Scharffeuertechnik
Signatur/Marke: keine
5,6 × 5 × 3 cm, 43 g
Inv.-Nr. A 63

Sitzender Hund fröhlich nach
rechts schauend auf flacher recht-
eckiger, blau staffierter Plinthe,
weißes Fell mit getupften mangan-
violetten Flecken, weiß-blaues
Halsband; unglasierter Boden;
stilisierte Darstellung eines kleinen
Terriers.

**129 Sitzender Hund
auf rechteckiger Plinthe**

Braunschweig, um 1750
Fayence, gelbe und manganviolette
Bemalung in Scharffeuertechnik
Signatur/Marke: keine
12,5 × 11 × 7,5 cm, 351 g
Inv.-Nr. A 107
Literatur: Spies 1971, Kat.-Nr. 70 a,
Text S. 92.

Sitzender Hund auf flacher recht-
eckiger Plinthe mit gemalten man-
ganvioletten Blüten, naturalistisch
modelliert, manganfarbene Ge-
sichtszeichnung, gelbes Halsband;
unglasierter Boden.

130 + 131 Zwei sitzende
Hunde auf achteckigem
Sockel

Niederlande, 18. Jahrhundert
Fayence, polychrome Bemalung in
Scharffeuertechnik
Signatur/Marke: keine
14,5 × 9,8 × 7,5 cm, 299 g
14,5 × 10,5 × 7,5 cm, 232 g
Inv.-Nr. A 42, 43

Sitzende Hunde auf je einem acht-
eckigen Sockel; weißes Fell mit
manganvioletten Flecken, gelbes
Halsband mit den Buchstaben
„GW ZB", langer, auf dem Rücken
abgelegter Schwanz; abgetreppter,
unstaffierter bzw. grünblau staf-
fierter Sockel; glasierter Boden,
Brennloch vorn am Halsband
bei A 42.

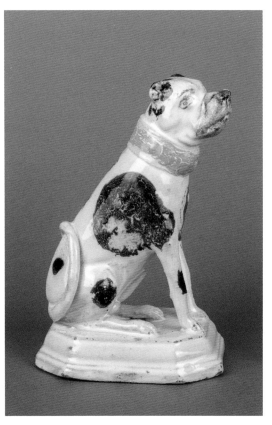 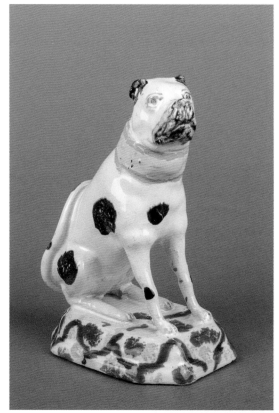

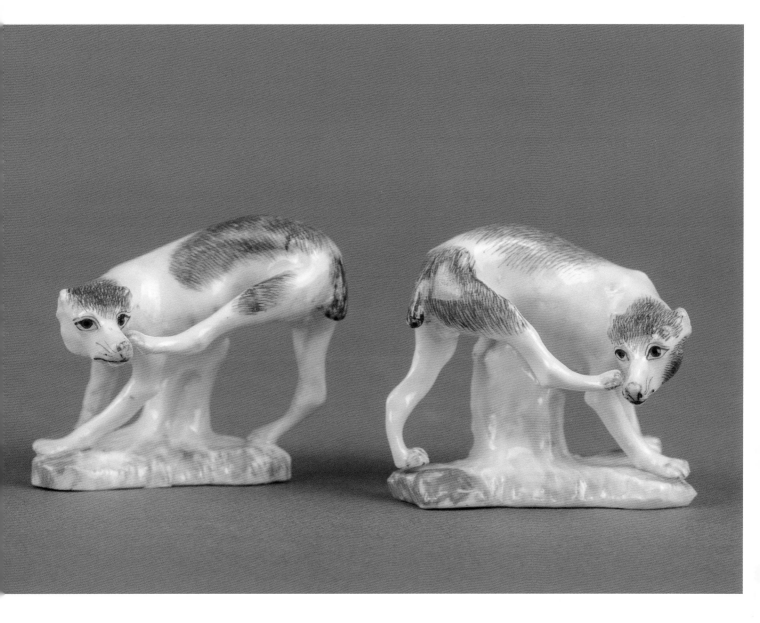

132 + 133 Ein Paar sich kratzender Jagdhunde auf Terrainsockeln

Meissen oder Kelsterbach, um 1750
Modell: Peter Reinicke
Porzellan, polychrome Bemalung
in Aufglasurtechnik
Signatur/Marke: Löwenmarke
in Blau
4 × 4,5 × 4,5 cm, 25 g
4 × 4,5 × 4 cm, 27 g
Inv.-Nr. A 44, 45

Zwei sich kratzende Jagdhunde,
einer nach rechts, der andere nach
links gewandt; weißes Fell mit
braunen Flecken, kupierte Ohren
und Schwänze; Terrainsockel mit
grüner Staffierung und Standhilfe
unter dem Bauch; unglasierter
Boden.

Nächste Doppelseite:

134 + 135 Zwei sitzende Hunde

Meissen, um 1745
Modell: Johann Joachim Kändler
Porzellan, polychrome Bemalung in
Aufglasurtechnik
Signatur/Marke: keine
17,3 × 17,5 × 10 cm, 747 g
16,2 × 18,5 × 9 cm, 757 g
Inv.-Nr. A 46, 47
Literatur: Newman 1977, S. 108.

Zwei sitzende Hunde nach rechts
bzw. links schauend, weißes Fell
mit braunen Flecken, große rot-
braune Augen, flache, trichter-
förmige Ohren, seitlich gebogener
bzw. nach oben geringelte Rute;
unglasierter Boden mit Brennloch;
naturalistische Darstellung der im
18. Jahrhundert üblichen Rehpin-
scher, die als Jagdhunde eingesetzt
wurden.

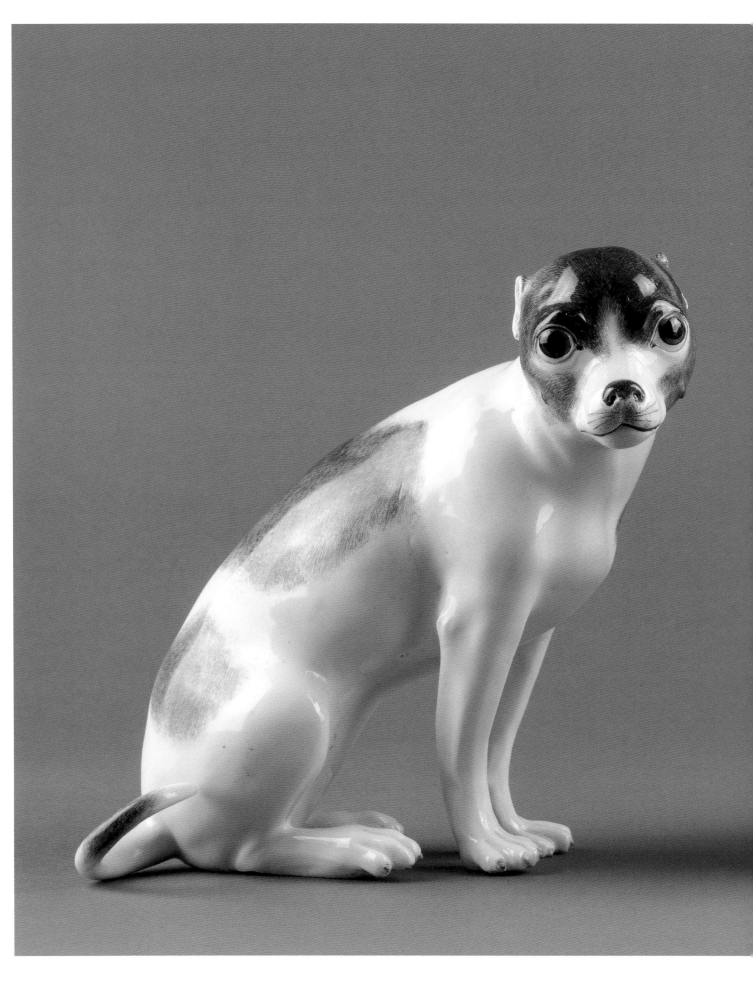

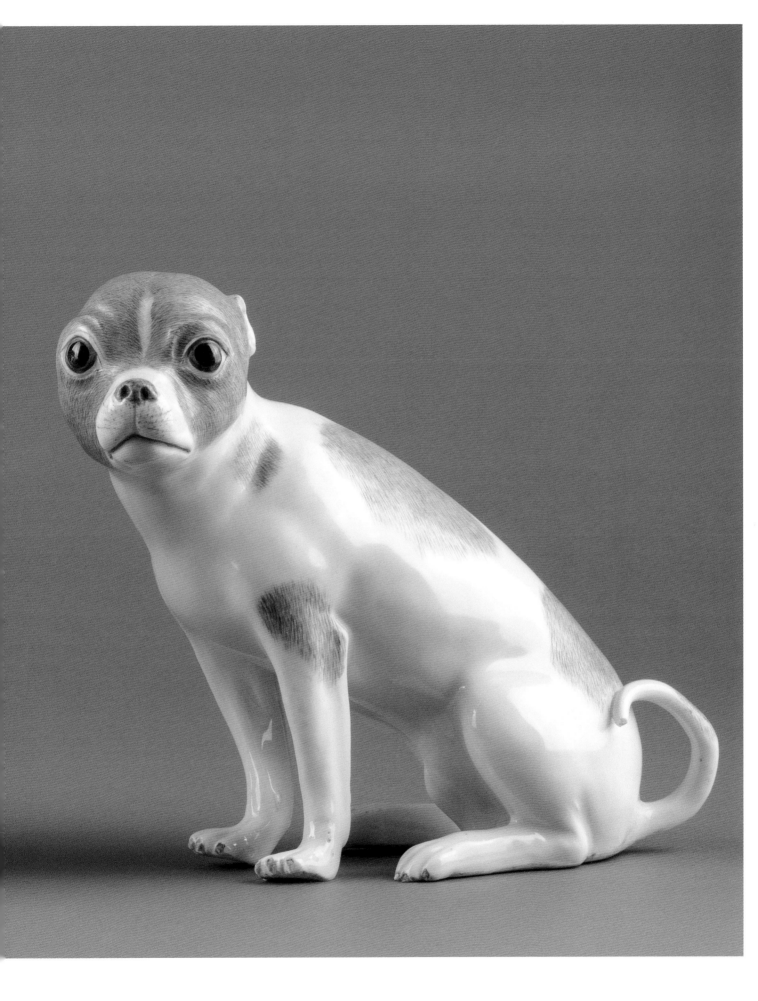

**136 Sitzender Hund
auf Grassockel**

Meissen, um 1750
Porzellan, polychrome Bemalung
in Aufglasurtechnik
Signatur/Marke: keine
3,5 × 2,8 × 1,7 cm, 11 g
Inv.-Nr. A 51
Provenienz: Collection of Sir
Gawaine and Lady Baillie; Röbbig,
München.

Sitzender Hund auf Terrainsockel
mit grüner Staffierung, weißes Fell
mit braunen Flecken, spitz aufge-
stellte Ohren, dicker Schwanz, der
sich um den Sockel legt; unglasier-
ter Boden; leicht stilisierte Darstel-
lung der kleinen, aus Asien stam-
menden Jagdhundrasse Shiba Inu.

137 Jagdhund

Frankenthal, 1759–1762
Modell: Johann Friedrich Lücke
Porzellan, polychrome Bemalung
in Aufglasurtechnik
Signatur/Marke: Löwenmarke
in Blau
7 × 12,5 × 5 cm, 154 g
Inv.-Nr. A 48

Schnüffelnder Jagdhund; weißes
Fell mit braunen Flecken, Maul
leicht geöffnet, langer Schwanz,
Rippen und Muskulatur plastisch
modelliert; Terrainsockel mit
grüner Staffierung; unglasierter
Boden; naturalistische Darstellung
der Jagdhundrasse Deutsches
Kurzhaar.

138 Sitzender Hund auf Grassockel

Süddeutschland, um 1760
Fayence, polychrome Bemalung
in Scharffeuertechnik
Signatur/Marke: keine
9,8 × 8 × 5,5 cm, 208 g
Inv.-Nr. A 38

Sitzender Hund nach vorn schau-
end, weißes Fell mit Binnenzeich-
nung, grünes Halsband; Sockel und
Hund ineinander übergehend,
unglasierter Boden.

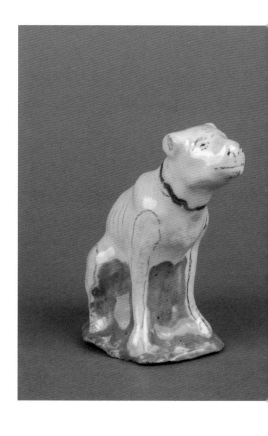

139 Sitzender Hund auf rechteckigem Sockel

Ludwigburg, 1762–1772
Modell: Johann Jacob Louis
Fayence, polychrome Bemalung in
Scharffeuertechnik
Signatur/Marke: CC-Marke legiert
6,5 × 4,5 × 3 cm, 47 g
Inv.-Nr. A 109

Sitzender Hund auf grün staffier-
tem Terrainsockel, nach oben
schauend, naturalistisch model-
liert, braune Fellflecke und
Gesichtszeichnung; gewölbter,
glasierter Boden mit Brennloch;
leicht stilisierte Darstellung der
Jagdhundrasse Shiba Inu.

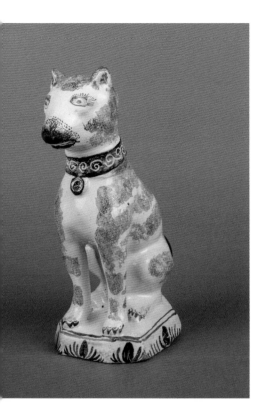

140 Sitzender Hund

Delft, 18. Jahrhundert
Fayence, blaue und manganviolette
Bemalung in Scharffeuertechnik
Signatur/Marke: keine
19,5 × 12 × 7,5 cm, 708 g
Inv.-Nr. A 39

Sitzender Hund auf achteckigem,
hohem Sockel, weißes Fell mit
manganvioletten, geschwämmelten
Flecken, Schnauze und Augen blau
staffiert, langer, nach oben gerin-
gelte, blaue Rute, Halsband mit
Spiraldekor und Anhänger, Sockel
mit blauer Staffierung; glasierter
Boden; leicht stilisierte Darstellung
eines Shiba Inus.

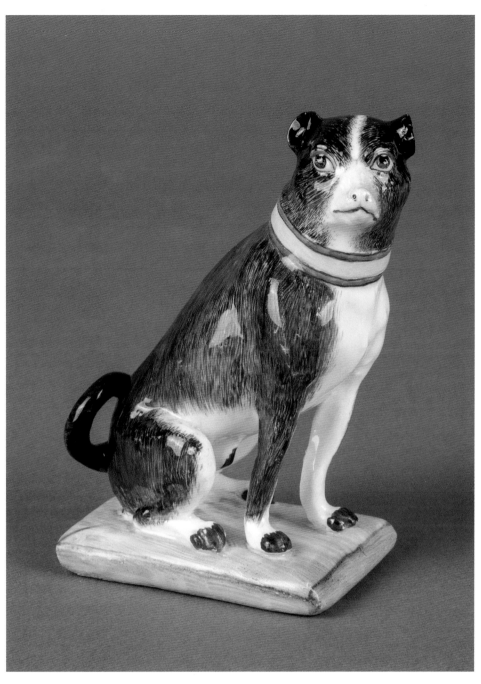

141 Sitzender Dänischer Hund auf Kissen

Meissen, 1740–1745
Porzellan, polychrome Bemalung in
Aufglasurtechnik
Signatur/Marke: keine
11 × 7,8 × 4,8 cm, 220 g
Inv.-Nr. A 37

Sitzender Hund auf rosa Kissen
nach rechts schauend, schwarzes
Fell mit weißem Bauch, rosa-lila
Halsband mit roter Schleife, flache,
trichterförmige Ohren, nach oben
geringelte Rute; unglasierter
Boden; naturalistische Darstellung
eines Kleinen Dänischen Hundes.

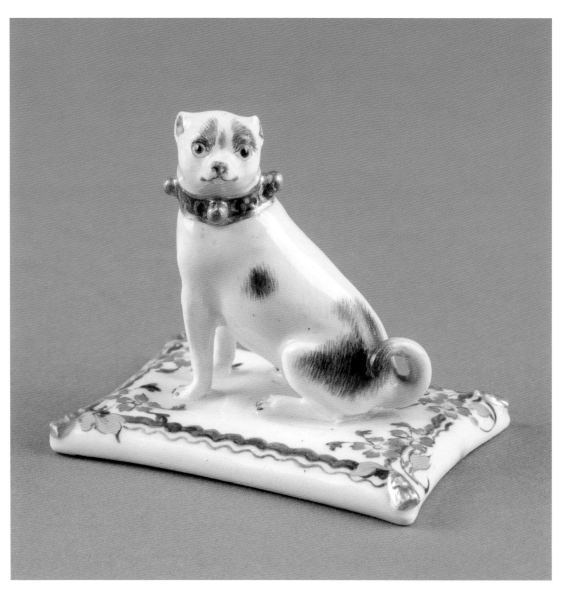

**142 Sitzender Kleiner
Dänischer Hund auf Kissen**

Meissen, 1750–1760 (Malerei etwas
später)
Modell: Johann Gottlieb Ehder
Porzellan, polychrome Bemalung in
Aufglasurtechnik, Goldmalerei
Signatur/Marke: Schwerter in Blau
6 × 6 × 4,5 cm, 59 g
Inv.-Nr. A 515
Literatur: Kunze-Köllensberger 1999:
„Arbeitsbericht J. G. Ehder, Mai 1743:
1 sitzender Hund auf einem Kissen";
vgl. Sammlung Jahn, Auktionskatalog
Lempertz, Köln, Juni 1989, Los 208.
Provenienz: Dresden, Johanneums-
Nr. 189; Collection of Sir Gawaine and
Lady Baillie.

Sitzender Hund auf flacher, rechtecki-
ger, als Kissen staffierter Plinthe mit
Blumen und Quasten, Kopf rückwärtig
nach links gewandt, weißes Fell mit
braunen Flecken, purpur-goldenes
Halsband mit goldenen Schellen und
Ornamentdekor, flache trichterförmi-
ge Ohren, geringelte Rute; unglasierter
Boden. Naturalistische Darstellung
eines Kleinen Dänischen Hundes.

**143 Sitzender Dänischer
Hund auf Kissen**

Meissen, 1750–60
Modell: Johann Gottlieb Ehder
Porzellan, polychrome Bemalung
in Aufglasurtechnik, Goldmalerei
Signatur/Marke: keine
10,5 × 9 × 4,5 cm, 198 g
Inv.-Nr. A 516
Literatur: s. Kat.-Nr. 142

Sitzender Hund auf flacher,
rechteckiger, als Kissen staffierter
Plinthe mit Blumendekor und
Goldrand, Kopf nach links zurück-
gewandt, weißes Fell mit schwarz-
braunen Flecken, gold-schwarzes
Halsband mit türkisfarbener
Schleife und Ornamentdekor,
flache trichterförmige Ohren,
geringelte Rute; unglasierter Boden
mit Brennloch. Naturalistische
Darstellung eines Kleinen Däni-
schen Hundes.

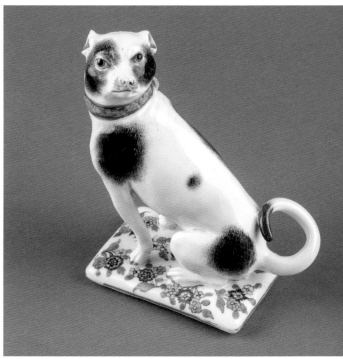

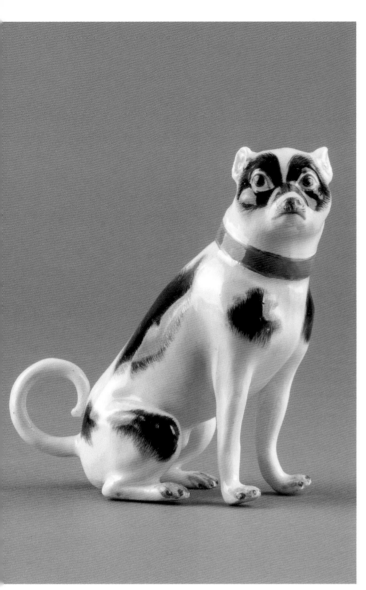

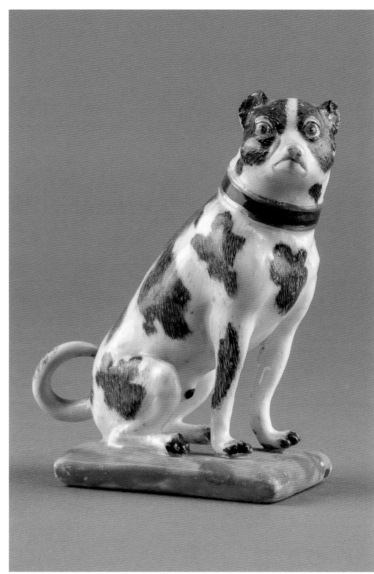

144 Sitzender Dänischer Hund

Meissen, 1740–1745
Porzellan, polychrome Bemalung in
Aufglasurtechnik, Goldmalerei
Signatur/Marke: Schwerter in Blau
10 × 9 × 5 cm, 142 g
Inv.-Nr. A 52
Literatur: Albiker 1959, Kat.-Nr.
178; Möller 2006, Kat.-Nr. 22, S. 69.
Provenienz: Collection of Sir
Gawaine and Lady Baillie; Röbbig,
München.

Sitzender Hund nach rechts schau-
end, weißes Fell mit schwarz-
braunen Flecken, grün-goldenes
Halsband mit purpurfarbener
Schleife, flache, trichterförmige
Ohren, nach oben geringelte Rute;
unglasierter Boden mit Brennloch
unterm Schwanz; naturalistische
Darstellung eines Kleinen Däni-
schen Hundes.

**145 Sitzender Dänischer
Hund auf Grassockel**

Meissen, 1740–1745
Porzellan, polychrome Bemalung in
Aufglasurtechnik, Goldmalerei
Signatur/Marke: Pressnummer „50"
11 × 9 × 4,5 cm, 222 g
Inv.-Nr. A 53

Sitzender Hund nach rechts schau-
end, weißes Fell mit schwarzen
Flecken, rot-goldenes Halsband
mit gelber Schleife, flache, trichter-
förmige Ohren, nach oben gerin-
gelte Rute; unglasierter Boden
mit Brennloch unterm Schwanz;
naturalistische Darstellung eines
Kleinen Dänischen Hundes.

146 Hütehund mit Knebelhalsband

Meissen, um 1750
Modell: Johann Joachim Kändler,
um 1745
Porzellan, polychrome Bemalung
in Aufglasurtechnik
12,5 × 15 × 10 cm, 438 g
Signatur/Marke: Schwerter in Blau
Inv.-Nr. A 113
Literatur: Möller 2006, S. 69,
Kat.-Nr. 20.

Sitzender Hund, den Kopf nach
links gewandt, naturalistische
Modellierung des langhaarigen,
hellen Fells mit grau-braunen
Flecken, aufgestellte, spitze Ohren,
im Halbkreis aufgerichteter
Schwanz, kräftiges Halsband mit
waagerechtem Holzstock über der
Brust (sogenanntes Knebelhals-
band, siehe S. 68); unglasierter
Boden mit Brennloch; naturalisti-
sche Darstellung eines Border
Collie.

147 Sitzende Dänische
Hündin mit zwei Welpen

Meissen, um 1745
Modell: Johann Joachim Kändler
Porzellan, polychrome Bemalung
in Aufglasurtechnik, montierter
Bronzesockel
Signatur/Marke: keine sichtbar
(Montierung)
22,5 × 24 × 18 cm, 4340 g (mit
Montierung)
Inv.-Nr. A 112
Literatur: Albiker 1959, Kat. Nr. 182;
Pietsch 2006, Kat.-Nr. 299, S. 193.

Sitzende Hündin mit zwei Welpen,
einen Welpen hat sie schützend
zwischen den Vorderbeinen, dem
andere leckt sie die nach oben
gestreckte Schnauze; weißes Fell
mit schwarzen Flecken, sitzender
Welpe, braun gefleckt mit rotem
Halsband mit roter Schleife; flache,
trichterförmige Ohren, geringelte
Rute; Gruppe ist auf ein vergoldetes
Bronzekissen mit Brokatmuster
und Randkordel montiert; natura-
listische Darstellung eines Kleinen
Dänischen Hundes.

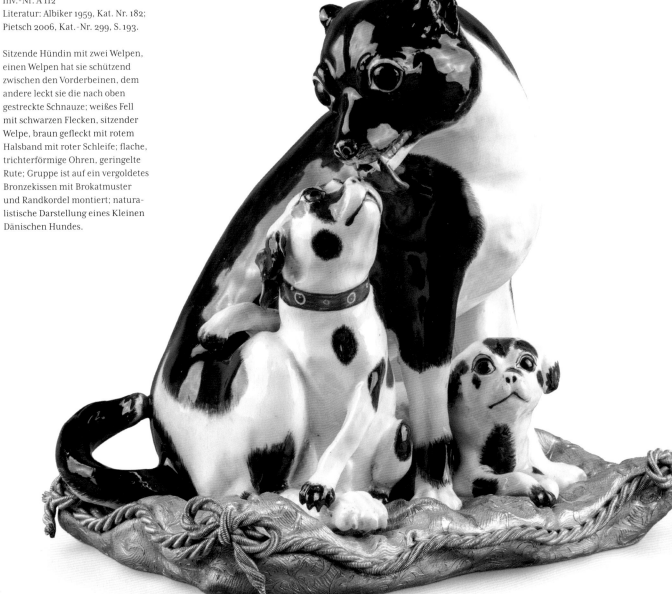

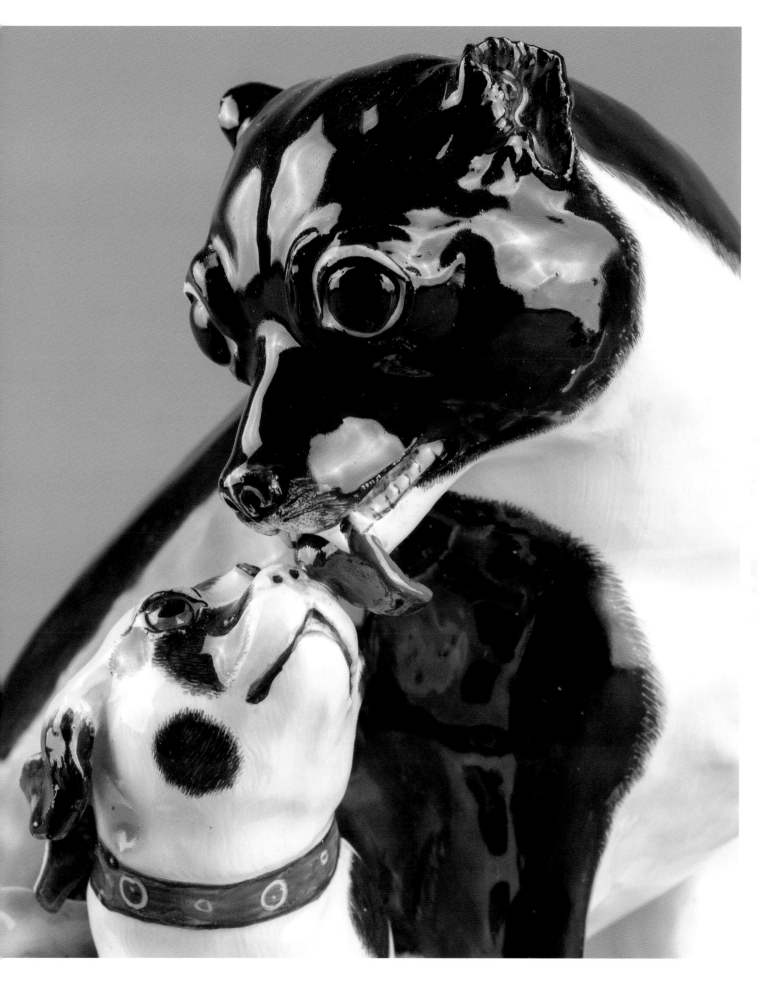

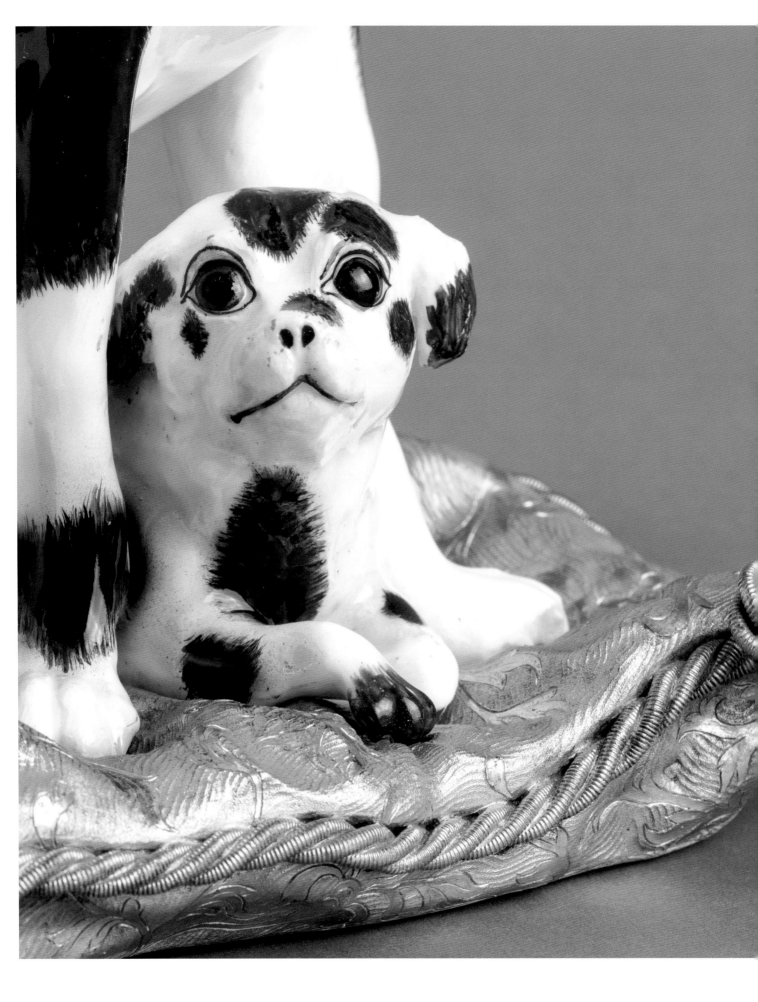

148 Sitzender Dänischer Hund

Meissen, um 1745
Modell: Johann Joachim Kändler
Porzellan, polychrome Bemalung
in Aufglasurtechnik, montierter
Bronzesockel
Signatur/Marke: keine sichtbar
(Montierung)
24 × 25 × 18 cm, 3371 g (mit
Montierung)
Inv.-Nr. A 111
Literatur: s. Kat.-Nr. 147

Sitzender Hund nach links zurück-
schauend; weißes Fell mit schwarzen
Flecken, flache, trichterförmige
Ohren, spitze Schnauze, geringelte
Rute; auf ein vergoldetes Bronzekissen
mit Brokatmuster und Randkordel
montiert; naturalistische Darstellung
eines Kleinen Dänischen Hundes.

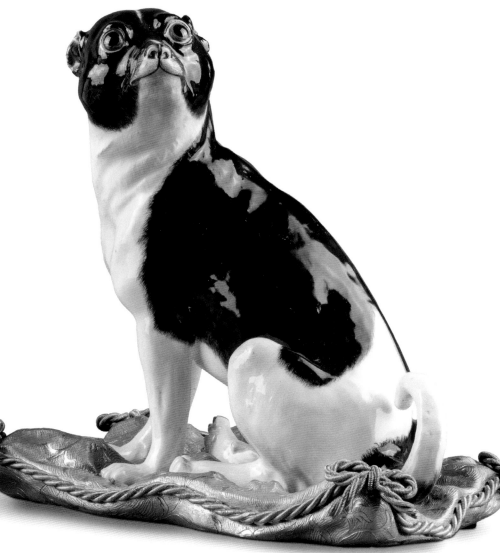

149 Sitzender Dänischer Hund

Meissen, um 1745
Modell: Johann Joachim Kändler
Porzellan, schwarze Bemalung in
Aufglasurtechnik
Signatur/Marke: keine
22,5 × 22,5 × 9,5 cm, 1461 g
Inv.-Nr. A 108
Literatur: s. Kat.-Nr. 147

Sitzender Hund, naturalistisch
modelliert und staffiert, Kopf
nach links gewandt, trichterförmige
Ohren; unglasierter Boden mit
Brennloch.

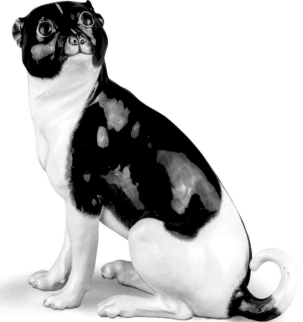

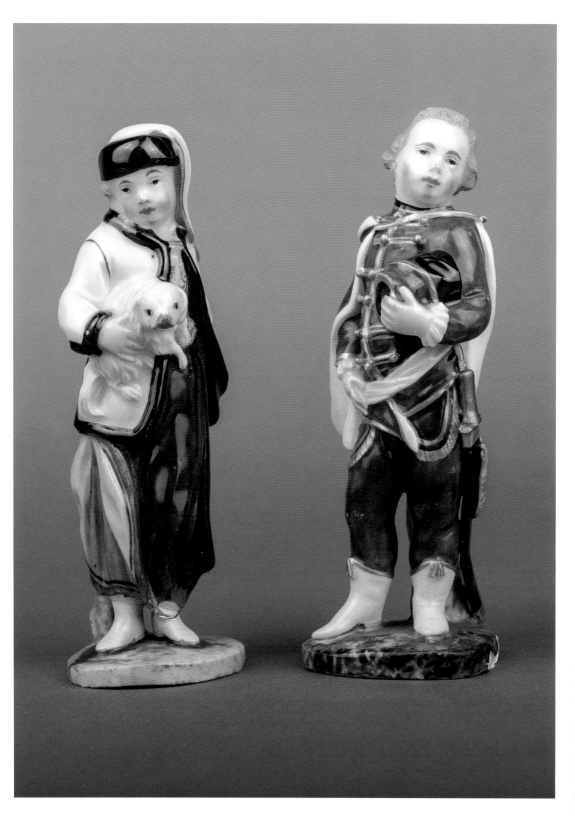

150 Orientalin mit
Bologneser Hund unter
dem Arm und Kavalier

Ludwigsburg, 18. Jahrhundert
Porzellan, polychrome Bemalung in
Aufglasurtechnik, Goldmalerei
Signatur/Marke: CC-Marke (Dame)
11 × 4 × 3,5 cm, 86 g
11 × 4 × 4 cm, 90 g
Inv.-Nr. A 116 a, b

Stehende Dame auf rundem Terrain-
sockel mit weißem Bologneser
Hündchen unter dem rechten Arm,
orientalische Tracht mit rotem
Rock, goldenem Mieder, weißer
Jacke mit schwarzem Besatz, Kappe
mit langem Zipfel und Quaste;
Kavalier in roter Husarenuniform
auf rundem Sockel, hohe Mütze im
linken Arm; unglasierter Boden.

151 Sitzender Jagdhund auf Grassockeln

Meissen, um 1750
Porzellan, polychrome Bemalung in Aufglasurtechnik
Signatur/Marke: keine
5,5 × 6 × 2,5 cm, 24 g
Inv.-Nr. A 59

Sitzender Jagdhund auf grün staffiertem Terrainsockel, weißes Fell mit schwarzen Flecken, gold-schwarzes Halsband, nach oben geringelte Rute; unglasierter Boden mit Brennloch unterm Schwanz; naturalistische Darstellung der englischen Jagdhundrasse Greyhound.

152 Knurrender Jagdhund auf Grassockeln

Meissen, um 1750
Porzellan, polychrome Bemalung in Aufglasurtechnik
Signatur/Marke: keine
3,5 × 5,7 × 3 cm, 30 g
Inv.-Nr. A 60

Knurrend nach vorn gestreckter Jagdhund auf grün staffiertem Terrainsockel, weißes Fell mit schwarzen Flecken, gold-schwarzes Halsband, nach oben geringelte Rute; unglasierter Boden mit Brennloch unterm Schwanz, kurze Standhilfe unter der Brust; naturalistische Darstellung der englischen Jagdhundrasse Greyhound.

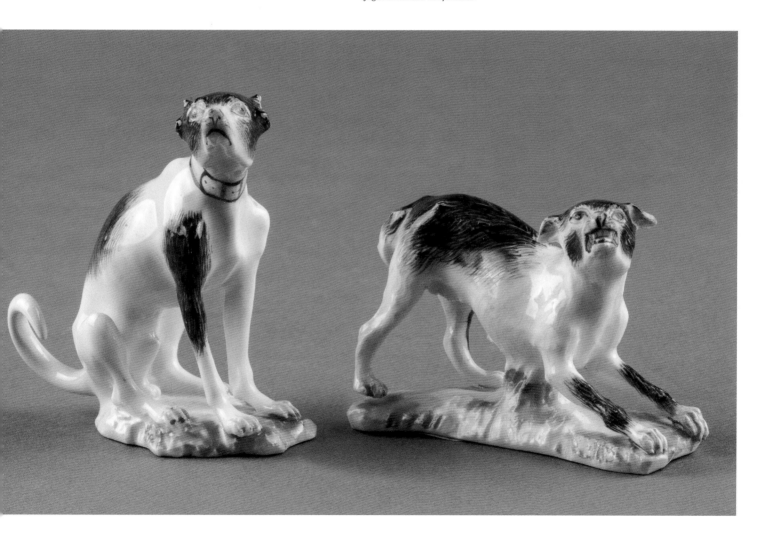

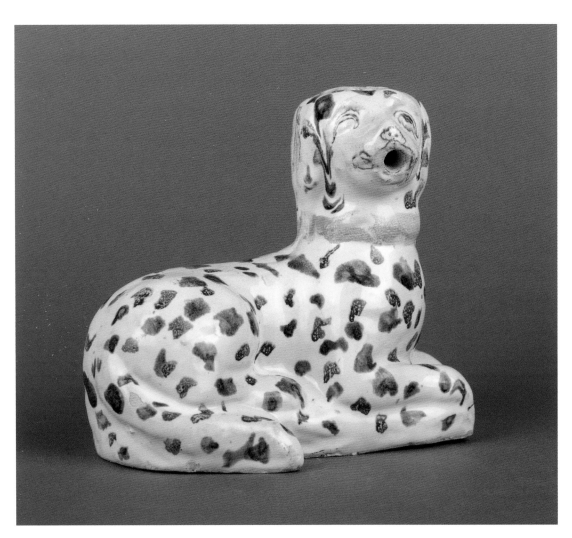

**153 Sitzender Hund
als Scherzgefäß**

Delft, 18. Jahrhundert
Fayence, polychrome Bemalung
in Scharffeuertechnik
Signatur/Marke: keine
13,5 × 15 × 8,5 cm, 521 g
Inv.-Nr. A 85
Provenienz: B. F. Edwards
Collection, zuvor: Mark and
Marjorie Allen.

Sitzender Hund, weißes Fell mit
manganvioletten und blauen
Flecken, Schnauze und Augen
manganviolett staffiert, gelbes
Halsband; Öffnung am Scheitel
(Verschlussstopfen fehlt), Ausguss-
loch in der Schnauze; teils glasierter
Boden; stilisierte Darstellung einer
Deutschen Bracke.

**154 Sitzender Miniatur-
windhund auf Grassockel**

Meissen, um 1750
Porzellan, polychrome Bemalung in
Aufglasurtechnik
Signatur/Marke: Schwerter in Blau
5,8 × 5,5 × 3 cm, 25 g
Inv.-Nr. A 101

Sitzender Windhund nach rechts
schauend auf grün staffiertem
Terrainsockel, weißes Fell mit
braunen Flecken, gelb-schwarzes
Halsband, nach oben geringelte
Rute und kopierte Ohren; ungla-
sierter Boden mit Brennloch;
naturalistische Darstellung der
englischen Jagdhundrasse Grey-
hound.

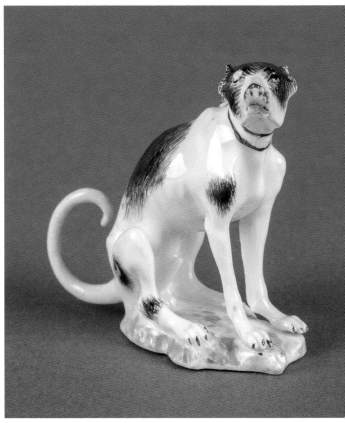

**155 Zierdose in Form
eines Hundekopfes**

Berlin, 1820–1830
Porzellan, polychrome Bemalung
in Aufglasurtechnik
Signatur/Marke: Zepter-Marke KPM
18,5 × 18 × 8,5 cm, 458 g
Inv.-Nr. A 64

Runde Dose in Form eines Hunde-
kopfes mit langer, schlanker
Schnauze, schwarz-weißes Fell;
beide Teile verbunden durch
Silbermontierung mit Deckel;
naturalistische Darstellung eines
Greyhound-Kopfes.

Manufakturenverzeichnis Index of Manufactories

Anmerkungen zum Katalog

Wenn man als Kunsthistoriker eine Privatsammlung bearbeiten darf, ist das eine besonders schöne Herausforderung, die wir gern angenommen haben. Das Buch soll Freude bereiten und den individuellen Charakter der Sammlung wiederspiegeln. Gleichzeitig entspricht es wissenschaftlichen Kriterien und zieht nicht nur Möpse, sondern zusätzlich verschiedene Hunderassen als höfische Begleiter in die Betrachtung mit ein. Dazu boten die keramischen Tiere aus verschiedenen Manufakturen eine hervorragende Grundlage.

Auf eine Markentafel haben wir verzichtet, da ausschließlich die bekannten Manufakturmarken zu finden sind und im Katalog benannt wurden. Genauere Angaben können gern bei den Autorinnen erfragt werden. Als neues wissenschaftliches Kriterium haben wir das Gewicht der Objekte aufgenommen. Es ist für die Spezifizierung und Datierung ein erstaunlich präziser Parameter. So ist beispielsweise die Neuausformung eines Rokokomodells aus dem 19. Jahrhundert in der Regel deutlich schwerer bei fast identischen Maßen als eines aus dem 18. Jahrhundert. Dadurch zeichnen sich allein anhand des Gewichts bereits Datierungstendenzen ab. Literatur ist dann angeführt worden, wenn sie sich direkt auf das Objekt bezieht oder relevante, weiterführende Informationen enthält. Auf Vergleiche aus Auktionskatalogen haben wir verzichtet, da sie niemals vollständig sein können.

Wir wünschen allen Lesern viel Vergnügen an und mit den höfischen Begleitern.

Gun-Dagmar Helke und Hela Schandelmaier

Notes on the catalogue

Being permitted to work on a private collection as art historians represents a particularly daunting challenge but is one we have gladly taken on. This book is meant to be fun to read while reflecting the individual character of the collection. At the same time, it meets scholarly standards and includes observations on several other breeds of dog besides pugs as courtly companions. The china animals made by the various manufactories have provided an outstanding basis for study.

We have eschewed a table of porcelain and pottery marks because all the manufactories represented are so well known and are named in the catalogue. The authors would be delighted to provide more precise data on request. The new scholarly criterion added here is the weight of each object. It represents an astonishingly precise parameter for specification and dating. A nineteenth-century cast taken from an eighteenth-century Rococo model tends, for instance, to be considerably heavier than an eighteenth-century cast from the same model even though the dimensions of the piece have remained virtually identical. Hence weight alone provides an important indicator of date. Specialist literature is cited when it refers directly to an object or contains further relevant items of information. Auction catalogues are not included in our bibliography because they can never be complete.

We wish our readers a lot of fun with this book and these courtly companions.

Gun-Dagmar Helke and Hela Schandelmaier

Ausgewählte Literatur Selected Bibliography

Adams 2001
Elizabeth Adams, Chelsea
Porcelain, London 2001

Albiker 1959
Carl Albiker, Die Meissner Porzel-
lantiere im 18. Jahrhundert, Berlin
1959

Bahn 2011
Peter Bahn, Das Brettener Hundle.
Eine Spurensuche, Bretten 2011

Beaucamp-Markowski 1985
Barbara Beaucamp-Markowski,
Porzellandosen des 18. Jahrhun-
derts, München 1985

Bertuch/Kraus 1789
Friedrich Justin Bertuch und
Georg Melchior Kraus (Hrsg.),
Journal des Luxus und der Moden,
4. Jg. Weimar, Julius 1789

Binder 1988
Dieter Anton Binder, Die diskrete
Gesellschaft. Geschichte und
Symbolik der Freimaurer, Graz/
Wien/Köln 1988

Blauween 2000
Abraham L. den Blauween,
Meissen Porcellain in the Rijks-
museum, Catalogues of the Decora-
tive Arts in the Rijksmuseum
Amsterdam 4, Zwolle 2000

Brattig 2010
Patricia Brattig, Meissen. Barockes
Porzellan, Stuttgart 2010

Buffon 1755
Georges Louis Leclerc Comte de
Buffon, Bernard-Germain-Étienne
Comte de Lacépède, Louis-Jean-
Marie Daubenton, Histoire natu-
relle gènèrale et particulière avec
la description du Cabinet du Roi
tome V., Paris 1755

Bursche 1974
Stefan Bursche, Tafelzier des
Barock, München 1974

Bursche 1996
Stefan Bursche, Galanterien,
Dosen, Etuis und Miniaturen aus
Gold, Edelsteinen, Email und
Porzellan – Eine Berliner Privat-
sammlung, Berlin 1996

Caius 1570
John Caius, De Canibus Britan-
nicis, London 1570

Caius 1576
John Caius, Of Englishe Dogges,
the diversities, the names, the
natures, and the properties,
London 1576

Cassidy-Geiger 2008
Maureen Cassidy Geiger, The
Arnold Collection, Meissen Porcel-
ain 1710–1750, London 2008

Chilton 2001
Meredith Chilton, Harlequin
Unmasked. The Commedia dell'
Arte and Porcelain Sculpture,
New Haven/London 2001

Commedia 2001
Commedia dell' Arte. Fest der
Komödianten – Keramische Kost-
barkeiten aus den Museen der
Welt, mit separater englischer
Übersetzung und Begleitheft der
Stichfolgen, Ausst.-Kat. Schloß
Charlottenburg und Bröhan
Museum Berlin, hrsg. v. Reinhard
Jansen i.A. der Gesellschaft der
Keramikfreunde e.V., Stuttgart
2001

Dresden 1991
Ey, wie schmeckt der Coffee süße.
Meissner Porzellan und Grafik,
Ausst.-Kat. Staatliche Kunst-
sammlungen Dresden, hrsg.
von der Porzellansammlung im
Zwinger, Sammlung Eduscho,
Bremen, Bremerhaven 1991

Flach 1997
Hans Dieter Flach, Ludwigsburger
Porzellan. Ein Handbuch, Stutt-
gart 1997

Fleming 1749
Hans Friedrich von Fleming,
Der Vollkommene Teutsche Jäger.
Haupt-Theil 1. Die andere Auflage.
Martini, Leipzig 1749

Franz 1781
Johann Georg Friedrich Franz,
Ausführliche Geschichte der
Hunde, von ihrer Natur, verschie-
dene Arten, Erziehung, Abrich-
tung, Krankheiten, Leipzig 1781

Gersdorff 1986
Dagmar von Gersdorff, Kinder-
bildnisse aus vier Jahrtausenden
aus den Sammlungen der Stiftung
Preußischer Kulturbesitz Berlin,
Berlin 1986

Illgen 1973
Gudrun Illgen, Mopsiade, Möpse
aus drei Jahrhunderten, Ausst.-
Kat. Schlossmuseum Darmstadt
1973

Jedding 1968
Hermann Jedding, Porzellan aus der
Sammlung Blohm, Museum für
Kunst und Gewerbe, Hamburg 1968

Jedding 1974
Hermann Jedding, Europäisches
Porzellan Bd. 1. Von den Anfängen
bis 1800, München 1974

Jedding 1982
Hermann Jedding, Meissener
Porzellan des 18. Jahrhunderts in
Hamburger Privatbesitz, Hamburg
1982

Köllmann 1970
Erich Köllmann, Der Mopsorden,
in: Keramos 50, Oktober 1970,
S. 71-82

Krünitz 1839
Johann Georg Krünitz, Oecono-
misch-technologische Encyklo-
pädie, oder allgemeines System
Staats-, Stadt-, Haus- und Land-
wirtschaft, und der Kunstge-
schichte in alphabetischer Ord-
nung, 172. Theil, Berlin 1839

Kunze-Köllensperger 1996
Melitta Kunze-Köllensperger,
Idylle in Porzellan. Kostbare
Tischdekorationen aus Meissen,
Leipzig 1996

Kunze-Köllensperger 1999
Melitta Kunze-Köllensperger,
Alexanders Tiere, Mainz 1999
(Sammlung Axel Gutmann 7)

Kunze-Köllensperger 2008
Sammlung Ritter Kempski von
Sarkoszyn, Meissner Porzellan des
18. Jahrhunderts, Privatdruck,
München 2008

Krueger 2011
Thomas Krueger, Mops! Eine
kleine Kulturgeschichte, Brevier
zur Sonderausstellung im Museum
im Schloss, Porzellanmanufaktur
Fürstenberg, April – August 2011,
Holzminden 2011

Langeloh 2019
Elfriede Langeloh, 100 Jahre.
Porzellane und Fayencen des
18. Jahrhunderts 1919-2019,
Weinheim 2019

Lanz 1983
Hans Lanz, Porzellan des 18. Jahr-
hunderts im Kirschgarten aus der
Pauls-Eisenbeiss-Stiftung Basel,
Basel 1983

Lauer 2014
Céline Lauer, Tiere machen
Geschichte. Auf den Mops
gekommen, in: Welt online
vom 09.11.2014

Lessmann 2006
Johanna Lessmann, Porzellan.
Glanzstücke der Sammlung des
Museums für Kunst und Gewerbe
Hamburg, Hamburg 2006

Leyen 2002
Katharina von der Leyen, Der
Geliebte. Möpse sind die Hunde
der Saison. Ein Bekenntnis, in: Die
ZEIT, Nr. 33/2002 vom 8.8.2002

Mahnert 1993
Adelheid Mahnert, Thüringer
Fayencen, Leipzig 1993

**Mariën-Dugardin/Duphénieux
1966**
Anne Marie Mariën-Dugardin,
Gabriel Duphénieux, Faiences
Tournaisiennes, Brüssel 1966

Menzhausen/Karpinski 1993
Ingelore Menzhausen und Jürgen
Karpinski, In Porzellan verzau-
bert. Die Figuren Johann Joachim
Kändlers in Meissen aus der
Sammlung Pauls-Eisenbeiss Basel,
Basel 1993

Möller 2006
Karin Annette Möller, Meissner
Porzellanplastik des 18. Jahrhun-
derts, Die Schweriner Sammlung,
hrsg. von Kornelia von Bersword-
Wallrabe, Schwerin 2006

Mops 2008
Der Mops – ein Kunstwerk, hrsg.
H2SF editions 2008

Mrazek/Neuwirth 1970
Wilhelm Mrazek und Waltraud
Neuwirth, Wiener Porzellan
1718–1864, Katalog des Öster-
reichischen Museums für ange-
wandte Kunst Nr. 3, Wien 1971

Newman 1977
Michael Newman, Die Deutschen
Porzellanmanufakturen Bd. 1 und
2, Braunschweig 1977

Noeske 2001
Felicitas Noeske, Das Mopsbuch,
Frankfurt a. M./Leipzig 2001

Perau 1745
Abbé Gabriel Louis Calabre Perau,
Der verratene Orden der Freimäu-
rer und das offenbarte Geheimniß
der Mopsgesellschaft, aus dem
Französischen bei Arktee und
Merkus, Leipzig 1745

Pietsch 2002
Ulrich Pietsch, Die Arbeitsberichte
des Meissner Porzellanmodelleurs
Johann Joachim Kändler 1706–1775,
Leipzig 2002

Pietsch 2005
Ulrich Pietsch, Porzellan Parforce,
Jagdliches Meissner Porzellan des
18. Jahrhunderts, München 2005

Pietsch 2006
Ulrich Pietsch, Die figürliche
Meissner Porzellanplastik von
Gottlieb Kirchner und Johann
Joachim Kändler. Bestandskatalog
der Porzellansammlung Staatliche
Kunstsammlungen Dresden,
München 2006

Pietsch/Banz 2010
Ulrich Pietsch und Claudia Banz,
Triumph der blauen Schwerter,
Meissner Porzellan für Adel und
Bürgertum 1710–1815, Leipzig 2010

Porcelain Pugs: A Passion 2019
Porcelain Pugs: A Passion, Brüssel
2019

Rafael 2009
Johannes Rafael, zur Taxa Kaend-
ler, in: Keramos 203/204, 2009,
S. 25-70

Räber 1993
Hans Räber, Enzyklopädie der
Hunderassen, Bd. 1, Stuttgart 1993

Reber 1986
Horst Reber, Die Kurmainzische
Porzellanmanufaktur Höchst,
München 1986

Rückert 1966
Rainer Rückert, Meissner Porzel-
lan 1710–1810, Ausst.-Kat. Bayeri-
sches Nationalmuseum München,
München 1966

Rudi 1998
Thomas Rudi, Augenlust und
Gaumenfreude, Fayencegeschirre
des 18. Jahrhunderts, Ausst.-Kat.
des Museums für Kunst und Ge-
werbe Hamburg, Hamburg 1998

Sammlung Jahn 1989
Sammlung Jahn, Auktionskatalog
Lempertz, Köln, Juni 1989

Schandelmaier 1993
Hela Schandelmaier, Niedersäch-
sische Fayencen. Sammlungskata-
log des Kestner-Museums Hanno-
ver 11, Hannover 1993

Spies 1971
Gerd Spies, Braunschweiger Fa-
yencen, Braunschweig 1971

Sturm/Bednarczyk 2007
Elisabeth Sturm-Bednarczyk (hrg.)
und Elisabeth Sladek, Zeremo-
nien, Feste, Kostüme, Die Wiener
Porzellanfigur in der Regierungs-
zeit Maria Theresias, München
2007

Teusch 2015
Katharina Teutsch, Der Mops.
Kulturgeschichte eines Gesell-
schaftshundes, Berlin 2015

Teuscher 1998
Simon Teuscher, Hunde am Fürs-
tenhof. Köter und „edle wind" als
Medien sozialer Beziehungen vom
14. bis 16. Jahrhundert, in: Histori-
sche Anthropologie, Bd. 6, H 3,
online 1998

Treue Freunde 2019
Treue Freunde, Hunde und
Menschen hrsg. von Frank
Matthias Kammel, Ausst.-Kat.
des Bayerischen Nationalmuseums
München, November 2019 – April
2020, München/Berlin 2019

Wegmann/Schmitz 2016
Angela Wegmann und Siegfried
Schmitz, Der große BLV Hunde-
rassenführer, Aussehen, Eigen-
schaften, Haltung, München 2016

Winckell 1858
George Franz Dietrich aus dem
Winckell, Handbuch für Jäger,
Jagdberechtigte und Jagdlieb-
haber. Bearbeitet und hrsg. von
Johann Jacob von Tschudi. Brock-
haus, Leipzig 1858

Zubeck 1985
Paul Zubeck, Potpourris und
verdorbene Töpfe, in: Weltkunst
Jg. 55, Nr. 24, 1985, S. 3828–3832

Impressum Imprint

© 2020 arnoldsche Art Publishers, Stuttgart, und die Autoren and the authors

Alle Rechte vorbehalten. Vervielfältigung und Wiedergabe auf jegliche Weise (grafisch, elektronisch und fotomechanisch sowie der Gebrauch von Systemen zur Datenrückgewinnung) – auch in Auszügen – nur mit schriftlicher Genehmigung der Copyright-Inhaber.
www.arnoldsche.com

All rights reserved. No part of this work may be reproduced or used in any form or by any means (graphic, electronic or mechanical, including photocopying or information storage and retrieval systems) without written permission from the copyright holders.
www.arnoldsche.com

Autorinnen Authors
Gun-Dagmar Helke
Hela Schandelmaier

Übersetzung Translator
Joan Clough

Lektorat Copy editing
Wendy Brouwer

arnoldsche Projektkoordination
arnoldsche project coordination
Matthias Becher

Grafische Gestaltung
Graphic designer
Karina Moschke

Offset Reproduktion
Offset reproductions
Schwabenrepro

Druck Printed by
Schleunungdruck

Bindung Bound by
Hubert & Co.

Papier Paper
170 g/m² Dacostern

Bibliografische Information der Deutschen Nationalbibliothek
Die Deutsche Nationalbibliothek verzeichnet diese Publikation in der Deutschen Nationalbibliografie; detaillierte bibliografische Daten sind im Internet über www.dnb.de abrufbar.

Bibliographic information published by the Deutsche Nationalbibliothek
The Deutsche Nationalbibliothek lists this publication in the Deutsche Nationalbibliografie; detailed bibliographic data are available on the Internet at www.dnb.de.

ISBN 978-3-89790-600-6

Made in Europe, 2020

Bildnachweis Photo credits
Alte Nationalgalerie, Berlin: Abb. 69 | Château de Versailles, Versailles: Abb. 12 | Bayerische Staatsbibliothek, München: Abb. 61 | Bibliothèque nationale de France, Paris: Abb. 8 | bpk/Klassik Stiftung Weimar/Alexander Burzik: Abb. 11 | Buffon, 1755: Abb. 1 | Gordon 2009, S. 37: Abb. 19 | Hessisches Landesmuseum, Darmstadt: Abb. 62 | Jagdschloss Grunewald, Berlin: Abb. 60 | Kunsthistorisches Museum, Museumsverband, Wien: Abb. 59 | Kunsthaus Lempertz, Helmut Buchen: Abb. 70 | Langeloh Porcelain, Weinheim: Abb. 17 | Museum Aschenbrenner, Garmisch-Partenkirchen: Abb. 15 | Museum für Kunst und Gewerbe Hamburg; Hamburg: Abb. 16 | National Gallery of Art, Washington: Abb. 9, 10 | Historisches Museum Basel, Depositum der Pauls-Eisenbeiss-Stiftung, Foto: P. Portner: Abb. 18 | Perau 1745, Pl. II, VII, VIII: Abb. 20–22 | Privatbesitz: Abb. 14, 64 | Schloss Fontainebleau, Seine-et-Marne: Abb. 66 | Tate Images, London: Abb. 13 | Thomas Rebel, Bretten: Abb. 6 | Süddeutschland, Privatbesitz, Fotos: Bernd Bauer: Abb. 2, 3, 5, 23–58, 63, 65, 71, Kat.-Nr. 1–155 | Stadt Winnenden, Peter D. Hartung: Abb. 7 | Wikimedia Commons, Stephencdickson: Abb. 67 | Wellcome Images, London, Abb. 68